STRIPES
R.E.M.
Simon
KATE BUSH
THE MODERN LOVERS
CREEDENCE CLEARWATER REVIVAL
PJ. HARVEY
ELVIS COSTELLO + THE ATTRACTIONS
Mitchell
CURTIS MAYFIELD
BLONDIE
MIDNIGHT OIL
PINK FLOYD
PIXIES
SONIC YOUTH
PRIMAL
BLACK SABBATH
George Harrison
BRUCE SPRINGSTEEN
BEASTIE BOYS
GANG OF FOUR
THE BYRDS
KANYE WEST
JAY-Z
SEX PISTOLS
mes
ARCTIC MONKEYS
OASIS
KING
BECK
HEADS
PUBLIC ENEMY
DUSTY SPRINGFIELD
U2
the
GREEN DAY
JIMI HENDRIX EXPERIENCE
PORT CONVENTION

THE
100 BEST ALBUMS OF ALL TIME

'And tell all the stars above/This is dedicated to...'

Samantha, Alice
Clare, Jules, Soren
Sue, Matt, Lach, Anna

Special thanks to:
The Hardie Grant team: Julie Pinkham, Sandy Grant, Lucy Heaver, Paul McNally and more for believing in this book and patiently waiting and supporting us as we pushed to the finish line. Our great friends at Debaser (Aaron, Dave, Jo) for their design dexterity and eternal goodness. Ariana Klepac for expert editorial guidance, hard slog and great passion and enthusiasm for this book and its words.

Thank you to our friends/colleagues/collectors/supporters/believers for indulging and assisting us on matters of great musical importance and for tracking down the original vinyl covers, photos and approvals for all of these and more: Denis Handlin, Tony Glover, Dan Biddle, Raani Costelloe, Tim McLean; Tom Burleigh, John Jackson, Jeff Rosen, Mark Poston, Adrian Fitz-Alan, Sarah Le Messurier, Tabitha Fleming, Vicky Vogiatzoglou, Tony Harlow, Mark Williams, Sarah Woolcott, Max Hole, George Ash, Tim Kelly, Darren Aboud, Sean Warner, Emily Crews, Liam Dennis, Nicole McCarthy, John Watson, Damian Trotter, Craig Hawker, Philip Mortlock, David Albert, Shaun James, Chit Chat, Danny Keenan, Baz Scott/Egg Records, Jules Normington, Steve Kulack/Title, Rachel Newman, Tracey Hannelly, Janelle McCarthy, Hayley Richardson, Luke Bevans, T C Chan, Chris Burgess, Dixie Battersby, Craig Treweek, Brett Oaten, Steve Kilbey, Robert Hambling, Chris O'Hearn ... and to Tim for buying Highway 61 half a century ago.

THE
100 BEST ALBUMS
OF ALL TIME
(Toby Creswell & Craig Mathieson)

MONO

STEREO

OA459-45

THE 100
BEST ALBUMS
OF ALL TIME:

Contents

THE 100 BEST ALBUMS OF ALL TIME:

Introduction

Sunshine Superman by Donovan was the first album I ever bought, circa 1969. It cost me $5.25 from Palings in George Street, Sydney, and I have it still. It was on Epic with a yellow label and it was a thing of mystery and wonder. The title track was the hit single but that was just the door into a strange world. On the album there's 'Season of the Witch', with its classic line 'beatniks out to make it rich', which summed up the exotic new world of the '60s that was seductive and dangerous; 'The Trip', a Dylanesque story about taking LSD; 'The Fat Angel' with the admonishment 'fly Jefferson Airplane, get you there on time'; or 'Bert's Blues', a slice of steamy, slightly sleazy jazz blues that pays tribute to guitar player Bert Jansch.

Sunshine Superman was like a rock that landed in the pond – the ripples just went out and out. 'Season of the Witch' is a trip all in itself, across its many and varied versions (including Mike Bloomfield's and Stephen Stills' 16-minute improvised version, or the numerous versions used in films of the '60s as few songs sum up the dark side of the '60s better). Then there are the resonances through people like producer Joe Boyd, who named his production company Witchseason and went on to bring Nick Drake and Fairport Convention, the Incredible String Band and R.E.M. to the wider world. And then there are all of the other versions by Terry Reid, Julie Driscoll, Hole, Luna, Dr. John, Lou Rawls, Joan Jett, Richard Thompson and Karen Elson. Just that one song will lead you into a whole pantheon of music. There is also the journey you could take with Bert Jansch, following the

trail led by the song 'Bert's Blues'. Jansch was one of the masters of English music, whose unique guitar style was the bedrock of Jimmy Page's style and from Page whole generations of heavy metal. And, of course, Page himself plays on 'Sunshine Superman'. Although only the title track of Sunshine Superman got any radio play, the meat of the LP was all in the album-only songs.

The point of this lengthy trip down my memory lane is to illustrate how albums can be more than the sum of their parts. There have been songs that changed the way people saw the world, for example: 'I Want to Hold Your Hand' (the Beatles), '(I Can't Get No) Satisfaction' (the Rolling Stones), 'That's All Right (Mama)' (Elvis Presley) or 'Smells Like Teen Spirit' (Nirvana). But the album as a piece of work was something that you could explore and live with. (I use the past tense because in this digital age albums have a more precarious, uncertain place.)

The classic album format was a long time coming. In April 1955 Frank Sinatra released In the Wee Small Hours, one of the first 12-inch vinyl records. The album contained songs that all fitted around the theme of despair and lost love but they were all expressed with a lush emotionalism. Sinatra wanted the album to make a singular statement. Sinatra's success notwithstanding, singles dominated music in the 1950s and early 1960s. The demands of Top 40 radio determined the shape of pop music, as songs needed to be around three minutes to accommodate advertisers.

Artists pumped out singles and twice a year compiled those singles with whatever happened to be around to make an LP. There were titles like Ella Fitzgerald Sings The Cole Porter Songbook, which did have a conceptual framework. And then, as jazz took on greater artistic aspirations, works appeared like Miles Davis' Kind of Blue (page 126), which was an album statement. The individual tunes existed on their own but were greatly enhanced by being within the larger format of the album.

The merging of the Beatnik era, the folk music boom and pop music, which occurred in the early 1960s, gave a greater artistic depth to popular music. By 1965, when Bob Dylan was planning Highway 61 Revisted, even the lead track 'Like a Rolling Stone' was too long to be a single – early versions were split across two sides of a 45 rpm disc. Dylan's song was sufficiently powerful to get radio airplay despite its six minutes-plus length, but that was still an anomaly.

Then in 1967 the Beatles released Sgt. Pepper's Lonely Hearts Club Band, an album that was conceived to fit an overarching concept. After Sgt. Pepper's, artists began to think of their work differently. We had an age of rock operas and concept albums and triple albums and whatever else. The album, because of its higher unit price and greater profitability, changed the music business and turned it into a profit-making machine.

But it was in the late 1980s that the rot began to set in. The compact disc format provided

digital quality reproduction, a more resilient object and 70 minutes with which to record music. In retrospect, 40 minutes – the optimum running time of a vinyl LP – is the ideal format for a popular music 'long player'. CDs just go on too long.

Now we have digital downloads. Yes, the compression required for internet distribution does degrade the sound, but more damaging is the way that these single tracks are disassociated from any context, possibly robbing the songs of meaning and certainly divorcing them from being part of a bigger narrative. The beauty of the LP was that in listening to 'Sunshine Superman' you also found 'Season of the Witch'. That serendipity will happen less and less as time goes on.

My personal history notwithstanding, *Sunshine Superman* doesn't make this list of the 100 best albums of all time. Nor does *In the Wee Small Hours* or *Sgt. Pepper's*. The methodology we adopted for creating the list was that, regardless of genre or era, the albums had to be 'the best'; full of undeniable artistry and internal qualities that have continued to resonate through the years. All the records included here are of huge, rare artistic merit. They aren't necessarily the biggest sellers or even the most influential (although very often they are both of these).

For us, *Sgt. Pepper's* is a line in the sand. Too often critics and lists have praised *Sgt. Pepper's* because of its game-changing qualities, encouraging popular artists to focus on a body of work rather than just individual songs, and because it marked the end of the Beatles as a performing (read: teenybop) band and the beginning of them being a more experimental (read: serious) studio band. And obviously it was incredibly successful – the first genuine blockbuster album. However, while *Sgt. Pepper's* may have boasted a high concept, the conceptual thread is weak and it is arguably the band's most patchy collection of songs. Yes, there are moments of greatness ('A Day in the Life', 'Lucy in the Sky with Diamonds', 'She's Leaving Home') but equally there are weak, throwaway moments ('Good Morning Good Morning', 'Lovely Rita', 'When I'm Sixty Four'). The spirit of *Sgt. Pepper's* was, in fact, better articulated by the Kinks on *The Kinks Are the Village Green Preservation Society* (page 220).

For the next 30 years artists thought in terms of creating albums – building a format that could tell multi-dimensional stories. Fleetwood Mac's *Rumours* (page 44), for instance, famously documents the conflicts of the couples within the band. These soap operas are contained within one of the most complex, orchestrated pop operas. Similarly the Beach Boys' *Pet Sounds* (page 58) and Van Morrison's *Astral Weeks* (page 32) are works that push the boundaries of what constitutes popular music. *Layla and Other Assorted Love Songs* by Derek and the Dominos (page 248) is a double album dedicated to unrequited love, and you'd be hard pressed to find a novel or a film on the subject that is as nuanced, emotive and rigorous. All of these statements needed the space of an album to really get into the nitty gritty and properly tell their story. 'Layla' by itself is a terrific song edited into a single, but then you add the piano coda and it stretches to seven minutes and its beauty truly unfolds. Look at it in the context of the rest of the album – from the elegiac, medieval Persian love poem, 'I Am Yours', to the desperate Freddie King blues, 'Have You Ever Loved a Woman', and you're starting to see the full picture. Iggy and the Stooges' *Raw Power* (page 112) is the diary of a madman with a backbeat. No Russian author has been more creatively deranged than Iggy Pop and James Williamson were when making that record. The Ramones, who seemed completely dedicated to the glory of the 45 rpm single, made a debut album – in a shorter time than most groups take to make a single – that was an art statement of the order of Andy Warhol's soup cans, from its songs to its amazing black and white cover.

So, in every case we went for the definitive collection of songs that, when put together on the one release, were bigger than the sum of their parts. Perhaps the only arbitrary restriction that we loosely imposed was a limit of two albums per artist – and it was a restriction that we failed to adhere to. In reality that restriction was a self-regulator, another reminder to ourselves to stay true to the course and constantly challenge our own choices. We have also kept one eye on the notion of the album as a discrete statement in itself. For this reason we have not included greatest hits collections or the like. Almost all of these albums are as the artists themselves intended them. This has meant that we don't

THE 100 BEST ALBUMS OF ALL TIME:

have an Elvis Presley album. (*The Sun Sessions* LP that occurs on many 'best of' lists was compiled as a 'greatest hits'.) Two of the LPs from the 1950s, by Little Richard and Chuck Berry, were compiled from different sessions but they do tell a consistent story. In a sense they prefigure the shape that albums took on in the 1960s.

This is mostly a list of rock & roll and pop records. We thought that stretching across too many genres would ultimately make a list like this redundant, so we have stuck to the brief of rock & roll and its near neighbours. There are other books that obviously can be written about jazz or country or blues music alone. We have only included albums from those genres where they crossed over to sit within the broader definition of popular music. Having said that, we were cognisant of the different shapes that contemporary popular music takes. The key albums in soul, rap, R&B, alternative, punk, metal and hardcore are all represented on this list, but only because they forced themselves on the list of 'the best'.

Obviously, this is not the first project to codify the 100 best albums of all time. Bearing that in mind, we thought that for the list to have real value we needed to rethink some of these records, challenge some of the perceptions that are held about them, and spark some debate. There are controversial choices here, such as the Monkees – often derisively referred to as the Pre-Fab Four. The Monkees remain an interesting harbinger of the way that music has evolved over the past 10 years through

synergies with television. Comparing the career trajectory of the Monkees with any number of TV talent show victors is a salutary lesson in what ails the music business. (It's also worth noting that the Monkees' album *Headquarters* – page 156 – featured country rock before the Byrds and Bob Dylan got there.)

The Top 10 is always problematic. There is an accepted canon among music critics of certain albums that represent a peak achievement – *Astral Weeks* and *Pet Sounds* are two of them. These records were not major hits on release, so it was important to re-examine the albums and put them to the test rather than just reiterate critical platitudes. Of the other records in the Top 10, Nirvana's *Nevermind* (page 28) was the catalyst for a generational change in popular culture, and it's unlikely that we will ever see another album that so clearly draws a line in the sand between eras. Public Enemy's *It Takes A Nation of Millions to Hold Us Back* (page 52) was similarly the album that gave rap music a new sonic and literary vocabulary. *The Velvet Underground & Nico* was for white rock & roll what Public Enemy was for rap. It gave us punk and alternative music and it still sounds fresh today. *Rumours* has never had the critical cachet it deserves. Not even the Beatles achieved a complete collection of pop songs burnished so exquisitely as Fleetwood Mac did on *Rumours*. By the same token, no singer-songwriter ever exposed themselves as nakedly as Joni Mitchell did on *Blue* (page 36). That album is one of the most unvarnished, raw and minimal records ever made.

We hope to create controversy and trigger debate, but only because that kind of discourse is healthy, and any and all focus on these great artistic monuments is positive and deserved. There's no point in just having an opinion, though. For each of these 100 entries we carried out extensive research, filing through interviews with artists, producers and musicians. We have looked behind the velvet rope to bring out the story behind the album and to see how much of the final product was the intention of the artist.

Our methodology for compiling these lists was to take our own hard-won opinions and match them against lists from reputable sources – NPR radio, *Mojo* magazine, *Rolling Stone* magazine, *NME*, Pitchfork, the BBC, Metacritic and more. Our unique position is that we are Australian writers, so therefore we hope this book avoids the UK- and US-centric biases that usually dominate this debate. It was important when compiling the list to take those subjectivities into consideration – which is why Donovan's *Sunshine Superman* hasn't made the cut. But each of the 100 albums that has made it here has the richness and the texture of that record.

Although it's fair to say that rock & roll did have a golden age that ran from the Beatles to Nirvana, it's also true that music continues to surprise, inspire and illuminate our lives and times. Hopefully this book will encourage you to reconsider, revisit, recalibrate ... and rejoice in the magic of these great albums.

Toby Creswell

THE
100 BEST ALBUMS
OF ALL TIME
(Toby Creswell & Craig Mathieson)

MONO

OA459-45

Nº: 1

BOB DYLAN
HIGHWAY 61 REVISITED

Columbia
Produced by Bob Johnston and Tom Wilson
Released: August 1965

'The first time that I heard Bob Dylan I was in the car with my mother, and we were listening to, I think, maybe WMCA, and on came that snare shot that sounded like somebody kicked open the door to your mind, from "Like a Rolling Stone". And my mother, who was – she was no stiff with rock & roll, she liked the music, she listened – she sat there for a minute, she looked at me, and she said, "That guy can't sing". But I knew she was wrong. I sat there, I didn't say nothin', but I knew that I was listening to the toughest voice that I had ever heard. It was lean, and it sounded somehow simultaneously young and adult, and I ran out and I bought the single … then I went out and I got *Highway 61*, and it was all I played for weeks. I looked at the cover, with Bob, with that satin blue jacket and the Triumph Motorcycle shirt. And when I was a kid, Bob's voice somehow – it thrilled and scared me. It made me feel kind of irresponsibly innocent. And it still does. … He had the vision and the talent to expand a pop song until it contained the whole world. He invented a new way a pop singer could sound. He broke through the limitations of what a recording artist could achieve, and he changed the face of rock and roll forever and ever.' (*Bruce Springsteen inducting Bob Dylan into the Rock and Roll Hall of Fame, 1988*)

Did Bob Dylan know in 1965 that he was blowing rock & roll wide open? Probably. Did he know what he was doing? Probably not. He was simply running on instinct. Does the bomber know how the walls will tumble down? The painter Eugène Delacroix said it best: 'Talent does whatever it wants to do. Genius does only what it can.'

One doesn't get the sense that Bob Dylan is in control of his work in the way that, say, Bruce Springsteen or Neil Young are – indeed, at times in his career he has seemed to be lost or drowning, unable to make a good album.

TRACKLISTING

01 **Like a Rolling Stone**
02 **Tombstone Blues**
03 **It Takes a Lot to Laugh, It Takes a Train to Cry**
04 **From a Buick 6**
05 **Ballad of a Thin Man**
06 **Queen Jane Approximately**
07 **Highway 61 Revisited**
08 **Just Like Tom Thumb's Blues**
09 **Desolation Row**

But at those moments when the genius was engaged, Dylan saw music in a way that no-one else had ever done. There are very few artists, perhaps a dozen in the 20th century, who actually had a completely new vision, but Dylan was one of them.

At the age of 21 Dylan wrote the track 'A Hard Rain's a-Gonna Fall'. He took the traditional English ballad 'Lord Randall', supercharged it with an Old Testament perspective and then, crucially, he delivered it with a youthful righteousness that was closer to the spirit of rock & roll.

Many of Dylan's early songs were topical; he was writing about the world he saw around him and trying to find his own voice. He was still a very young man and perhaps didn't have a sophisticated inner life to write about yet. In any case, the important thing about Bob Dylan is not just the topics of his lyrics but the attitude.

Jean-Luc Godard said that it's not where you get things from that matters, it's where you take them. Dylan never disguised his sources. Nor did he disguise his quest to learn from his elders. He sought out Woody Guthrie and studied at the knee of elder folksingers. He courted Allen Ginsberg and the senior poets

BOB DYLAN HIGHWAY 61 REVISITED

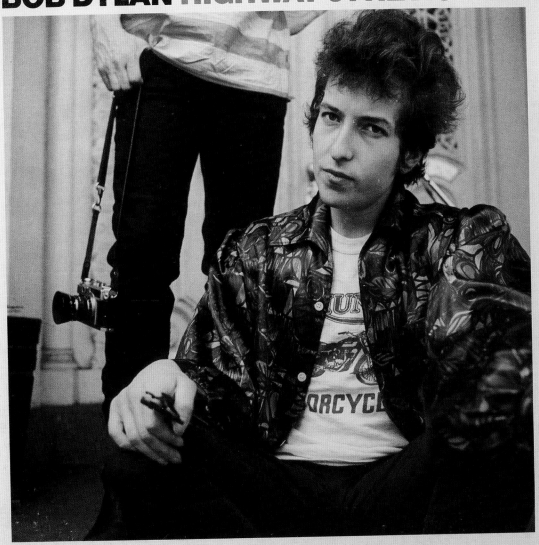

of the day and unashamedly borrowed from them and evolved his own writing.

There are two things that are consistent in Bob Dylan's writing during the 1960s: he deplored injustice and he refused to be dictated to by his audience or anyone.

Dylan's early, acoustic albums show a clear progression as the influences become submerged by Dylan's own language and style. His antennae were keenly attuned to the world around him and so it was natural that once the Beatles started their own revolution, Dylan would also electrify his music.

through Dylan's music and expanded the ambit of his songs. A short four months later, on 20 July 1965, Dylan released a new single, 'Like a Rolling Stone', and completely reinvented rock & roll yet again. It was a week later when Dylan headlined the Newport Folk Festival, appearing with an electric band for the first time. There was widespread disapproval – mixed with the cheers of younger fans – in what has become one of the most discussed concert performances of all time. Pete Seeger and other members of the folk establishment wanted Dylan's set stopped but he continued, defiant.

escalating into a real war and throughout the South young black men were being murdered by the Ku Klux Klan.

The prosperity of the Pax Americana brought an unprecedented leisure, education and wealth. The Pill meant non-marital sex without fear or guilt. New industries needed new minds and where once experience and seniority counted for everything, now it meant nothing. With men orbiting the earth, how long could it be before we were holidaying on the moon? Always though, there was the palpable threat of the Bomb. With the possibility of apocalypse at any moment, having fun was critical.

There are two things that are consistent in Bob Dylan's writing during the 1960s: he deplored injustice and he refused to be dictated to by his audience or anyone.

Much has been made of Dylan's performance at the 1965 Newport Folk Festival where he performed electric blues with the Butterfield Blues Band. However his first 'electric' tracks appeared on the first side of his fifth album, *Bringing It All Back Home*, which began with 'Subterranean Homesick Blues' – a rewrite of a Chuck Berry song that was Dylan's first Top 40 single. When the Byrds had a #1 hit with an electric version of 'Mr. Tambourine Man' in May 1965, it was inevitable that Dylan's next album would be a rock & roll record.

By now Dylan had made it clear to anyone paying attention that he was not going through anything twice. His first professional recording date was playing harmonica for calypso singer Harry Belafonte back in 1961. (He left after one song because the producer asked him to play his part the same way in multiple takes.)

Always ambitious, Dylan's response to stardom, when it came, was ambivalence. Fans felt they owned Dylan; that if he changed it was somehow a repudiation of them. They took it personally. Dylan, however, couldn't have given them what they wanted even if he wanted to.

The album *Bringing It All Back Home* was released in March 1965. Electricity howled

The legend of Newport spread. It became de-rigueur at Dylan concerts for fans to jeer during the electric set. One fan famously yelled 'Judas!' at a gig immortalised on the *Live at the Royal Albert Hall* bootleg. Dylan's response was to tell his musicians that when the booing started, to turn their amplifiers up louder. How often does an artist wilfully alienate his audience?

As much as any piece of art is inevitable, Bob Dylan's trajectory was probably bound to lead to the electric explosion of *Highway 61 Revisited*. Jack Kerouac had brought the rhythms of jazz to literature. Dylan brought the vocabulary and the intellectual spirit of literature to rock & roll. That was his singular achievement.

Context is everything. In June 1965 America was still reeling from the November 1963 assassination of JFK. President Lyndon Johnson had outlined his plan for the 'Great Society', dedicated to delivering the benefits of the immense American prosperity to all Americans, regardless of race. It was a time of great leaps in consumer wealth – a colour TV in every home. The Space Race was in full flight. Education and opportunity were everywhere. But hanging over the party was the ever-present Cold War, Vietnam was

This was indeed a 'brave new world' to use Aldous Huxley's phrase but, to borrow another that writer also made famous, members of this generation believed that they had opened 'the doors of perception' and thought they could see beyond the closed world of suburbia. The new world needed a new artform.

Elvis Presley and even the Beatles were different versions of established pop music genres – Tin Pan Alley, country, R&B. The Rolling Stones were still a covers band, although '(I Can't Get No) Satisfaction' was released on 6 June 1965 and there's no doubt its blues changes, soul tempo and sarcastic lyric would have been ringing in Dylan's ears when he arrived to cut 'Like a Rolling Stone' on 15 June at Columbia's Studio A on Seventh Avenue, New York. We will probably never know whether England's newest hitmakers gave him the title of his first hit.

It was time to draw up the blueprint for the new artform and that's exactly what *Highway 61* is. Even a cursory look at the albums produced after August 1965, compared with those beforehand, will show the watershed that is *Highway 61*.

The change in rock music post 1965 was that it became the most effective artistic form through which young people could communicate. Dylan's emphasis on words as equal to, but not more important than, the music, meant that people could express themselves. Few people could make mass market films or publish big books, but making a song was achievable.

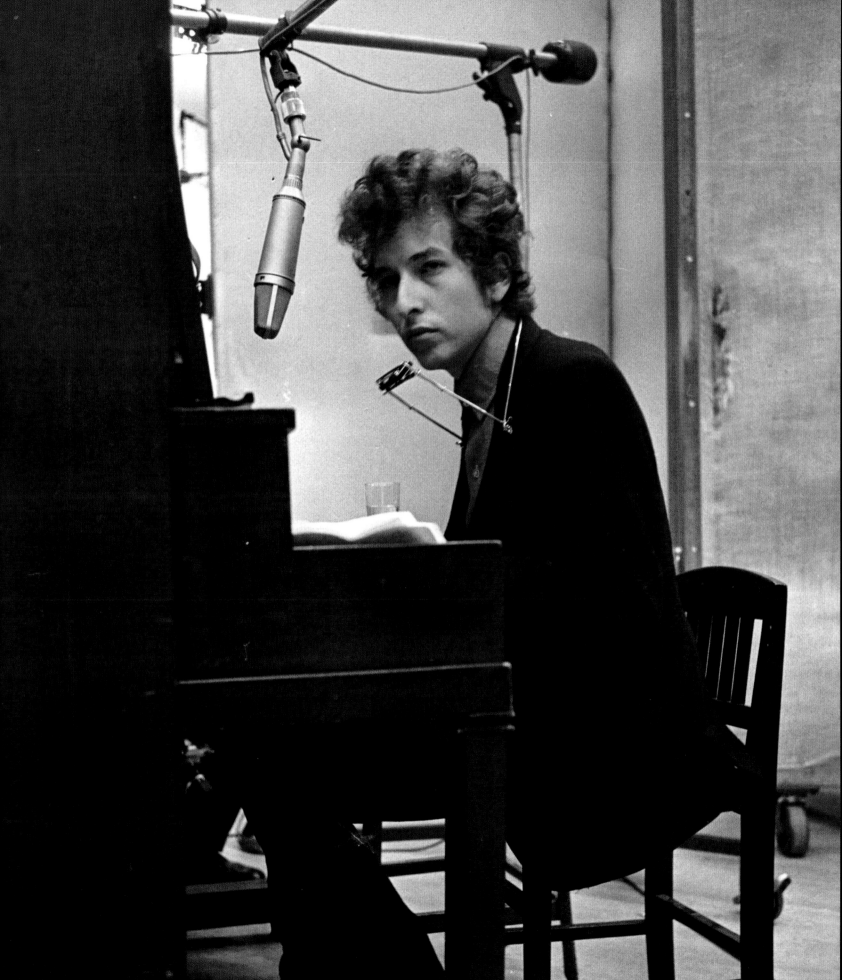

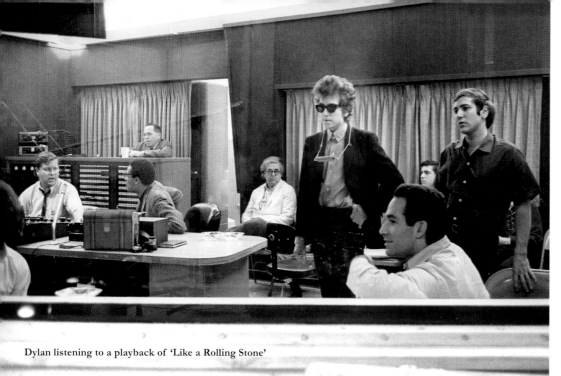

Dylan listening to a playback of 'Like a Rolling Stone'

Dylan was attuned to what was going on in America. *Highway 61 Revisited* was his response.

The highway US Route 61 rises out of New Orleans, Louisiana and runs north through the Mississippi Delta, crossing Highway 49 at Clarksdale – the 'Crossroad' where legendary blues guitarist Robert Johnson supposedly made his Faustian pact with the devil for success. Route 61 ambles through the heartland of America, rolling across the desolate plains of Wisconsin before rising into the iron ore mountains of Minnesota, until it reaches Dylan's hometown of Duluth on the shore of Lake Superior. This is one of the highways that transported the slaves and their children from the cotton fields of the Delta to the industrial north, carrying with them the blues.

For *Highway 61 Revisited* Dylan went back to Columbia's Studio A. The first session was produced, as Dylan's previous three albums had been, by Tom Wilson, and session players Paul Griffin (piano), Bruce Langhorne (guitar), Bobby Gregg (drums) and bass player Joe Macho Jr were back from the last album. Dylan also brought along Mike Bloomfield, a young Jewish guitar prodigy from Chicago. On the second day Al Kooper, a guitarist and friend of Wilson's, hung around the studio hoping to get an opportunity to sit in. During

that first session they recorded a couple of tracks, but most of that night and the next was spent working on 'Like a Rolling Stone'. With the song ready for release as a single, Dylan played the Newport Festival and returned to finish the album.

Wilson left the project to be replaced by Bob Johnston, who remained Dylan's producer until 1973. However, the essential elements on *Highway 61* were already in place from the 'Like a Rolling Stone' session: Griffin's piano and Gregg's drums plus Al Kooper's scary, primitive organ playing (Kooper, a guitarist, had never played organ before the 'Like a Rolling Stone' session!) and Bloomfield's switchblade guitar was the bridge between the blues and the new sound that Dylan heard in his head. Bloomfield said that prior to the recordings, Dylan had invited him up to the house to learn the songs:

'Bob picked me up at the bus station and took me to this house where he lived … and he taught me these songs,' Bloomfield recalled. 'All those songs from that album and he said. "I don't want you to play any of that BB King shit, none of that fucking blues, I want you to play something else." So we fooled around and I finally played something that he liked. It was very weird, he was playing in weird keys which he always does, all on the black keys of the piano.'

Dylan didn't do demos so, other than Bloomfield, the other players first heard each song in the studio when Dylan counted it in. It was rare for him to return to a song if it wasn't working and most were recorded in one or two takes.

The tone of *Highway 61* was new. The tenderness of 'Mr. Tambourine Man' or 'Love Minus Zero' just six months earlier, is only apparent on 'It Takes a Lot to Laugh, It Takes a Train to Cry'. The other tracks are all taking names and keeping score. Dylan gave up writing topical songs on his fourth album but he never stopped writing protest songs. He just changed his gaze a little from the topical to the mythic. As far back as '62 he was writing Rabelaisian satires on the absurdity, the mendacity and the vanity of human society. By removing the specific issues, Dylan gave freer rein to his poetic imagination but he also ensured that, humankind being what it is, these songs are as relevant now as they were half a century ago and will still be a hundred years from now.

'Tombstone Blues', 'It Takes a Lot to Laugh' and 'From a Buick 6' are all standard blues songs borrowing from the masters with their licks and lyrics and, while they have the sharp intelligence and amphetamine frenzy of Dylan's new sound, they are warming up for the main game.

'Ballad of a Thin Man' closes the first side of the album with an excoriating attack on the media specifically, but more generally on the straight world. In 1965 the world was undergoing the profound transformation and you were on one side or the other. Whereas two years earlier, on 'The Times They Are a-Changin', Dylan had requested that people 'don't criticise what you don't understand', now on 'Thin Man' he was positively spitting 'there ought to be a law against you coming around'.

Dylan leads with his piano pounding out a funeral march and the musicians fall in behind, hard on the beat. This is not so much a ballad as a requiem. Kooper's organ is part church and part horror movie. You can feel the weight of Dylan's shoulders as he pumps on the piano. He sings with such a sneer that it's almost as though he can't bear wasting breath on this person. In the version in the

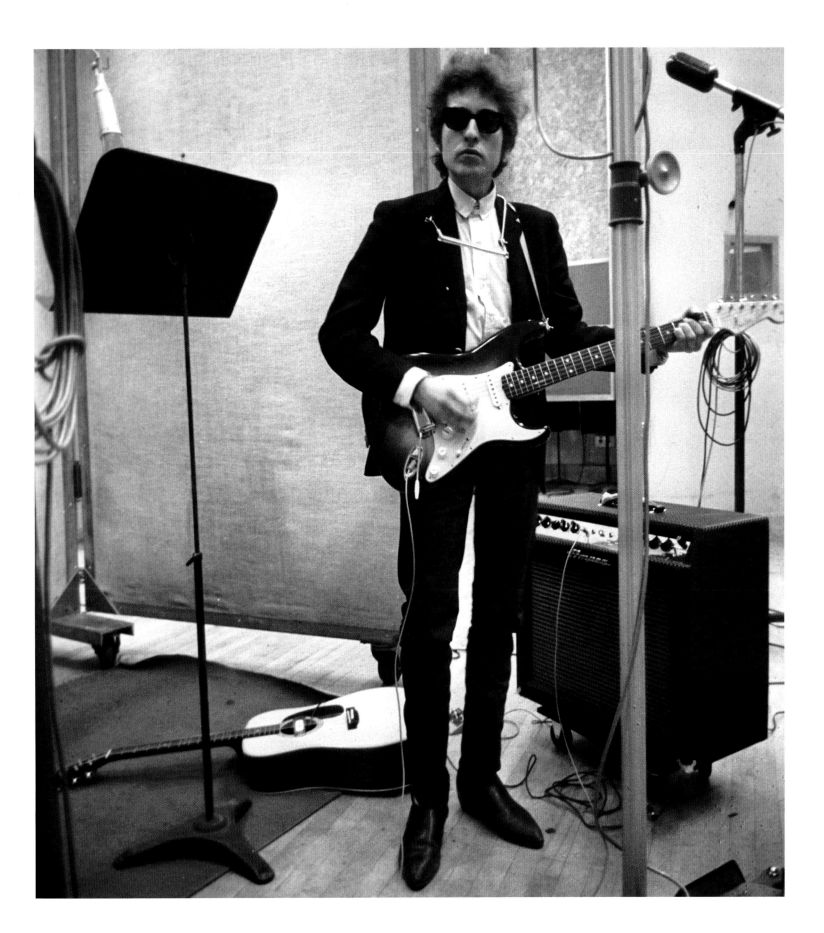

film *No Direction Home* he's holding his hand above the keyboard as if he's about to plunge a dagger into its heart. Dylan's vocal matches the violence in the music. He rolls the words around and seems to examine them before he hurls them out. No-one has ever sung with such contempt. His targets are not only the hapless journalist so frequently cited as the song's inspiration, Dylan is also attacking the lack of imagination in 'respectable' bourgeois life, in academia.

The title track is the thematic cornerstone to the album. Highway 61 is the heart of America and 'Highway 61 Revisited' is a state of the nation address. Dylan sings about a country gone crazy with greed, violence, lust, phonies and hucksters. He had written these songs before ('115th Dream', 'Bob Dylan's Blues', 'A Hard Rain's a-Gonna Fall') but never quite with the attack he has here. Drummer Sam Lay arrived at the recording session with a whistle that Dylan uses like a siren, and Bloomfield's slide guitar is completely ferocious.

The only really personal song on the album is the track 'Just Like Tom Thumb's Blues'. Set

Dylan's central complaint, which is that we live in a merciless society where nothing is beyond commercial exploitation.

Dylan said at the time that 'Desolation Row' was a breakthrough for him and certainly it's a great leap in terms of poetic imagery and developing a narrative. There is an enormous cast on Desolation Row – from Romeo to Cinderella, jealous monks, T S Eliot hanging with Ezra Pound, fortune tellers and characters from the Bible. He has Cain and Abel in the same line as Quasimodo. Dylan sings the song with a weariness distinct from the earlier songs. He's still lashing out at the people who claimed to know him well, but he's getting beyond caring.

The roots of the song go back to the English ballad tradition – you can hear echoes of 'Matty Groves' in the melody. Johnston brought in Nashville guitarist Charlie McCoy and bassist Russ Savakus. McCoy, who shows a remarkable sensitivity to Dylan's lyrics, brings a wind-blown Tex Mex flavour to the track – Dylan likened it to an old time carnival sound.

word. I had never thought of it as a song, until one day I was at the piano, and on the paper it was singing, "How does it feel?" in a slow motion pace, in the utmost of slow motion.'

An early run through of the song without Kooper's organ is available on the *No Direction Home* soundtrack. Dylan runs it through in waltz time. The extraordinary imagery is there but Dylan hasn't found the spirit of the song. The next day it blossomed. On take #4 (the version that made the album) the music is fitted around the words. Starting with the sharp crack of Bobby Gregg's snare before the arrival of Griffin's playful piano and some hammy washes of organ, Dylan lets fly with 'Once upon a time you dressed so fine/You threw the bums a dime in your prime, didn't you?'. The music tumbles forward, wrapped in the words and following the lyrics rather than the other way around. Even the original Mr Tambourine Man, Bruce Langhorne, sits his tambourine right in the groove. Every so often the vocal rises in accusatory questions, such as 'how does it feel?', or statements like 'When you got nothing, you got nothing to lose'.

The howling, scowling organ floats around Bloomfield and jibes with Dylan's harmonica, giving the song its dark beauty and mystery. This mixture of prickly guitar, swelling organ and jabs of harmonica were to be the basis of Dylan's new sound.

> ... at those moments when the genius was engaged, Dylan saw music in a way that no-one else had ever done.

in Mexico, it's a song about being strung out on drugs. There seems to be the influence of Kerouac's *Desolation Angels* and Burroughs' *Junkie* here. Critic Andy Gill sees a reference to Rimbaud's 'Ma Bohème: Fantaisie', ('My only pair of pants had a big hole in them/ Tom Thumb the dreamer, sowing the roads/ With rhymes'). The instrumentation with tack piano, electric piano and sharp guitar and harmonica sees Dylan move closer to the unique 'thin, wild mercury' sound he was aiming for.

Almost perversely, the album closes with the one acoustic song – 'Desolation Row'. This 11-minute epic opens with the line 'they're selling postcards of the hanging', which may refer to a lynching that took place in Duluth of which photographs were sold. More importantly, though, the image captures

And finally there is 'Like a Rolling Stone'. It's clearly a finger pointing exercise. The singer ridicules and derides the rich and the fatuous. Many people have speculated on who were the 'real' subjects he was writing about. There are lyrical clues suggesting that Dylan was mocking Andy Warhol and his circle but it's more likely that he composited a number of characters into this song. The gist of it – that the material world is full of distractions and vanity – is of a piece with 'Ballad of a Thin Man' and 'Desolation Row'.

'It was ten pages long,' Dylan said at the time. 'It wasn't called anything, just a rhythm thing on paper all about my steady hatred directed at some point that was honest. In the end it wasn't hatred, it was telling someone something they didn't know, telling them they were lucky. "Revenge", that's a better

Dylan cut the song intending it to be a single. At six minutes it was almost twice as long as anything else in the Top 40 (radio stations often refused to play songs over 3.30 minutes) and it was not a love song (the Beatles' current single was 'Help!'). Mostly, though, it was the mood of the song – an ornate language and a venomous vocal delivery – that set it apart. It was one thing for Dylan to make complex albums and quite another to have an international hit single such as 'Like a Rolling Stone'.

As Dylan said 33 years later, 'The first two lines, which rhymed "kiddin' you" and "didn't you" just about knocked me out and later on when I got to the jugglers and the chrome horse and the princess on the steeple, it just about got to be too much.'

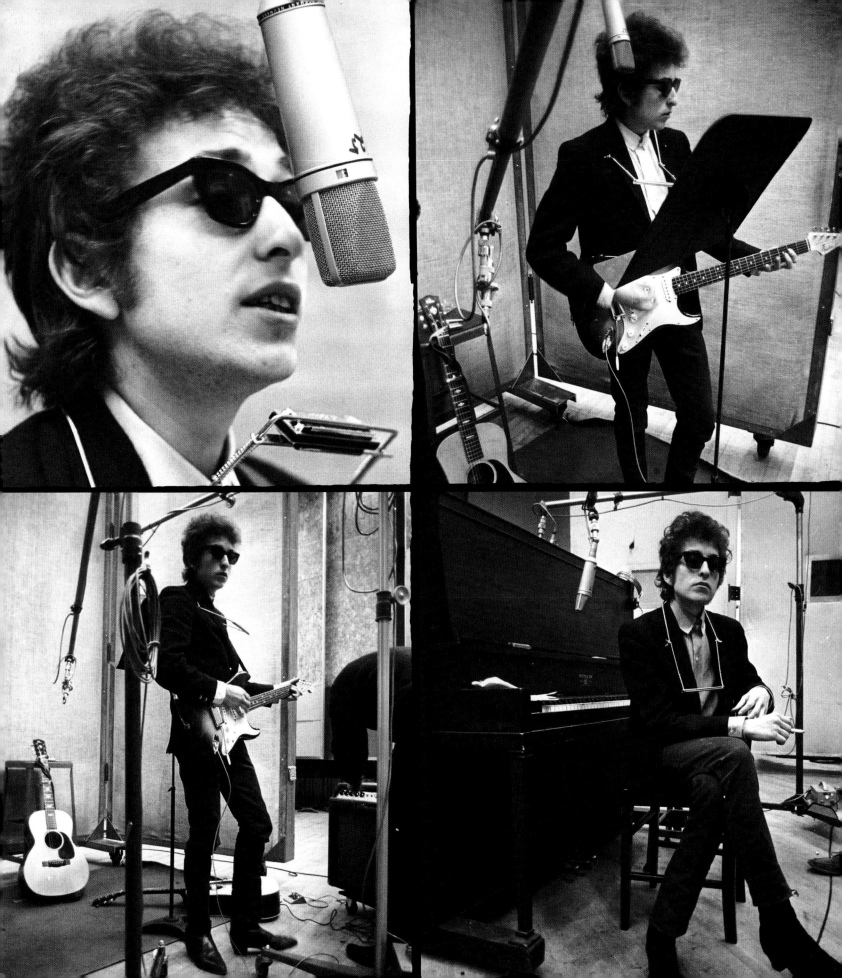

Nº2

THE BEATLES
REVOLVER

Parlophone/EMI
Produced by George Martin
Released: August 1966

Recorded in less than three months during the London spring of 1966, *Revolver* is the album where pop music sheds any residual limitations and stops second guessing what it may be capable of. It is a remarkably concise yet hugely diverse collection of songs from a quartet who had attained their creative peak while onlookers were still trying to judge them by their earlier work. Both individually and as a group the Beatles broke new ground with their seventh studio album, and it remains an incredibly influential set. In the weeks and months after its release, *Revolver* would contribute to the rise of psychedelic rock and electronic experimentation; in the years and decades since, it has become a touchstone that offers inspiration and sustenance.

The Beatles had proven to be revolutionary when they broke through in 1962, essentially creating the modern teenager with their string of hit singles and chaotic concert appearances. Instead of resting on those laurels and coasting into satiated respectability, they turned on their own framework and launched a second revolution, this time in the studio. *Revolver* is the album that conceives the idea of the record as creating a self-contained world; one that remakes the accepted reality by virtue of its very presence.

You couldn't hear a track like 'Eleanor Rigby' or 'Tomorrow Never Knows' for the first time and simply carry on as if nothing had changed.

In 'And Your Bird Can Sing' John Lennon observes, 'When your prized possessions start to weigh you down/Look in my direction, I'll

TRACKLISTING

01 **Taxman**

02 **Eleanor Rigby**

03 **I'm Only Sleeping**

04 **Love You To**

05 **Here, There and Everywhere**

06 **Yellow Submarine**

07 **She Said She Said**

08 **Good Day Sunshine**

09 **And Your Bird Can Sing**

10 **For No One**

11 **Doctor Robert**

12 **I Want to Tell You**

13 **Got to Get You into My Life**

14 **Tomorrow Never Knows**

be round, I'll be round', which sounds like a coded reference to the power of a vinyl record and a reminder of how important the studio was becoming to the Beatles. The group – guitarists Lennon and George Harrison, bassist Paul McCartney and drummer Ringo Starr – would tour briefly after they finished *Revolver* (although they didn't include anything from it in their simplified live set), culminating in what was their final paid concert at San Francisco's Candlestick Park on 29 August 1966. But gigging was already on the way out in 1965; so was working to a record company's expectations. There was no new Beatles album for Christmas in 1965.

Prior to beginning work on *Revolver* the four members of the band had enjoyed three months off – the first considerable break they'd had in years and, more importantly, their first lengthy period of time away from each other. Differences, and the egos and excess that exacerbated them, would eventually pull the Beatles apart, but in 1966 the band was becoming four different artists who were still intent on making the best record possible together; they were still greater than the sum of their individual parts.

'We were really starting to find ourselves in the studio. We were finding what we could

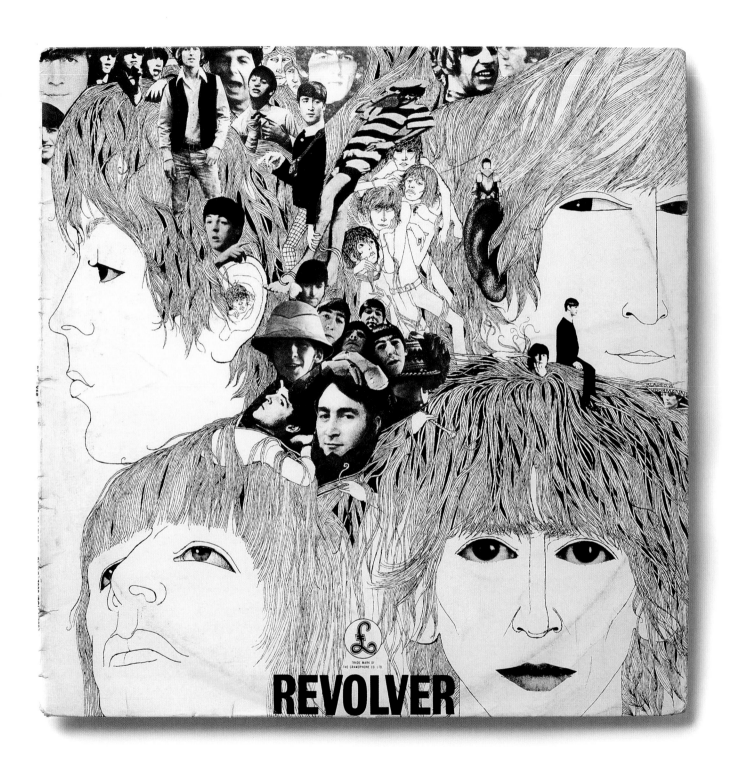

REVOLVER

do, just being the four of us and playing our instruments. The overdubbing got better, even though it was always pretty tricky because of the lack of tracks. The songs got more interesting, so with that the effects got more interesting,' Ringo Starr would later recall. 'I think the drugs were kicking in a little more heavily on this album. I don't think we were on anything major yet; just the old usual – the grass and the acid. I feel to this day that though we did take certain substances, we never did it to a great extent at the session. We were really hard workers. That's another thing about The Beatles – we worked like dogs to get it right.'

According to Paul McCartney at the time, the Beatles had pondered recording in America,

'Eight Miles High' and Brian Wilson's first (solo) take on the lushly poignant 'Caroline, No', as well as Bob Dylan's groundbreaking *Highway 61 Revisited* album. Each album, in its own way, suggested that the recording studio was a place of reinvention, where the artists and their music could be remade free of constraints. For the *Revolver* sessions the Beatles took this idea to its zenith, looking to rewrite the rules of both how music was recorded and thus how it would be heard.

In the studio the musicians and their enablers experimented with Artificial Double Tracking – invented by an EMI engineer the month sessions began – which allowed for a vocal to be played back with a minute separation so that two vocals could be combined. It was

were focused on the dismantling of reality, whether through the use of narcotics or the loss of mortality.

'You're making me feel like I've never been born,' he sings on the loose, incandescent 'She Said She Said', where Ringo Starr absolutely swings behind his drum kit, and Lennon would combine his obsessions on 'Tomorrow Never Knows', a song that closes the album with the exhortation to 'surrender to the void'. The lyrics were inspired by the *Tibetan Book of the Dead*, via counterculture seer Timothy Leary, and were matched to instrumental loops, backwards tracking, potent percussion and a heavily processed vocal. With its lysergic shards and restorative drones – you can dance to the song or disappear into it – 'Tomorrow Never Knows' helped detonate psychedelic rock. But to the Beatles it was just another idea to explore, not a genre to base a career around.

On *Revolver*, the Beatles were determined to break the rules. They insisted that every instrument sound unlike itself.

but they considered the studio rates quoted to them as outrageous, so they reconvened at the EMI Studios on London's Abbey Road – where there were World War II veterans working as porters and a dress code for employees that was unequivocal about the need for a collar and tie. Their producer, George Martin, had resigned from EMI after requests for improved remuneration were flatly rejected despite the Beatles' enormous profitability, and he was now an independent contractor. He still favoured a tie, but it was metaphorically loosened as he and 19-year-old studio engineer Geoff Emerick became co-conspirators with the musicians.

'The group encouraged us to break the rules. It was implanted when we started *Revolver* that every instrument should sound unlike itself: a piano shouldn't sound like a piano, a guitar shouldn't sound like a guitar,' Emerick more recently noted. 'There were lots of things I wanted to try, we were listening to American records and they sounded so different.'

The records that were arriving in England included singles such as the Byrds' mesmeric

used extensively on the album, especially by John Lennon, and the machine also allowed for recordings to be sped up or slowed down via a dedicated oscillator, which changed a sound's texture.

Another crucial strategy was backwards recordings which, according to Emerick, became a default experiment as the band pursued the idea. On 'I'm Only Sleeping', a song that sounds as if it's suspended between being awake and asleep, the conscious and the subconscious, George Harrison took the notation for his guitar solo, played the notes in reverse order and then had the tape played backwards. The result is otherworldly and uneasy, a genius intrusion into the song's floating reverie.

'I'm Only Sleeping' was one of Lennon's compositions, reportedly inspired by Paul McCartney having to wake his fellow songsmith in the afternoon for writing sessions and, like most of his pieces on the album, it is insular and arrives at a distance that may or may not be bridged. Lennon was living outside London, in privileged seclusion with a young family, where he was stewing in existential doubts. His contributions

'Their ideas were beginning to become much more potent in the studio. They would start telling me what they wanted and pressing me for more ideas and for more ways of translating those ideas into reality,' George Martin subsequently noted, and for 'Tomorrow Never Knows' they pulled out all the stops. To achieve Lennon's wavering, hypnotic vocal in the track's latter half (Lennon famously told Martin he wanted to sound like the Dalai Lama chanting on a hilltop) they had to open up a recording console and literally alter the circuitry.

That, in essence, was what Lennon was trying to do to his own psyche. Even when he was writing the album's catchiest guitar-based tune, 'Doctor Robert', Lennon was referencing a physician happy to prescribe highs for his patients, and drugs would be a reference point that the band's members would all log into for the album. Paul McCartney wrote the exuberantly celebratory 'Got to Get You into My Life' about marijuana, picking up on the horn-driven soul music that was coming out of America in the wake of the R&B blasts that the Beatles were originally turned on by.

Unlike Lennon, McCartney was living in central London, and his influences were external, from art galleries to experimental music gatherings. On *Revolver* he supplied the most eclectic selection of tracks, sometimes embracing the

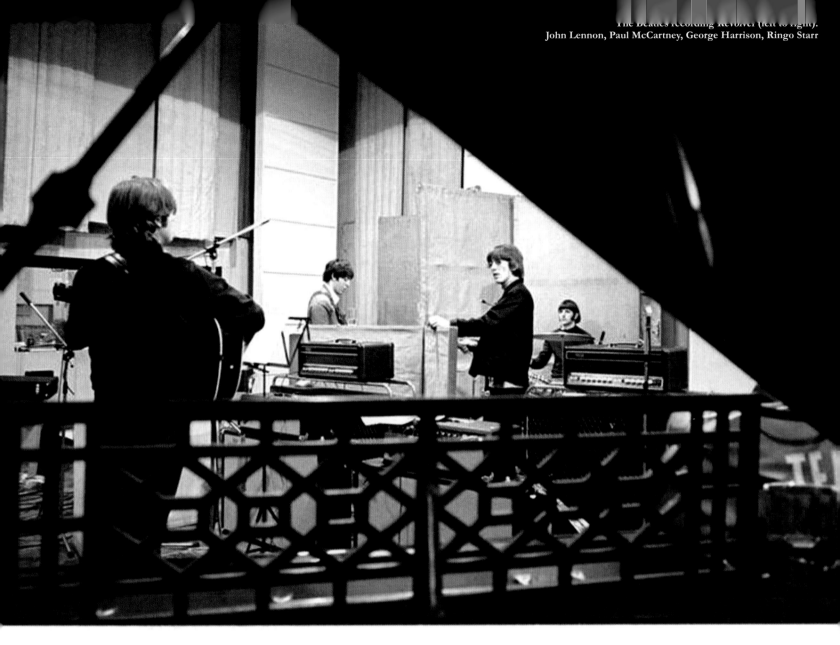

studio experimentation but also creating a contrast by treating his ballads with unadorned precision. 'Here, There and Everywhere' took the layered harmonies of the Beach Boys and married them to a bittersweet melody that perfectly conveyed the intersection of love and outright need. 'I want her everywhere and if she's beside me/ I know I need never care,' he sings, and the song's beauty never quite extinguishes the hint of doubt.

As they'd begun to do on 1965's *Rubber Soul* (a bridgehead to *Revolver*'s advances), the songwriters looked at society with fresh eyes, questioning not just the public deficits and failings, but how the smallest pieces could sit slightly apart. 'Eleanor Rigby',

starkly scored by a string octet, moves with a novelist's eyes across a modern city, intertwining the lonely woman of the first verse with the diligent, boxed-in priest of the second, so that the woman is buried in the final verse with no-one to mark her passing except the priest, who wipes the dirt from his hand as he walks away from her grave.

In between the achievements of the Lennon–McCartney union, George Harrison also comes of age as a songwriter on *Revolver*, using his passion for the Indian sitar to provide a new sound on the evocative raga rock of 'Love You To'. 'I Want to Tell You' is a celebration of how songwriting let him express himself, with the unease conveyed by the melding of

drums and piano, and the indignant groove of 'Taxman' is quite possibly the only song decrying excessive taxation rates for the rich to make it into the rock & roll canon.

So much of what the Beatles managed, seemingly without effort on the finished recordings, created a new strand for pop music. But they were not merely pioneers who were soon to be eclipsed. They were the first and they were the best, and *Revolver* is their most timeless recording, suspended for all time in their genius. It is the album where the potential of the Beatles is most fully realised, while their failings are virtually absent. Praise can barely do justice to this brilliantly inventive record.

N°:3

THE CLASH
LONDON CALLING

CBS
Produced by Guy Stevens
Released: December 1979

A dversity was always a tonic for the Clash, a band that played as if they had their backs to the walls but were nonetheless intent on shooting out the lights. Triumph often ensued when the quartet were up against it, and that was never more apparent than on their landmark 1979 double album. *London Calling* is at once a shout out to fellow travellers and a disavowal of those who don't stay the path; a staggering new vision of rock & roll in the autumn of punk, and a revivifying salute to the roots of popular music. It looked far and encompassed everything its gaze took in, channelling diverse styles and stances into a fierce, joyously rich sound. The end of the world may loom from the opening clamour of the title track, but the Clash were going to throw one hell of a going away party.

It was the third album from the group – vocalists/guitarists Joe Strummer and Mick Jones, bassist Paul Simonon and drummer Topper Headon – and it bore little relation to either predecessor. Their self-titled debut, issued in April 1977 as the punk explosion went from word of mouth to vinyl, was ragged and incendiary. The US arm of their record label refused to release it because they considered it unlistenable (it became a top selling import release in America and the execs reconsidered their decision in 1979). For their second long

player, November 1978's *Give 'Em Enough Rope*, they decamped to San Francisco and producer Sandy Pearlman, who gave them a heavy metal sheen and second thoughts.

TRACKLISTING

01 **London Calling**
02 **Brand New Cadillac**
03 **Jimmy Jazz**
04 **Hateful**
05 **Rudie Can't Fail**
06 **Spanish Bombs**
07 **The Right Profile**
08 **Lost in the Supermarket**
09 **Clampdown**
10 **The Guns of Brixton**
11 **Wrong 'Em Boyo**
12 **Death or Glory**
13 **Koka Kola**
14 **The Card Cheat**
15 **Lover's Rock**
16 **Four Horsemen**
17 **I'm Not Down**
18 **Revolution Rock**
19 **Train in Vain**

The sound of *Give 'Em Enough Rope* simply added to the doubts that constantly assailed the Clash. The idea that they'd somehow sold out, which had become an obsession with some of punk's fundamentalist believers – 'the punk police', Strummer sardonically labelled them – in the wake of their deal with London's CBS Records, simply grew ever louder, especially after the Sex Pistols imploded during their first US tour and their fellow Londoners were left as the public face of punk rock. Interviews became confrontations and obituaries were prematurely penned.

In February 1979 the Clash visited America on what they tactfully called the Pearl Harbour '79 tour. It was a comparatively compact run of dates, but eventful. They clashed with their US label, Epic, who baulked at financially supporting the tour and the presence of blues great Bo Diddley as opening act, and they eventually turned their back on the label's promotional staff at the kind of meet-and-greet event that successful bands were supposed to politely smile their way through. They were hardly a priority after that.

But the shows were well received and it enhanced the gang-like mentality that the band had fostered in their early days, and after they parted ways with manager Bernie Rhodes – a one-time associate of Sex Pistols svengali Malcolm McLaren – the decks were cleared and they were ready to progress

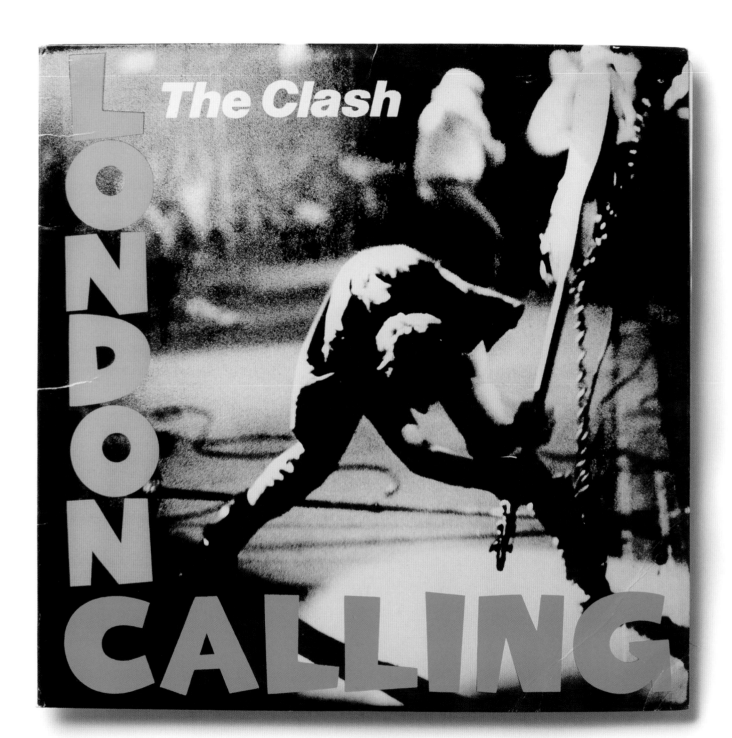

beyond simple expectations. Some American audiences were confused by the growing breadth of styles the band exhibited – wasn't this all about gobbing and pogoing? – but it was just the beginning.

Back in London they found a new rehearsal space at the dingy Vanilla Studios in Pimlico, where they moved in their gear and a portable four-track recording rig and got to work writing in comparative anonymity. The building was a former rubber factory mainly used by car repair workshops, and throughout May and June of 1979 the band worked on songs together nearly every day. Strummer and Jones originated most of the initial ideas, but the brooding Simonon was also ready to start writing, and when they wanted a break they would play football with whoever was around on a nearby school playground. At one point they played a visiting cadre of CBS staffers and ripped into them.

'It was the first time we played together in terms of creating the songs. There was a lot of experimentation,' Paul Simonon recalled in the liner notes for the album's 25th anniversary edition. 'I'd hear tunes on the radio or a record, I'd play it, then Topper would join in. Or Mick and Joe would arrive with something, and we would work on it. It was like doubles at ping-pong but with music as the ball.'

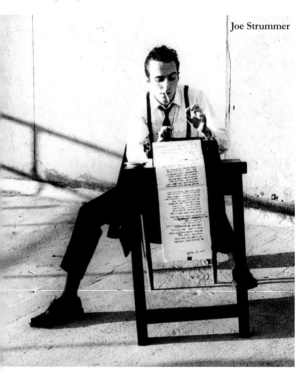

Joe Strummer

In August they went into Wessex Studios, linking up with veteran producer Guy Stevens, who was a voluble, enthusiastic catalyst, as likely to stalk the studio floor exhorting the musicians during a take as he was to throw a chair or wrestle with the recording engineer. Stevens was a former mod DJ, an inspiration to the Who, the first house producer at Island Records and, at one point, a guest of Her Majesty's Prisons for eight months due to drug offences. On 'Midnight to Stevens' (a tribute the band cut after his death in 1981 at the age of 38, after overdosing on the prescription drugs he was taking for alcohol dependency), Strummer would sing, 'Guy, you've finished the booze/And we've run out of speed/But the wild side of life/Is the one that we need.' The eccentric, quite possibly deranged, producer fit right in and, once he'd sorted out his mini-cab bill, or called up Mott the Hoople's Ian Hunter for a reassuring chat, or tuned the piano by pouring beer into it, the Clash were in good hands. Stevens valued the emotional integrity of a take over the technical qualities. Simonon, who was working hard to improve his playing after being a novice just three years prior, found him liberating.

Debates remain about what Stevens exactly did, but it's clear that the album reflects his all-or-nothing outlook. On *London Calling* the Clash are flying, turning eclecticism into a kind of audacious rallying cry: if we can be whatever band we want, you can achieve the same as a person. The first side remains phenomenal and immersive, leaping from the lean guitar swagger of the title track to the vintage, prowling rockabilly of 'Brand New Cadillac' and the sax-driven jive of 'Jimmy Jazz', before 'Hateful' shows their appreciation to recent tour-mate Bo Diddley and 'Rudie Can't Fail' is revealed as a ska exhortation.

At a time when punk was turning towards post-punk, electronic music was asserting itself and disco was informing black music – in other words, when fragmentation

was becoming the norm – the Clash took everything in. The sonic diversity on *London Calling* isn't just enjoyable, it's emboldening. 'There was a point where punk was getting narrower and narrower in terms of what it could achieve and where it would go,' Jones would later recall. 'They were painting themselves into a corner. We thought that you could do any kind of music.'

The idea that the Clash are ready to turn everything upside down is apparent from the first chords of 'London Calling'. It may be a classic setting of the scene, establishing both the landscape and the personal parameters – 'don't look to us,' spits Strummer, 'phoney

The idea that the Clash are ready to turn everything upside down is apparent from the first chords of 'London Calling'.

Beatlemania has bitten the dust' – but the further the song goes the more unsettled reality is shown to be. 'The ice age is coming, the sun's zooming in,' adds Strummer, and confusion reigns. There are too many ways for the world to end, and if they're competing with the likes of 'nuclear errors' then it's not clear what will prevail, even as Strummer offers a closing hint of apocalyptic charm with a request for a smile.

The only thing that bears true is the arrangement, especially the stirring bassline, and throughout the album the band plays with a passion that the world they're observing rarely has. The band retains an anti-authoritarian fervour, but Strummer's take on what he's witnessing is more complex; a riot won't solve anything. In the bracing 'Spanish Bombs' the lyric references the defeated Republican forces from the Spanish Civil War in the late 1930s, a struggle that was a rallying cry for the Left. But there are references to the Basque separatists of ETA, whose bombings were part of 1979's roll call of international terrorism. 'Can I hear the echo from the days of '39?,' asks Strummer, and suddenly there's nothing straightforward about the song's intentions.

It's followed by 'The Right Profile', a soulful rave-up about the 1950s Hollywood actor

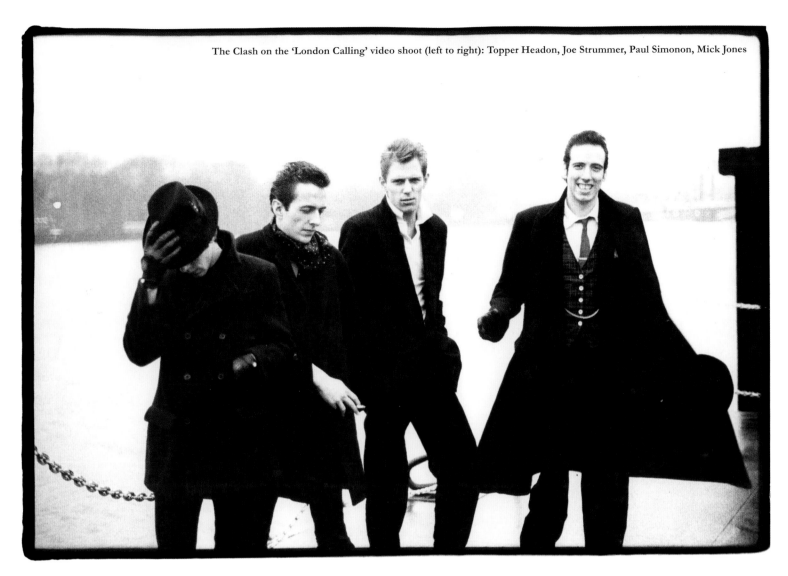

The Clash on the 'London Calling' video shoot (left to right): Topper Headon, Joe Strummer, Paul Simonon, Mick Jones

Montgomery Clift and, across the double album, larger than life characters, fictional or based on real life, give Strummer and his bandmates more room to move. The old R&B legend of Stagger Lee, based on a murder that informed an early folk standard, is updated for a Jamaican age with a cover of the Rulers' 'Wrong 'Em Boyo'. The band's taste for reggae didn't just result in specific tunes, it indirectly influenced Strummer's belief in writing about the world – he wanted to be like the MCs who toasted on Trench Town 12-inches that were a form of current affairs.

Simonon was the band's reggae obsessive, and it flowed through to 'Guns of Brixton', a track he wrote and sang sneering lead on that also demonstrates the versatility of drummer Topper Headon, whose extracurricular dependencies didn't prevent him playing a crucial role. The band's ideas and Stevens'

production even stretched to a take on Phil Spector's Wall of Sound with 'The Card Cheat', where another of the album's anti-hero characters is backed up by a layered sound that was achieved by recording the song twice and combining the takes.

As befitting a classic album, there are songs here that no-one thought the Clash capable of achieving, and that they would never be able to duplicate on later releases. On the brisk, reflective 'Lost in the Supermarket', Strummer wrote an autobiographical lyric for Jones, who then sang its descriptions of growing up and the subsequent encroachment of consumerism. The double album even closed with something of a pop hit, courtesy of Mick Jones' catchy last minute inclusion 'Train in Vain', a guitar and keyboards groove that was suffused with a healthy optimism.

The Clash could still stand tall like outlaws determined not to be taken in, providing a righteous profile on the likes of 'Four Horsemen' and 'Death or Glory'. But the best indicator is the defiant 'I'm Not Down', which sketches a maturity borne of going against the odds. 'I've been beat up, I've been thrown out/But I'm not down, no I'm not down,' Mick Jones sang. 'I've been shown up, but I've grown up/And I'm not down, no I'm not down.'

That was the Clash at the end of the 1970s, old enough and tough enough to know what was at stake and to celebrate the possibilities. The world never ends on *London Calling* because there's always another song, another passion, another sound, or another belief to take up the slack. It's a consummate rock & roll experience, as vivid and thrilling now as the day it appeared.

N°:4

NIRVANA
NEVERMIND

DGC
Produced by Butch Vig
Released: September 1991

irvana's second album was a life-changing experience, both for those who made it and the many millions who intimately responded to it. *Nevermind* would have been a momentous event no matter what had recently transpired, but being released in September of 1991 established it as both a beacon of change and a clearing of the decks. It washed away years of anodyne soft rock music and soulless hair metal, creating a sea change in popular music as crucial as those that occurred in 1962 and 1976 (via the Beatles and punk respectively) – rock & roll would forever be before *Nevermind* and after *Nevermind*. And there was no doubt which was preferable.

It is obvious that reality will be amended within the first 10-second unfolding. The infectious, eye-narrowing guitar riff from Kurt Cobain is joined by the pummelling drum beats of Dave Grohl and the thick, viscous bass of Krist Novoselic to begin 'Smells Like Teen Spirit', a song that is both hardened and heavenly. The trio from the Pacific Northwest were as taken with the Pixies as Black Sabbath and on an album that would go on to sell in excess of a staggering 30 million copies, they divined a new compatibility – the unlikely becomes essential on both the album and its flag-bearing single.

'Smells Like Teen Spirit' has an oceanic calm in the verses, which builds with inexorable excitement to a chorus that is physically contagious. 'I'm worse at what I do best/And for this gift I feel blessed,' sings Cobain, his tone a mix of ennui and dread. And every time you think you have a grip on the song it inverts itself: pride becomes dejection, apathy resembles hope, and the guitar solo sets off the powerhouse drumming with a treated thunder. 'I feel stupid and contagious/Here we are now, entertain us,' Cobain insists, and the

TRACKLISTING

01 **Smells Like Teen Spirit**
02 **In Bloom**
03 **Come as You Are**
04 **Breed**
05 **Lithium**
06 **Polly**
07 **Territorial Pissings**
08 **Drain You**
09 **Lounge Act**
10 **Stay Away**
11 **On a Plain**
12 **Something in the Way**

song just keeps pushing and pulling at you. It's so complete and so primal that it's frightening.

What makes *Nevermind* such a wonderful album is that it takes everything that 'Smells Like Teen Spirit' has compressed into a cataclysmic five minutes and opens it out, expanding elements and themes so that the music can breathe; you're shocked and then given sense, with a collection of tracks that combine melody and noise, disdain and soulfulness, until the parts bleed from one into the next and you're transported beyond normal expectations.

Any album that becomes a cultural touchstone is subsequently dissected by those searching for portents of what was to come, and that goes doubly for Nirvana because of Kurt Cobain's subsequent suicide at the age of 27 on 5 April 1994. But there was little hint, in either Nirvana's formation or the recording of *Nevermind* itself, that greatness loomed. If there was, chances are the band would have either changed course, or practised some self-sabotage. They never seriously wanted to exist on the scale they subsequently had to, and part of the album's mystique is counterpointing the determinedly small expectations with the mass impact.

Kurt Cobain and Krist Novoselic had attended the same high school in the small

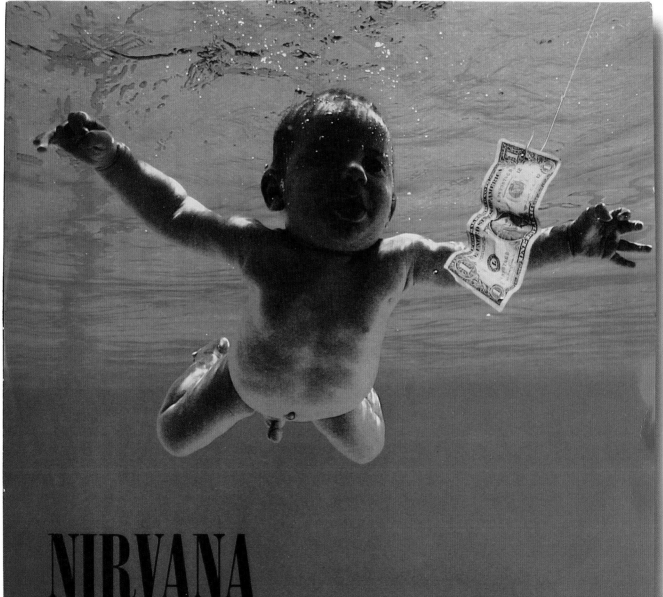

Washington state city Aberdeen, but it was not until several years later that they eventually started playing together – given purpose by the locale's underground punk scene and local band the Melvins. There would be a succession of drummers after the band was formed in 1987, and it was with Chad Channing that they made their first album, June 1989's *Bleach*, for Seattle label Sub Pop, and began touring America under ramshackle circumstances.

By April of 1990 they were ready to begin making a new album and, with a recommendation from roadmates Tad, they drove to Madison, Wisconsin to record with drummer and producer Butch Vig. They got through seven tracks in five days, despite Cobain blowing out his voice at a local club gig, and the session would have several unforeseen outcomes. Novoselic and Cobain were unhappy with Channing's playing in the studio, and decided that he had to be replaced, auditioning and quickly recruiting Grohl, whose previous band, Scream, had recently broken up.

'Kurt had left an answering machine message telling me, "We got the best drummer in the world, man. He's Dave Grohl. He's awesome!"' Butch Vig would recall. 'And I thought, "Right, I've heard that one before." But he was right.'

Grohl completed Nirvana in September 1990 and his powerful, precise style was a catalyst for the songs Kurt Cobain was bringing to rehearsals. But even as Nirvana were rebuilding their set, dubs of a tape with the initial Butch Vig tracks were beginning to circulate. When Sonic Youth, a band Nirvana admired and had befriended, passed it on to the A&R staff at their new major label, DGC, a quintessentially underground band became enmeshed with the mainstream of the music industry.

At one stage the group was receiving so many enquiries from hopeful talent scouts that they took to collecting business cards and then handing them out to the worst singers in karaoke bars, telling the excited amateurs to give them a call. Dinners with potential record companies were a chance to eat both well and substantially, but otherwise Nirvana spent months living in dives and rehearsing in a barn back in the Northwest, creating the 'Boombox Rehearsal' versions of many of *Nevermind*'s entries before they relocated to Sound City Studios in Hollywood.

'By the time I went out to L.A. to do *Nevermind*, I knew the songs we had done for the demo, and Kurt had sent me a boombox tape from the rehearsals in the barn. They sounded terrible because they were so distorted, but I could hear the songs in the background,' Vig noted. 'I think the first thing the guys played

me was "Teen Spirit", and I was fucking floored. It was so good. I just remember getting up and sweating and trying to act cool. They got done and I just said, "Hmmm, play it again," but I was thinking, "Holy shit that was fucking cool".'

The trio, Grohl would remember, had been rehearsing so much that they just needed someone to press play. The drummer – who liked recording at Sound City so much that he would subsequently buy the recording desk for his own studio – was among the first to hear the raw power that Nirvana could harness in the studio. The scene that radiated out from Seattle had never stinted on volume, and on a track such as the buzzsaw blast of 'Breed' Nirvana combined the weight of heavy metal's pioneers with the explosive energy of punk rock.

On *Nevermind* Nirvana moved effortlessly between the hardcore fury of 'Territorial Pissings', the barbed energy of 'Lounge Act', and the solemn, searing 'Something in the Way' – the closing acoustic ballad that sounded like it had taken in every emotion spat out and sped up by the record and transformed it into graceful acceptance. Butch Vig had heard echoes of John Lennon and Paul McCartney's songwriting beneath the distortion of Nirvana's demos, and there's little doubt that the songs allied considerable craftsmanship to the raw inspiration – there's a restraint on 'Come as You Are' that only adds to the yearning, with the guitars creating an otherworldly contrast.

Throughout the album the cathartic drive of the material didn't produce pleasure or a sense of triumph, instead it was the forceful recognition that the lyricist and the listener were genuine outsiders who would stay that way. Kurt Cobain's songs, in most cases, weren't out to destroy anything except any illusions he might have made for himself. 'I'm so happy 'cause today/I found my friends/They're in my head,' he sang on 'Lithium', and right through *Nevermind* there are only the barest references to outside structures or organisations. Society is some distant, alien concept, and the raw insularity of the lyrics was so compelling that it enveloped the audience.

After an adolescence that was increasingly torrid, including a spell as a devout Christian

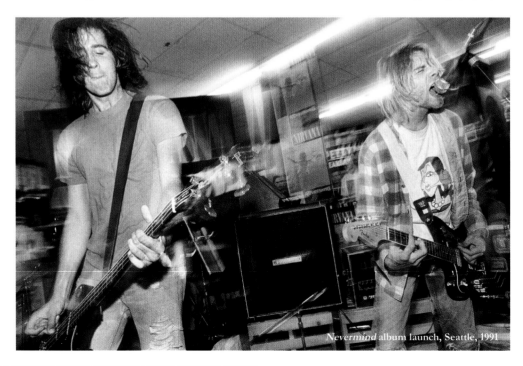

Nevermind album launch, Seattle, 1991

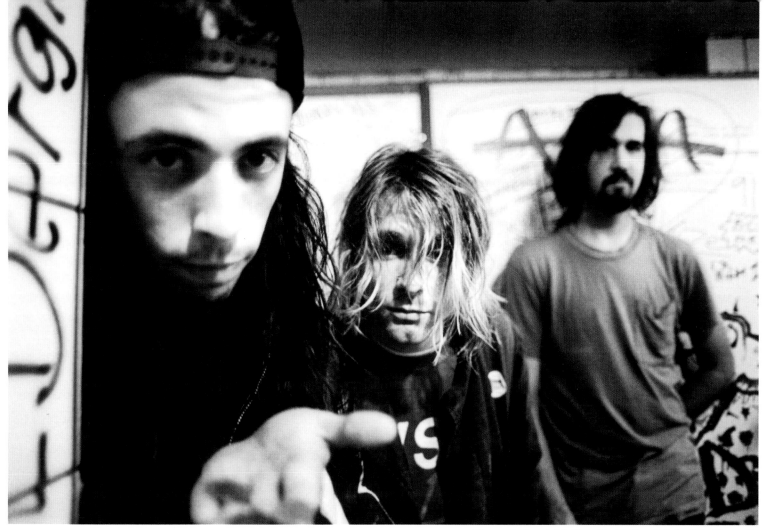

Nirvana (left to right): Dave Grohl, Kurt Cobain, Krist Novoselic

and witnessing his mother suffering domestic violence at the hands of the man she took up with after divorcing Kurt's father, some of the most influential people in Cobain's life were the politicised and committed young women he met when he started to frequent punk rock gigs in Olympia, Washington. Early girlfriends, such as Tobi Vail, the future drummer with riot grrrl outfit Bikini Kill, would debate philosophical and political issues with the young artist and musician.

On *Nevermind* the song most clearly about a female is 'Polly', an acoustic tale that Cobain wrote from the perspective of a man who has kidnapped, tortured and raped a young woman. The singer gives his male monster – inspired by a notorious Washington state criminal, Gerald Friend, who received a 75-year sentence in 1987 – an everyday demeanour. His crimes are casual, as if it's the most natural thing in the world: 'I think she wants some water/To put out the blowtorch,'

is one observation, but as the song stays still the resourceful girl outwits her captor. 'Amazes me the will of instinct,' the man marvels, and it's the beginning of a Nirvana tradition of celebrating women struggling to survive a patriarchal world.

The album would get a bright sheen from mixer Andy Wallace, who was chosen because he'd mixed Slayer's *Reign in Blood* and turned up looking – as Grohl recalls – like a friend of his dad's, but the band pulled no punches. Butch Vig soon realised that he had to tape Kurt Cobain's warm-up vocal takes because the frontman would give everything, and often his voice only had a handful of takes in it before it gave out from the raw exertion of how he sang. You can hear his voice falter on 'Territorial Pissings' and 'In Bloom', but it only adds to the excitement.

Nevermind was released in America on 24 September 1991 – a year and two days after

Dave Grohl joined the band – and it soon became clear that an entire generation was responding both to that excitement and the powerful self-identification that surged beneath it. Nirvana were out on tour and initially were mystified as to why their audience was swelling (MTV was constantly airing the 'Smells Like Teen Spirit' video). By January of 1992, with the band in Australia, they had knocked Michael Jackson's *Dangerous* off the top of the American charts.

The album flowed from one great song to the next, each recognisable in its own right. It would take an extremely prejudiced outlook to identify anything on *Nevermind* as filler, and the cumulative effect of these tracks – of the barely contained 'Stay Away' and the squeezed, agnostic guitar break on 'In Bloom' – leaves the listener both astounded and aware that everything has changed. Popular music is a broad church, but this was a road to Damascus moment. *Nevermind* will always burn true and bright.

N°:5

VAN MORRISON
ASTRAL WEEKS

Warner Bros
Produced by Lewis Merenstein
Released: November 1968

Van Morrison called one of his early '80s albums *Inarticulate Speech of the Heart* but there is no better phrase to describe *Astral Weeks*. His second LP, released in 1968, is one of the most enigmatic, impenetrable albums ever made. It stands alone in the history of music. Despite its fame, no-one has attempted to imitate it. It's a work that is enormous in its ambition and yet utterly unpretentious.

In the summer of 1968, Van Morrison had a lot on his mind. He had seen the heights and was now hitting the bottom. Them, the band he rode out of Belfast with a roaring R&B sound and a couple of hits ('Gloria' and 'Here Comes the Night') was over. His solo career had yielded one lacklustre pop album and one hit single ('Brown Eyed Girl') but Bang, his record label, wanted a pop star and Morrison didn't see himself that way. Legal disputes had left him penniless and Bang tried to have him deported from the USA. He married his girlfriend Janet Planet who already had a son. All of these issues come up in places throughout *Astral Weeks*.

A less driven man would have surrendered, but Morrison doggedly pursued his new style. In early 1968, Warner Brothers offered a lifeline – they would buy him out of his old contracts and record his new songs. Warner Bros Records assigned Lewis Merenstein as Morrison's producer.

Van Morrison has been quoted with a number of contradictory views about *Astral Weeks*. In the early '70s he avoided discussion of the album other than to say the final product had been taken out of his hands and was presented in a way that didn't represent his vision. Other times he has said it was all the result of his design.

TRACKLISTING

In the Beginning
01 **Astral Weeks**
02 **Beside You**
03 **Sweet Thing**
04 **Cyprus Avenue**

Afterwards
01 **The Way Young Lovers Do**
02 **Madame George**
03 **Ballerina**
04 **Slim Slow Slider**

'Merenstein came about when my back was against the wall,' Morrison said recently. 'I didn't have a choice at the time. I was all the way on the ground. People only have a choice when they have money. I didn't, they made sure of that.'

Merenstein booked the key musicians for the album. *Downbeat* magazine's jazz bassist of the year, Richard Davis, had a pedigree that stretched to Eric Dolphy, Miles Davis and Sarah Vaughan; drummer Connie Kay was a member of the Modern Jazz Quartet and guitarist Jay Berliner had worked with Charles Mingus. Morrison's flute player, John Payne, also came to the sessions.

'What stood out in my mind was the fact that he allowed us to stretch out,' said Berliner. 'We were used to playing to charts, but Van just played us the songs on his guitar and then told us to go ahead and play exactly what we felt.'

'There wasn't much communication,' recalled Davis. 'As far as I can recall, I don't think I exchanged one word with the guy. We just listened to his songs one time, and then we started playing. People told me later that he was shy, but to me he seemed aloof, maybe a bit moody. He was caught up in his own thing. He communicated through his singing.'

Morrison, however, clearly listened to what the musicians were doing with his songs. One of the highlights of the album is the way that he improvises lyrics and phrases based on where the music is going. In the middle of 'Madame George' he dives into this whirlpool of chanting 'the loves to love the loves to love the loves to love' that is almost spiritual. He chews the words until the meaning is subverted to the spirit, the essence of the line.

The singer went to a booth, the band set up and while Morrison strummed and sang his songs the others improvised the backing tracks. Perhaps Morrison was overawed to be in the presence of such elder statesmen or perhaps he felt it best just to stay out of their way and let their improvisational creative juices fill the spaces that he left in the songs. The musicians on these dates don't play their instruments, they sound like they are exploring the songs, providing the song with what's needed.

'There were no music charts. He ran it down once for the players and went into the vocal booth. Then we got the sound levels right and I hit the red light and he started singing,' recalled engineer Brooks Arthur. 'There wasn't too much stopping and starting. Van took off and the musicians went with him. They were serious players, they didn't have to think about it, they just did it instinctively, and it caught fire. We were working at the speed of sound. I tell you, we were breathing rarefied air in there.'

The first date, on 7pm on 23 September at Century Sound Studios in midtown Manhattan, comprised two 3½-hour sessions and it yielded four songs: 'Cyprus Avenue', 'Astral Weeks', 'Madame George' and 'Beside You'.

'You know how it is at dusk, when the day has ended but it hasn't,' Davis recalled of that first session. 'There's a certain feeling about the seven-to-ten session. You've just come back from a dinner break, some guys have had a drink or two, it's this dusky part of the day, and everybody's relaxed. Sometimes that can be a problem but with this record I remember that the ambience of the time of day was all through everything that we played.'

Another date proved unproductive. On 15 October the musicians reconvened for the third time and recorded 'The Way Young

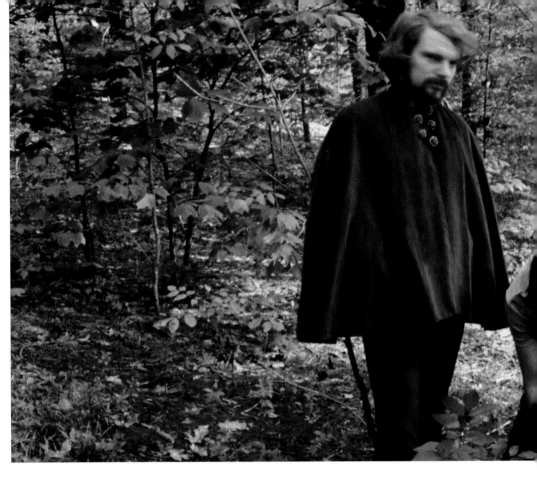

Lovers Do', 'Sweet Thing', 'Ballerina' and 'Slim Slow Slider' and two other songs that were rejected. Larry Fallon then overdubbed strings and horns. Much has been written about the importance of Miles Davis' jazz players in anchoring *Astral Weeks*' songs. It's the strings and horns that make them soar, however. Fallon's sympathetic violins give wings to Morrison's voice. His tuba and trombone parts are like foghorns cutting through the mists of words – it's an effect that Morrison would return to on his 1972 album *Saint Dominic's Preview*.

The songs came out of a notebook that Morrison carried with him. 'Ballerina' dated back to 1966 and was performed at least once by Them. 'Beside You' and 'Madame George' were songs that Morrison had recorded for Bang records and was contractually obliged to include on *Astral Weeks*. There is a lifetime of difference between the early, rough R&B-ish numbers from the Bang sessions compared to the *Astral Weeks* versions. In the latter case, the songs are allowed to breathe and to fly free.

Most of the action seems to take place in Belfast. 'Cyprus Avenue' is a real street near

where Morrison grew up, Sandy Row is a section of Belfast and parts of 'Madame George' draw vivid pictures of childhood. But it would be a mistake to assume this is somehow Morrison's childhood. 'It's not about me,' he says. 'It's totally fictional. It's put together of composites, of conversations I heard – you know, things I saw in movies, newspapers, books, whatever. It comes out as stories. That's it. There's no more.'

As the title suggests, *Astral Weeks* is about adventures on a plane other than this one. It's a world of dreams and half-recollected scenes and a place where the past and the present coexist. Many of the lyrics go back to childhood and others refer to innocence lost. The American music critic Lester Bangs wrote in an acclaimed essay on the album: '*Astral Weeks*, insofar as it can be pinned down, is a record about people stunned by life, completely overwhelmed, stalled in their skins, their ages and selves, paralyzed by the enormity of what in one moment of vision they can comprehend'.

So many of the characters in these songs are trapped, poised in a moment. In 'Ballerina'

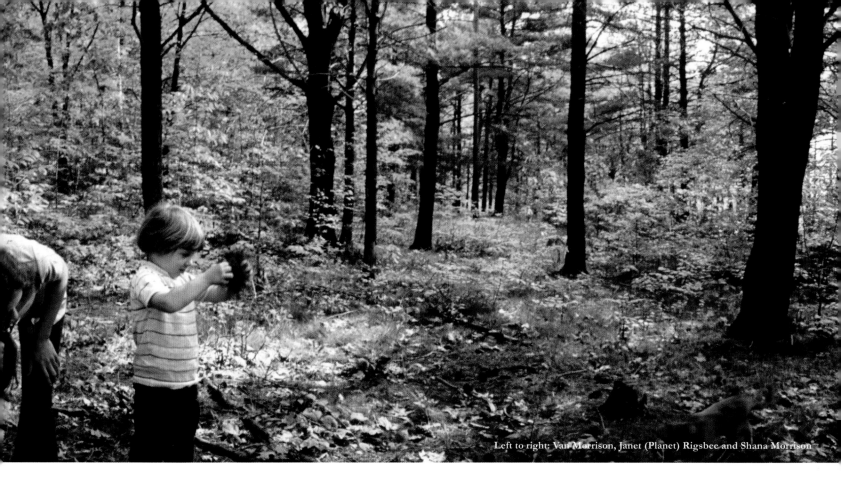

the singer is standing on the doorstep of the woman he loves crushed with fear and love. Elsewhere the singer is caught on 'Cyprus Avenue' thinking that he may go mad: 'My tongue gets tied, every time I try to speak,' he sings and then mangles up the words as if to show how the emotion that he can barely express is bursting out of him. The song goes through a number of images – school children, the railways that recur on 'Madame George', the changing of the seasons and a teenage love interest with ribbons in her hair. Morrison clearly has these snatches of images from his past that he is struggling to turn into a coherent story but it's all too emotionally charged.

He returns to Cyprus Avenue and the flat of Madame George where the kids gather to smoke cigarettes and drink and play dominoes in drag. 'Madame George' is the perplexing epic at the centre of *Astral Weeks*. Backed mostly just by Morrison's acoustic guitar strum, Davis lays down magnificent bass notes like a trail of exploding lotus bombs. On top of this duet Larry Fallon's strings fly and whirl, creating vertiginous spirals of emotion chasing Morrison's hypnotic, repetitive scat

singing. Then it ends as the singer gets on the train and leaves for the rest of his life.

Morrison had previously recorded this song for Bang and that version sounds like a Bob Dylan pastiche, of which there were so many at the time. It sounds like he's following up Them's version of 'It's All Over Now Baby Blue'. The original has none of the vocal improvisations or the complex phrasing that he brings to the recording on *Astral Weeks*. It's very much as though he is telling the story. When he sings it on *Astral Weeks* he puts himself, and us, right there in the room.

James Joyce's collection of stories about Dublin was built on what he described as epiphanies – those ordinary moments that when apprehended evoke a larger life; the divine. It could be the light catching the left side of a woman's face, a snatch of conversation or children throwing coins at passing trains. Joyce described these epiphanies as 'inadvertent revelations, little errors and gestures – mere straws in the wind – by which people betrayed the very things they were most careful to conceal'. These revelations can be both lyrical and radiant. It

may well be that Morrison in September 1968 was so raw that his defences were down and what flowed through him had that fearsome beauty of emotional truth.

'It's all poetry I made up,' Morrison said recently. 'I'm not exactly sure where the location it comes to me from is located, but it always comes from the realm of the imagination. It's subjective. I think it would be reductive for me to try to answer "why".'

Astral Weeks was not a commercial success on its release. It's likely that the label didn't quite know what to do with it and someone came up with the nonsensical idea of dividing the sides into 'In the Beginning' and 'Afterwards', which only confused matters more. His relationship with Warners put him back on his feet, though, and his next album *Moondance* was a major critical and commercial hit. Morrison was on his way, never to return to Cyprus Avenue. As he sang in 'Sweet Thing', 'I will never ever, ever, ever/Grow so old again'. He never again let anyone else control his recording sessions. Lewis Merenstein went on to produce many artists but he never made an album as ambitious as this. *Astral Weeks* was bigger than all of them.

Nº: 6

JONI MITCHELL
BLUE

Reprise
Produced by Joni Mitchell
Released: June 1971

Many songwriters will tell you that they deal in stories and archetypes and that their songs are not to be confused with memoir. Joni Mitchell is not one of those.

'I'll tell you, any acts of frustration or concern or anxiety in my life are all peripheral to a very solid core,' Joni Mitchell told Cameron Crowe. 'A very strong, continuing course I've been following. All this other stuff is just the flak that you get for engaging in the analytical process in the first place. Even Freud knew that; to me it was the hippest thing he ever said: "Dissection of the personality is no way to self knowledge." All you get out of that is literature, not necessarily peace of mind. It's a satisfying, but dangerous, way to learn about yourself.'

No-one ever dissected their personality on record with a sharper scalpel than Joni Mitchell. And she never did it better than on *Blue*.

'During the making of *Blue* I was so thin-skinned and delicate that if anybody looked at me I'd just burst into tears,' Mitchell says in the book *Woman of Heart and Mind*. 'I felt so vulnerable and naked in my work. I was demanding of myself a deeper and greater honesty, more and more revelation in order to give it back to the people so that it strikes against the very nerves of their life, and to do that you have to strike against the very nerves of your own.'

Blue opens with the phrase 'I am on a lonely road and I am traveling/Traveling, traveling, traveling/Looking for something, what can it be …'. In 1969 Mitchell was running away from success and emotional security and running towards its opposite. At the time Mitchell had three successful albums to her name and she was widely regarded as one of the best songwriters of her generation. Her boyfriend, Graham Nash of Crosby, Stills, Nash and Young, proposed marriage. Joni ran away.

At the age of nine Joni Anderson had contracted polio which kept her bedridden for much of her childhood. The disease was to affect her muscle growth, leading to her developing an idiosyncratic method of forming chords. She began singing as a means to exercise her diseased lungs. An only child, she took up art and music, and in her late teens she gravitated towards the Canadian folk scene. There was an unplanned pregnancy, with the destitute Joni deciding to give up the child for adoption, and shortly after a marriage to fellow folksinger Chuck Mitchell. The marriage soon soured and with her growing belief in her talents as an artist buoyed by Judy Collins and others covering her songs, she struck out on her own, leaving Chuck behind. Her adventures led her to David Crosby of the Byrds, who helped secure her first record deal and also produced her first album.

TRACKLISTING

01 **All I Want**
02 **My Old Man**
03 **Little Green**
04 **Carey**
05 **Blue**
06 **California**
07 **This Flight Tonight**
08 **River**
09 **A Case of You**
10 **The Last Time I Saw Richard**

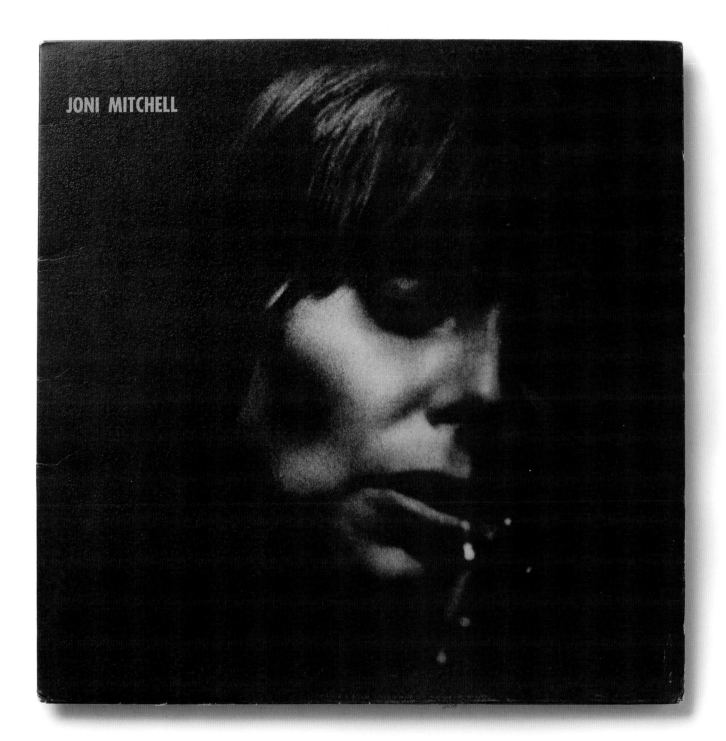

The association with Crosby placed her firmly in the middle of the Laurel Canyon scene along with the Mamas and the Papas, the Eagles, Jackson Browne and of course Crosby, Stills, Nash and Young. She and Young had been teenage friends on the Canadian folk scene and she was soon to move in with Graham Nash. While they were together they wrote some of the great hymns to domesticity: 'Our House', 'My Old Man' and 'Willie'. But Joni Mitchell had realised she was not the marrying kind.

Mitchell's ambivalence towards relationships and love was very much at the edge of the zeitgeist. One of Mitchell's difficulties was reconciling her own ambition with the desire for a rugged macho man. 'It's a funny time for women,' she told Cameron Crowe. 'We demand a certain sensitivity. We've made our outward attacks at machismo, right, in favour of the new sensitive male. But we're just at the fledgling state of our liberty where we can't handle it. I think we ask men to be sensitive and equal but deep down think it's unnatural. And we really

want them to be stronger than us. So you get into this paradoxical thing.'

Mitchell's records were remarkable for their melodic invention – her guitar was often strung in tunings of her own devising that led to different voicings of otherwise familiar melodies. According to James Taylor, 'Joni invented everything about her music, including how to tune the guitar. From the beginning of the process of writing, she's building the canvas as well as she is putting paint on it.'

'For years everybody said "Joni's weird chords, Joni's weird chords" and I thought, How can chords be weird?' she said. 'Chords

are depictions of your emotions, they feel like my feelings. I called them Chords of Inquiry, they had a question mark in them. There were so many unresolved things in me that those suspended chords that I found by twisting the knobs on my guitar, they just suited me.'

> No-one ever dissected their personality on record with a sharper scalpel than Joni Mitchell. And she never did it better than on *Blue*.

Most of all it was the honesty in Mitchell's songs that was startling. Crosby had stated that he saw his role as her record producer as being more like a gatekeeper. He wanted to keep producers and engineers away from Mitchell and to present her music as intimately and directly as possible. His main technique was to mike the singer closely so that you could almost hear her heart beat. 'When it comes to knowing where to put the chords, how to tell a story and how to build to a chorus, most of them can't touch me,' Joni Mitchell told the *Sunday Times*.

Mitchell's voice was a complex instrument, too. This album may well have been titled as a homage to Miles Davis' classic *Kind of Blue*. Mitchell sings more like a jazz singer than a folk artist. There's playfulness in her phrasing that avoids the songs becoming self-pitying dirges.

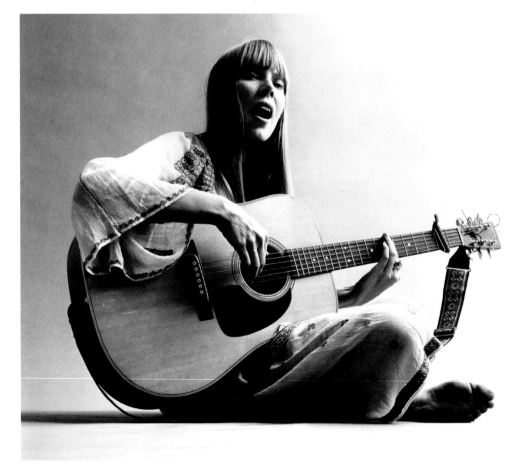

As befitted these intimate songs, the sessions comprised mostly just Mitchell and her longtime engineer Henry Lewy. Mitchell accompanied herself on guitar, piano and dulcimer with help from Stephen Stills (who plays bass and guitar on 'Carey'), James Taylor plays guitar on three tracks, Russ Kunkel plays drums on three songs and Sneaky Pete Kleinow adds pedal steel to two tracks. The rest is undiluted Mitchell.

The album opens with the beginning of her odyssey, 'All I Want'. This is going to be a trip looking for adventures but it's also a spiritual journey.

'By the time of my fourth album I came to another turning point – the terrible opportunity that people are given in their lives. The day

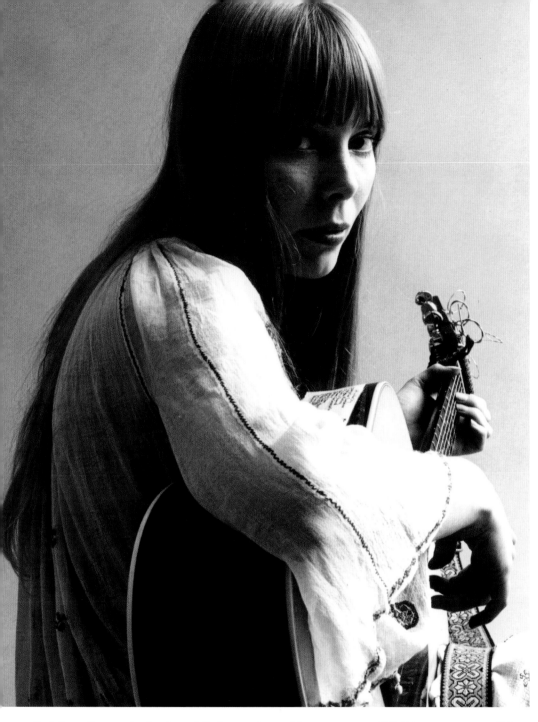

but in the end love is not enough. 'Little Green' is a deeply moving song to a child but one that doesn't sweeten the message. Mitchell tries to be unsentimental, especially at the end where she announces that she doesn't apologise for her decision to say goodbye.

'Carey' is an unabashed song of lust. The subject of the song is the red-headed chef Cary Raditz with whom Mitchell had an affair while she was staying in an alternative community on Crete. 'California' is another song from her European vacation. It's a song about the global community of beautiful people, including Raditz. She travels through France and Spain but the pull of home is too great.

The first side of *Blue* may be about going and the second side, which begins with another plane trip, is where the tough moments are. 'River' is one of the most powerful songs Mitchell, or anyone, has ever penned. There is the recurrent theme 'I wish I had a river I could skate away on', a line that seems full of remorse, a desire to escape herself or at least that part that is inclined to be cruel.

'A Case of You' is another of Mitchell's finest songs. It begins with one of the most vicious putdowns set to music: 'Just before our love got lost you said/"I am as constant as a northern star"/And I said "Constantly in the darkness/Where's that at?/If you want me I'll be in the bar". After that cruel remark, Mitchell goes on to sing of the depth of her love ('you're in my blood like holy wine') and acknowledges the importance of the relationship ('part of you pours out of me/In these lines from time to time'). There is no better love song. Mitchell had already performed the song while still with Nash, suggesting that her ambivalence to 'marriage' was longstanding.

The album closes with 'The Last Time I Saw Richard'. We have gone from the Greek Isles to a dark bar in Detroit where Joni meets her former husband. He's now a drunk, with a wife and children, a coffee percolator and a lifetime of disappointments. He's still trying to put her down but the burden of his own failures is too apparent. The song may be about her first husband but it's also a statement about Joni Mitchell's own ambitions.

Bob Dylan got one of his best song titles when he got tangled up in *Blue*. It's easy to do.

that they discover to the tips of their toes that they're assholes,' she told journalist Cameron Crowe. 'And you have to work on from there. And decide what your values are. Which parts of you are no longer really necessary? They belong to childhood's end.

'*Blue* really was a turning point in a lot of ways. In the state that I was at in my inquiry about life and direction and relationships, I perceived a lot of hate in my heart. You know, "Oh I hate you some, I hate you some

I love you some/Oh I love you some, I love you when I forget about me" ('All I Want'). I perceived my inability to love at that point. And it horrified me some. It's still something that I … I hate to say I'm working on, because the idea of work implies effort, and effort implies you'll never get there. But it's something I'm noticing.'

'My Old Man' sounds like a farewell song to Graham Nash. The acknowledgement of a great and nurturing love between two people

No: 7

THE ROLLING STONES
STICKY FINGERS

Rolling Stones Records
Produced by Jimmy Miller
Released: April 1971

In 1969 the Rolling Stones toured America after a three-year hiatus. Their tour manager Sam Cutler acted as MC and, on the first night, introduced the band with the line 'Ladies and gentlemen, the greatest rock & roll band in the world – the Rolling Stones'. Mick Jagger asked him not to be so bold, to which Cutler replied, 'Well you either are, or you aint. What's it gonna be?'. No question, in 1970 the Rolling Stones were the greatest rock & roll band in the world.

The 1960s were over. The Beatles were dead. The revolution was on. The world was turning and whatever the vanguard was going to be, the Rolling Stones knew they were in it. The documentary of the '69 tour, *Gimme Shelter*, shows just how they bristled with energy: the satin scarves, velvet hipsters, feline waists, the wry quips to the press, the snakeskin boots, the rotten teeth and the cocaine eyes. You can see them wandering through America like princes, as if their feet didn't even touch the ground.

In the documentary there's a scene where Jagger, Richards and Gram Parsons are hanging around yet another hotel room. Richards plays a rough mix of 'Brown Sugar' and the room comes alive – he and Jagger just falling into their serpentine moves as casually as breathing.

For those years – 1968 to 1972 – the Rolling Stones were either in the studio or on stage continuously. In that time they produced five of their best albums (*Beggars Banquet*, *Let It Bleed*, *Get Yer Ya Yas Out*, *Sticky Fingers* and *Exile on Main St*). In a sense it's all one masterpiece – tracks that were recorded for *Let It Bleed* came out on *Exile*. But if you have to pick just one album, then *Sticky Fingers* represents the peak.

There were two key elements to the Stones' heyday – producer Jimmy Miller and guitarist Mick Taylor. Miller, a former drummer and an American in London, came on board with *Beggars Banquet*. 'A great producer who, for the first time, the band actually listened to,' said bass player Bill Wyman. 'Jimmy was able to stand up to us.

TRACKLISTING

01 **Brown Sugar**

02 **Sway**

03 **Wild Horses**

04 **Can't You Hear Me Knocking**

05 **You Gotta Move**

06 **Bitch**

07 **I Got the Blues**

08 **Sister Morphine**

09 **Dead Flowers**

10 **Moonlight Mile**

Everybody knew that we had to get back to our roots and start over. That's why we got Jimmy Miller as a producer and came out with *Beggars Banquet* and those kinds of albums after, which was reverting back and getting more guts – which is what the Stones are all about.'

Mick Taylor replaced original guitarist Brian Jones during *Let It Bleed*. Taylor's concise lines complemented Keith Richards' open-tuned sweeping chords. Richards also saw Taylor as a potential threat and lifted his own game lest he be shown up. 'He made it very musical. He was a very fluent, melodic player, which we never had, and we don't have now,' Jagger said of the new guitarist. 'He was very good for me working with him ... He was exciting, and he was very pretty, and it gave me something to follow. Some people think that's the best version of the band that existed.'

'The rough edges came off a bit,' said Miller. 'Mick Taylor started putting on the polish that became the next period of the Stones out of the raw rock and blues band.'

The line-up was further extended by the semi-permanent addition of horn players Jim Price and Bobby Keys and pianist Nicky Hopkins. 'I was staying with Mick for a brief period of time, and they were working on *Sticky Fingers*,' said Keys. 'Otis Redding and the Memphis sound was big on everybody's

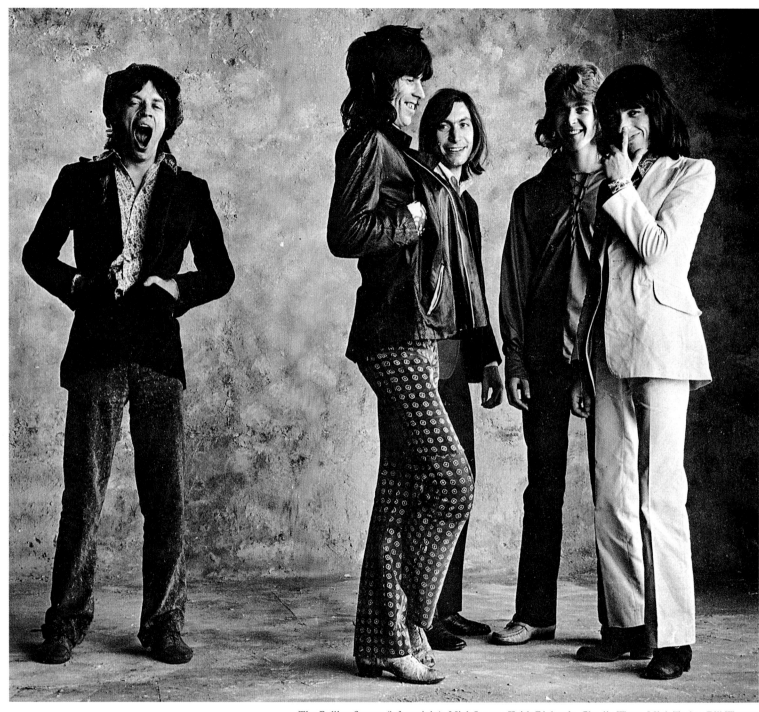

The Rolling Stones (left to right): Mick Jagger, Keith Richards, Charlie Watts, Mick Taylor, Bill Wyman

minds at the time and the Stones wanted to do something that had horns on it. Jim Price and I were available; we did a couple tracks, and then they said, "Let's do a couple more". One thing led to another.'

The first recorded track on *Sticky Fingers* predated this new line-up. 'Sister Morphine'

was written by Jagger and Richards and Marianne Faithfull for her to record. In March 1969 Jagger suggested cutting a Rolling Stones version. Opening smoothly with Richards' acoustic guitar and Jagger's dispassionate vocal, the track just gets nastier as it goes. Charlie Watts waits two minutes before coming in on the kick drum with spectacular

playing off the beat and then finally the piano accelerates this vortex of paranoia.

The horrors of addiction would haunt the Rolling Stones for a decade, and more than a dozen members of the band and inner circle would die or be decimated by drugs. But in 1970 they thought they were indestructible.

The next track, 'Dead Flowers', is a jovial country rave up featuring 'a needle and a spoon and another girl to take my pain away'.

Drugs notwithstanding, the Stones squeezed recording dates into the touring schedule, spending a week at the legendary Muscle Shoals Studio in Alabama. 'It worked very well,' recalls drummer Charlie Watts. 'It's one of Keith's things to record while you're in the middle of a tour and your playing is in good shape. We cut some great tracks – "You Gotta Move", "Brown Sugar" and "Wild Horses". The Muscle Shoals Studio was a great studio to work in, a very hip studio, plus you wanted to be there because of all the guys who had worked in the same studio.'

'Brown Sugar' is a signature Stones song – salacious, politically incorrect and powered by a biting riff. It was the first song Jagger had written entirely by himself. He penned it during downtime in Australia, where he was starring in the film *Ned Kelly*. Richards was primarily responsible for 'Wild Horses', which was inspired by his having to leave his newborn son Marlon in the UK, and informed musically by his close friendship with Gram Parsons.

Although only three tracks were cut in that session, the Muscle Shoals feel permeates the album – especially in the contributions from Price and Keys. The Stones' attempt at a soul torch ballad is 'I Got the Blues', a steady roiling track that ebbs and swells with the horns and Billy Preston's organ. It's far and away the best pure R&B song that the Rolling Stones ever recorded.

'Can't You Hear Me Knocking' started out as a straight up R&B track gliding on Keith Richards' funk groove. This is Richards at his best; slipping and sliding around Charlie Watts. Around 2½ minutes in, the song sounds as if it's about to end when Mick Taylor and Bobby Keys hijack the tune for another four minutes of improvisation. The resulting track has become one of the great showcases of the band's musicality.

As 1970 unfolded and work on *Sticky Fingers* continued, Keith Richards' heroin habit steadily grew and, like Brian Jones, he began to miss sessions. Longtime Stones insider Jo Bergman said, 'I never noticed anything about Keith particularly 'til 1970 ... I didn't

think Keith was going to live through the '70 tour of Europe.' 'Was I even there for the last sessions of *Sticky Fingers*?,' the guitarist asked Robert Greenfield in a 1971 interview. 'When did they finish it? I was very out of it by the end of the album ... We were all surprised at the way that album fell together. *Sticky Fingers* – it pulled itself together.'

In fact, Mick Jagger and the rest of the crew pulled it together, much of the time recording at Jagger's estate with the Rolling Stones Mobile Studio. 'We made (tracks) with just Mick Taylor, which are very good and everyone loves, where Keith wasn't there for whatever reasons,' said Jagger. 'All the stuff like "Moonlight Mile", "Sway". These tracks are a bit obscure, but they are liked by people that like the Rolling Stones. It's me and (Mick Taylor) playing off each other – another feeling completely, because he's following my vocal lines and then extemporizing on them during the solos.'

'The house that we used, Stargroves, was ideally suited because it was a big mansion and a grand hall with a gallery around with bedroom doors and a staircase,' recalls engineer Andy Johns. 'Big fireplace, big bay window – you could put Charlie in the bay window. And, off the main hall there were other rooms you could put people in. We did "Bitch" there, and you can hear "Moonlight Mile" when Mick is singing with the acoustic, it sounds very live, because it was! Four or five in the morning, with the sun about to come up.'

'Moonlight Mile' is a companion piece to 'Wild Horses', another melancholy song about distance and being lost on the road. 'Moonlight Mile' has a defiant aloneness to it that's amplified by the lavish orchestration by Paul Buckmaster. It's quite unlike anything else in the Rolling Stones' canon.

Finally there's the track 'Sway', which is perhaps the best cut of all, buried between

the singles 'Brown Sugar' and 'Wild Horses'. Jagger makes his debut on guitar here. 'Mick started playing the guitar a lot,' Watts recalled. 'He plays very strange rhythm guitar ... very much how Brazilian guitarists play, on the upbeat. It is very much like the guitar on a James Brown track, for a drummer it's great to play with.' The circular groove here is magnificent with Charlie Watts grooving off Taylor and Hopkins. Backing vocals came from the Who's Pete Townshend and the Faces' Ronnie Lane.

'Was I even there for the last sessions of *Sticky Fingers*?' asks Richards.

'The thing about Mick Taylor was that he was a brilliant musician, probably the best musician in the band during the years he was there,' said Bill Wyman. 'I've always loved those albums more than any of the others because, to me, that's where we were playing at our very best.'

Sticky Fingers was the first album on the Rolling Stones' own label. With full creative control Mick Jagger chose pop artist Andy Warhol to design the sleeve – a well-endowed man in a pair of jeans. As was no doubt intended, several retail chains refused to stock the album and in some countries the cover was completely banned. Meanwhile, the metal fly that ran down the front of the original pressings upset retailers because it damaged the other stock.

At this time, the Rolling Stones were completely unstoppable and *Sticky Fingers* would prove to be their biggest selling album to date.

Typically, Charlie Watts was bemused by the whole thing. '[I'm] not amazed that the band is still going, just amazed they get anything together,' he said at the time. 'That's our claim to fame, you know. Carry on lads, regardless. Should be the title of our next film. We're a terrible band, really. But we are the oldest. That's some sort of distinction, isn't it? Especially in this country. The only difference between us and Westminster Abbey, you know, is we don't do weddings and coronations.'

N°8

FLEETWOOD MAC
RUMOURS

Warner Bros
Produced by Fleetwood Mac, Ken Caillat, Richard Dashut
Released: February 1977

Unless you've been living under a rock, you already know that *Rumours* is Fleetwood Mac's break-up album. The two couples in the band had split up prior to recording the album, but for the sake of the band they kept it all together, aided by the complete annual illegal production of Bolivia. All of the salacious rumours certainly add to the charms of *Rumours* but gossip alone would not have made it such a wildly successful album. It's the unique chemistry in Fleetwood Mac and the craftsmanship in songwriting and production that makes *Rumours* the most perfect pop record of all time.

Fleetwood Mac was always a curious ensemble. Drummer Mick Fleetwood and bass player John McVie were blues players, veterans of John Mayall's Bluesbreakers. Their partnership was based around supporting guitar virtuosos like Peter Green, who gave them their first hit, the instrumental 'Albatross'. Singer/pianist Christine Perfect, whose background was also in the blues, married McVie and joined the Mac in 1970. For the next few years the group slowly mutated into a conventional rock band and in December '74, at Fleetwood's instigation, they hired the Californian pop duo and couple Lindsey Buckingham and Stevie Nicks. To everyone's surprise, the mixture of British blues and light pop proved to be a winning formula.

The 1975 album *Fleetwood Mac* vaulted the group to superstardom but across the next 18 months it also saw both the McVie marriage and the Nicks/Buckingham relationship fall apart. After a decade of relentless touring, poverty and anonymity, Fleetwood Mac the group was too much to sacrifice for the sake of romantic turmoil. 'We had two alternatives – go our own ways and see the band collapse,

TRACKLISTING

01 **Second Hand News**
02 **Dreams**
03 **Never Going Back Again**
04 **Don't Stop**
05 **Go Your Own Way**
06 **Songbird**
07 **The Chain**
08 **You Make Loving Fun**
09 **I Don't Want to Know**
10 **Oh Daddy**
11 **Gold Dust Woman**

or grit our teeth and carry on playing with each other,' Christine McVie told Johnny Black. 'Normally, when couples split, they don't have to see each other again. We were forced to get over those differences.'

There were no songs ready when sessions for *Rumours* began, so it was written in the studio. In those circumstances the songs reflected contemporary events. 'We started trying to put down basic backing tracks,' recalled Fleetwood. 'We spoke to each other in clipped, civil tones, while sitting in small airless studios, listening to each other's songs about our shattered relationships.'

According to engineer/co-producer Ken Caillat, 'I remember them [Nicks and Buckingham] singing background vocals to "You Make Loving Fun", sitting on two stools in front of a pair of microphones, directly facing me on the other side of the control room glass, and if we had to stop tape for whatever reason, they'd be shouting and screaming at one another.'

In reality, all five of the band were rarely together in the studio at the same time except for recording vocals and rhythm tracks and the occasional band meeting. Christine McVie and Lindsey Buckingham were responsible for the piano and guitar parts and the majority

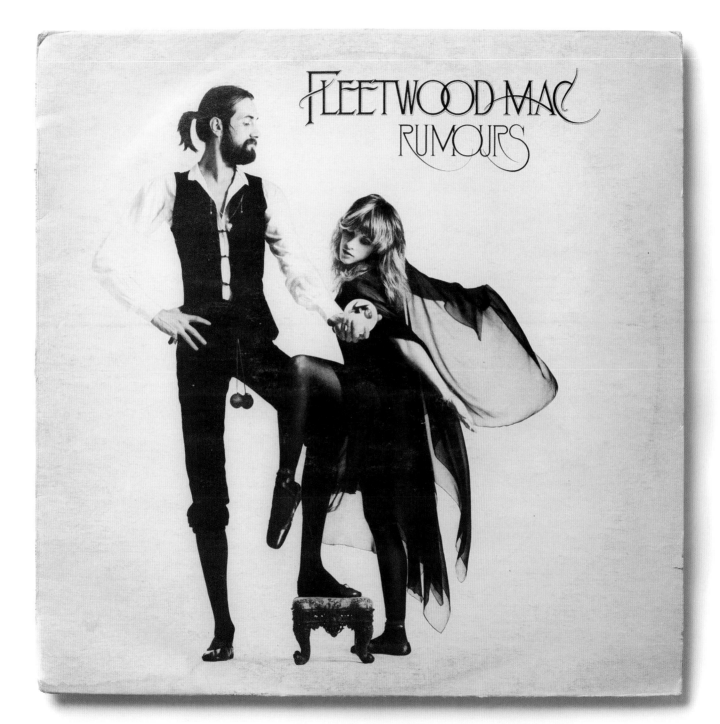

of the song crafting and they were not at loggerheads. The album was generally pieced together in the editing.

'The only two instruments that were actually played together on that entire album was the guitar solo and drum track on "The Chain",' recalled co-producer Richard Dashut. 'It wasn't necessary or even expedient for them all to be in the studio at once. Virtually every track is either an overdub, or lifted from a separate take of that particular song. What you hear is the best pieces assembled, a true aural collage. Lindsey and I did most of the production. That's not to take anything away from Ken or the others in the band – they were all very involved. But Lindsey and myself really produced that record and he should've gotten the individual credit for it, instead of the whole band.'

Buckingham was very much in the driver's seat. Richard Dashut was appointed co-producer because of his friendship with the guitarist after a previous engineer was fired for being into astrology. Buckingham really wanted a partner in crime. 'I was really just around keeping Lindsey company,' Dashut said. 'Then Mick takes me into the parking lot, puts his arm around my shoulder and says, "Guess what? You're producing the album". I brought in a friend, Ken Caillat, to help me. Mick gave me and Ken each an old Chinese l-Ching coin and said, "Good luck".'

'"Never Going Back Again", took forever,' recalls engineer Chris Morris of the song which is effectively a solo piece by Buckingham. 'It was Lindsey's pet project, just two guitar tracks but he did it over and over again.'

Buckingham grew up on Brian Wilson and the highly orchestrated pop of the late '60s and early 1970s but his taste also leaned towards the sharper power pop of Big Star and Sparks. Without Buckingham's edge, *Rumours* could easily have drifted into the middle of the road.

The album's best known song was also a Buckingham composition that was inspired by the Rolling Stones' 'Street Fighting Man'. '"Go Your Own Way"'s rhythm was a tom tom structure that Lindsey demoed by hitting Kleenex boxes or something to indicate what was going on,' said Fleetwood. 'I never quite got to grips with what he wanted, so the end result was a mutated interpretation of what he was trying to get at. It's completely back to front, and I've seen really brilliant drummers totally stumped by it. When Lindsey went out on his own, he took three drummers onstage and they did "Go Your Own Way", but they couldn't get it right. It's a major part of that song, a back to front approach that came, I'm ashamed to say, from capitalising on my ineptness. There was some conflict about the "packin' up, shackin' up" line, which Stevie felt was unfair, but Lindsey felt strongly about.'

'I very much resented him telling the world that "packing up, shacking up" with different men was all I wanted to do,' Nicks told *Rolling Stone*. 'He knew it wasn't true. It was just an angry thing that he said. Every time those words would come onstage, I wanted to go over and kill him. He knew it, so he really pushed my buttons through that.' As if to push his point, Buckingham piled on a sublime electric guitar part that cut through the layers of acoustics, perfectly playing off Fleetwood's liquid drums. The solo was in fact edited from six different takes into one.

The strength of Fleetwood Mac was having three singer-songwriters, two of whom were women, which helped balance out the machismo. On *Rumours*, Nicks and Christine McVie were both at the height of their powers, able to write with style and candour about their interior lives. Nicks was the more flowery and esoteric; McVie more earthy and plaintive.

Nicks' songs like 'Dreams' and 'Gold Dust Woman' displayed her abilities as a storyteller. 'Dreams' with its lines 'Thunder only happens when it's raining/ Players only love you when they're playing/Say, women, they will come and they will go' was written in one go in the studio and perfectly summed up the soap opera that surrounded the recording. '"Dreams" developed in a bizarre way,' recalled McVie. 'When Stevie first played it for me on the piano, it was just three chords and

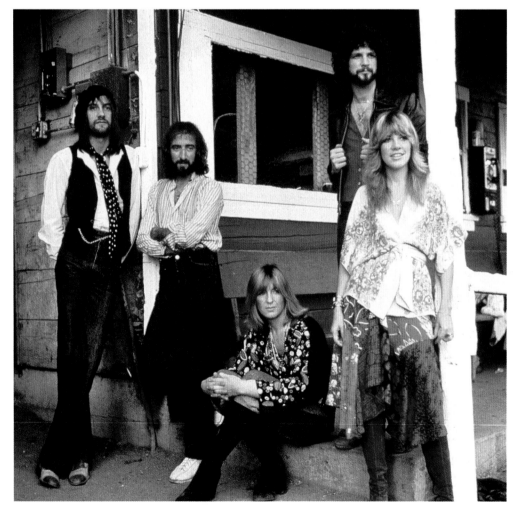

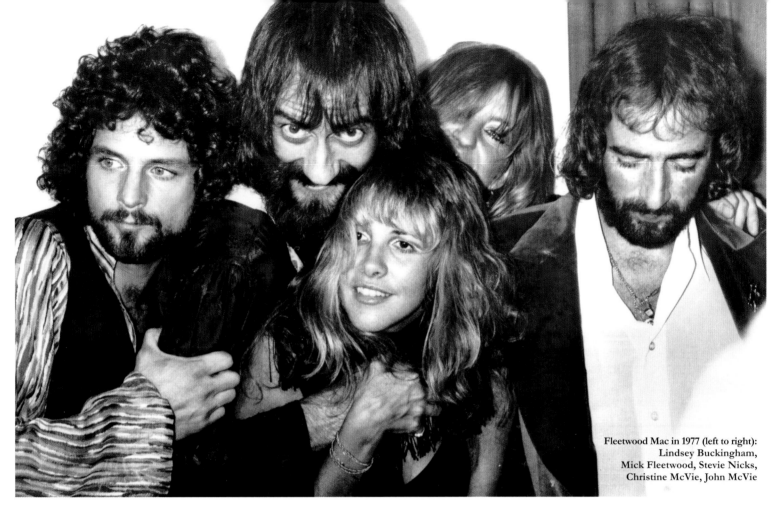

Fleetwood Mac in 1977 (left to right):
Lindsey Buckingham,
Mick Fleetwood, Stevie Nicks,
Christine McVie, John McVie

one note in the left hand. I thought, 'This is really boring, but the Lindsey genius came into play and he fashioned three sections out of identical chords, making each section sound completely different. He created the impression that there's a thread running through the whole thing.'

Christine McVie was always the shyest member of the group and her self-confidence, never strong, was at its weakest as the recording began. 'When we went in, I thought I was drying up,' she said. 'I was practically panicking because every time I sat down at a piano, nothing came out. Then, one day in Sausalito, I just sat down and wrote in the studio, and the four-and-a-half songs of mine on the album are a result of that.'

Her 'Songbird' is her tribute to the Fleetwood Mac situation – its lyric about the redemptive qualities of song and the resilience of real love was an important centring for the band. She performs it almost entirely alone on the piano. The tune harks back to the lilting melodies of classic British pop and folk music.

McVie's talents as a musician and an arranger also came strongly to the fore. Her Fender Rhodes piano or Hammond B-3 organ are on every track giving a cool, dark weight to Buckingham's layers of guitars and vocal harmonies. 'Second Hand News', which was inspired by the Bee Gees' 'Jive Talkin', is a perfect example of the way her clear vocal pierces the galloping rhythm section and the sea of guitar and vocals. It's the sound of a woman who is taking control of her emotional life and is feeling very upbeat about the whole thing. This is the positive side of divorce. Indeed, given that these are break-up songs, no-one seems to have any regrets.

The *Rumours* sessions were notorious not only for the emotional dilemmas but also for the amount of studio time the project ate up. The band spent two solid months in San Francisco before moving to Miami and then Los Angeles for several more months. At one point there had been so much overdubbing that the magnetic tape actually wore out.

'It was the craziest period of our lives,' said Fleetwood. 'We went four or five weeks without sleep, doing a lot of drugs. I'm talking about cocaine in such quantities that, at one point, I thought I was really going insane.

'Things got so tense that I remember sleeping under the soundboard one night because I felt it was the only safe place to be. Eventually the amount of cocaine began to do damage. You'd do what you thought was your best work, and then come back next day and it would sound terrible, so you'd rip it all apart and start again.'

The romantic soap opera around *Rumours* was a perfect hook on which to hang the promotion of the album but it wasn't the reason for the album's success. *Rumours* brought together English and American musicians from different schools – the blues and pop. It had strong lyrics written and performed by both men and women, three exceptional singers plus the sonic ambition of Lindsey Buckingham, the fluid inventiveness of a great rhythm section and it had the unlimited resources to make a totally state of the art pop album.

N°:9

THE VELVET UNDERGROUND & NICO
THE VELVET UNDERGROUND & NICO

Verve
Produced by Andy Warhol
Released: March 1967

The famous line about the Velvet Underground – 'They only sold a few thousand records, but everyone who bought one started a band' – is both correct and yet also immortal, given that those acts include David Bowie, Television, the Patti Smith Group, R.E.M., the Strokes and Roxy Music. But you could just as easily say that every song on their epochal 1967 debut, *The Velvet Underground & Nico*, started a musical genre. Punk and post-punk, indie-rock, alternative pop, Gothic rock, trance music and more – the tendrils of these 11 songs stretch so far that we now take them for granted even as new generations find fresh inspiration from this collection.

The New York group and their German guest vocalist made a record so far ahead of its time that most people who came across the band or this release rejected them with explicit antagonism (radio stations banned it from the airwaves, magazines rejected ads for it, stores refused to stock it), but it's now easily the most prophetic release in the history of popular music. No album that peaked at #193 on the American album charts has ever been so contentious, which would have delighted both the musicians – vocalist/guitarist Lou Reed, multi-instrumentalist John Cale, guitarist Sterling Morrison, drummer Maureen 'Mo'

Tucker, and vocalist Nico – and their enabler, pop art icon Andy Warhol.

Reed and Cale, both the creative core of the band and one of many intensely close yet doomed relationships that nurtured the music, met in 1964 in the most mainstream of settings: music company Pickwick Records. The two men – a rebellious Jewish kid from Long Island (Reed) and a Welsh prodigy who had arrived in New York City on a classical music scholarship (Cale) – were not that

TRACKLISTING

01 **Sunday Morning**
02 **I'm Waiting for the Man**
03 **Femme Fatale**
04 **Venus in Furs**
05 **Run Run Run**
06 **All Tomorrow's Parties**
07 **Heroin**
08 **There She Goes Again**
09 **I'll Be Your Mirror**
10 **The Black Angel's Death Song**
11 **European Son**

successful at writing pop hits for *American Bandstand*, but they made an impression on each other and soon added likeminded musicians to their various early incarnations, notably the idiosyncratic Sterling Morrison.

Original drummer and the group's bohemian connection, Angus MacLise, quit when they got their first paid gig – a $75 support slot at a New Jersey high school in December 1965 – because he refused to play for money at a set time. This resulted in the last-minute audition and recruitment of Maureen 'Mo' Tucker, who played primitive rhythms on a minimally sized kit while standing up. She, like nearly every other element in the Velvet Underground, made perfect sense in no other circumstances except these.

That first show scared the unprepared suburban audience half to death, but a subsequent Manhattan residency brought in members of Andy Warhol's entourage, including poet Gerard Malanga, who danced on stage with a whip, and then Warhol himself. Warhol saw the band as a musical extension of his creative philosophy of making people uncomfortable, and before long he signed on as manager. 'Andy, the problem is these people have no singer,' Warhol's aide-de-camp, Paul Morrissey, told

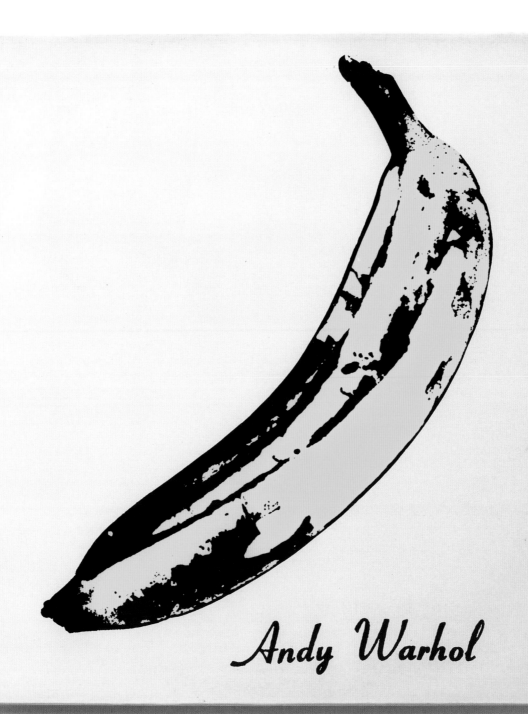

Andy Warhol

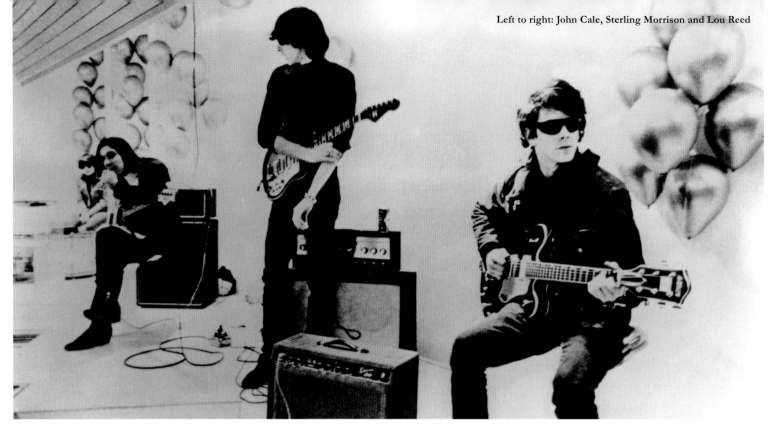

him. The downtown maven agreed, deciding that they should join up with the German model, actress and singer Nico, who had presented herself at his headquarters, The Factory, just the previous week.

Nico's addition was tolerated as opposed to being accepted, although that didn't stop Reed – who as the nominal lead singer was the most aggrieved – from having an affair with her (Cale later did the same). But having to come up with material for her austere stage persona and narrow vocal range provided a telling contrast to the songs Reed had already written and that Cale had fleshed out. They already had noise provocations, such as a track titled 'Heroin', and now they had a psychological counterpoint with tracks of quiet obsessions such as 'I'll Be Your Mirror'.

The group toured as part of the Exploding Plastic Inevitable, a multi-media happening that attempted to bring the avant-garde into the mainstream in 1966, attracting Salvador Dalí, a pre-Doors Jim Morrison and Jackie Kennedy, among others. They also began recording their album, which was partially financed by the parsimonious Warhol and some outside investors. They got a semi-condemned recording space on Broadway, the Cameo-Parkway Studios, for three nights

at the cost of $2500, and once they found enough existing floor space for Mo Tucker to set up her (thankfully) abbreviated drum kit they made history.

Warhol, as was his wont, was the album's producer, although definitely not in the traditional sense. But if he didn't know the first thing about faders or recording a snare drum he was unequivocal about what he did and didn't like, and in that sense his support and input proved to be crucial.

'Andy was like an umbrella. We would record something and Andy would say, "What do you think?" We'd say, "It's great!" and then he would say, "Oh, it's great!" The record went out without anyone changing anything because Andy Warhol said it was okay,' Lou Reed would later recall. 'He made it so that we could do anything that we wanted. But when we recorded the album, we had our sound. It wasn't even a matter in those days whether it was good equipment, it was just, did it work? In those days, engineers would walk out on us anyway.'

'We were really excited. We had this opportunity to do something revolutionary – to combine avant garde and rock & roll, to do something symphonic,' John Cale subsequently noted. 'No

matter how borderline destructive everything was, there was real excitement there for all of us. We just started playing and held it to the wall. I mean, we had a good time.'

Most of the era's leading rock labels turned down *The Velvet Underground & Nico*, including Atlantic and Elektra. Eventually a minor label, the MGM-owned Verve, agreed to release it, spurred on by a newly recruited staff producer, Tom Wilson, brought in from Columbia Records (another label that had rejected the band). Wilson oversaw the re-recording of three tracks, and then in November 1966 a prospective single was added. 'Sunday Morning' was meant to be sung by Nico, but Reed was adamant he would do it. He delivered a vocal of feminine mystery, doused in melancholy and reverb – so you can add androgyny to the album's long list of popular music firsts.

When the album was quietly released in March of 1967 after delays with Warhol's iconic banana cover – in the wake of the Beatles' *Revolver* and Bob Dylan's *Blonde on Blonde*, instead of alongside them as would have been fitting – 'Sunday Morning' proved to be the perfect introduction. It was a lullaby, beginning with the delicacy of a child's music before a sighing bass ushers in the rest of the

band, who play with tender regard even as the song slowly unveils a dreamy paranoia. 'Sunday morning/And I'm falling/I've got a feeling I don't want to know…' Instead of ending with the comedown, the album begins there, which is typical of a record that not only defies expectations, but also easily shocks.

These were Reed's first walks on the wild side and he wrote with clarity about drug addiction, prostitution and S&M.

Once emotionally becalmed, the quartet breaks into 'I'm Waiting for the Man', a thumping piece of minimalist repetition that cycles over the same chords with the same kind of single-minded obsessiveness that the heroin addict in Reed's lyric has in his quest for a fix. 'Don't change the words just because it's a record,' Warhol told Reed, and the words are cut-to-the-bone realism, junk cinema vérité: 'Up to Lexington 125/Feeling sick and dirty, more dead than alive … He's got the works, gives you sweet taste/Ah then you gotta split because you got no time to waste'.

Reed had been a fan of Bob Dylan, but most of his lyrical influences were writers and poets. He was inspired by the Beat writers and the French Symbolists, and he was the first rock & roll artist to combine Jack Kerouac and Arthur Rimbaud. Reed's mentor, poet Delmore Schwarz, who died a year before the band's debut, had also impressed upon Reed the importance of everyday vernacular, and the verses on *The Velvet Underground & Nico* would have a directness and sense of place that pre-empted flowery excess or ornate symbolism.

These were Reed's first walks on the wild side and he wrote with clarity about drug addiction, prostitution and S&M. The latter was the subject of 'Venus in Furs', which was inspired by Austrian author Leopold von Sacher-Masoch's 1870 novella of the same name (the term masochism is derived from his surname). 'Tongue of thongs, the belt that does await you/Strike, dear mistress, and cure his heart', declaims Reed.

But the song wouldn't have the same evocative clarity if the arrangement didn't find exacting accompaniment for these concentrated images of Old World transgression. Cale used an electric viola, strung with guitar strings, which allowed him to play long, droning sequences or hold a single note. Cale, an experimentalist greatly influenced by composers John Cage and La Monte Young, could slow down time or rupture it, and when his viola drones combined with Reed's unique guitar tunings, it created an entirely new landscape.

'We were trying to do a Phil Spector thing with as few instruments as possible,' Cale would subsequently explain, and this was an exciting, liberating wall of sound. 'The Black Angel's Death Song' skitters and snarls on the edge of electric eruption without ever quite getting there, while the solemn invocation of 'Heroin' – beginning with single tom beats and elegiac guitar notes before Cale supplies the undertow – captured the rush of opiates and the floating high that matched Reed's lyric 'When I put a spike into my vein'.

'Heroin, it's my wife and it's my life,' the song confesses, but Nico's presence also answers to the same description. Singing in a Germanic accent that renders 'clown' as 'clon', she inverts the girl group era into Continental torch songs on the likes of 'I'll Be Your Mirror' and 'Femme Fatale'. There's a snatch of heavenly harmonies on the former, while the latter supplies a pop landscape to match the extremes of elsewhere. There's a deceptive beauty to her contributions, a thorny languor, and it's a reminder that whatever you desire can satisfy you to the point of self-destruction.

Sounding like a Weimar Republic chanteuse, Nico narrates the oblique ode to the dimming of beautiful young things the world over that is 'All Tomorrow's Parties', where her austere narration is matched by Cale's evocatively repetitive piano part. Fittingly, the song's title is now also the name of a leading alternative music festival, and it's not hard to draw a line back from most of its annual headliners to the Velvet Underground. The songs on *The Velvet Underground & Nico* invented our cities and our failings, our romances and our despairing realisation, our songs and our singers. In more than 40 years it hasn't aged a single day.

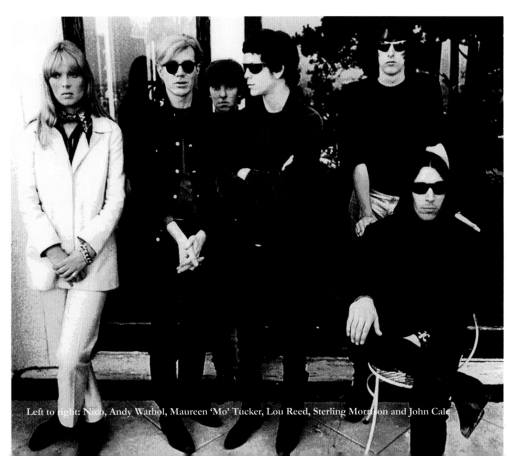

Left to right: Nico, Andy Warhol, Maureen 'Mo' Tucker, Lou Reed, Sterling Morrison and John Cale

N°: 10

PUBLIC ENEMY

IT TAKES A NATION OF MILLIONS TO HOLD US BACK

Def Jam
Produced by Hank Shocklee and Chuck D
Released: April 1988

'An important message should have its importance embedded into the way it's relayed,' Public Enemy's architect and chief provocateur, rapper Chuck D once explained. 'You hear Public Enemy, you hear a tone that says, "Look out! This is some serious shit coming!"'

That was never more true than on the group's incendiary second album, *It Takes a Nation of Millions to Hold Us Back*. Released in 1988, the record is a compelling, joyous overload of sound. It's urgent, scary and provocative, yet also thrillingly catchy and fastidiously assembled. It was a landmark release for hip-hop, a political statement that spoke in languages old and new, and once you'd heard it it was apparent that the world looked, and sounded, different from what you'd previously known.

It Takes a Nation of Millions appeared about a decade after hip-hop had first found a public profile, making it the equivalent of Bob Dylan's *Highway 61 Revisited*, which arrived roughly 10 years after the dawning of rock & roll. Both albums took everything in their field that had preceded them and then reinterpreted it with new influences and outcomes. They were aware of history and its truths, but also defied it in the name of creating a new reality.

Or as Chuck D – the D rightly stands for 'dangerous' – puts it on 'Don't Believe the Hype', 'The book of the new school rap game/Writers treat me like Coltrane, insane/ Yes to them, but to me I'm a different kind/ We're brothers of the same mind, unblind/ Caught in the middle/And not surrenderin'/ I don't rhyme for the sake of riddlin'.'

TRACKLISTING

01 **Countdown to Armageddon**
02 **Bring the Noise**
03 **Don't Believe the Hype**
04 **Cold Lampin' with Flavor**
05 **Terminator X to the Edge of Panic**
06 **Mind Terrorist**
07 **Louder Than a Bomb**
08 **Caught, Can We Get a Witness?**
09 **Show 'Em Whatcha Got**
10 **She Watch Channel Zero?!**
11 **Night of the Living Baseheads**
12 **Black Steel in the Hour of Chaos**
13 **Security of the First World**
14 **Rebel Without a Pause**
15 **Prophets of Rage**
16 **Party for Your Right to Fight**

With Public Enemy, speed – and the sense of unstoppable momentum it engendered – was the key. Their songs often rocked at a ferociously fast beats-per-minute rate, daring you at once to keep up mentally and not to physically stand still, and it was the same with their career. They'd been together little more than two years when they released their second album, having been custom built by Chuck D once he was signed to Def Jam Records by Bill Stephney – the former Program Director at New York state college radio station WBAU, where Chuck D (Carlton Ridenhour) once DJd.

His first choice as musical partner was a multi-instrumentalist, former church choir singer and previously jailed burglar named William Drayton Jr who, when he was swapping verses with Chuck while they delivered furniture as a part-time job, called himself Flavor Flav. He would prove to be Chuck's aural counterpoint, and a subversive presence, while an entire production team that Chuck had already collaborated with, the Bomb Squad – Hank Shocklee, his brother Keith and Eric 'Vietnam' Sadler – were also scooped up, along with turntablist Terminator X (Norman Rogers) and Professor Griff – Public Enemy's self-styled Minister of Information (who would leave the group in 1989 after making anti-Semitic remarks).

PUBLIC
ENEMY

IT TAKES A NATION OF MILLIONS TO HOLD US BACK

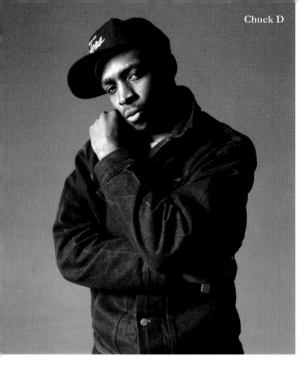

At university Chuck D studied graphic design, and he put together his group with thoroughness and anticipation. Public Enemy always appeared to be one step ahead of expectations. Everyone had their roles, and whether they were serious (Chuck D), surreal (Flavor Flav) or publicly silent (Hank Shocklee), they carried them out with diligence. Their debut album, April 1987's *Yo! Bum Rush the Show*, introduced the group's politicised lyrics and intense studio aesthetic, winning critical acclaim and commercial success as Public Enemy went on tour with label-mates the Beastie Boys, but with *It Takes a Nation of Millions to Hold Us Back* they only accelerated the process.

'We knew we had to be different and we had to jolt people with the sound as well as the lyrics. It was about urgency. It had to sound like a wake-up call,' Chuck D would later explain. 'When we were making *It Takes a Nation of Millions*, we knew we had to take it further still, and make a *What's Going On* for the hip hop generation. The concept, the musical segues, the beats per minute – no-one had done that sort of thing before. It reflected the past in terms of our influences, but it sounded like nothing else you'd ever heard.'

The album was made in little more than six weeks, working at New York's Greene Street Recording under the working title *Countdown to Armageddon*. The Bomb Squad didn't take part in the group's extensive touring schedule, so when the performers came off tour they were greeted with a welter of semi-completed instrumental beds and possible samples. Chuck D would hole up to write lyrics, with contributions and catcalls from Flavor Flav, and the finished track would be signed off on by Hank Shocklee, who had the final right of say.

The philosophy of Shocklee and his cohorts was brutally simple: 'We took whatever was annoying, threw it into a pot, and that's how we came out with this group,' he once noted. 'We believed that music is nothing but organised noise. You can take anything – street sounds, us talking, whatever you want – and make it music by organising it. That's still our philosophy, to show people that this thing you call music is a lot broader than you think it is.'

Chuck D would call Hank Shocklee the Phil Spector of hip-hop, although there was nothing lush about the Bomb Squad's wall of sound. On 'Bring the Noise' a clarion call that announces itself after the introductory 'Countdown to Armageddon', there's a collage that pivots on a drum sound from James Brown's 'Funky Drummer', together with further samples of Brown, Funkadelic and the Commodores, which are pared down and manipulated into squealing, abrasively alive samples, Morse code scratching and tensile exhortations.

Public Enemy could match the rhythmic intensity of metal and the harsh, spectral blasts of free jazz. Hip-hop had never heard anything like this before. At a time when the prevailing standard was a drum loop and strident groove, Public Enemy studded every arrangement with information, creating a code that could be understood but not easily deciphered. There were only snatches of melody, but the beats had the pulse of excitement. On 'Caught, Can We Get a Witness?' the group answered up to the growing controversy in hip-hop over sampling – 'This is a sampling sport,' raps Chuck D, 'But I'm giving it a new name' – and the song, which storms forth, is at once a riposte to those threatening to issue writs and an example of the Bomb Squad's blistering style; this was funk pushed to its extreme.

At the end of the same track Chuck D declares, 'You singers are spineless/As you sing your senseless songs to the mindless/

Your general subject love is minimal/It's sex for profit,' and his disdain for peddlers of self-satisfied R&B and uncommitted soul music was reflected in the radical orientation of Public Enemy's lyrics. If the underlying sound of Public Enemy was revolutionary, they were making a noise that was literally trying to effect change, and Chuck D's deep but sinuous baritone was the overt edge.

Public Enemy brought back to prominence a lineage of black music that included the self-determination and pride of James Brown, the politically charged Last Poets, and Gil Scott-Heron's divining of society's true standards. 'We wanted our music to be the aural equivalent of black people wanting to scream out after having been silenced for so long,' Chuck D would later say, and the words on *It Takes a Nation of Millions* are a cross-section of consciousness raising, mordant commentary and outright defiance.

On 'Black Steel in the Hour of Chaos', a steely, mid-tempo broadside, spiked with a glinting piano part, Chuck D recounts how he got a letter from the government about serving in the army, evoking the travails of Muhammad Ali, and contrasting the demands of the state with the indifference white America has shown to its black populace. 'Here is a land that never gave a damn,' he raps, as the story grows ever more involved, turning into a contemplation of power that is interrupted by a prison riot that becomes a jailbreak –

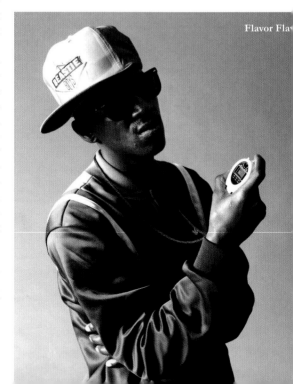

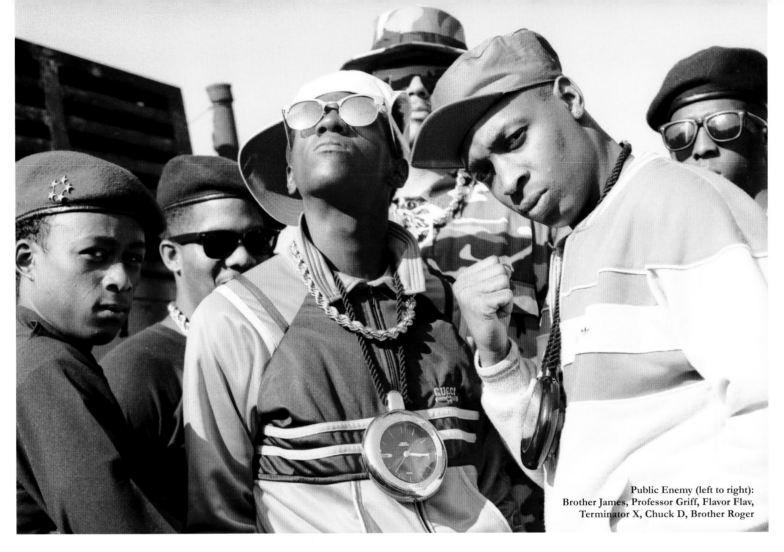

Public Enemy (left to right):
Brother James, Professor Griff, Flavor Flav,
Terminator X, Chuck D, Brother Roger

after such a lengthy narrative, Chuck D wasn't opposed to a little satisfaction for the listener.

Public Enemy saw the system as being corrosive in its mass indifference, vehement in its focused disdain. They would list those persecuted by J Edgar Hoover and the FBI and then wonder whether anything had changed, and in the same way that they remade sounds into a narrative they stripped back old ones so that the past revealed itself to the present. In such charged surrounds their rhetoric sounds like the opening of a manifesto, and it's nigh on impossible not to enjoy the pleasure Public Enemy take in the likes of 'Louder Than a Bomb' or the bubbling, incantatory 'Prophets of Rage'.

'No one has been able to approach the political power that Public Enemy brought to hip hop,' the late Adam Yauch, aka MCA of the Beastie Boys, would explain. 'I put them on a level with Bob Marley ... but where

Marley's music sweetly lures you in, then sneaks in the message, Chuck D grabs you by the collar and makes you listen.'

Public Enemy were just as likely to dissect the easy acceptance of the status quo by the majority of the African-American community, with 'She Watch Channel Zero?!' ripping into a woman who values the fantasy satisfaction of her television soaps above the needs of family and friends. 'Her brain's retrained, by a 24-inch remote,' raps Chuck D, while 'Night of the Living Baseheads' swings on a siren-like horn sample to condemn the drug dealers who prey on their own communities and create the bleakly ubiquitous environment of black-on-black crime.

Flavor Flav proved his worth by not only accentuating the themes, but playing the livewire eccentric whose interjections often provided an off the wall alternative. His lead spot, 'Cold Lampin' with Flavor' was madcap,

taking the idea of flavour to a whole new level. As with the scratch-laden 'Terminator X to the Edge of Panic', 'Cold Lampin' was a reminder that Public Enemy worked as a unit (or a sports team) where they were only as good as their weakest link. In 1988 it was clear that they didn't have one.

In a way Public Enemy were so impressive, so exemplary, that they weren't highly influential. They were so site specific, so daunting, that few groups followed them (the Bomb Squad would have more of an effect, albeit in electronic music). The loping funk of gangsta rap would dominate hip-hop in the 1990s, but by then Public Enemy had stopped being simply a hip-hop group. In the same way that they were a band of unimpeachable technique, their message was relevant across the entire spectrum. It doesn't matter who you are, or where you're coming from: there's inspiration and belief to be gained from *It Takes a Nation of Millions to Hold Us Back.*

JACK WHITE ON BOB DYLAN

Impossible for us to not call Dylan an influence. Important: do not trust people who call themselves musicians or record collectors who say that they don't like Bob Dylan or the Beatles.

Jack White
(White Stripes)

IGGY POP ON NIRVANA

The first time I saw Nirvana was at the Pyramid Club, a rank, wonderful, anything-goes dive bar on Avenue A in New York. ... You could smell the talent on Kurt Cobain. He was jumping around and throwing himself into every number. He'd sort of hunch over his guitar like an evil little troll, but you heard this throaty power in his voice. At the end of the set he tossed himself into the drums. It was one of maybe 15 performances I've seen where rock & roll is very, very good.

ELVIS COSTELLO ON *REVOLVER*

When you picked up *Revolver*, you knew it was something different. Heck, they are wearing sunglasses indoors in the picture on the back of the cover and not even looking at the camera ...

ELVIS COSTELLO ON *ASTRAL WEEKS*

It's still the most adventurous record made in the rock medium, and there hasn't been a record with that amount of daring made since.

THE EDGE ON THE CLASH

I can vividly remember when I first saw the Clash. It was in Dublin in October 1977. Dublin had never seen anything like it. It really had a massive impact. I still meet people who are in the music business today – maybe they are DJs, maybe they are in bands – because they saw that show. They are, next to The Stones, the greatest rock & roll band of all time.

The Edge (U2)

MARTIN SCORSESE ON *ASTRAL WEEKS*

I based the first 15 minutes of *Taxi Driver* on *Astral Weeks*.

LEWIS MERENSTEIN (PRODUCER OF *ASTRAL WEEKS*)

To this day it gives me pain to hear it. Pain is the wrong word ... I'm so moved by it.

MADONNA ON *BLUE*

I worshipped her [Joni Mitchell] when I was in high school. *Blue* is amazing. I would have to say of all the women I've heard, she had the most profound effect on me from a lyrical point of view.

THURSTON MOORE ON *THE VELVET UNDERGROUND & NICO*

The first real rhythm of the street in an America gone to war 1966. Lou's vocal tone is revolutionary in how it depicts the manic weariness of city cool rock & roll.

Thurston Moore (Sonic Youth)

PATTI SMITH ON *THE VELVET UNDERGROUND & NICO*

They were the stark, elusive balloon that burst upon a deflated scene, injecting that scene with a radiance that connected poetry, the avant-garde and rock and roll.

BRIAN ENO ON *THE VELVET UNDERGROUND & NICO*

I was talking to Lou Reed the other day and he said that the first Velvet Underground record sold 30,000 copies in the first five years. The sales have picked up in the past few years, but I mean, that record was such an important record for so many people. I think everyone who bought one of those 30,000 copies started a band!

ADAM YAUCH ON PUBLIC ENEMY

PE completely changed the game musically. No one was just putting straight-out noise and atonal synthesizers into hip-hop, mixing elements of James Brown and Miles Davis; no one in hip-hop had ever been this hard, and perhaps no one has since. They made everything else sound clean and happy, and the power of the music perfectly matched the intention of the lyrics.

Adam Yauch (Beastie Boys)

Nº:11

THE BEACH BOYS
PET SOUNDS

Capitol
Produced by Brian Wilson
Released: May 1966

In December 1965 Brian Wilson, the 23-year-old Californian genius behind the Beach Boys' run of surf and hot-rod hit singles, heard *Rubber Soul* by the Beatles and experienced a moment of epiphany. 'Marilyn, I'm gonna make the greatest album! The greatest rock album ever made!' he exclaimed to his wife, and within six months he had come close to doing that. *Pet Sounds*, a coming of age triumph for Wilson, for the West Coast scene, and for subsequent generations of the young and those who remember youth all too well, remains a masterpiece.

It was just four years since the Beach Boys had released their debut single, 'Surfin'', but Wilson was already in a state of flux. In 1964, after anxiety attacks brought on by the group's hellacious schedule, he withdrew from touring and took up in the studio with session musicians who could deliver what he was hearing in his head. The Beach Boys were becoming two bands; one version was out touring the world while Wilson was focused on his version, determined to make a definitive album instead of padding out hit singles with quickly cut filler to deliver another quarterly release.

Wilson's key collaborator on *Pet Sounds* was lyricist Tony Asher, with whom he co-wrote the majority of the album in early 1966. The pair created a world of lost innocence; one that would be as relevant for the transformation of the 1960s as the move from the teenage years to adulthood. There's no generational conflict on *Pet Sounds*, no clearing of the decks. 'I'm a little bit scared because I haven't been home in a long time,' runs 'That's Not Me', and the song turns homesickness into a kind of heavenly reverie. *Pet Sounds* would help revolutionise rock & roll, but the world it creates is neither rock & roll nor revolutionary.

The rest of the band – Wilson's brothers Carl and Dennis, his cousin Mike Love and high school friend Al Jardine – were on tour in Japan when the tracks were cut, with more than 60 guest players involved. They returned

TRACKLISTING

01 **Wouldn't It Be Nice**
02 **You Still Believe in Me**
03 **That's Not Me**
04 **Don't Talk (Put Your Head on My Shoulder)**
05 **I'm Waiting for the Day**
06 **Let's Go Away for a While**
07 **Sloop John B**
08 **God Only Knows**
09 **I Know There's an Answer**
10 **Here Today**
11 **I Just Wasn't Made for These Times**
12 **Pet Sounds**
13 **Caroline, No**

to provide vocals and tender harmonies to a pop symphony, a melodic wall of sound that used guitars and strings, drums and horns, harpsichord, piano and even a theremin. Tinged with melancholy, the arrangements took in the proto-psychedelia of 'I'm Waiting for the Day', the eclectic soundscape of 'I Just Wasn't Made for These Times', and an invocation of childhood on 'You Still Believe in Me'.

Some of Wilson's bandmates, particularly the vituperative Love, doubted the material's direction, but they were on hand to wend their voices across these songs, resulting in some of popular music's most beautifully realised songs. When the swell of voices permeates 'God Only Knows' it sounds heartbreakingly original, and throughout the album the accumulation of vocal parts adds a tragic gravity to these celestial tunes. Even the sweetest of teenage soliloquies, 'Here Today', foretells how quickly loss can arrive.

On the closing 'Caroline, No' a girl who has shed her long hair and youthful glow is rhapsodised, and that's a portent of the era about to begin. But *Pet Sounds* sits apart from any one time. Like other masterful American composers, Wilson's dedication was to his music, not its social significance. 'I've been trying hard to find the people/That I won't leave behind,' Brian Wilson sings on 'I Just Wasn't Made for These Times', and it wouldn't be his family or bandmates that would ultimately stick with him. It was the listeners who heard *Pet Sounds* as a record for the ages.

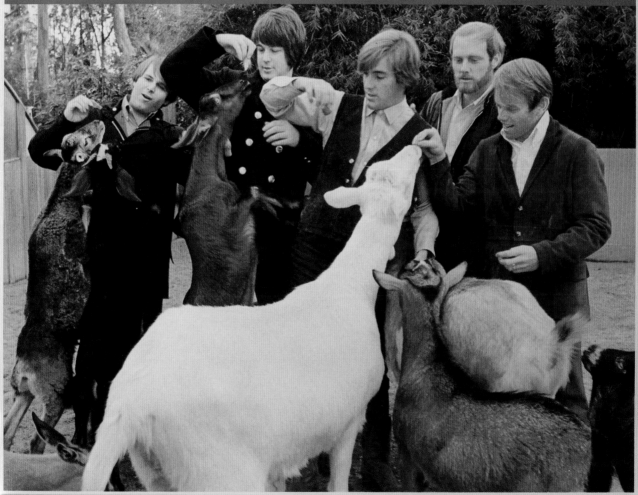

The Beach Boys Pet Sounds

stereo

Sloop John B. / Caroline No
Wouldn't It Be Nice / You Still Believe In Me
That's Not Me / Don't Talk (Put Your Head on My Shoulder)
I'm Waiting For The Day / Let's Go Away For Awhile
God Only Knows / I Know There's An Answer / Here Today
I Just Wasn't Made For These Times / Pet Sounds

Nº: 12
BRUCE SPRINGSTEEN
DARKNESS ON THE EDGE OF TOWN

Columbia
Produced by Bruce Springsteen, Jon Landau and Steven Van Zandt
Released: 2 June 1978

Born to Run was an album about kids getting out. *Darkness on the Edge of Town* is about the kids who didn't. In the three years following *Born to Run*, the '70s recession bit hard and Springsteen studied the Clash and Hank Williams; these forces and a law suit hang heavy on Springsteen's fourth album.

'The stakes were even higher in certain respects [than with *Born to Run*],' said drummer Max Weinberg recalling the *Darkness* sessions. In 1975 *Born to Run* had catapulted Springsteen and the E Street Band from New Jersey heroes to somewhere near the top of the music industry. However, a legal dispute with former manager/producer Mike Appel kept Springsteen out of the studio for 18 months and, had Appel won, it could have ended Springsteen's career. 'The future was pretty cloudy,' said Springsteen. 'We'd had one success. A lot of people – that's all they have. I'd had that one success and I was millions of dollars in debt. You didn't know if this would be the last record you'd make.'

Springsteen was soaking up influences, particularly films such as John Ford's *The Grapes of Wrath*, Terrence Malick's *Badlands* and a huge number of film noir classics. He began to listen to country music, which he thought dealt with 'adult' issues, rather than the sounds of Spector and the '60s R&B he associated with the romance of youth. On *Darkness*, Springsteen quotes from the classics – 'Dancing in the Street', Chuck Berry's 'The Promised Land' – but he turns these teen fantasies into the darker reality of life. The opening riff of 'Badlands' is based on 'Don't Let Me Be Misunderstood': 'That's every song I've ever written,' he recently said of the Animals' hit. 'That's all of them. I'm not kidding, either. "Born to Run", "Born in the USA". Everything I've done for the past 40 years, including all the new ones.'

Where *Born to Run* had started with nine songs of which eight were used, some 70 songs were written for *Darkness*. He gave away 'Fire' and 'Because the Night' (hits for the Pointer Sisters and Patti Smith) because they didn't fit with the themes of the album.

TRACKLISTING

01 **Badlands**
02 **Adam Raised a Cain**
03 **Something in the Night**
04 **Candy's Room**
05 **Racing in the Street**
06 **The Promised Land**
07 **Factory**
08 **Streets of Fire**
09 **Prove It All Night**
10 **Darkness on the Edge of Town**

Where previous records had been led by elaborate keyboard and saxophone parts, on this album the band was very much an ensemble, led by Max Weinberg's drumming. Even the vocals were submerged, intentionally placed lower in the mix.

'I wanted the record to have a relentless feeling,' he said. 'I stripped it down to its barest and most austere elements and I decided that I wanted something that felt like a tone poem. I didn't want any distractions from the narrative and the story, I wanted it to have a sort of apocalyptic grandeur.'

According to co-producer Jon Landau, 'One phrase that we would use to discuss the sound of the record as it evolved was the sound picture – what kind of picture was the sound of the record suggesting? We did want a certain unglamorous sound. There were no sweetening strings. We wanted the coffee black.'

Darkness on the Edge of Town is Springsteen's most personal record – the helplessness and the vulnerability of his characters reflect Springsteen's own life at the time. But if it reeks of the bleakness its title speaks of, there's still a resilience and defiance permeating the sepia; the characters moving forward, unbowed. '*Darkness* is a meditation on where are you going to stand and with who,' Springsteen said. 'Not forsaking your own inner life force … how do you hold on to those things? That was the question that record asked over and over again.'

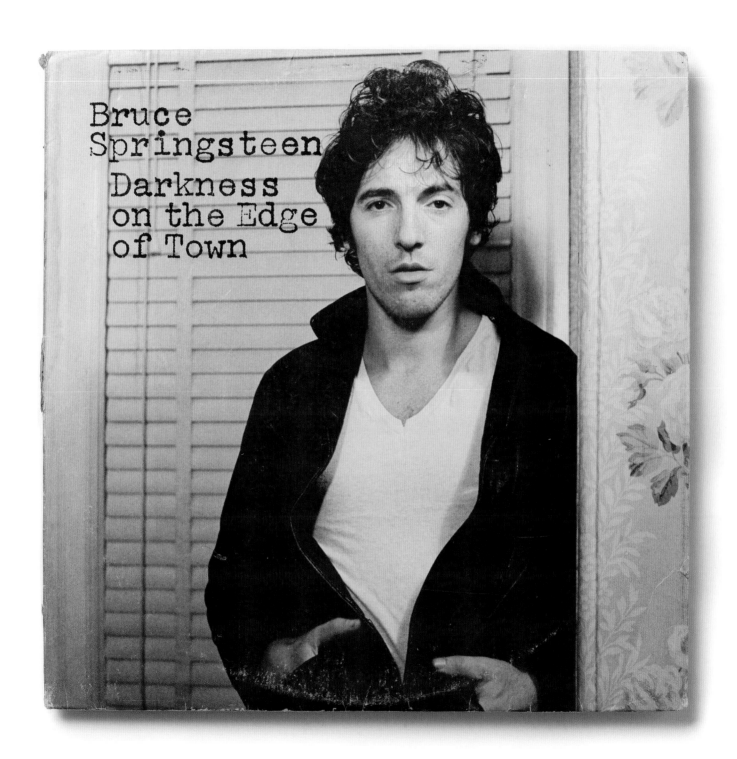

Nº 13

TELEVISION
MARQUEE MOON

Elektra
Produced by Andy Johns and Tom Verlaine
Released: February 1977

On 'Marquee Moon', the intoxicating, effortlessly epic title track from Television's debut album, the otherworldly takes hold as if a dream has turned to reality. In the first two lines frontman Tom Verlaine remembers how 'the darkness doubled' and that 'lightning struck itself'. 'I was listening, listening to the rain/I was hearing, hearing something else,' he adds, and that sense of unbelievable change unfolding before your eyes typified what Television would do to guitar rock. After *Marquee Moon*, a record of ecstatic repetition and grave guitar solos offset by spectral characters and theatrical asides, nothing else sounded the same.

School friends and aspiring poets Tom Verlaine and Richard Hell, guitarist and bassist respectively, had been searching for their entry point since late 1973. They formed the Neon Boys with drummer Billy Ficca and then added a second guitarist in Richard Lloyd to become Television. The New York scene was foundering at the time, and Television mainly rehearsed in a Chinatown loft before they fronted a bar owner on the Bowery and talked their way into a booking at the downtown venue that would soon gain a worldwide reputation as the American epicentre of punk and new wave – CBGB-OMFUG.

'You are four cats with a passion,' read the quote on the tiny ad for the show in *Village Voice*, provided by exiled 1950s Hollywood filmmaker Nicholas Ray (*Rebel Without a Cause*, *In a Lonely Place*), and he wasn't wrong. But it was a bumpy early ride. Hell left Television in 1975, taking his nihilistic proto-punk anthems to the Voidoids and the Heartbreakers (he was replaced by Fred Smith), while not even demo sessions with Brian Eno could provide a satisfying outcome. The quartet were equal opportunity iconoclasts – the clarity and formal design of their songs were not only a rejoinder to prog rock's portly self-regard, they also stood aside from the new wave's furious and liberating loathing.

From the opening 'See No Evil' their distinct parameters are clear, with Smith's warm basslines and Ficca's stern playing forming the foundation for a pair of complementary guitarists and Verlaine's edgy, upper atmosphere vocals. The elements on *Marquee Moon* are easily recognisable, but what was done with them was something hitherto unknown. Television were one of many bands that would draw inspiration from the Velvet Underground, but what they soaked up was John Cale's conceptual clarity and Lou Reed's guitar tone. On a song like 'Friction', rhythm parts would segue into brief solos that subtly remade the song again and again even as it strode into the chorus.

Television was quite probably the only credible band in 1977 notating the individual guitar solos (shared fairly evenly between Lloyd and Verlaine). This kind of activity was usually the domain of rampant egotists or prog rock posers, or both. But with Television ego wasn't behind it. On 'Marquee Moon' the lyrical, sometimes ringing clusters of notes from the singer were drawn from the song's architecture. Television were a model of efficiency and that was why the title track could run for 10 minutes and yet feel like it had barely begun. The song builds and abates, growing in intensity until a crescendo that feels final but instead returns to where it all began. It closes what would have been side one, and from then on *Marquee Moon* is untouchable.

'Elevation' has a sighing guitar refrain that informs the song's melancholy, while 'Guiding Light' is a tremulous ballad that finds Verlaine dedicating himself with quiet ardour. 'Prove It' riffs on old cop show reruns – 'just the facts,' mock snarls Verlaine – as it leads into a spiralling, extended solo, before 'Torn Curtain' finds Verlaine and Lloyd's guitars not-so-gently weeping. The song plays like a requiem for a tragedy, and the final minutes with their mournful chorus of 'Tears, tears. Years, years' sounds like an invocation from a funeral, which is the least likely but nonetheless fitting stop for an album that offered so much new life.

TRACKLISTING

01 **See No Evil**
02 **Venus**
03 **Friction**
04 **Marquee Moon**
05 **Elevation**
06 **Guiding Light**
07 **Prove It**
08 **Torn Curtain**

TELEVISION

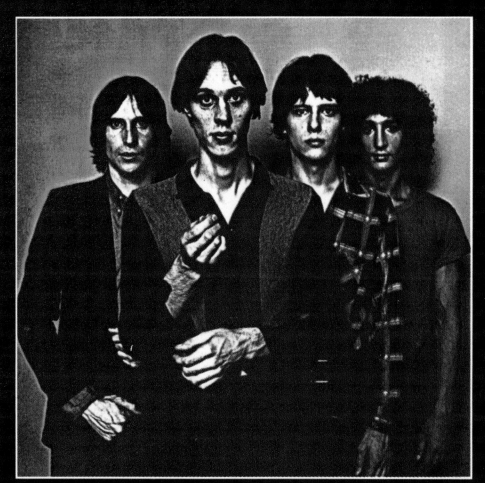

MARQUEE MOON

Nº: 14

LITTLE RICHARD
HERE'S LITTLE RICHARD

Specialty Records
Produced by Robert 'Bumps' Blackwell
Released: March 1957

In September 1955 producer Robert 'Bumps' Blackwell set up an audition in New Orleans for Richard Penniman, a young man he'd heard about who was washing dishes in a local Greyhound bus station. The session was at Cosimo Matassa's studio where the cream of New Orleans players hung out. But the feeling in the room that day was lacklustre: 'So I called a lunch break and we went to the Dew Drop Inn,' Blackwell recalled. 'Richard saw a piano and a crowd of people: he was one of those people who's always on stage, and he hit the piano and hollered, "A-wop-bop-a-loo-bop-a-good-God-damn!".' Blackwell saw the glory that is Little Richard and, as writer Barney Hoskyns observed, rock & roll had its Big Bang.

Little Richard was a misfit. One leg and arm shorter than the other, he had been sexually abused and thrown out of home; he was effeminate, polymorphously perverse ... and desperate to be a star. The stage of the Dew Drop Inn was his last chance to impress the talent scout and so he let it all out: the pain of the years of being knocked down but also the incredible spirit; the appetite for excitement and adventure and sex and deliverance.

Little Richard's music was completely new and existential – the fire and brimstone of gospel from the Adventist church of his childhood, funky New Orleans R&B, the silky pop of the '50s, the blues and 'somethin' else' as Eddie Cochrane would say.

Everything that subsequently happened in rock & roll is prefigured in that anarchic, mad, poetic absurdity full of sexual energy and desperation.

'Tutti Frutti' – the song Richard let fly at the Dew Drop Inn – was way too X-rated for the Top 40 so Blackwell had singer Dorothy LaBostrie pen some new words and Little Richard's a cappella syncopated scream became 'awopbopaloobopalopbamboom!' Everything from the Beatles to the Stooges to Lady Gaga is prefigured in those two minutes and 20 seconds. In terms of

TRACKLISTING

01 **Tutti Frutti**

02 **True Fine Mama**

03 **Can't Believe You Wanna Leave**

04 **Ready Teddy**

05 **Baby**

06 **Slippin' and Slidin'
(Peepin' and Hidin')**

07 **Long Tall Sally**

08 **Miss Ann**

09 **Oh Why?**

10 **Rip It Up**

11 **Jenny, Jenny**

12 **She's Got It**

sexuality, Richard made Presley look like the missionary position. The song topped the 'Negro' charts and sold half a million copies. As Richard said, 'Tutti Frutti was a blessin' and a lesson'. When white Tennessee crooner Pat Boone covered the song it sold a million copies and topped the Billboard Hot 100. Richard realised he had to up the ante. Next, 'Long Tall Sally' broke Richard into the white teen market and there was no looking back. As John Lennon said of 'Long Tall Sally', 'When I heard [it], it was so great I couldn't speak. I didn't want to leave Elvis, but this was so much better.'

Elsewhere, 'Rip It Up' is a teenage call to arms: 'Saturday night and I just got paid/I'm a fool about my money, don't try to save'. Richard attacks the lyrics with a beautiful violence, timing his vocals against the drums and shredding his voice with equal parts desperation and joy. 'Rip It Up' is a bacchanal and an incitement to anarchy. The screaming, the craziness, the excess and the funk in rock & roll start here.

Little Richard and Blackwell struck up a creative partnership that ran for most of Richard's career but it all started with these songs and this album. 'I'm the Architect of rock & roll,' said Richard. 'The Originator, the Emancipator. Before me, there wasn't nothin' but a few pigs, and they didn't have no ham, y'know?'

HERE'S
LITTLE
RICHARD

N°: 15

LED ZEPPELIN
UNTITLED (SYMBOLS) IV

Atlantic
Produced by Jimmy Page
Released: November 1971

On the first three Zeppelin albums Jimmy Page reimagined what rock & roll could sound like. The revolution those records started can't be overstated and it was fully realised on the fourth album – an album which had no title, no credits or catalogue number. 'I remember one agent telling us it was professional suicide,' said guitarist Jimmy Page. 'The fourth album was to my mind the first fully realized Zeppelin album. It just sounded like everything had come together on that album.'

The chemistry in Led Zeppelin was critical. Jimmy Page and bass player/keyboardist John Paul Jones were two of London's most in demand session players. Drummer John Bonham was a veteran of regional pub bands who had a unique sense of time and he hit the drums really hard. It was this combination of technique, experience and raw power that made Led Zeppelin unique. Robert Plant's vocal bravura and Thor-like swagger were more than just the icing on the cake.

As on their previous record, *III*, Zeppelin retired to Headley Grange, a dilapidated old manor house in Hampshire. They spent a week working up the material for the album and then had a mobile studio set up for a further week of recording. The bucolic setting may have something to do with the Tolkien-inspired 'Battle of Evermore' and 'Misty Mountain Hop'. 'Going to California', an ode to Joni Mitchell, has a similar folk feel. 'Four Sticks' has a rolling pattern influenced by Indian music.

The album's most famous track is of course 'Stairway to Heaven', with its layers of guitars and recorders and Plant's arcane medieval lyrics. It has become one of the most famous rock songs of all time.

Despite *IV*'s folk flourishes, Led Zeppelin is defined and this album is bookended by the blues. The opener 'Black Dog' is a crazed blues started by Jones that turns itself inside out. The final track is a version of Memphis Minnie's 'When the Levee Breaks'. Zeppelin kept the 12-bar structure but theirs is built around a massive drum feel which was recorded in the stairwell of Headley Grange. With just two microphones at 3 m (10 ft) and another at 6 m (20 ft) hung over his head, so the whole house became a giant echo chamber, Bonham pounds the drums and sounds like doom itself. Then there are layers of greasy harmonica and guitar, some running backwards, and layers of backwards echo and phased vocals. According to Page, 'At the end of it, where we've got the whole works going on this fade, it doesn't actually fade. As we finished it, the whole effects start to spiral – all the instruments are now spiralling with the mixing and the voice remaining constant in the middle. You hear everything turning right around.'

Having taken blues and folk to new places, there's 'Rock and Roll' where they go back and reinvent the wheel. Bonham launched into a demented version of 'Keep a Knockin' and the others jumped in. '"Rock and Roll" was a spontaneous combustion. We were doing something else at the time. I played the riff automatically,' Page recalled. His astonishing guitar playing channels rockabilly heroes like Scotty Moore and Cliff Gallup except wilder and more furious. Plant improvised the lyrics and the sixth Stone, Ian 'Stu' Stewart, added piano. Rock & roll they called it, but rock & roll had never sounded like this before.

'Jimmy Page revolutionised everything,' said producer Rick Rubin. 'There was no real blues rock in that bombastic way before Zeppelin. Plus, with the insane drumming of John Bonham, it was radical playing at a very, very high level – improvisational on a big-rock scale. It was brand new.'

TRACKLISTING

01 **Black Dog**
02 **Rock and Roll**
03 **The Battle of Evermore**
04 **Stairway to Heaven**
05 **Misty Mountain Hop**
06 **Four Sticks**
07 **Going to California**
08 **When the Levee Breaks**

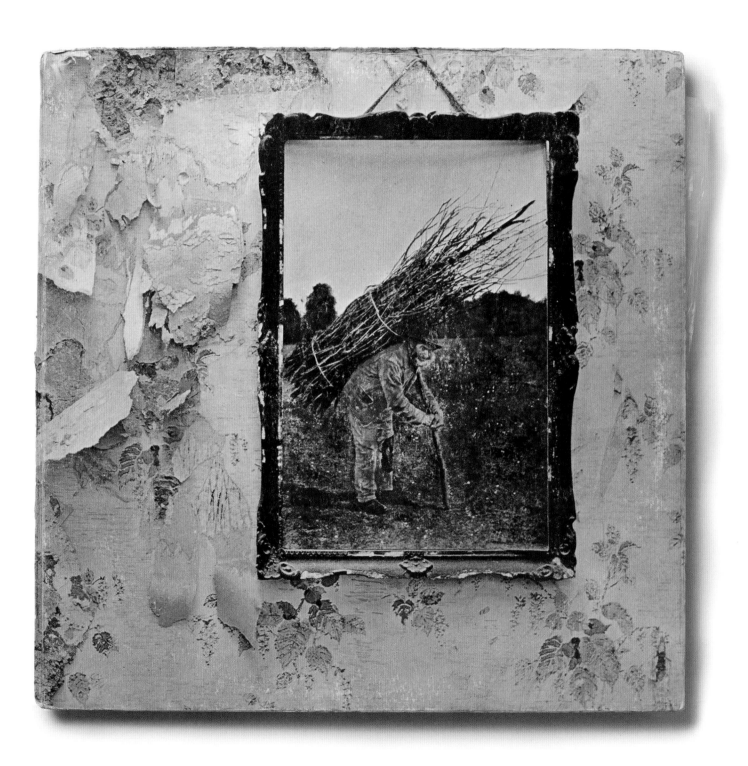

N°: 16
RADIOHEAD
OK COMPUTER

Parlophone
Produced by Radiohead and Nigel Godrich
Released: May 1997

With Radiohead's magnificently dense third album, you have to put aside everything that came after its release. Forget the ecstatic, often hysterical critical acclaim, forget the placing of a generational touchstone upon these 13 tracks, and especially forget the band's own discomfort and eventual disavowal of the cult of personality that sprang up around the record. *OK Computer* may have inspired the most depressing tour documentary ever made – Grant Gee's *Meeting People Is Easy* – but when you strip away the suffocating accoutrements you're left with the rock album that rebuilt the genre and propelled it towards the 21st century.

The English five-piece – singer and lyricist Thom Yorke, guitarists Jonny Greenwood and Ed O'Brien, bassist Colin Greenwood and drummer Phil Selway – had already come a long way on 1995's *The Bends*, a collection of often riveting pocket symphonies for the guitar, which dived deep into the psyche of the group's frontman. *OK Computer* accepted that record's answers, but it asked completely different questions – it's an album of savage observations where the world outside sits somewhere between a sci-fi novel and a soap opera (one of the many things the album predicts: 'reality' television), and the songs pinball between styles and movements. In lesser hands the record's aims would have resulted in something embarrassing.

2000's *Kid A*, the anguished and influential successor to *OK Computer*, would be simplistically hailed as the record where Radiohead went electronic, but it's more fitting to describe *OK Computer* as an electronic album recorded with guitars. The band were already experimenting with electronics – the beat on the opening 'Airbag', a panoramic tune slowly discovering the arrangement's gravity, is a brief snatch of Selway's playing looped and edited – and if they didn't know what buttons to push, they knew which strings to repurpose. The guitar sounds here change shape convulsively, and they're cut together to create dissonance not grandeur.

There are moments of outright beauty, such as the glockenspiel-accentuated melody of 'No Surprises', but then the lyric captures a worn out firebrand's descent into self-defeat and the preparation for suicide ('a handshake of some carbon monoxide'). The outside world constantly intrudes and proves unfulfilling: the protagonist of 'Subterranean Homesick Alien' wishes a UFO and its occupants would snatch him away from the everyday, but he knows that even if that happened he'd just be derisively dismissed by his friends and family. 'They'd shut me away,' Yorke shrugs.

The vocalist sees the world as a dystopia that has come to pass without anybody realising. The stark, nightmarish landscape of 'Climbing Up the Walls' captures the interior reality of a serial killer, building to a bleak crescendo, while 'Let Down', underpinned by an assertive bass figure, captures the feeling of travelling without pause until you're anaesthetised to your surroundings. These ideas would attract comparisons to Pink Floyd, but Yorke didn't see himself as a redemptive figure or self-aware seer. He was more likely to identify with the office drones trapped in 'Karma Police'.

OK Computer could find sweetness in its most savage moment, and soil beauty with selfishness or consumerism gone mad. But its condemnations are arresting, such as the 'kicking squealing Gucci little piggy' of the whiplash-inducing suite, 'Paranoid Android', and the album's outgoing nature – full of songs about flawed transactions, a theme enhanced by the artwork – brought listeners along with it. It found a sense of equilibrium with the hymn-like sunset of 'The Tourist', and it didn't just dismantle your life and the assumptions behind it into pieces, it put them back together. *OK Computer* was ultimately liberating.

TRACKLISTING

01 **Airbag**
02 **Paranoid Android**
03 **Subterranean Homesick Alien**
04 **Exit Music (For a Film)**
05 **Let Down**
06 **Karma Police**
07 **Fitter Happier**
08 **Electioneering**
09 **Climbing Up the Walls**
10 **No Surprises**
11 **Lucky**
12 **The Tourist**

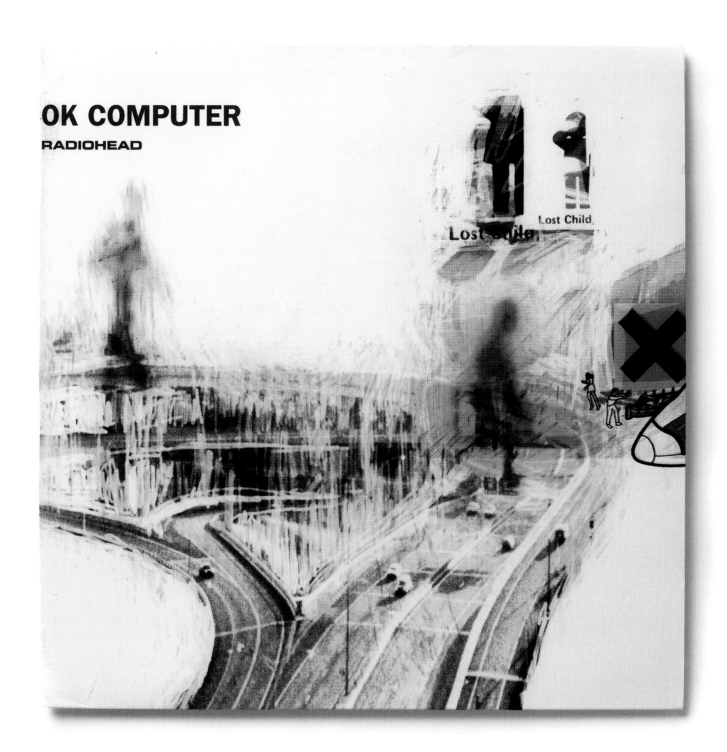

N°: 17

THE BAND
THE BAND

Capitol
Produced by John Simon
Released: September 1969

In 1968 *Music from Big Pink* broke on the music world like a tsunami. After hearing it Eric Clapton broke up Cream and George Harrison almost left the Beatles. The group that made the album had no name – they were simply known as 'the Band'. The name stuck. The simplicity of the name and its distance from show business razzamatazz seemed to fit. These five musicians had spent eight years playing one night stands in bars behind '50s rocker Ronnie Hawkins before they were recommended to back Bob Dylan for his legendary 1966 world tour. In 1967 they retreated to a house in upstate New York where, with Dylan's assistance, they worked up their own sound. All five players – Jaime Robbie Robertson, Rick Danko, Richard Manuel, Garth Hudson and Levon Helm – were multi-instrumentalists, steeped in R&B, blues, early rock and country music. They swapped instruments, sang in harmony and unison. *Big Pink* was a unique and powerful statement in 1968 and the following year the album called simply *The Band* upped the ante.

Rather than face another New York winter, the Band decamped to Los Angeles where they turned Sammy Davis Jr's pool house into their own clubhouse-cum-recording studio. All the instruments were set up in one room facing each other and the steam room became the echo chamber. Photos suggest the studio looked like a moonshiner's hideout.

During his tenure with Dylan, Robbie Robertson started to write character-based songs. Fascinated by Levon Helm's stories of rural Arkansas and the myths of the American South, Canadian-born Robertson began writing songs that recreated this dream world. 'The Night They Drove Old Dixie Down' is Robertson's telling of the Civil War story, attempting to convey why and how the notion that the South will rise again has survived for more than 100 years.

The Band is an expression of Americana and the South that ranks with the works of Faulkner or Steinbeck's best novels. Critic Griel Marcus said of the album, 'It felt like a passport back to America for people who had become so estranged from their own country that they felt like foreigners even when they were in it'.

The Band was a completely unique ensemble in every respect. Helm, Danko and Manuel shared lead vocals. Helm had a hard-bitten dirt farmer rasp while Manuel had an exquisite high register that sounded like an angel with a broken heart. The fact that both were also drummers created the unique syncopation and, with Rick Danko's bass, this trio made up the funkiest white band in history. 'Up on Cripple Creek', featuring Garth Hudson on a clavinet that sounds uncannily like a Jew's harp, is as funky as any Stevie Wonder track. Danko's fiddle on 'Rag Mama Rag' sounds like a bluegrass with a whole different shade.

For Robertson the key to the album was the last song, 'King Harvest (Has Surely Come)'. 'That's when life begins, not in spring but in the autumn,' he said. 'In the fall that's when the harvest is in and the carnival is in town.' The steady loping rhythms of the song have the sense of the weather roiling across the Great Plains and the hope and fear in the voice of the farmer who has bet the farm on the promise of rain.

The Band took the familiar – carnival music, R&B and country – and created something completely unfamiliar and unique. 'Everything in rock was kind of going in that high end direction,' said Robbie Robertson. 'We wanted a kind of woody, thuddy sound – something different.'

TRACKLISTING

01 **Across the Great Divide**

02 **Rag Mama Rag**

03 **The Night They Drove Old Dixie Down**

04 **When You Awake**

05 **Up on Cripple Creek**

06 **Whispering Pines**

07 **Jemima Surrender**

08 **Rockin' Chair**

09 **Look Out Cleveland**

10 **Jawbone**

11 **The Unfaithful Servant**

12 **King Harvest (Has Surely Come)**

THE BAND

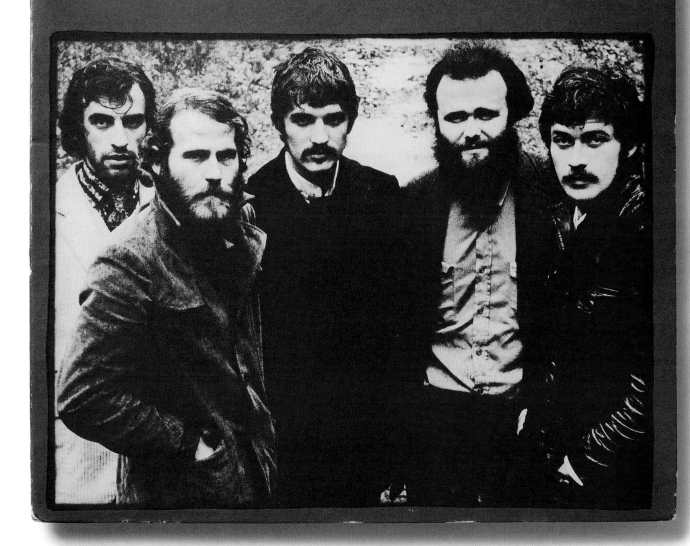

N°: 18

THE BEATLES
THE BEATLES (THE WHITE ALBUM)

Apple
Produced by George Martin
Released: November 1968

Interviewed during the making of *The Beatles*, Paul McCartney commented: 'We are family grocers. You want yoghurt; we will give it to you. You want cornflakes, we have that too.' He might have added that in 1968 they expanded into homewares; even the kitchen sink was included.

Often criticised for its excessive length and for its vast range of styles, *The Beatles*, or 'The White Album', has improved and become more influential with age. In fact, the album's diversity is its strength. Having made a hugely successful 'concept' album on *Sgt. Pepper's Lonely Hearts Club Band*, the Beatles fell back on what they did best which was channelling the spirit of their times into popular song.

The world in 1968 was a non-stop riot and the ferment that is known as 'the '60s' was at its high point. The group itself was being harassed by the drug squad, getting arrested, getting divorced, experimenting with gurus and dealing with the death of their manager, Brian Epstein. Much of this mess and turmoil was addressed in the song 'Revolution' and all of it spilt across this wildly divergent double album.

Underpinning all of this was that the Beatles were pulling apart, starting to express themselves as four brilliant individuals rather than one fab whole. During the recording of 'Back in the USSR' Ringo quit the band; George Harrison brought Eric Clapton to a session for 'While My Guitar Gently Weeps' (because he needed the extra cachet for Lennon and McCartney to consider the song); and many tracks feature just Paul McCartney alone. It is almost as though the Fab Four were bursting with so many ideas that they couldn't go back to their old methods of recording everything together. And yet by flying their freak flags, they blossomed.

The Beatles has so many highlights: the unbridled mania of 'Helter Skelter', 'Yer Blues', 'Revolution' and 'Everybody's Got Something to Hide Except Me and My Monkey', the great simplicity of 'Why Don't We Do It in the Road?'; the inventive story telling of 'Rocky Raccoon', 'Glass Onion' and 'Happiness Is a Warm Gun'; and the experimental soundscape of 'Revolution 9'. John Lennon shines with his song to his mother (and Yoko), 'Julia', while McCartney is equally plaintive and successful with 'I Will'. Even Ringo shines on 'Don't Pass Me By'. All in all there isn't a bad track on the album. Some of the more experimental moments still sound groundbreaking and ballads such as 'Long, Long, Long' are still heartbreaking.

Where the cover of *Sgt. Pepper's* turned out to be more memorable than most of its songs, here the Beatles contacted Britain's leading pop artist, Richard Hamilton, whose minimal design turned out to be as iconic as *Sgt. Pepper's*.

'Paul never liked it because, on that one, I did my music, he did his, and George did his,' said Lennon of *The Beatles*. 'First, he didn't like George having so many tracks, and second, he wanted it to be more a group thing, which really meant more Paul. So, he never liked that album. I always preferred it to all the other albums, including *Pepper*, because I thought the music was better. The *Pepper* myth is bigger, but the music on the White Album is far superior, I think. I like all the stuff I did on that and the other stuff as well. I like the whole album.'

TRACKLISTING

01 **Back in the USSR**
02 **Dear Prudence**
03 **Glass Onion**
04 **Ob-La-Di, Ob-La-Da**
05 **Wild Honey Pie**
06 **The Continuing Story of Bungalow Bill**
07 **While My Guitar Gently Weeps**
08 **Happiness Is a Warm Gun**
09 **Martha My Dear**
10 **I'm So Tired**
11 **Blackbird**
12 **Piggies**
13 **Rocky Raccoon**
14 **Don't Pass Me By**
15 **Why Don't We Do It in the Road?**
16 **I Will**
17 **Julia**
18 **Birthday**
19 **Yer Blues**
20 **Mother Nature's Son**
21 **Everybody's Got Something to Hide Except Me and My Monkey**
22 **Sexy Sadie**
23 **Helter Skelter**
24 **Long, Long, Long**
25 **Revolution 1**
26 **Honey Pie**
27 **Savoy Truffle**
28 **Cry Baby Cry**
29 **Revolution 9**
30 **Good Night**

The BEATLES

Stereo PCSO 7067·8 Mono PMCO 7067·8

N°:19

PIXIES
DOOLITTLE

4AD
Produced by Gil Norton
Released: April 1989

Doolittle, the second Pixies album and a touchstone for the looming alternative rock era, is a distinctly American record, both wholesome and depraved, seeing both salvation and savagery in the spiritual, and strangely friendly.

The band came from Boston, a city founded by Puritans and subsequently known for more nefarious residents, and they had welcoming songs about the end of the world and ritualistic murders. 'Must be a devil between us/Or whores in my head/Whores at my door/Whores in my bed,' the group's frontman and songwriter, Black Francis, sang on 'Hey', and across the album the Pixies brought these snatches of timeless revelation to life. Fittingly, the record became the Old Testament of grunge rock.

The Pixies congealed in January 1986 and from there things moved fast, with university acquaintances Black Francis and guitarist Joey Santiago joined by bassist Kim Deal and drummer David Lovering. They were playing shows by the middle of that year and cut a demo soon after that ended up at Britain's 4AD Records, who swiftly released the *Come on Pilgrim* mini-album in September 1987 and the *Surfer Rosa* album in March 1988. By October of that year they were preparing for the next album, and the speed with which they moved is important, for there was something unfiltered about the Pixies, as if the songs had emerged complete and without second thought.

The difference between their previous tracks and those on *Doolittle* was the presence of English producer Gil Norton. He worked on the arrangements and provided a contrast to the band's abrasive force, and that would enhance the soft/loud dynamic (or what could also be considered the stable/deranged dynamic) that would become a Pixies trademark. The initial parts on 'Tame' are crisply focused – a snare drum and an undulating bassline, with Black Francis whispering about how the woman that fascinates the song's protagonist has 'got hips like Cinderella' – but once he's screaming the title above razor sharp guitar the title is a misnomer. The singer's laboured, excited breathing is echoed by Deal's backing vocal and in just under two minutes the song is a psychosexual cauldron.

In an America where the college rock scene was still getting to grips with R.E.M.'s Michael Stipe, Black Francis was an exciting presence. On 'Debaser' he alludes to Salvador Dalí and Luis Bunuel's 1929 film *Un Chien Andalou* ('Got me a movie/I want you to know/Slicing up eyeballs'), and surrealism was a recurring inspiration. Perhaps the best comparison at the time was David Lynch's film *Blue Velvet*, which uncovered a nightmarish world poised to engulf everyday normalcy. The Pixies' tracks such as 'Dead' and 'Crackity Jones' created their own fractured world, and there was no feeling of slow immersion – Santiago's strangled, sometimes scorched guitar created a backdrop from scratch.

But along with the fervent was a graceful, sometimes serene, embrace of the apocalyptic. On 'Monkey Gone to Heaven', accentuated by a string section, an environmental disaster allows for humanity's obliteration of a deity (Neptune gets taken out by 'ten million pounds of sludge') and a reordering of the spiritual order, while 'Gouge Away' sets the biblical narrative of Samson and Delilah to a menacing bassline. And the songs unfurl with startling ease and almost instantaneous accommodation: 'I Bleed', with its layers of voices from the subconscious, gives way to the lovely 'Here Comes Your Man', before the rumbling, primal 'Dead' storms forth. There is no friction, just an ecstatic acceptance. 'My mind secedes,' declares Black Francis in 'I Bleed', and subsequent generations knew just what he meant.

TRACKLISTING

01 **Debaser**
02 **Tame**
03 **Wave of Mutilation**
04 **I Bleed**
05 **Here Comes Your Man**
06 **Dead**
07 **Monkey Gone to Heaven**
08 **Mr. Grieves**
09 **Crackity Jones**
10 **La La Love You**
11 **No. 13 Baby**
12 **There Goes My Gun**
13 **Hey**
14 **Silver**
15 **Gouge Away**

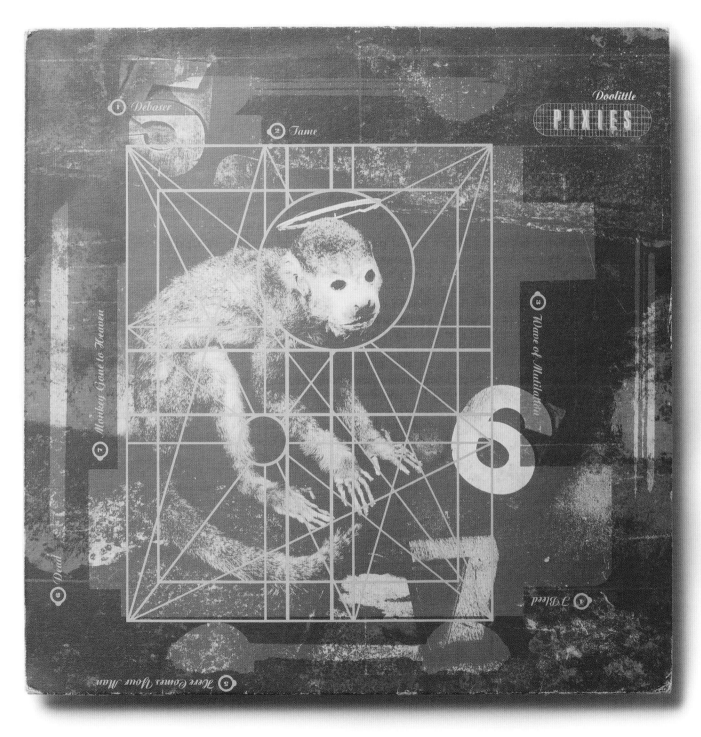

Doolittle
PIXIES

1 Debaser
2 Tame
3 Wave of Mutilation
6
7 Monkey Gone to Heaven
8 Dead
9 Blud
5 Here Comes Your Man

Nº:20

JOHN LENNON
JOHN LENNON/PLASTIC ONO BAND

Apple
Produced by John Lennon, Yoko Ono and Phil Spector
Released: December 1970

I think it's the best thing I've ever done. I think it's realistic and it's true to the me that has been developing over the years from my life,' is how John Lennon described his first proper solo album to *Rolling Stone*'s editor Jann Wenner in December 1970. It had been a cathartic few years for Lennon. His marriage to Cynthia had ended, the Beatles were over and he was smitten with artist Yoko Ono who had challenged him to rethink everything about being an artist and a man. Then there was the heroin, a miscarriage, police harassment and just being one of the most famous people on earth. In early 1970 Lennon was in the midst of a full nervous breakdown, almost catatonic. Ono called on psychologist Arthur Janov who had made a name for himself with what he called 'primal therapy'.

For Lennon the fundamental issue was being abandoned by his parents when he was a young child. All his life he had the need to be loved while under the surface a seething anger raged. The extraordinary, unimaginable fame that the Beatles experienced made no sense to him; the group that he formed and fronted had turned into a poisoned chalice. Janov worked with the Ono-Lennons for several months through the summer of 1970. Then, in September, Lennon went into Abbey Road studios for a month and emerged with his own masterpiece.

Always shy and modest about his abilities in the studio, Lennon recruited the rhythm section that was closest to him – Ringo Starr on drums and Klaus Voormann on bass. Billy Preston played piano on one track and Phil Spector co-produced and played piano on 'Love'. Yoko provided her inspiration and the rest was Lennon at his most pure ... and raw. Having flirted with the avant-garde in previous years, for this album the musicians primed themselves by listening to early Jerry Lee Lewis records and playing traditional blues. The result was an album that melded avant-garde minimalism with pure rock & roll and created a sound that was new and unique. From the gorgeous melodies of 'Love' and 'Look at Me' to the searing 'Well Well Well' and venomous 'I Found Out', this is Lennon's strongest selection of songs, before or after.

'All these songs just came out of me. I didn't sit down to think "I'm going to write about Mother" or "I'm going to write about this, that or the other",' Lennon told Wenner.

Once written, Lennon knew that the album had to begin with 'Mother'. The song opens with the ominous pealing of a church bell and it proceeds at a funereal pace as Lennon lets out the unfiltered appeal of a bewildered son crying 'Mother ... you left me, but I never left you'. It doesn't get more real and honest than that and it is the central issue that his life and *Plastic Ono Band* pivots on.

From the intimate and particular, Lennon turns his gaze to society at large. There's 'Working Class Hero' in which Lennon debunks not only the class system but also the entertainers like himself who churn out protest songs. In a sense it echoes Dylan's line 'Don't follow leaders/Watch the parkin' meters' ('Subterranean Homesick Blues').

The other key track on the album is 'God', which opens with a piano dirge before Lennon runs through a laundry list of faiths and cults to which he doesn't subscribe. But then he gets to 'I don't believe in Elvis/I don't believe in Zimmerman/I don't believe in Beatles/I just believe in me/Yoko and me ... The dream is over'. This was 1970 – the time when the youthquake of the '60s was supposed to deliver utopias for everyone. In that context, Lennon singing the line 'the dream is over' was a reality check and it was heard everywhere around the world. John Lennon was calling time on the Fab Four and on history's greatest ever party, as only he could do.

TRACKLISTING

01 **Mother**
02 **Hold On**
03 **I Found Out**
04 **Working Class Hero**
05 **Isolation**
06 **Remember**
07 **Love**
08 **Well Well Well**
09 **Look at Me**
10 **God**
11 **My Mummy's Dead**

PAUL MCCARTNEY ON *PET SOUNDS*

It was *Pet Sounds* that blew me out of the water. I love the album so much. I've just bought my kids each a copy of it for their education in life, I figure no one is educated musically 'til they've heard that album.

STEVE KILBEY ON *MARQUEE MOON*

i had been reading about Television long before i ever heard them
journalist after journalist raved on about them in hip US and English rock rags
so i was well set up to enjoy
of course the record did not let me down
i got it the day it arrived at the import shop in canberra
it was everything the journos had been saying
the mysterious lyrics the twin guitars
the long guitar solo on the title track and how it releases into the next bit
Verlaine's weird droll voice and even the photocopy cover art
everything about this record was special to me
it was one of a kind. an influence in every way
an absolute classic and milestone! Steve Kilbey (the Church)

GEORGE MARTIN ON *PET SOUNDS*

Without *Pet Sounds*, *Sgt. Pepper* wouldn't have happened. *Revolver* was the beginning of the whole thing. But *Pepper* was an attempt to equal *Pet Sounds*.

George Martin (Beatles producer)

LOU REED ON LITTLE RICHARD

Little Richard was one of the most astonishing things I ever heard in my life. It changed my world view. I first heard him on the radio, doing 'Long Tall Sally', sometime in the late '50s, and I just couldn't believe it. There was life out there, compared to where I was. It changed everything. I wanted to be wherever that was, go there and make a life whatever planet that was on.

" ERIC CLAPTON ON THE BAND

They were white, but they seemed to have derived all they could from black music, and they combined it to make a beautiful hybrid. And for me it was serious. It was serious, and it was grown up, and it was mature, and it told stories, and it had beautiful harmonies, fantastic singing, beautiful musicianship without any virtuosity. Just economy and beauty. "

" JOE PERRY ON LED ZEPPELIN

They weren't musical snobs, and never held on to any one style. Zeppelin changed gears six times on one album, and they played blues, rock, funk, reggae, and ballads with equal ease. "

Joe Perry (Aerosmith)

" JOE STRUMMER ON BRUCE SPRINGSTEEN

Bruce is great. If you don't agree with that you're a pretentious Martian from Venus. Bruce looks great. Like he's about to crawl underneath the hood with a spanner and sock the starter motor one time so that the engine starts up, humming and ready to take us on a golden ride way out somewhere in the yonder. Bruce is great. Because he'll never lay down and be conquered by his problems, he's always ready to bust out the shack and hit the track. Bruce is great. There ain't no whingeing, whining or complaining. There's only great music, lyrics and an ocean of talent. Me? I love Springsteen. "

" NOEL GALLAGHER ON *OK COMPUTER*

I've never even heard *OK Computer*, but anything by Radiohead doesn't make much sense to me. Everyone's going on about Radiohead pushing things forward, but the only thing they're famous for really is songs like 'Creep' innit? ... They then go off-roading for the rest of their career. I just don't get it. I mean, we've all written songs like 'Creep', y'know, them classic songs. So that's what makes them what they are. 'Karma Police' is alright, but it's The Beatles, innit? "

N°:21

U2
ACHTUNG BABY

Island
Produced by Daniel Lanois and Brian Eno
Released: November 1991

This time, Berlin was calling. America, as both a destination and an idea hefty enough for their ambitions, had drawn U2 from their earliest days. Since their beginnings they had toured heavily there. But after the success of 1986's *The Joshua Tree*, which sold a staggering 25 million copies worldwide, the group took on the US's iconography and obvious pleasures, resulting in the patchy and imitative *Rattle and Hum*. If they'd continued on that path, cliché and stagnation awaited them. Instead they decamped to Berlin, where a year's worth of sessions began that resulted in *Achtung Baby*, the record that reinvented U2 and created an exciting new framework for arena rock.

The album returned rock & roll to Europe, admitting lust and existential doubts, tenderness and cruelty to a list of inspirations that had narrowed as groups became ever more anthemic. *Achtung Baby* would subsequently scale up with little problem into stadium-filling material, but at the time it was a radical rebirth. 'And I must be an acrobat/To talk like this and act like that,' the quartet's vocalist, Bono, sang on 'Acrobat', and it exemplified a record where noble sentiment is undercut by reality and the song's protagonists know that a coarse reality awaits them.

From the opening track, 'Zoo Station', Bono's bandmates – the Edge on guitar, Adam Clayton on bass and Larry Mullen Jr on drums – redraw their parameters. The song's intro sounds like a train rattling ever closer on the Berlin S-Bahn system, with industrial guitar squalls and a distant rhythm drawing into alignment. Bono sounds like he's on a shortwave radio, negotiating at some kind of surreal stand-off ('I'm ready/I'm ready for the laughing gas,' he whispers). But the effect is not to simply muddy U2's virtue, it's to provide a bottom end that makes any ascension thrilling. It gives U2 a full spectrum to range across.

The input of Brian Eno, a co-producer and catalyst alongside Daniel Lanois, was crucial (he was back in Hansa Studios, where he'd helped David Bowie cut *Heroes* 15 years prior). But the band knew they wanted something new, even if they initially couldn't agree on just what. Rather than pay homage to the past, with *Achtung Baby* U2 addressed its future with a percussive liveliness that suggested an appreciation of hip-hop and club sounds. A lithe, funky, groove-powered single 'The Fly', anchoring Bono's leaps into falsetto.

There's barely a speck of sunshine in these songs. They're songs for the night; a night that gets steadily more compromised as it unfolds. The optimism of 'Even Better Than the Real Thing', where the Edge metaphorically burns his cowboy hat with a sequence of subtle, sighing guitar effects and a serrated solo, gives way to sustained pleas for a troubled relationship to endure – 'feel like trash,' the singer confesses on 'Ultraviolet (Light My Way)', 'you make me feel clean'. The personal replaces the political on *Achtung Baby*, and Bono's focus on the intimate struggle two people share makes for a soulful, adult perspective.

In such conditions a pledging of faith has genuine spirituality, and with 'One', a tremulous ballad of supple keyboards and a genius bassline, U2 found a centrepiece for these songs, and one whose optimism was earnt amidst the double-dealing and personal flaws that surrounded it. The song gets stronger, but not larger, and the sentiment – 'Carry each other/Carry each other' – stays true. The song, like the album, made U2 relevant at a time of great change. Grunge and electronic music would render many of U2's contemporaries from the 1980s redundant, but *Achtung Baby* delivered greatness.

TRACKLISTING

01 **Zoo Station**
02 **Even Better Than the Real Thing**
03 **One**
04 **Until the End of the World**
05 **Who's Gonna Ride Your Wild Horses**
06 **So Cruel**
07 **The Fly**
08 **Mysterious Ways**
09 **Trying to Throw Your Arms Around the World**
10 **Ultraviolet (Light My Way)**
11 **Acrobat**
12 **Love Is Blindness**

N°22

SIMON AND GARFUNKEL
BRIDGE OVER TROUBLED WATER

Columbia
Produced by Paul Simon, Art Garfunkel and Roy Halee
Released: January 1970

This last album for Simon and Garfunkel tells you everything you need to know about their history – both professional and personal, the good and the bad. The album is a masterpiece of flawless songwriting, production and performance.

Simon began writing the title track at the house George Harrison immortalised in 'Blue Jay Way' after hearing the Swan Silvertones' 'Mary Don't You Weep'. Originally a two-verse ballad that was meant to be a gospel song, Garfunkel and co-producer Roy Halee convinced Simon to take a leaf from Phil Spector and the Righteous Brothers' version of 'Ol Man River' and come in big on the final verse. The song starts with a tiny piano tinkling and an almost whispered vocal. As it progresses, Garfunkel heads off to his high register and soars against Larry Knetchel's piano.

Knetchel spent four days just on his piano arrangement and Simon and Halee put in 100 hours on that one song alone. This is Garfunkel's finest vocal performance – everything is precisely in the right place and the words just shine. Simon comes in for the third verse along with Moog synthesisers, pedal steel guitar, two basses and the tune sails to its epic climax.

Simon was inspired to write the song for his wife, Peggy Harper, but equally the song could be about his friendship with Garfunkel, which had begun when they were kids and was now coming apart.

The album's creation was painstaking in every way. Sessions stretched across an entire year as each track was laboriously assembled – 'Bridge' alone has two bass players, other tracks had layers and layers of voices piled on top of each other. Most of the backing was done by the session supremos, the Wrecking Crew, led by drummer Hal Blaine.

Much of the rest of the album reflects Simon's struggle with his craft. 'Keep the Customer Satisfied' and 'Song for the Asking' reference the pressures of writing and recording hits. 'Cecilia' is a love song to St Cecilia the patron saint of music. Then there is 'The Boxer', ostensibly the story of a pug who has been battered around. Simon has admitted that the song is a

TRACKLISTING

01 **Bridge Over Troubled Water**
02 **El Condor Pasa (If I Could)**
03 **Cecilia**
04 **Keep the Customer Satisfied**
05 **So Long, Frank Lloyd Wright**
06 **The Boxer**
07 **Baby Driver**
08 **The Only Living Boy in New York**
09 **Why Don't You Write Me**
10 **Bye Bye Love**
11 **Song for the Asking**

crude metaphor for his own experience as a performer (Seventh Avenue, where the whores are, was also the headquarters of Columbia Records). 'The Boxer' has some of Simon's most vivid writing, backed by an inspired mix of arpeggiated guitar, pedal steel and Moog synthesiser. This song also took Simon and Halee more than 100 hours. ('It was like their religion,' quipped Garfunkel.) 'El Condor Pasa' was a Peruvian traditional song to which Simon added lyrics about the desire for freedom. He sings that a man in bondage 'gives the world its saddest sound'. In retrospect it's clear that Simon felt the need to break free of his partnership with Garfunkel and to try new paths.

Just prior to recording this album, Garfunkel had embarked on an acting career with a role in Mike Nichols' film *Catch 22*, which was shot in Mexico. 'The Only Living Boy in New York', which is addressed to 'Tom' – a reference to the duo's original name as Tom and Jerry – is a wonderfully sweet ode to their friendship. 'So Long, Frank Lloyd Wright' is more cutting with its reference to bluntness and rigidity (Garfunkel had studied architecture), but it's still affectionate in its lilting bossanova beat.

The penultimate song is a live recording of the Everly Brothers' 'Bye Bye Love', a song about a relationship ending. It is also a sweet touchstone to Simon and Garfunkel's early days as a duo, when they harmonised 'til dawn.

Simon
and
Garfunkel
Bridge
Over
Troubled
Water

Nº:23

BOB DYLAN
BLONDE ON BLONDE

Columbia
Produced by Bob Johnston
Released: May 1966

'The closest I ever got to the sound I hear in my mind was on the *Blonde on Blonde* album. It's that thin, that wild mercury sound. It's metallic and bright gold with whatever that conjures up. That's my particular sound.' This is an often-quoted line from Bob Dylan because *Blonde on Blonde* sounds absolutely unlike any record before or since.

'Like a Rolling Stone' was a breakthrough single in mid-1965. By the end of the year Dylan had an even more complex song as the heart of what would be his third album in a year. Widely considered one of Dylan's masterpieces, 'Visions of Johanna' captures the atmosphere of New York after midnight, mixing surreal images ('the ghost of electricity howls in the bones of her face') with specific scenes; the song is very clear in its intent but the meaning remains as elusive as Cocteau's *Orphee* or Picasso's *Les Demoiselles d'Avignon*. It was exactly at this point that rock & roll ceased being a hybrid of popular music styles and became something else.

Producer Bob Johnston suggested that Dylan record in Nashville. 'While the rest of the world was doing an album with [the idea that] the more musicians they could get, the better it was,' said Johnston. 'We went in with four people ... in the middle of a psychedelic world!'

In February 1966 Dylan and pals Al Kooper and Robbie Robertson flew to Nashville where session musicians Charlie McCoy (guitar, bass), Wayne Moss (guitar), Joe South (bass) and Kenny Buttrey (drums) finally nailed 'Visions of Johanna'. The key to the recording was to be able to play live in the studio and keep up with Dylan: 'I told everybody if they quit playing they were gone,' said Johnston. 'If you quit with him you'll never hear that song again.' Dylan disliked overdubbing, which required McCoy to play both bass and trumpet simultaneously on one song. Six songs were cut in one 13-hour session.

Then there was the track 'Sad Eyed Lady of the Lowlands'. When the session started at 6pm

TRACKLISTING

01 **Rainy Day Women #12 & 35**

02 **Pledging My Time**

03 **Visions of Johanna**

04 **One of Us Must Know (Sooner or Later)**

05 **I Want You**

06 **Stuck Inside of Mobile with the Memphis Blues Again**

07 **Leopard-Skin Pill-Box Hat**

08 **Just Like a Woman**

09 **Most Likely You Go Your Way and I'll Go Mine**

10 **Temporary Like Achilles**

11 **Absolutely Sweet Marie**

12 **4th Time Around**

13 **Obviously 5 Believers**

14 **Sad Eyed Lady of the Lowlands**

Dylan hadn't finished the lyric. The musicians killed time until 4am when he was ready. He showed the band the chords and they started. 'After the second chorus starts building and building like crazy, and everybody's just peaking it up 'cause we thought, Man, this is it ... This is gonna be the last chorus and we've gotta put everything into it we can,' recalled Kenny Buttrey. 'And he played another harmonica solo and went back down to another verse and the dynamics had to drop back down to a verse kind of feel ... After about ten minutes of this thing we're cracking up at each other, what we were doing? I mean, we peaked five minutes ago. Where do we go from here?' The 11-minute track would take up one side of the double vinyl album.

Between these epics, Dylan included some of his funniest songs ('Rainy Day Women #12 & 35', 'Leopard-Skin Pill-Box Hat'), his most tender love songs ('I Want You', 'Just Like a Woman') and his most accessible songs ('Pledging My Time', 'Absolutely Sweet Marie'). *Blonde on Blonde* bore plenty of traces of Dylan's life then – his recent marriage to Sara Lownds, the birth of their son Jesse, mixing with the beautiful and damned New York bohemians, the amphetamines and heroin, hanging with Allen Ginsberg and the literary cognoscenti and the craziness of his concerts. In an interview shortly before the album came out the interviewer inevitably came to the issue of what Dylan's songs were 'about'. 'I do know what my songs are about,' the songwriter laughed. 'Some are about four minutes; some are about five, and some, believe it or not, are about eleven.'

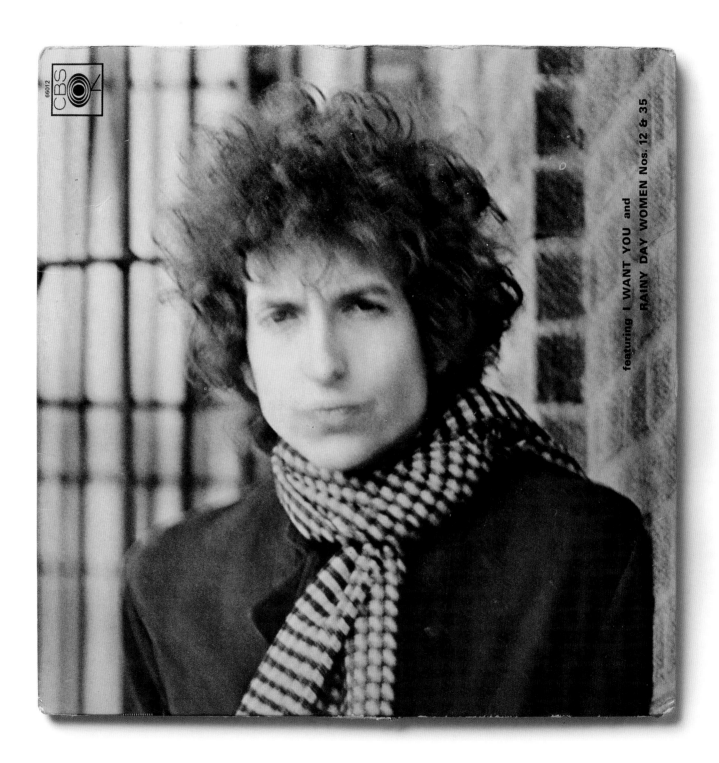

CBS
66012

featuring I WANT YOU and RAINY DAY WOMEN Nos. 12 & 35

N°: 24

SEX PISTOLS

NEVER MIND THE BOLLOCKS, HERE'S THE SEX PISTOLS

Virgin
Produced by Chris Thomas and Bill Price
Released: October 1977

It's not possible to disengage this record from the controversy it caused. You probably know a bit about the Sex Pistols: artist, troublemaker and would-be Svengali Malcolm McLaren finds four working-class yoofs and makes them into a band. They, being young and mostly drunk, go along with his stunts to offend polite English sensibilities (easier in the mid-'70s than nowadays). The fact that the boys can't play their instruments is not a problem for McLaren (ironically they are much better musicians than he is a manager). Anyway, they get people hot under the collar, they make punk rock into a phenomenon and the second bass player may or may not kill his girlfriend before dying himself. And then suddenly it's all over. Somewhere they find enough time to make just one album.

None of the stunts would have worked were *Never Mind the Bollocks* less than brilliant. Bass player Glen Matlock had a rudimentary sense of his instrument and an abiding love for the Beatles, so almost all of the music came from him. Singer Johnny Rotten had an incredible talent for lyrics, and drummer Paul Cook held it together. But the real find was guitarist Steve Jones. His previous experience was in stealing guitars but he proved to have a natural gift for playing them.

Despite their image, there was nothing amateurish about the Pistols' time in the studio. Chris Thomas was one of the most experienced producers in the UK. He created for them their own wall of sound. Jones' guitar is particularly strong – aggressive, violent, monumental – but perfectly judged, always economical, always driving the band.

'"Anarchy" has something like a dozen guitars on it,' Thomas explained. 'I orchestrated it, double-tracking some bits and separating the parts and adding them ... It was quite laboured. The vocals were laboured, as well.'

'Steve and Paul had nothing to do, so they'd go out in the studio and run through the set from beginning to end, and they'd have it down perfectly,' Thomas recalled. 'One afternoon, we did "EMI", "Pretty Vacant",

TRACKLISTING

01 **Holidays in the Sun**
02 **Liar**
03 **No Feelings**
04 **God Save the Queen**
05 **Problems**
06 **Seventeen**
07 **Anarchy in the U.K.**
08 **Bodies**
09 **Pretty Vacant**
10 **New York**
11 **EMI**

"God Save the Queen" and the B-side of "God Save the Queen", all in about thirty minutes.'

McLaren's talent was capturing the zeitgeist. 'God Save the Queen' arrived coincidentally with celebrations for the Queen's silver jubilee. The single was banned from the charts but was a hit anyway. Its follow-up, 'Pretty Vacant', perfectly captured the attitude of disaffected British youth. All their singles were tightly wound productions relying on Jones' massive guitar sound.

The album consisted of every song the band had written to date: 'EMI' was about the label that had first signed them and then dropped them in a matter of weeks; 'Holidays in the Sun' was a rant about taking holidays in the Third World; and 'Bodies', the best of the album tracks, seems to be about abortion, sex and some girl that Lydon knew. The other songs are generally railing against ... everything. Although often dashed-off, Lydon's lyrics captured an attitude and combined brilliantly with Chris Thomas' wall of sound.

Jamie Reid was an artist McLaren cultivated to do the band's graphics. He chose garish colours for the album cover, using cut-up newspaper headlines for type, in the style of urban terrorists sending letters of demand. Reid's style was as startling as the music and he gave punk an iconography. The liner notes thanked 'no one'. Everything was blunt. 'We upset a lot of people at the start,' recalls drummer Paul Cook.

NEVER MIND
THE BOLLOCKS

HERE'S THE

SeX PiSTOLS

N°: 25

PRINCE
SIGN O' THE TIMES

Paisley Park/Warner Bros
Produced by Prince
Released: March 1987

Has there ever been a better start to a (double) album that was less indicative of what was to follow? On 'Sign o' the Times', the title track from Prince's devoutly varied ninth studio album, the Minneapolis polymath encompasses the world's decay through blistering social commentary that has the cruel economy of reportage: a couple in France die from AIDS-related causes, 17-year-old boys smoke crack and arm themselves, a hurricane kills everyone inside a church, a marijuana user escalates to heroin within months. Backed by cold, apocalyptic funk, Prince declares that, 'Some say a man ain't happy, truly/Until a man truly dies'.

But if that's the end of the world, then much of what follows is a resurrection delivered through the contemplation of sexual pleasure and personal freedom. *Sign O' the Times* is an album of lean R&B rhythms and salacious pop jams – 'Play in the Sunshine' follows up the title track with an exuberant groove. 'Some way, somehow, I'm gonna have fun,' sings Prince as drums crack, keyboards flourish and guitars flare up in the background; it's as if Little Richard got his hands on Paisley Park and went to town.

As with the Rolling Stones' *Exile on Main St*, *Sign 'O' the Times* is Prince at his best, despite having few of his signature songs included. 'Produced, arranged, composed and performed by Prince,' the credits coolly state, although the gestation wasn't so clear cut. Some of the sessions had been intended for *Dream Factory*, a proposed final double album collaboration with his band the Revolution, while 1986 had

also seen a side project involving Prince's dream woman, Camille (i.e. Prince's singing voice sped up to sound more feminine than he was already capable of). At one point it was going to be *Crystal Ball*, a triple album, but Warner Bros baulked, and the result was this 16-track double album that encapsulated his genius.

Prince had already worked his way through the popular music canon, anointing himself a successor to Jimi Hendrix with 'Purple Rain'

TRACKLISTING

01 **Sign o' the Times**
02 **Play in the Sunshine**
03 **Housequake**
04 **The Ballad of Dorothy Parker**
05 **It**
06 **Starfish and Coffee**
07 **Slow Love**
08 **Hot Thing**
09 **Forever in My Life**
10 **U Got the Look**
11 **If I Was Your Girlfriend**
12 **Strange Relationship**
13 **I Could Never Take the Place of Your Man**
14 **The Cross**
15 **It's Gonna Be a Beautiful Night**
16 **Adore**

and mastering funk with '1999', and on *Sign O' the Times* he returned to the dancefloor, taking in soul deliverance and elusive disco escalations. When Prince wasn't dancing with himself, Sheena Easton played Ginger Rogers to his libidinous Fred Astaire on 'U Got the Look' – 'You've got the look, you've got the hook,' they sang on a duet that was less a seduction than a union.

Sex is a promise across the two albums – 'With you I swear, I'm a maniac,' insists 'It' – but the vivid carnality of Prince's early records is offset here by an appreciation of the strange places desire and love take you too. As on 'If I Was Your Girlfriend' and 'I Could Never Take the Place of Your Man', role-playing takes on a whole new dimension on *Sign O' the Times*, with Prince wondering if he's ready for what comes the next day. It's no coincidence the final track is 'Adore', a slow burn of utter devotion with Prince yowling before he pledges himself.

Every excursion feels connected to the record's psyche, even the truly eccentric 'The Ballad of Dorothy Parker', where a waitress asks Prince if he wants to join her in a bath and he agrees but keeps his pants on, 'cuz I'm kinda going with someone'. Stylistic excursions, such as the proto-hip-hop party of 'Housequake' and the minimal swing of 'Forever in My Life', feel intrinsically part of the album that promises a second coming. 'Don't cry, he is coming,' Prince gently sings on 'The Cross', a track that builds to a ragged reckoning, and amid the masterful *Sign O' the Times* he could be foretelling his own triumph.

N°:26

ARCADE FIRE
FUNERAL

Merge/Spunk
Produced by Arcade Fire
Released: September 2004

If ever there was a record to not judge by its title, it's Arcade Fire's *Funeral*. On their debut album, the exiled siblings from Texas and their fellow Canadian conspirators turned in a blistering, exhilarating celebration of life's rich if uncertain potential. On a record that dips repeatedly and deeply into memory, and which was titled following the deaths of several band members' relatives during recording, *Funeral* turns out to be about those who live on. In an era when '80s revivalism was becoming codified, the album arrived like a liberating army. So much more felt possible after these 10 songs had left their indelible mark.

There were six of them, tied tightly by bonds formal and otherwise. Win Butler was the chief songwriter and co-vocalist; Régine Chassagne his fellow singer, multi-instrumentalist and wife; Howard Bilerman was the drummer. Butler's younger brother William, Timothy Kingsbury and Richard Reed Parry all played too many instruments to keep a clear count of. They were unpredictable, like their music.

The Butlers had come via school in Boston and the band had subsequently gone through various members and mêlées between 2001 and 2003, when they began recording *Funeral*. The group's gentlemen favoured a sartorial look best described as elite Bulgarian border guard circa 1931, but formality made few other claims on the record, which exploded internationally and took Arcade Fire from Canadian clubs to the main stage of international festivals in less than a year.

Voices were everywhere on these songs, with Win Butler's impassioned squawk finding fervour as it was shaded first by Chassagne and then caught up in the congregational swell of his bandmates. Tracks such as the opening 'Neighborhood #1 (Tunnels)' swept you up, but they didn't ascend into airy inconsequentiality. Butler imagines a snowed-in town, as he digs a tunnel from his parents' home to that of his beloved, and the band's off-kilter rhythms and sawing textures recreate that world, drawing higher and higher above the memory as the protagonists enter adulthood.

Childhood would become a formal, distant concept on later Arcade Fire albums, but on *Funeral* the past threatens to overwhelm the present as the songs go to wonderful,

TRACKLISTING

01 **Neighborhood #1 (Tunnels)**

02 **Neighborhood #2 (Laïka)**

03 **Une Année Sans Lumière**

04 **Neighborhood #3 (Power Out)**

05 **Neighborhood #4 (7 Kettles)**

06 **Crown of Love**

07 **Wake Up**

08 **Haiti**

09 **Rebellion (Lies)**

10 **In the Backseat**

unexpected places with a lightness of touch and offhand charm that belies the elemental forces they summon. 'Neighborhood #2 (Laïka)' made the effect transcendent, as Butler's treated vocal sits at odds with the raw strings as the lyric recalls an older brother defined by the disruptions he caused, both in presence and then absence. By the song's end, with a doleful accordion refrain circling, the sibling and his father are fighting and the police car lights suggest a disco.

Part of the album's appeal rested in the uncertainty over whether Arcade Fire were the heaviest folk band or the most fragile rock group around. Stringed instruments gradually coalesce on the redemptive 'Crown of Love', while the opening thump of 'Neighborhood #3 (Power Out)' ushered in a song whose subterranean rumble and ecstatic disco backbeat suggested a peculiar offshoot of early New Order. 'Look at 'em go,' demands Butler repeatedly on the latter, and he could be easily talking about his bandmates.

'If the children don't grow up/Our bodies get bigger but our hearts get torn up,' Butler sang on 'Wake Up', a song that could fill a stadium but retained a hold on intimacy – 'Haiti' in turn enveloped an entire troubled country (Chassagne's family had fled the Duvalier family's regime). There was little *Funeral* tried that did not only come together easily, but also felt intrinsically right. The songs moved too fast and too far for the drama to become staged, and the passion became euphoric and empowering.

N°:27

MICHAEL JACKSON
THRILLER

Epic
Produced by Quincy Jones
Released: November 1982

At the close of 1982 when *Thriller* was released, Michael Jackson was 24. He still had the instincts of a musical prodigy, but they were now presented to the world by a young African-American man. He was private, but not inaccessible, and nearly everything that would come to drag down his legacy hadn't yet occurred. The glow surrounding Jackson on the album's cover was deserved. *Thriller* is often referred to as the highest selling album of all time, but it exists outside that label. It's a dazzling record, melding flashes of inspiration with consummate professionalism, and it had an aura and energy that would help it break the colour barriers that still remained in pop music.

It starts with a statement of intent: the intricate, intoxicating 'Wanna Be Startin' Somethin', which combines overlapping drum patterns with the work of percussionist Paulinho da Costa and sets the trend for an album where the traditional and the modern are just two tools to be used as required by Jackson and producer Quincy Jones. The song is a come on, part challenge and part promise, and Jackson's vocal performance revels in the spotlight, recreating the joyous 'Ma Ma Se/Ma Ma Sa, Ma Ma Coo Sa' hook from Manu Dibango's 1972 disco hit 'Soul Makossa' (a lift that Jackson would ultimately settle with Dibango after the latter sued) as a celebratory conclusion.

If the song's imagery was all over the place – Jackson had reportedly written it for his sister La Toya, who had a contentious relationship with her then husband's family – the sentiment kept bringing it back to music. It signals that Jackson himself is starting something on *Thriller*, aiming to establish himself as the centre of pop music and eclipse race as a distinguishing factor. Sometimes he did it with blunt intent, such as the soulful ballad with Paul McCartney, 'The Girl Is Mine', where the former Jackson 5 and Beatles members don't so much argue as agree to disagree.

'Beat It' was incisive; one of several tracks that demonstrated how far Jackson had moved past his previous album, 1979's excellent funk experience *Off the Wall*. The opening rhythm, which became a template for modern

TRACKLISTING

01 **Wanna Be Startin' Somethin'**
02 **Baby Be Mine**
03 **The Girl Is Mine**
04 **Thriller**
05 **Beat It**
06 **Billie Jean**
07 **Human Nature**
08 **P.Y.T. (Pretty Young Thing)**
09 **The Lady in My Life**

R&B, is sparked by a guitar line that's nearly as threatening as the lyric. 'They're out to get you, better leave while you can,' sings Jackson, dispensing with his boyish falsetto, and it's offset by a shredding guitar solo from Eddie Van Halen that pushes the song into tormented pleasure.

Jackson's life could still be clearly identified in his music, and it made for pop songs, at once joyous in their openness and tortured in how they hold secrets close to the surface of scrutiny. That notion reached its apotheosis in 'Billie Jean', a defiant response by Jackson to being named in a paternity suit. The song is emphatic – 'the kid is not my son,' Jackson repeatedly declares – but it can't help creating an environment where Jackson is so compelling that he could bend anyone to his will. There are flashes of paranoia but, as on much of *Thriller*, it humanises Jackson; whereas on subsequent albums he would disappear into a carefully designed illusion.

The title track, 'Thriller', gave disco a dose of Hammer Horror melodrama and the song's obvious delight proves transformative, while 'Human Nature' keeps Jackson's populism on an intimate scale. The record took approximately seven months to make from start to finish, and it's as focused and expressive as subsequent Michael Jackson albums would be stultifying and ornate. Michael Jackson never again got everything right like he did on *Thriller*. On these songs he really was the king of pop.

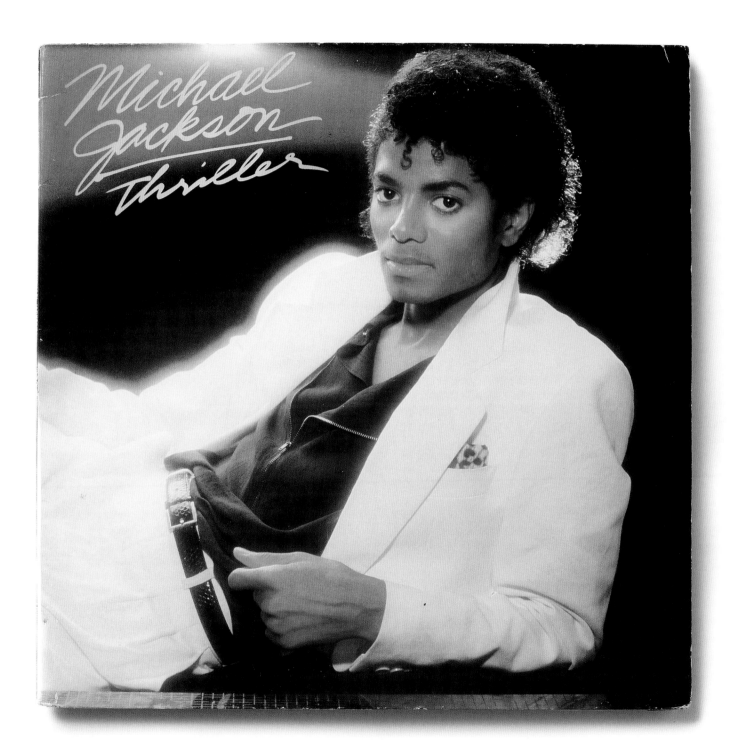

N°: 28

NEIL YOUNG
ON THE BEACH

Reprise
Produced by Neil Young, David Briggs and Mark Harman
Released: July 1974

On the Beach is the title of a Gregory Peck film about the few people left alive in Melbourne, Australia after nuclear war has destroyed the northern hemisphere. In the film they get a signal from San Diego suggesting that someone in California survived Armageddon. On the cover of the album *On the Beach*, Neil Young stands beside his boots in front of a Cadillac buried in the sand. He is staring out at the Pacific. He could just be that survivor.

In 1972 *Harvest* made Neil Young a superstar. '*Harvest* was probably the finest record that I've made,' he said. 'But that's really a restricting adjective for me.' He reacted, saying he left the mainstream and 'headed for the ditch'. Young made three albums – *Time Fades Away*, *On the Beach* and *Tonight's the Night*, which are commonly referred to as 'the ditch trilogy' because they were mostly bleak albums that were recorded roughly, almost haphazardly, and the songs were the antithesis of his monster *Harvest* hits 'Heart of Gold' and 'Old Man'.

On the Beach was not enthusiastically received on its release in 1974. The drugs then circulating in Young's world – heroin and cocaine – were taking their toll. The Watergate scandal was ripping apart the American dream. The fans wanted escape or consolation, not a downer.

The album opens happily enough with the jaunty track 'Walk On', a reply to Lynyrd Skynyrd's 'Sweet Home Alabama', which itself was a reply to Young's 'Southern Man'. 'Walk On' is also a statement of Young's credo – to keep moving. 'See the Sky About to Rain' is a country lament that predates *Harvest*, but its mood of impending doom fits better here. 'Revolution Blues' is a song about the Sharon Tate killings sung from Charles Manson's point of view. 'I knew Charlie Manson,' Young told the *Guardian*. 'I was meeting them and he was not a happy guy ... It was the ugly side of the Maharishi. You know, there's one side of the light, nice flowers and white robes and everything, and then there's something that looks a lot like it but just isn't it at all.' 'Revolution Blues' features one of Young's best, most colourful verses, both witty and spine chilling: 'I got the revolution blues/ I see bloody fountains/And ten million dune buggies/Comin' down the mountains/ Well, I hear that Laurel Canyon/Is full of

TRACKLISTING

01 **Walk On**
02 **See the Sky About to Rain**
03 **Revolution Blues**
04 **For the Turnstiles**
05 **Vampire Blues**
06 **On the Beach**
07 **Motion Pictures**
08 **Ambulance Blues**

famous stars/But I hate them worse than lepers/And I'll kill them/In their cars'. Crosby, Stills and Nash didn't see the humour and refused to perform the song on the CSN&Y tour in '74.

The title cut moves at an almost somnolent pace lit by flashes of light from Young's guitar. It's a song about feeling hollow, going through the motions of the music business and the incessant progress of time ending with Young's usual solution: 'I head for the sticks/With my bus and friends/I follow the road/Though I don't know/Where it ends'.

The melody of 'Ambulance Blues' comes from Bert Jansch's 'Do You Hear Me Now?'. The story begins in the Riverboat folk club, where Young started out. From there he meanders past the hippies burned out on their dreams, superstars going through the motions in arenas. John Paul Getty Jr's kidnapping by Italian revolutionaries cutting off his ear is covered in 'the entertainment section' – a remarkably prescient observation considering the way that news has now converged with pop culture. Finally there's the image of Nixon ('I never knew a man/Could tell so many lies') who would appear in many of Young's best songs. The song returns to Toronto with Young playing with Crosby, Stills, Nash and Young, suggesting his old friends are 'pissin' in the wind'.

'Everybody said that *Harvest* was a trip,' Young said in 1974. 'But that was only me for a couple of months. I'm just not that way anymore.'

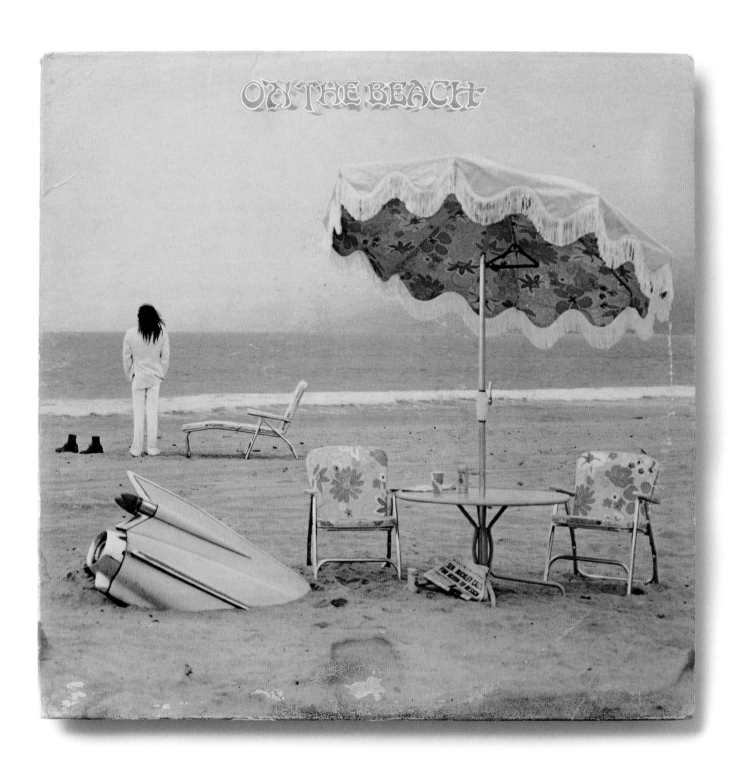

N°:29

JAY-Z
THE BLUEPRINT

Roc-a-Fella
Produced by Kanye West, Just Blaze, Bink, Timbaland, Eminem, Poke and Tone
Released: September 2001

Prior to releasing *The Blueprint* – on 11 September 2001 no less – Jay-Z was considered one of hip-hop's leading MCs. The man himself thought he was close to the summit set by his late friend, The Notorious B.I.G., rapping on 'Hola' Hovito', 'If I ain't better than Big, I'm the closest one'. But once these 13 tracks had sunk in, revealing their lyrical dexterity and soulful arrangements, the debate was effectively over. *The Blueprint* took the rapper born Shawn Corey Carter to a new level: it was Jay-Z's world and everyone else was just living in it.

Jay-Z had cut an album a year since his dramatic 1996 debut, *Reasonable Doubt*, but increasingly there was a belief that he would never match its street tales and pulp memoir. At the same time he was awaiting trial on two separate criminal charges (gun possession and assault). But it all proved to be inspiration as opposed to an impediment. The extensive lyrics were reportedly written in all of two days, and the MC met criticism head on before transcending it. On 'Takeover' he turns on Mobb Deep's Prodigy and, in particular, Nas, dropping a bunker-busting diss track on the two rappers that still stings.

But even as Jay breaks down Nas' musical output as 'one hot album every ten year average', producer Kanye West is manipulating The Doors' 'Five to One' so that the bass is confrontational and the melody hallucinatory.

The Blueprint was crucial in returning the art of sampling to the forefront of hip-hop, with young producers such as West – who, a decade later, would be Jay-Z's partner in the spotlight – and Just Blaze returning soul classics from the 1960s and 1970s (the music Shawn Carter grew up listening to in Brooklyn), to the radio. The record sounds inclusive, sturdy, free of quick fixes.

That's Bobby 'Blue' Bland's 'Ain't No Love in the Heart of the City' that's repurposed by Kanye West for 'Heart of the City (Ain't No Love)', and on the song the mood is defiant

TRACKLISTING

01 **The Ruler's Back**
02 **Takeover**
03 **Izzo (H.O.V.A.)**
04 **Girls, Girls, Girls**
05 **Jigga That Nigga**
06 **U Don't Know**
07 **Hola' Hovito**
08 **Heart of the City (Ain't No Love)**
09 **Never Change**
10 **Song Cry**
11 **All I Need**
12 **Renegade**
13 **Blueprint (Momma Loves Me)**

but self-aware. *The Blueprint* is a turning point in Jay-Z's evolution, moving from the exultant autobiographical swagger of his early hits towards a more nuanced outlook. The boasting of 'Never Change', set to a sweet melody that could score a slow dance at the end of the night, matches a sad wariness to the hustler's lifestyle. 'You are now looking at a 40 million boy,' Jay declares on 'U Don't Know', and it's clear that's just the start.

When he's faced with the age-old topic of appreciating women, the rapper turns it into a tour-de-force on 'Girls, Girls, Girls', traversing NYC as he accumulates a United Nation's worth of companionship. 'I got this model chick that don't cook or clean/But she dress her ass off and her walk is mean,' observes Jay, before later noting, 'Got a chick from Peru, that sniff Peru/She got a cousin at customs that get shit through'. The song is funny, but also telling – the insights are sharp – and line by line it's a perfect example of the rapper's magisterial flow, working on and off the beat so that the story has punctuation for every move.

The only guest brought in is Eminem, and the result is 'Renegade', where a deftly expressive bass part and spectral flourishes turn into a song where the two stars break down their own histories. It's caustic about the media, but like so much of *The Blueprint* it also looks past the initial target and finds that it all leads back home. This is an album where it's easy to sing along, but the meaning runs deep and true.

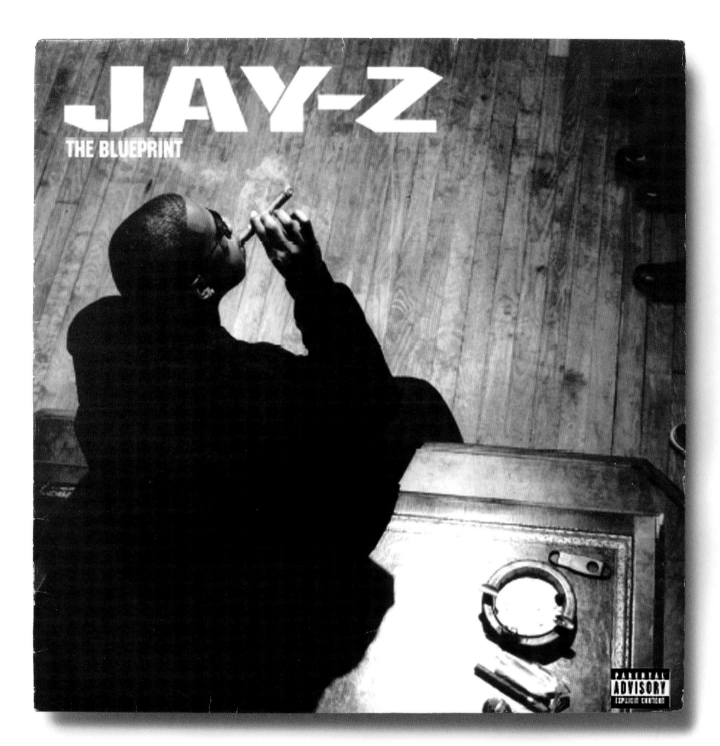

N°:30

BLUE LINES
MASSIVE ATTACK

Virgin
Produced by Massive Attack, Cameron McVey and Jonny Dollar
Released: April 1991

Who would have thought Bristol would be the place to be? For a time in the late 1980s, this unattractive west-coast English port changed music. Most of the action came from the Wild Bunch – a loose collective of musicians and DJs who adapted the Jamaican tradition of sound systems to British clubs. It became a logical move from playing in clubs to remixing and producing their own records. The Wild Bunch included Neneh Cherry, Soul II Soul's Jazzy B, Tricky and what would become Portishead. Horace Andy described the Bristol sound as the 'new world music' and this was in large part due to the diversity – English, West Indian and American musicians whose backgrounds were in hip-hop, reggae, rap, soul and pop music – all collaborating together. It was soul music but not as we had known it.

'When we were the Wild Bunch,' explained Grant 'Daddy G' Marshall, 'we got our reputation as a sound system from the fact that we played all kinds of music – punk, funk, reggae. For us to try and make an album that's all one sound just wouldn't be natural.'

Daddy G, Robert '3D' Del Naja and Andy Vowles, aka Mushroom, appeared in 1991 as Massive Attack with the game-changing album *Blue Lines*. They were ably assisted by Cherry, Tricky and the vocalists Shara Nelson and Horace Andy (already a well-known reggae singer-songwriter). *Blue Lines* is generally acknowledged to be the first trip-hop album (a term that didn't appear for some years) but in fact it's such a bold musical statement that it defies easy classification. 'I was still DJing,' said Daddy G, 'but what we were trying to do was create dance music for the head, rather than the feet'.

John McCready wrote in *The Face*, 'Massive Attack are Pink Floyd with bigger bass sounds and better drum patterns. Sometimes they are that trippy, and most of the time they are that good. A spaced out mix of dub tactics, ambient effects and downright surreal rap.'

Unlike the club music that had come before, *Blue Lines* was down-tempo with heavy dub grooves that really moved forward but at a languid pace. The lyrics were thoughtful.

TRACKLISTING

01 **Safe from Harm**
02 **One Love**
03 **Blue Lines**
04 **Be Thankful for What You've Got**
05 **Five Man Army**
06 **Unfinished Sympathy**
07 **Daydreaming**
08 **Lately**
09 **Hymn of the Big Wheel**

Some rapped at a whisper against the big gospel sound that Nelson brought to the party. This was music that transcended nightclubs and genres while at the same time promoting a pan globalism. 'Hymn to the Big Wheel' for instance, with its hip-hop didgeridoo in the mix, delivers the message of environmental awareness and Buddhist positivism but never sounds false or preachy. The opening track, 'Safe from Harm', with its anti-violence message delivered with a dose of Billy Cobham's jazz drumming, was released at the height of the first Gulf War and spelt out Massive Attack's commitment to do more than make good time music.

Blue Lines' key track is 'Unfinished Sympathy' where the insistent beat is moved along by sampled percussion and the percussive effect of a distant vocal chiming 'hey hey hey' grooving against a massed string section and Shara Nelson bringing her best soul diva voice. This was an influential, landmark song influencing many subsequent British artists, and even the video clip, a single shot of Nelson walking along the street, has become a legend – the Verve's 'Bitter Sweet Symphony', in particular, pays respect to both the song and the video.

Massive Attack would never release an album this strong again. But in its wake came legions of drum 'n' bass and trip-hop and countless other permutations of soul music. Massive Attack had opened the door and club music left the disco.

massive attack

blue lines

YOKO ONO ON *THE BEATLES* (THE WHITE ALBUM)

I thought The White Album was very hip … I know that, initially, critics were not so kind to The White Album since it came just after Sgt. Pepper – the big bang. A lot of them made little niggling remarks that did not add up to anything. 'Why a double?' was one. I totally agreed with Paul when he said that a double was fine. In fact, the fact that it was not a carefully edited single album was great. Not contrived. It was an album of strings of songs seemingly strung in that order for almost no reason. It was hodge-podge in a grand way, showing the state of mind that they were in then. I liked that.

LENNY KRAVITZ ON *JOHN LENNON/PLASTIC ONO BAND*

It's a monumental work of genius. I was blown away by how minimal it was, and how expressive it was. Lennon had just finished doing primal-scream therapy, and he was just unloading all this stuff, about his mother leaving him, about the Beatles and about who he was … On *Plastic Ono Band*, he stripped it down musically: He went into a studio with just a guitar, a bass, a piano and drums, and he made a raw record. The attitude and emotion of that album are harder than any punk rock I've ever heard. And the honesty of that music is why I became an enormous fan of his solo work, maybe even more than what he did with the Beatles. It inspired me and made me want to go deeper with my own song writing.

NOEL GALLAGHER ON *THE BEATLES* (THE WHITE ALBUM)

I remember listening to The White Album and thinking, 'What the fuck is this all about?'. It was like opening a treasure chest.

BRIAN ENO ON *ACHTUNG BABY*

Buzzwords on this record were trashy, throwaway, dark, sexy, and industrial [all good] and earnest, polite, sweet, righteous, rockist and linear [all bad]. It was good if a song took you on a journey or made you think your hi-fi was broken, bad if it reminded you of recording studios or U2. Sly Stone, T.Rex, Scott Walker, My Bloody Valentine, KMFDM, the Young Gods, Alan Vega, Al Green and Insekt were all in favour. And Berlin itself, where much of the early recording was done (nostalgically for me – we were in the same room where Bowie's *Heroes* was made) became a conceptual backdrop for the record. The Berlin of the Thirties – decadent, sensual and dark – resonating against the Berlin of the Nineties – reborn, chaotic and optimistic – suggested an image of culture at a crossroads. In the same way, the record came to be seen as a place where incongruous strands would be allowed to weave together and where a probably dis-unified (but definitely European) picture would be allowed to emerge.

KURT COBAIN ON THE PIXIES

I was trying to write the ultimate pop song [when writing 'Smells Like Teen Spirit']. I was basically trying to rip off the Pixies. I have to admit it [smiles]. When I heard the Pixies for the first time, I connected with that band so heavily I should have been in that band – or at least in a Pixies cover band. We used their sense of dynamics, being soft and quiet and then loud and hard.

AMY WINEHOUSE ON MICHAEL JACKSON

I could never decide whether I wanted to be Michael Jackson or marry him. He's a fucking genius.

NOEL GALLAGHER ON *NEVER MIND THE BOLLOCKS, HERE'S THE SEX PISTOLS*

To me, the Sex Pistols were up there with the Beatles because they were never shit, and none of us would be sat here now if it weren't for the Pistols. When people compile the greatest albums of all time I can never understand why *Never Mind The Bollocks...* isn't Number One because it changed everything ... My mum hated it and it had to be really good if she didn't like it. She even used to hide the record from me, so I had to buy it on tape and hide it in my pocket.

BILLIE JOE ARMSTRONG ON *NEVER MIND THE BOLLOCKS, HERE'S THE SEX PISTOLS*

The Sex Pistols released just one album but it punched a huge hole in everything that was bullshit about rock music, and everything that was going wrong with the world, too. No one else has had that kind of impact with one album. You can hear their influence everywhere from Joy Division to Guns n' Roses to Public Enemy to the Smiths to Slayer ... It's a myth that these guys couldn't play their instruments. Steve Jones is one of the best guitarists of all time, as far as I'm concerned – he taught me how a Gibson should sound. Paul Cook was an amazing drummer with a distinct sound, right up there with Keith Moon or Charlie Watts ... The difference between John Lydon and a lot of other punk singers is that they can only emulate what he was doing naturally. There was nothing about him that was contrived.

Billie Joe Armstrong (Green Day)

THOM YORKE (RADIOHEAD) ON THE PIXIES

The Pixies had changed my life.

ALICIA KEYS ON PRINCE

He's the only man that I've ever seen that lights the stage on fire, leaving you to burn within it in a frenzy of movement, lights, electric guitars, slide piano, dancing, voices, splits and songs. Oh my god. Songs so powerful that you are forever changed.

Nº:31

THE SMITHS
THE QUEEN IS DEAD

Rough Trade
Produced by Morrissey and Marr
Released: June 1986

No-one could keep up with the Smiths during their five furiously creative years together. At times even the Manchester quartet struggled to keep pace with their own output. *The Queen Is Dead*, their third album and undoubted masterpiece, was held up for more than six months as the group sparred with their often wayward independent label, Rough Trade, which had signed the group in 1983 and watched them swiftly establish themselves as the most important British group of the decade. When it finally appeared, the album proved to be an alchemical finality; every strand of the Smiths' ability was fully realised, every song tied together.

It began with the bedsit giving way to Buckingham Palace. A sample of the old music hall staple, 'Take Me Back to Dear Old Blighty', is overrun by a pummelling drum tattoo and a catalytic guitar part, with the title track matching vocalist Morrissey's whimsy to a deft condemnation of Britain's ruling bodies. The song is a sustained burst of fantastical imagery – at one point Morrissey asks Prince Charles if he's keen to wear his mother's bridal veil in the *Daily Mail* newspaper – and the scope of the words drew an equally inventive tune from guitarist Johnny Marr.

The idea that the Smiths were fey, already mocked by 1985's *Meat Is Murder* set, is rendered ludicrous by the fury of the track 'The Queen Is Dead' and the sophistication of what followed.

The Morrissey and Marr team, the core of the group (as subsequent lawsuits involving drummer Mike Joyce and bassist Andy Rourke would sadly make clear), never repeated themselves across the 10 tracks. The melancholic indie-pop and intuitive jangle of their early singles and self-titled debut is updated here by snarling guitar rock ('Bigmouth Strikes Again'), sparkling acoustic pop ('Cemetry Gates'), a pungently melodramatic ballad ('I Know It's Over'), and post-punk rockabilly ('Vicar in a Tutu'). No sound was beyond them.

As a lyricist Morrissey had never been funnier – all 139 seconds of the bouncy 'Frankly Mr. Shankly' mock Rough Trade's boss Geoff Travis in excruciating detail. But humour and

TRACKLISTING

01 **The Queen Is Dead**
02 **Frankly, Mr. Shankly**
03 **I Know It's Over**
04 **Never Had No One Ever**
05 **Cemetry Gates**
06 **Bigmouth Strikes Again**
07 **The Boy with the Thorn in His Side**
08 **Vicar in a Tutu**
09 **There Is a Light That Never Goes Out**
10 **Some Girls Are Bigger Than Others**

mordant truth are two sides of the same coin on this album. The despairing 'I Know It's Over' is a requiem for a hoped-for relationship that never truly existed, and even as it begins with Morrissey picturing his own burial, the sentiment proves to be stark and self-lacerating. 'With your triumphs and your charms/While they're in each other's arms,' he sings, and the song's defiance can't lessen the distress.

The hopeful 'There Is a Light That Never Goes Out' became a signature selection, with wretchedly comic tragedy in the form of accidental death by oversized vehicle (10-ton truck, double-decker bus – take your choice) seguing into an expansive melody that turns the song into a last hope for the emotionally wracked. Critics always wrote Morrissey off via clichés – the term 'miserablist' was popular – but his lyrics explored those very labels to their extreme, until they were turned inside out. Tragedy had a punchline; satire revealed unwelcome truths.

Little more than a year later, in the winter of 1987, and with the release of their frustratingly uneven final studio set, *Strangeways, Here We Come*, the Smiths fractured under self-imposed stresses. But they have remained a crucial presence and a touchstone for subsequent generations of young music fans. As with another Manchester four-piece, Joy Division, their music has transcended the ready-made image supplied by their devotees. *The Queen Is Dead* is an album of concise clarity: 37 minutes, 10 songs – a lifetime's worth of revelatory music.

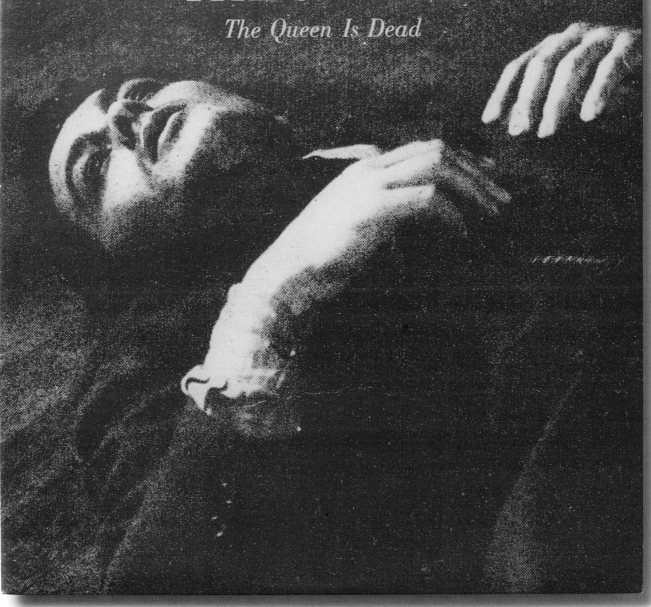

N°:32

CAROLE KING
TAPESTRY

Ode
Produced by Lou Adler
Released: February 1971

Carole King had been around for many years before *Tapestry*, her second solo album, became the most popular album of its era. With her then husband, Gerry Goffin, King had written some of the most extraordinary pop songs for Ben E King, Dusty Springfield, Little Eva, Dionne Warwick, the Byrds and the Monkees. Then Bob Dylan and the Beatles created the era of the singer-songwriter and Tin Pan Alley was closing. To stay in the game, Carole King needed to reinvent herself.

After her divorce from Goffin in 1968, King fell into a new crowd that included James Taylor and his guitarist pal Danny 'Kootch' Kortchmar. She moved to Laurel Canyon in Los Angeles where Joni Mitchell and all the other singer-songwriters congregated around bowls of organic brown rice. It was here that the cover of *Tapestry* was shot, depicting King as an empowered single woman and her cat.

Carole King's story – a woman who leaves the shadow of her husband and finds her voice and a new career – mirrored the social upheaval that feminism was just starting to create. In this context, the fact that she couldn't sing like Dusty Springfield added authenticity to the songs – a valuable commodity in that era of brown rice and organics.

King brought unparalleled experience to *Tapestry*. Most of the singer-songwriters of the time came from a folk music background. King's songs drew from the harmonic structure of jazz, Motown and soul. Songs like 'It's Too Late', 'I Feel the Earth Move' and 'You've Got a Friend' all start out in minor keys before changing into a major and then back again, taking the listener on an emotional journey. The band – guitarist Danny Kootch and bassist Charles Larkey with Russ Kunkel or alternatively Joel O'Brien on drums – formed a very tight unit. Producer Lou Adler had known King since 1961. *Tapestry* then was a selection of personal songs delivered by master craftspeople.

'What I think happened in late '70–'71 with James Taylor and Joni Mitchell and Carole, is that the listening public and the record-buying public bought into the honesty and

the vulnerability of the singer-songwriter,' said Adler. 'The emotions that they were laying out there allowed the people to be okay with theirs. And I think that along with the honesty of the records, there was a certain simplicity to the singer-songwriter's record because they either start with vocal-guitar or piano-voice.'

Songs like 'It's Too Late', 'You've Got A Friend' and 'I Feel the Earth Move' are pop romance songs for adults. A track like 'So Far Away' perfectly captured the restlessness of the era. King also included two of her biggest previously released songs. '(You Make Me Feel Like) A Natural Woman' was written by Goffin/King for Aretha Franklin and was a powerful song for African-Americans, but on *Tapestry* King reclaims it for the post-feminist women who faced the sharp end of their own struggle. King wrote 'Will You Love Me Tomorrow?' in 1960 at the age of 18. It allowed Gerry Goffin to quit his job as a chemist and was, in the hands of the Shirelles, their first #1 hit. At the time it was written this was every girl's teenage dilemma – losing your virginity could lose you a husband. King slows the song down and turns this gorgeously expressed teen problem into an existential dilemma.

'They're timeless love songs,' said Adler, explaining the massive success of *Tapestry*. 'Those emotions have not gone away because of any change in technology or space or any other reason. They're basic love songs, they're basic emotions. It's true-sounding instruments, and the emotions are still the emotions. She hit the chords.'

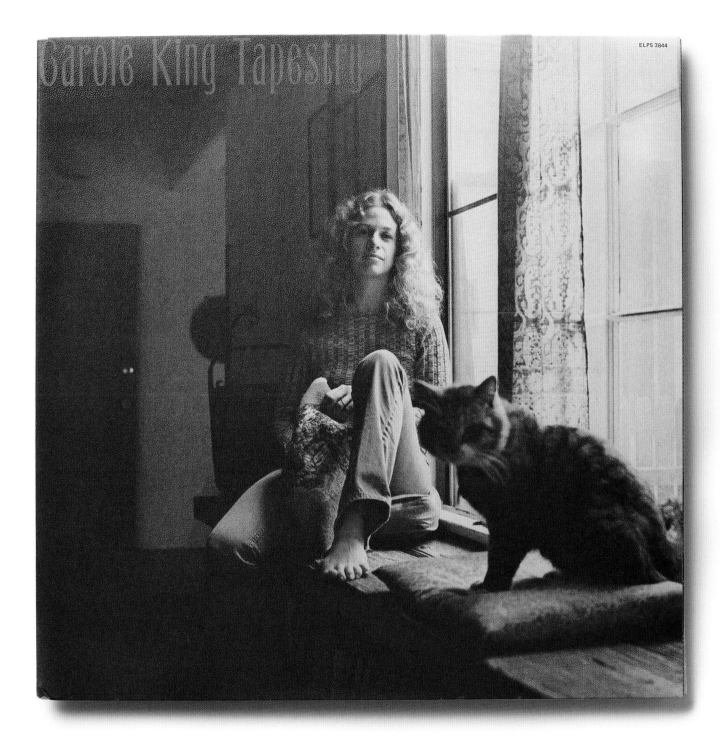

Carole King Tapestry

ELPS 3844

Nº 33

DAVID BOWIE
HUNKY DORY

RCA
Produced by Ken Scott and David Bowie
Released: December 1971

The Rise and Fall of Ziggy Stardust and the Spiders From Mars made David Bowie a superstar but, before that, Hunky Dory had made him an artist.

'Hunky Dory gave me a fabulous groundswell,' said Bowie. 'First, with the sense of "Wow, you can do anything!" You can borrow the luggage of the past, you can amalgamate it with things that you've conceived could be in the future and you can set it in the now. Then, the record provided me, for the first time in my life, with an actual audience – I mean, people actually coming up to me and saying, "Good album, good songs". That hadn't happened to me before.'

David Bowie, then 24, had already tried on a number of guises – a mod, a folk singer, a jazz buff. He'd made three albums and had one hit, 'Space Oddity'. He had just lost his father, his brother was in an asylum and he was about to become a father himself. Talk about changes. The song 'Changes' opens Hunky Dory with a manifesto that Bowie has carried ever since.

As the '60s closed, music was undergoing tectonic shifts and Bowie, as the song said, 'turned to face the strange'. 'I found that I couldn't easily adopt brand loyalty, or genre loyalty,' he said. 'I wasn't an R&B artist, I wasn't a folk artist, and I didn't see the point in trying to be that purist about it. What my true style was is that I loved the idea of putting Little Richard with Jacques Brel and the Velvet Underground backing them. What would that sound like? Nobody was doing that.'

Side one of Hunky Dory sees Bowie flexing his muscles as a songwriter. 'Life on Mars?' recalls the theme of Bowie's signature tune 'Space Oddity', but here it tells the story of a girl in suburbia hoping that there is life elsewhere because it sure isn't here. In between her musings Bowie describes the decadence of the West: 'It's on Amerika's tortured brow/That Mickey Mouse has grown up a cow/Now the workers have struck for fame/'Cause Lennon's on sale again'.

'Oh! You Pretty Things' was a nod to the British '60s beat group and was originally given to Peter Noone of Herman's Hermits. Here Bowie reclaims it. 'Kooks' was a letter welcoming the arrival of his newborn son and

TRACKLISTING

01 **Changes**
02 **Oh! You Pretty Things**
03 **Eight Line Poem**
04 **Life on Mars?**
05 **Kooks**
06 **Quicksand**
07 **Fill Your Heart**
08 **Andy Warhol**
09 **Song for Bob Dylan**
10 **Queen Bitch**
11 **The Bewlay Brothers**

Bowie's attempt to explain to the boy about his kooky parents. It's probably the happiest Bowie has ever been on record.

The second half of the album has the hero songs: 'Andy Warhol' ('He hated it,' said Bowie. 'Loathed it.'), 'Song for Bob Dylan' and 'Queen Bitch' (which were unabashed fan letters, the latter to Lou Reed), and 'The Bewlay Brothers' (written about his relationship with his first idol – his bipolar brother Terry).

Bowie turned to Ken Scott to co-produce, whose pedigree was having engineered much of the later Beatles work. The album was recorded in two weeks at Trident Studios in London, working from lunchtime to midnight. The backing was provided by the band – guitarist Mick Ronson, bassist Trevor Bolder and drummer Woody Woodmansey – who would soon become the Spiders from Mars. Session pianist Rick Wakeman was told to play 'as much as possible' on the piano that produced 'Hey Jude'.

His previous album cover had been banned in the US and for Hunky Dory he struck a pose based on a photo of Marlene Dietrich, which was no less challenging and a good deal more subversive. 'I was looking to create a profligate world that could have been inhabited by characters from Kurt Weill or John Rechy – that sort of atmosphere,' Bowie wrote. 'A bridge between Enid Blyton's Beckenham and the Velvet Underground's New York. Without Noddy, though.'

N°: 34

RAY CHARLES

MODERN SOUNDS IN COUNTRY AND WESTERN MUSIC

ABC-Paramount
Produced by Ray Charles and Sid Feller
Released: April 1962

At the height of his fame as an R&B artist, Ray Charles announced that he was going to make a country music album. The executives at ABC-Paramount told him that the people who liked country music didn't want to hear it sung by a black man and the people who liked his music didn't like country.

In the 1950s Charles' hits like 'I Got a Woman?' synthesised blues and gospel into soul music. By the end of that decade he was one of the biggest stars in the US. Frank Sinatra called him 'the Genius'. But he had negotiated complete artistic control in his deal with Paramount (the first black artist to do so) and he could make whatever the hell record he liked.

According to sideman Marcus Belgrave, 'Sid Feller told him, "You shouldn't be doing this," and Ray said, "this is the music that I love, I'm definitely going to be doing this".' While Elvis Presley was a little bit country and a little bit rock & roll, Charles brought soul to the whole Nashville experience, complete with massed strings and voices. Eddy Arnold's 'You Don't Know Me' took on a whole different nuance in the context of a racially charged America. 'He used to give me the idea for an album – say country music and I'd dig up 40–50 songs in that category,' said Feller. 'Ray would select the songs he thought he could contribute something to, from those songs. It was mostly the lyrics that sold him ... the story.' The songs

on *Modern Sounds* tended towards the same themes as the blues – love gone wrong. As Charles himself said, 'The words to country songs are very earthy like the blues, very down. Country songs and the blues is like it is.'

On *Modern Sounds* the material ranged from the honky tonk style of Hank Williams' 'Careless Love' and 'Hey, Good Lookin', to the pop/rockabilly of the Everly Brothers' 'Bye Bye Love'. Recording took only two sessions, the first from 5–7 February and a week later on the 15th in New York.

TRACKLISTING

01 **Bye Bye Love**
02 **You Don't Know Me**
03 **Half as Much**
04 **I Love You So Much It Hurts**
05 **Just a Little Lovin'**
 (Will Go a Long Way)
06 **Born to Lose**
07 **Worried Mind**
08 **It Makes No Difference Now**
09 **You Win Again**
10 **Careless Love**
11 **I Can't Stop Loving You**
12 **Hey, Good Lookin'**

The centrepiece of the album and its biggest hit was Don Gibson's countrypolitan 'I Can't Stop Loving You', which had been recorded by Kitty Wells. Charles threw everything at it with a massive orchestration, the almost church-like swelling vocals from the Raelettes in the chorus and Charles' own inimitable phrasing. The song went to #1 across the country and propelled the album up the charts. One distributor was quoted as saying, 'the record is so hot that people who don't even own record players are buying it'.

The social and political implications of a record crossing racial barriers are obvious. But the key to the album was in the title (from Sid Feller) – 'Modern Sounds'. Charles took all of these songs and changed them substantially to make them his own. He broadened the emotional strictness of many and swung the tempos. After this album both country and R&B artists began to expand their palettes and the sound of music itself changed.

Ray Charles used to say that country and blues aren't just cousins – they're blood brothers. 'Like I've always said, man, all my life I've always liked different kinds of music,' said Charles. 'If you're a sportsman you like baseball, you like a little football, you might even care for golf ... know what I mean? I'm a musician, man. I can play Beethoven, I can play Rachmaninov, I can play Chopin. Every now and then I play these things and I shock the hell out of people.'

Nº:35

PAUL SIMON
GRACELAND

Warner Bros
Produced by Paul Simon
Released: August 1986

'Graceland', the title track of Paul Simon's masterpiece, is the tale of three journeys. First, it's a trip that Simon and his son Harper took to Elvis Presley's mansion in Memphis, Tennessee after the break-up of his marriage to actress Carrie Fisher. The tune is roughly in a South African genre known as 'township jive' and it marks the journey that Simon made to Johannesberg to play with African musicians. That South African trip then propelled Simon on a journey of rediscovery into music.

In 1985 Simon was given a tape that included the Boyoyo Boys' instrumental 'Gumboota', which piqued his interest in African music. ('Gumboots' on *Graceland* became a version of that song.)

At the time Simon was in the doldrums. His last album was a commercial and artistic flop. Like many of his contemporaries, he was a middle-aged guy in a young man's game and he struggled to find a way to write rock & roll songs for grown-ups.

'Musicians have tried to stay adolescent and naturally this has made them look ridiculous,' Simon said. 'You don't get this obsession with age in blues or jazz, or any other art form. You don't lose your rage as you grow older; it can deepen. Or you can acquire peace of mind – either way, let's hear what's on people's minds, but

let's not have everybody speak as if they were children.'

In South Africa Simon met a bunch of inspiring, untainted musicians, including Joseph Shabalala and his group Ladysmith Black Mambazo. 'I became bewitched by Ladysmith Black Mambazo because they were so beautiful [sounding],' Simon recalled. 'They were so good at what they did. I was totally intimidated.' Simon wrote 'Homeless' in the Ladysmith style and flew them all to London where the track was recorded. They also contributed to the coda of 'Diamonds on the Soles of Her Shoes'.

TRACKLISTING

01 **The Boy in the Bubble**

02 **Graceland**

03 **I Know What I Know**

04 **Gumboots**

05 **Diamonds on the Soles of Her Shoes**

06 **You Can Call Me Al**

07 **Under African Skies**

08 **Homeless**

09 **Crazy Love, Vol. II**

10 **That Was Your Mother**

11 **All Around the World or the Myth of Fingerprints**

'The Boy in the Bubble' opens the album with a Sotha feel (Sotha being one of the genres popular in South Africa). It's a laundry list of miracles and wonders as Simon looks at the modern world of organ transplants and high speed communication and satellites. Rather than the bleak, alienated world of 'The Sounds of Silence', this is a world of noise, full of vanities and buffoons, but one of beauty.

Simon's lyrical gifts came back to him strongly on this album. He has said 'Graceland' was the best song he has ever written and it would be hard to disagree. Lines like 'Losing love is like a window in your heart' is a devastating summation of the end of an affair. The song struggles with big issues – fatherhood, love and the ineffable – and finds solace and grace in there somewhere. Another song about his marriage, 'You Can Call Me Al', is a more humorous, if oblique, look at the same issues – the desperate search for love and the confusion that we feel trying to understand our place in the universe. 'Al', with its surreal imagery, also reflects his African experience – the imagery of the township songs and his own feeling of dislocation at being in an alien land.

On returning to the US Simon looked at his own roots, hooking up with Latino rockers Los Lobos for 'All Around the World or the Myth of Fingerprints' and also the Everly Brothers. Simon went on the trip to Graceland as a man who had nothing to lose and on the way he found it all.

N°:36

IGGY AND THE STOOGES
RAW POWER

Columbia
Produced by Iggy Pop and David Bowie
Released: February 1973

Writer Clinton Walker noted that the common factor among the first wave of punk rock bands was that they shared 'the secret knowledge of the Stooges'. However, in 1972 no-one much cared for them. Two albums of the most elemental rock & roll ever made (*The Stooges* and *Fun House*) had zero commercial success. The band had broken up. Pretty much their only fan was David Bowie. Iggy Pop was part of the inspiration for the character Ziggy Stardust and Bowie returned the favour. 'I had no money, no prospects,' guitarist James Williamson recalled. 'Then Iggy calls and says David Bowie wants him to come to London. Iggy brought me over, and then we brought the Ashetons over, and so now it's the Stooges, who nobody in their right minds would want as pop stars. Then Bowie got big and they forgot about us. We were left with no adult supervision.'

Between 10 September and 6 October 1972 the Stooges let fly in a London studio. Few bands in the history of music had been as misanthropic as the Stooges – working class kids who, when together, channelled decades of bad drugs, bad homes and evil into transcendentally beautiful, brutal art. Williamson had joined the band and relegated Ron Asheton to bass, further deteriorating the mood. Iggy Pop, who had no idea how to use a studio, was the producer. 'We didn't really understand multi-tracking or any of those concepts,' said Pop.

Nonetheless the songs were magnificent. The opening line on the album is genius: 'I'm a street walking cheetah with a heart full of napalm'. Only Iggy Pop could deliver the line and only James Williamson could back it up. His power chords established a massive wall of sound and then his riffs cut through it like a hot knife through butter. Smiths' guitarist Johnny Marr describes Iggy as 'both demonic and intellectual, almost how you would imagine Darth Vader to sound if he was in a band'. 'Search and Destroy' is the most violent and magnificent rock & roll. As the guitar rips through to a climax and Iggy sings 'I am the world's forgotten boy' it doesn't get any more rock & roll than that. 'The drugs we were taking heightened what was already a sense of acute disrespect for the music industry and the phony shitty music it was churning out at the time,' said Iggy.

Iggy's songwriting was on a roll. You can tell from the titles – 'Gimme Danger', 'Your Pretty Face Is Going to Hell', 'Raw Power', 'Death Trip' – that these are not campfire songs, they're Molotov cocktails. In 1972 when the talk was all about James Taylor, this wasn't the prevailing taste. 'Gimme Danger' featured some nice acoustic guitar but the mood was malevolent and alienated. 'Shake Appeal' has some nice riffing but it is delivered at breakneck speed and Iggy's vocal sounds more than half crazed.

When once asked to describe the sound of the Stooges, Iggy Pop smashed a glass. Lots of groups can make a big, ugly noise but the Stooges never sounded like that. They captured the emotions of fear and nihilism and expressed them convincingly.

Iggy Pop delivered the album and Columbia records declined to release it. Bowie stepped in and remixed the record in one day. 'David was interested in the primitive aspect of the Stooges,' said Iggy. 'I think to him we were a bunch of Neanderthals. I see his point.'

Raw Power was the right record at the wrong time and Iggy was soon the forgotten boy at least until the Ramones and the Sex Pistols brought the sound of the Stooges roaring back.

TRACKLISTING

01 **Search and Destroy**

02 **Gimme Danger**

03 **Your Pretty Face Is Going to Hell** (originally titled 'Hard to Beat')

04 **Penetration**

05 **Raw Power**

06 **I Need Somebody**

07 **Shake Appeal**

08 **Death Trip**

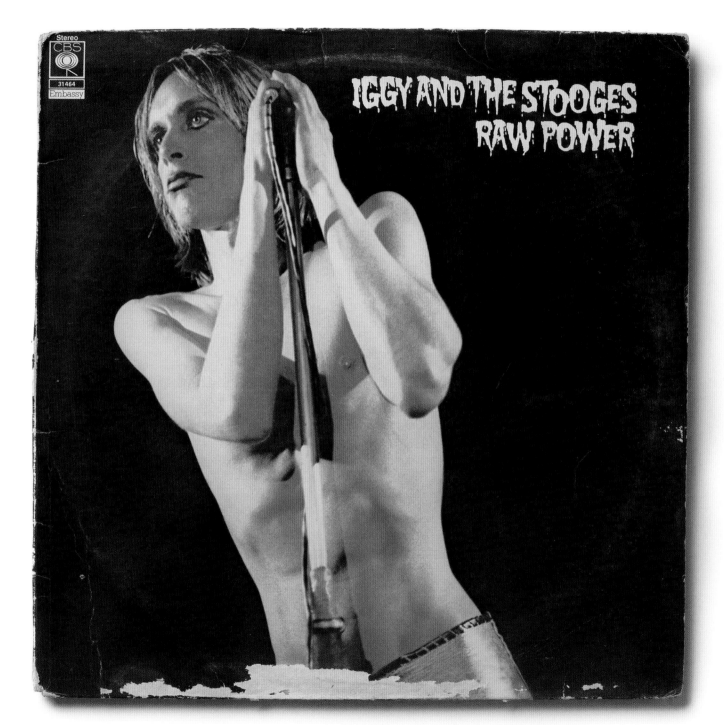

N°:37

THE JIMI HENDRIX EXPERIENCE

ARE YOU EXPERIENCED

Track
Produced by Chas Chandler
Released: May 1967

According to the liner notes to the US edition of this LP, 'Jimi Hendrix breaks the world into interesting fragments. Then reassembles it. You hear with new ears ...' Jimi Hendrix was a left-handed guitar player who arrived in London via Seattle, the US Air Force, Little Richard's band and the folk scene in Greenwich Village. Being a southpaw he played his guitar upside down. And as Pete Townshend of the Who noted, 'He changed the whole sound of the electric guitar and turned the rock world upside down.' There were plenty of virtuoso guitarists around but Jimi Hendrix reimagined the electric guitar as a whole new instrument. As Brian Jones of the Rolling Stones observed at one of Hendrix's early club dates, the front rows were wet with 'the tears of all the other guitar players' watching in awe.

The Jimi Hendrix Experience was a hastily assembled trio of Jimi and two Englishmen – drummer Mitch Mitchell and bassist Noel Redding. Almost from the moment Hendrix arrived in London in mid-1966 he was playing shows and winning converts. Pete Townshend and managers Chris Stamp and Kit Lambert were under his spell and he was soon signed to their label, Track. With Chandler as producer, the Experience knocked out three hit singles – 'Hey Joe', 'Purple Haze' and 'The Wind Cries Mary' – and *Are You Experienced* in less than five months. 'A lot of the early stuff was done in two or three takes,' recalled Mitch Mitchell. 'Chas Chandler never let us

forget that "House Of The Rising Sun" was made for £4 and sold ultra million copies!'

Recorded in a four-track studio in London, *Are You Experienced* is the most conventional of Hendrix's albums. He described it as 'a collection of free feeling and imagination'. There are some straightforward pop songs such as 'May This Be Love' and 'Remember', but even here Hendrix won't be tied down. He shades even a simple pop song with splashes of colour. Hendrix has the aim of drummer Mitch Mitchell who swings with a jazzy abandon but hits hard. Noel Redding keeps the bass interesting and his fluid playing nicely supports Hendrix's flights of fancy.

TRACKLISTING

01 **Foxy Lady**
02 **Manic Depression**
03 **Red House**
04 **Can You See Me**
05 **Love or Confusion**
06 **I Don't Live Today**
07 **May This Be Love**
08 **Fire**
09 **Third Stone from the Sun**
10 **Remember**
11 **Are You Experienced?**

Are You Experienced is both a challenge to the listener and a template for Hendrix's explorations. The imagery in his lyrics touches on the pastoral esoterica of the flower power years but there are plenty of references to transcending space and time, which is in effect what Hendrix was trying to achieve with his guitar. The touchstones of straight blues: 'Red House' and soul: 'Fire' show where Hendrix was coming from, but in each of these cases he takes the music somewhere completely new. 'Third Stone from the Sun' starts out as a conventional space jazz track. Over the rolling modal foundation Hendrix drifts off into a storm of elegant, majestic feedback. 'Manic Depression' picks up on the driving rifferama of the Yardbirds and takes that back to Chicago's Hubert Sumlin and rocks it into orbit.

The album closes with the title track all drenched in feedback and backwards guitar, relentless piano and Hendrix's seductive vocal asking the question 'have you ever been experienced?'. In one sense it's a typically soul revue play, but in the context of 1966 and the youth revolution and also the revolutionary sound coming out of Hendrix's Fender, this is a whole new demarcation line in the culture war. In May '67, Hendrix crossed a line and the world followed.

'He made the electric guitar beautiful. It had always been dangerous, it had always been able to evoke anger,' Pete Townshend wrote. 'Jimi made it beautiful.'

Nº:38

ARETHA FRANKLIN
LADY SOUL

Atlantic
Produced by Jerry Wexler
Released: January 1968

*L*ady Soul was Aretha Franklin's third album with Atlantic, who had signed the prodigiously talented vocalist after she parted ways with Columbia – a label that had identified her talent but didn't know quite what to do with it. Atlantic's Jerry Wexler did. 'We're going to put her back in church,' he announced, and the move paid off on 1967's double bill of *I Never Loved a Man the Way I Love You* and *Aretha Arrives*. Those two albums, especially the former, made it clear that the gospel-fuelled depths of Franklin's voice were bound for the pop charts, and on *Lady Soul* the then 25-year-old announced herself as the Queen of Soul.

Put simply, Aretha Franklin does things with her voice on this album that changed the very perceptions of pop music, finding a union between passion and technique that still sounds transcendent. Listen to 'Good to Me as I Am to You', where the singer launches herself off the cushion of the slow, defiant groove and makes her demand for satisfaction sound like an unholy alliance of pleasure and need (with the assistance of Eric Clapton on guitar). Franklin is near the top of her register for much of the track, but then at the close she lets out two staggering whoops, at once celebratory and a reminder that she could go further if she wanted.

The songs on *Lady Soul* are a collection of original pieces, commissioned compositions and covers, but whether the writers were James Brown ('Money Won't Change You') or Ray Charles ('Come Back Baby'), or Franklin and her husband/manager Ted White ('(Sweet, Sweet Baby) Since You've Been Gone'), with whom she shared a fractious union, the recordings were held in sway by Franklin's voice, which could roll with earthy delight or soar with emotional testimony. As if it needed it, the record had inspired backing vocalists, whether it was Franklin's sisters or the Sweet Inspirations, who transferred their collective strength to the principal.

1968 would be a tumultuous year, and while Franklin turned Curtis Mayfield's 'People Get Ready' into a pulpit-raising promise, on much of *Lady Soul* the personal would be political. Franklin had already had a hit the year prior

TRACKLISTING

01 **Chain of Fools**
02 **Money Won't Change You**
03 **People Get Ready**
04 **Niki Hoeky**
05 **(You Make Me Feel Like) A Natural Woman**
06 **(Sweet, Sweet Baby) Since You've Been Gone**
07 **Good to Me as I Am to You**
08 **Come Back Baby**
09 **Groovin'**
10 **Ain't No Way**

with her electrifying remake of Otis Redding's 'Respect', but here she searches for a balance between personal deliverance and shared love. The friction between the two is a source of much of the energy on the album. 'Ain't no way for me to love you/If you won't let me,' begins the closing track. But instead of surrendering, the lament becomes a final plea that grows steadily more arresting.

Wexler had some of his favourite – and the South's best – musicians play on these tracks, and their contributions are important. The American Sound Studios house band rhythm section of bassist Tommy Cogbill and drummer Gene Chrisman supply most of the bottom end. They're on the beat from the opening 'Chain of Fools', where Franklin castigates a former lover and, subtly, herself, for what has transpired. Elsewhere Atlantic house producer and arranger Arif Mardin supplies a scintillating horn part for 'Come Back Baby', which matches the fiery blues to the first stirrings of psychedelic pop.

But the focus is always Aretha Franklin, and it's clear why with cuts such as '(You Make Me Feel Like) A Natural Woman', a song penned by Gerry Goffin and Carole King, which summed up the great but never complete divide in black music between the spiritual and the physical. The way Franklin sings the ballad, the two halves are brought together as one. 'Oh baby, what you've done to me' asks Aretha, and by the chorus she's making it clear that she already knows the answer.

ARETHA: LADY SOUL

Nº 39

RAMONES
RAMONES

Sire
Produced by Craig Leon
Released: 23 April 1976

'We did the album in a week and we only spent sixty-four hundred dollars making it. Everybody was amazed,' said singer Joey Ramone. 'Especially since it was an album that really changed the world. It kicked off punk rock and started the whole thing – as well as us.'

Fourteen songs in 29 minutes and 52 seconds was statement enough, especially at a time when the Allman Brothers had done one song that took two sides of an album. Prior to the Ramones every rock group started out learning blues and Chuck Berry. After the Ramones every group started out learning Ramones songs.

Everything about the record was perfect – the songs, the sound, the titles, the members' 'brother' names (the gang concept). And it was totally complemented by the simple, brilliant black and white cover shot – the ripped jeans, the motorcycle jackets, the Converse sneakers. It all started with this photograph.

The Ramones – four misfits from the 'burbs of New York – were not trying to tear rock & roll down. They loved it. It's just that the things they loved, such as glam rock, the Stooges, Phil Spector and the early British Invasion, were no longer being heard. The Ramones simply wanted to play the music they loved, but when they did it sounded quite unlike anything else. Having decided to write their own songs they also chose to write about what they knew – which was being a drug addict and a male

hustler, in the case of bass player Dee Dee Ramone, or being OCD and too tall and kinda strange, in the case of Joey. According to Johnny Ramone, 'We couldn't write about girls or cars, so we wrote about things we knew.' 'We play short songs and short sets for people who don't have a lot of spare time,' quipped drummer Tommy Ramone.

So the end result was a repertoire of songs that brought the sparkling innocence of the Ronettes

TRACKLISTING

01 **Blitzkrieg Bop**
02 **Beat on the Brat**
03 **Judy Is a Punk**
04 **I Wanna Be Your Boyfriend**
05 **Chain Saw**
06 **Now I Wanna Sniff Some Glue**
07 **I Don't Wanna Go Down to the Basement**
08 **Loudmouth**
09 **Havana Affair**
10 **Listen to My Heart**
11 **53rd & 3rd**
12 **Let's Dance**
13 **I Don't Wanna Walk Around with You**
14 **Today Your Love, Tomorrow the World**

to the mean streets of '70s Manhattan. It was a completely unique sensibility. Although they couldn't play their instruments they couldn't play them quite unlike anyone else. And they had Johnny Ramone who created a one-man wall of sound with his guitar. There was nothing subtle here but there was a majestic beauty in it. When told that people thought the songs sounded too much the same, Tommy replied, 'Well, they didn't listen close enough'.

Ramones starts off with a simple count '1-2-3-4' and then charges into 'Blitzkrieg Bop' and it's on. Songs about sniffing glue sit with songs about schlock horror films, cartoonists, kids with death wishes and the eternal quest for the pure love of a girl.

Contrary to Joey's statement, a total of 17 days from 2–19 February in the studio at Radio City Music Hall were spent recording the album with novice Craig Leon producing. According to Johnny, 'We laid out the basic tracks in two days. We went through four or five songs in one take.' It was mixed in basic stereo like the early '60s classics they loved so much. Making what were in effect revolutionary aesthetic decisions of course has its cost, and while the Ramones and Sire thought the band should have topped the charts, the record was a long way from the public's taste.

According to drummer Tommy Ramone, 'it was conceptual like underground art or film, innovative. The first album was a statement of rawness – minimal, striking, unique.'

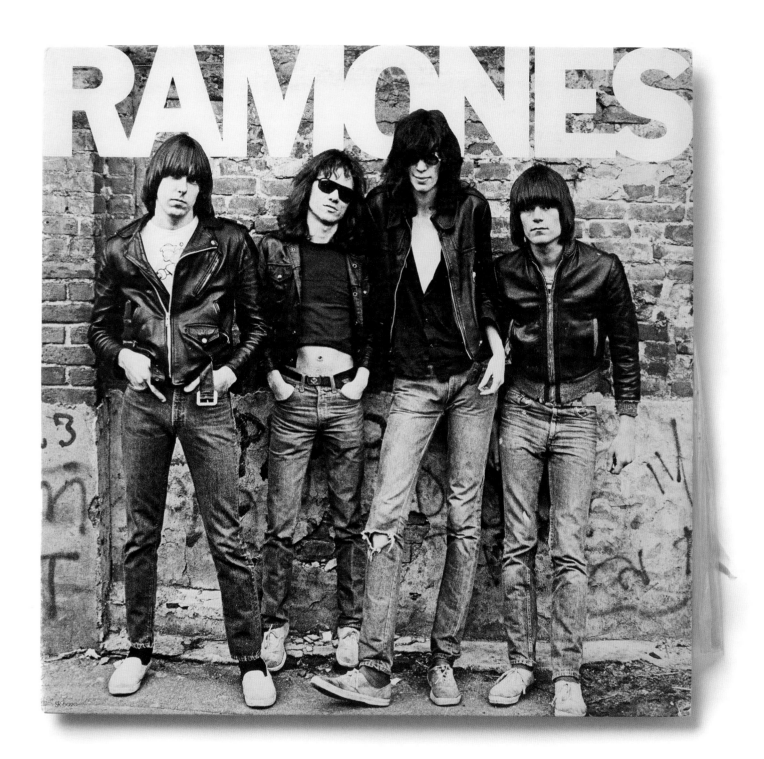

N°:40

THE ROLLING STONES
EXILE ON MAIN ST

Rolling Stones Records
Produced by Jimmy Miller
Released: May 1972

The ragged wonder of this 1972 double album – a set of songs sometimes shattered, sometimes shattering – is the soundtrack for a world of stately black cars: limousines and hearses. There's barely a hint of middle ground amid *Exile on Main St*; you're either alive or dead, strung out or strutting. And despite a lack of 'hit singles' it's become a signature release for the group. When people talk about the black magic of the Rolling Stones at work, this is the album they're referring to. 'I gave you the diamonds, you gave me disease', is a handwritten phrase repeatedly referenced in the sleeve, and from song to song *Exile* puts you on either side of that transaction.

Maybe one of the album's secrets is that the Rolling Stones didn't exist by the time they finished it, but no-one had yet realised and started the long cover-up. Facing tax bills they couldn't afford, and the attention of the constabulary, the band's members had decamped to France. Jagger, in the process of getting married, headed for Paris. But Richards, in the process of becoming a junkie, fetched up at a 19th century villa, Nellcote, outside Nice. The basement gained a mobile recording rig and the house gained notoriety as the band and a wayward entourage, which included Gram Parsons, felt their way towards a follow-up to *Sticky Fingers*.

Many of the songs don't feature all five official Stones – vocalist Jagger, guitarists Richards and Mick Taylor, bassist Bill Wyman and drummer Charlie Watts – but the makeshift ensembles and hired hands fit the aesthetic of tracks such as the skeletal, exhausted 'Casino Boogie' and

the soulful, redemptive 'Let It Loose'. Jagger, Watts and Wyman all skipped sessions, and the guiding force at Nellcote was Richards who, when he finally settled in for nighttime sessions, steered the sounds towards an explicit embrace of the American roots music they'd long listened to – whether it was the funky, juke joint take on Slim Harpo's 'Shake Your Hips' or the Little Richard groove of 'Rip This Joint'.

TRACKLISTING

01 **Rocks Off**
02 **Rip This Joint**
03 **Shake Your Hips**
04 **Casino Boogie**
05 **Tumbling Dice**
06 **Sweet Virginia**
07 **Torn and Frayed**
08 **Sweet Black Angel**
09 **Loving Cup**
10 **Happy**
11 **Turd on the Run**
12 **Ventilator Blues**
13 **Just Want to See His Face**
14 **Let It Loose**
15 **All Down the Line**
16 **Stop Breaking Down**
17 **Shine a Light**
18 **Soul Survivor**

Ultimately the sessions moved, partially as a survival instinct, to Sunset Sound Recorders in Los Angeles, and Jagger came to the fore. He's long said he doesn't particularly like *Exile*, but he got it finished. The overdubs brought in session hands like Billy Preston and Dr John, but this remains an exacting example of the Jagger–Richards partnership, not just as songwriters but as the key that unlocked each other's best instincts, whether through understanding or spite. The textures that accentuate the final suite of songs, where the initial bluster gives way to gospel-influenced reckoning on the likes of 'Shine a Light', provide a contrast to the narcotic murk and sudden snarls that preceded it.

'You're gonna be the death of me,' runs the refrain that holds tight to the guitar interplay on the closing 'Soul Survivor', and given the band's cavalier existence you could take your pick of suspects. Yet the Rolling Stones were still pushing on at a time when the Beatles had given in and one-time firebrands such as Jim Morrison and Jimi Hendrix had burnt out before passing away.

Exile on Main St is a definitive goodbye to the 1960s, completing a journey begun at Altamont, and a tired, defiant nod to the 1970s. 'Everybody walking 'round/Everybody trying to step on their creator,' Jagger sings on the punctuated blues of 'Ventilator Blues', where the horns and guitar sway to his side, and the Rolling Stones offer nothing more than the promise of another song, another roll of the dice. With *Exile on Main St* that was more than enough.

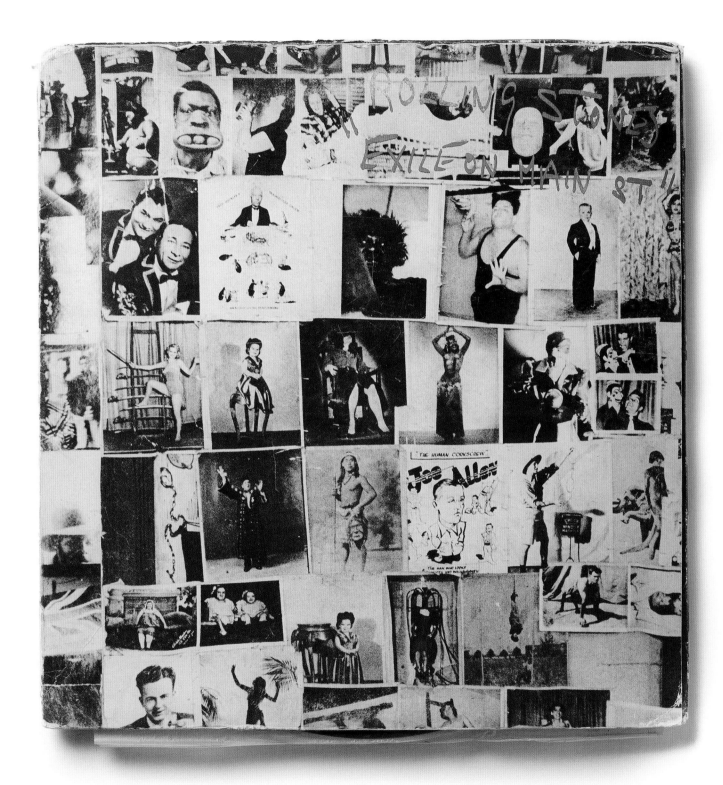

BONNIE RAITT ON NEIL YOUNG

The guy just inhabits the damn music. It doesn't matter if he looks like Ebenezer Scrooge.

NOEL GALLAGHER (OASIS) ON *THE QUEEN IS DEAD*

[Morrissey's] lyrics for The *Queen Is Dead* have never been bettered by anybody.

JAMES TAYLOR ON CAROLE KING

Who can explain it? This girl from Brooklyn, unannounced, on-the-scene ... 'Will You Still Love Me Tomorrow?', 'Natural Woman', 'Up on the Roof', 'I'll Do My Crying In The Rain' ... a tunesmith, a Brill Building pro, inventing popular music, hammering out songs for any occasion, tailor-made sequels ... Very accessible, very personal statements, built from the ground up with a simple, elegant architecture. Kootch introduced us in 1969, just around the time she was starting to perform her songs herself (people in the biz had treasured her demos for years). We recorded together, toured together, shared a band and hung out. She gave me my only #1 single. Those were remarkable days in Laurel Canyon. Joni, Jackson, CSNY, the Eagles, Carole King ... exceptional was commonplace. The record industry was a labour of love in the service of music. It was a hoot. We laughed, we cried, we lived, we died.

LOU REED ON DAVID BOWIE

I can't pick a favourite Bowie record. It always depends on my mood – any of the dance records; *Ziggy Stardust*; I always liked 'The Bewlay Brothers', that track on *Hunky Dory*. And the albums he did with Brian Eno, like *Low* and *Heroes*, are just phenomenal. He's always changing, so you never get tired of what he's doing.

PETER BUCK ON *EXILE ON MAIN ST*

This was the first album I just obsessed on. It gave me everything I ever wanted in a record. It was mysterious. I loved that way they were putting all their influences in. It gave me the feeling that there was this mystery and adventure that went with a record. Peter Buck (R.E.M.)

WILL SELF ON *BLUE LINES*

Somewhere back in the early 1990s, when Britain was dull in a different way, I first heard Massive Attack's *Blue Lines*. Then in my early thirties, I already thought I was way too old for popular music. I'd sat out 1987's so-called Second Summer of Love in a deckchair, and all the dancey-ravey music of that era struck me like someone stupidly wired beating up on a drum machine. The Wigmore Hall beckoned – and I was looking forward to it – when a girlfriend 10 years my junior plopped a vinyl disc onto my turntable and this sinuous, sensual, subversive soundscape sprang into being somewhere between my ears. Or was it in the room? Or even encompassing the whole block of flats? There was this outside-in feel to the music, the 'trippy' element supplied by echo, backbeat and tape-looping, then there was the underlying angular geometry of hip-hop: the Sprechgesang-geezer lyrics buttressing the high-flying notes of the soul diva Shara Nelson. The band have always kicked against the categorisation 'trip-hop', which was coined to describe the emergent Bristol sound, and there's something faintly charming about how they're still at it. Will Self (author)

ALICIA KEYS ON ARETHA FRANKLIN

A human being without an Aretha album is half a human being.

THURSTON MOORE ON *RAW POWER*

For me, the Stooges were the perfect embodiment of what music should be – of wanting it to be alive, riding the edge of control. Their music was total high-energy blues, with the contemporary freakout of Jimi Hendrix and the free-jazz spirit of John Coltrane … *Raw Power* is the ultimate fuck-off.

Thurston Moore (Sonic Youth)

DAVID BYRNE ON DAVID BOWIE

When David Bowie came along, well, rock and roll needed a shot in the arm and when I first saw him it was a shock, and yet it was very familiar. It was very necessary. It was something that was needed. It was essential. And like all rock and roll, it was tasteless, it was glamorous, it was perverse, it was fun, it was crass, it was sexy, it was confusing. And like all rock and roll, it was freedom, it was pain, it was liberation, it was genocide, it was hope, it was dread, it was a dream and it was a nightmare. It was about sex and drugs, it was about combining literature with rock and roll, with art, with anything you could name. It was about sex as an idea, and sex as a reality, and sex as a liberating force. It was about rebellion, it was about rebellion as a cliché, it was rebellion as an idea. It was about rebellion as a billboard, as an advertisement. It was about the joy of reckless prophecy. It was ironic when rock and roll became self-reverential. It was about joy and terror and confusion in our lives. It was about sexual politics, sexual theatre. It was a soundtrack to our lives, as someone else has said. He was both kind of a shrink and a priest, a sex object and a prophet of doom. He was kind of the welcome to the new world, to the brave new world.

David Byrne (Talking Heads)

LOU REED ON IGGY POP

Iggy is very stupid. Sweet, but very stupid.

NORAH JONES ON *ON THE BEACH*

On the Beach is one of my favourite Neil albums. ['Ambulance Blues'] is one of those songs that makes you feel like you're underwater. It's weird, beautiful, surreal.

PAUL MCCARTNEY ON RAY CHARLES

When I first heard it, I knew right then I wanted to be involved in that kind of music.

BILLIE JOE ARMSTRONG ON IGGY POP AND THE STOOGES

When I think of the sound of war, chaos and demolition, sex, sensuality, poetry and brutal truth, I think of The Stooges. It's the sound of blood n guts, sex and drugs, heart and soul, love and hate, poetry and peanut butter. The Stooges are like a battering ram – Iggy is the most confrontational singer we will ever see.

Billie Joe Armstrong (Green Day)

PETE TOWNSHEND ON JIMI HENDRIX

What he played was fucking loud but also incredibly lyrical and expert. He managed to build this bridge between true blues guitar – the kind that Eric Clapton had been battling with for years and years – and modern sounds, the kind of Syd Barrett-meets-Townshend sound, the wall of screaming guitar sound that U2 popularized. He brought the two together brilliantly. And it was supported by a visual magic that obviously you won't get if you just listen to the music. He did this thing where he would play a chord, and then he would sweep his left hand through the air in a curve, and it would almost take you away from the idea that there was a guitar player here and that the music was actually coming out of the end of his fingers. And then people say, 'Well, you were obviously on drugs'. But I wasn't, and I wasn't drunk, either. I can just remember being taken over by this, and the images he was producing or evoking were naturally psychedelic in tone because we were surrounded by psychedelic graphics. All of the images that were around us at the time had this kind of echoey, acidy quality to them.

Nº:41
PATTI SMITH
HORSES

Arista
Produced by John Cale
Released: December 1975

Robert Mapplethorpe's photo of Patti Smith on the cover of *Horses* is one of the most iconic images in rock & roll. Smith's slightly dishevelled appearance is very rock & roll, but the coat slung casually over the shoulder is pure Sinatra in downtown Manhattan. Her gaze is defiant and confident. Then there is the famous opening line – 'Jesus died for somebody's sins but not mine'.

The album arrived hot on the heels of another New York record with a black & white cover. If Bruce Springsteen was billed as the future of rock & roll, Patti Smith posited another future. Like *Born to Run*, *Horses* was a collection that drew its power from channelling the past. Smith dropped names like a drunk halfback drops the ball: Dylan, the Beat Generation, Rimbaud, Hendrix, Keith Richards, Jesus. Ornette Coleman and other jazz giants were a strong influence in the harmonics on the album. Patti Smith may have been a prophet of punk rock, but she didn't come to destroy rock & roll, she came to save it.

Patti Smith started out as a poet. Completely self-taught, Smith grew up on Top 40 radio and she sought out poets both literary and musical. In that sense she harked back to early Bob Dylan, seeing no distinction between rock & roll and 'art'. Smith found an early home at CBGB – the Patti Smith group were one of the first to play there. She was the first of the CBGB artists to get a record deal. With her literary influences and encyclopedic knowledge of rock history, Smith's references to pop culture history made her more explicable than, say, Television or Talking Heads.

The choice of Velvet Underground cellist John Cale as producer – not Smith's first choice – was inspired. He added to the album's pedigree while also respecting the band's raw qualities. But it was not an easy record to make – Smith recalled one night when Cale was banging his head against the mixing desk trying to deal with the craziness.

'I didn't know how to sing, I don't know about pitch,' she said recently. 'But the band's adolescent and honest flaws – I wouldn't say

TRACKLISTING

01 **Gloria**
 Part I: In Excelsis Deo
 Part II: Gloria

02 **Redondo Beach**

03 **Birdland**

04 **Free Money**

05 **Kimberly**

06 **Break It Up**

07 **Land**
 Part I: Horses
 Part II: Land of a Thousand Dances
 Part III: La Mer (De)

08 **Elegie**

weaknesses – John always left them in. But if he could subtly teach us to enhance what we were doing, he did that. It was a very beautiful, tortuous excursion.'

The songs had been worked up over the previous two years, some starting out at poetry readings that Smith did with only guitar accompaniment from Lenny Kaye. This is how the poem 'Oath' was morphed with Them's garage rock anthem 'Gloria' into a complex hymn to both a higher power and the raw power of rock & roll. 'It didn't have a category,' said guitarist Kaye. 'It was an attitude.'

Other songs like 'Redondo Beach' about a fatal lesbian affair or 'Elegie', a tribute to Hendrix, suggest new sonic realms for this garage band, embracing the chaos of switchblade guitars. 'Land', the album's epic, borrowed heavily from the soul classic 'Land of a Thousand Dances'. Smith was taking the past and rewriting it.

Not all of Smith's gambits came off, but the courage behind the album and its vision were undeniable. On tracks like 'Land' the Patti Smith group embraces and then transcends its limitations. For those very reasons, *Horses* remains one of the most influential records in rock & roll.

'It's time to figure out what happened in the '60s,' she announced. By the mid-'70s, when this album was released, most of the superstars of the '60s were burnt out. Rock & roll needed Patti Smith like the French needed Joan of Arc.

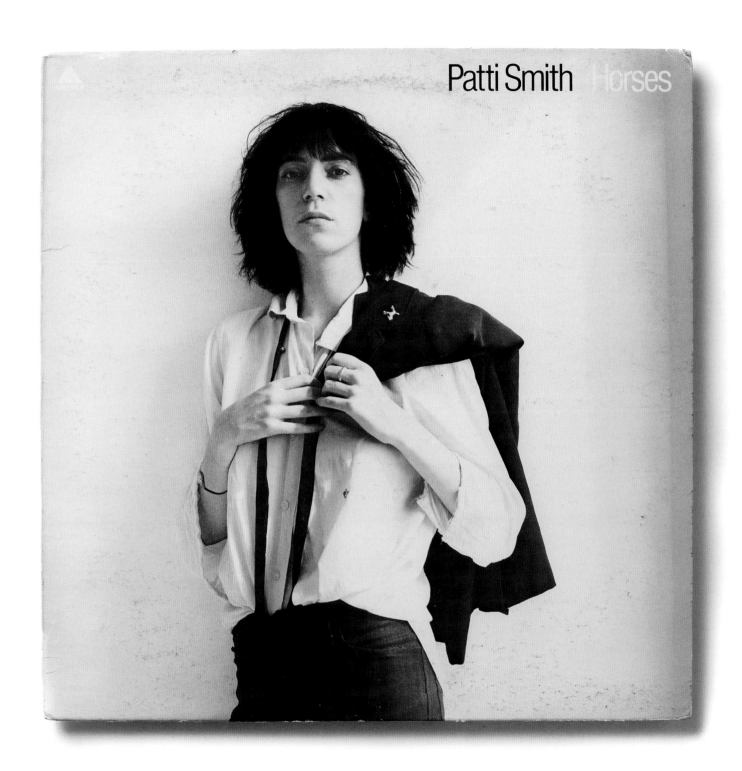

Patti Smith Horses

N°:42

MILES DAVIS
KIND OF BLUE

Columbia
Produced by Teo Macero and Irving Townsend
Released: August 1959

On 2 March 1959 Miles Davis, then 32 years old, arrived at 30th Street Studio in Manhattan for the first of two scheduled sessions. At the time the streets of New York echoed with the riotous cacophony of bebop. Instead of the usual chord charts and head arrangements, Miles hadn't discussed the material with his band. He suggested some keys and they improvised almost a whispering deep blues that spoke directly of the quiet place in all of us, the place where thoughts and emotions and dreams are born. No music, before or since, has so directly touched the soul. *Kind of Blue* is one of the most successful jazz albums of all time because it's music that transcends jazz.

'He had this sound that was like a haunting voice,' says bass player Charlie Haden, describing Davis' playing. 'The way he plays it makes you feel life so deeply you can almost cry. It didn't really sound like a trumpet anymore.'

Miles Davis was influenced by his pianist Bill Evans who in turn drew on classical composers such as Béla Bartók and Maurice Ravel. Davis saw a linkage with the blues. The trumpeter and pianist had been talking about this style for some time. They had recorded some of it on the previous two Miles Davis albums. The revolution of *Kind of Blue* was simply how far Miles took the style.

Part of the secret to the album was the exceptional sextet (Evans was just sitting in) – Julian 'Cannonball' Adderley (alto saxophone), John Coltrane (tenor saxophone), Paul Chambers (bass), Jimmy Cobb (drums) and Wynton Kelly (piano) were all soon-to-be legends in their own right. Davis and Evans had worked on outlines for the tracks but Davis thought first reactions were best and wanted to keep the songs free. 'He was giving [the band] instructions about the tunes they were going to play,' recalled drummer Jimmy Cobb. 'There wasn't a whole lot of music. I didn't have any music at all – a piece of manuscript paper with some chords scribbled on it. Miles tells me, "make this sound like it's floating".'

TRACKLISTING

01 **So What**
02 **Freddie Freeloader**
03 **Blue in Green**
04 **All Blues**
05 **Flamenco Sketches**

In his liner notes to the album Bill Evans draws a comparison with Zen and the art of Japanese painting; that the message is in the intent of the artist. 'The resulting pictures lack the complex composition and textures of ordinary painting,' he wrote, 'but it is said that those who see well find something captured that escapes explanation'. 'So What', which opens the album, is a perfect example: spare, elegant piano chords that hang in space, accenting the charged silence. The song is defined by its silences as much as its noises. 'All Blues' is just that – a simple blues in 6/8 time with the warmth and familiarity that evokes while the horns drip with emotion and Davis' trumpet sounds like a far off cry in the night.

Kind of Blue, like the best jazz of the '50s, evokes high modernism – the cosmopolitan sound of the post-war world and new designs for living. Davis' modal scales inspired the rock improvisers that would arrive 10 years later with Santana, Pink Floyd and the Allman Brothers. His horn phrasing would be copied by James Brown and in the hypnotic work of Phillip Glass and modern composers. As the great jazz and blues critic Robert Palmer wrote, 'listen to it until it seeps into your dreams … and fills your soul with the sacred expanding nothingness'.

STEREO FIDELITY

MILES DAVIS

COLUMBIA
GUARANTEED HIGH FIDELITY

LP

Kind of Blue

with Julian "Cannonball" Adderley

Paul Chambers

James Cobb

John Coltrane

Bill Evans

Wynton Kelly

PHOTO JAY MAISEL

N°43

SONIC YOUTH
DAYDREAM NATION

Blast First
Produced by Sonic Youth and Nicholas Sansano
Released: October 1988

As a vision of the future, Sonic Youth's magnum opus – on release a double record of just 12 extended tracks – sounds more relevant with every year that passes. The 21st century begins on this album. It took every improbable element of the downtown Manhattan four-piece, from their hardcore zealousness and pop sensibility to their art brat humour and cyberpunk worldview, and consolidated it into this album where the sheer fury obtains a graceful uplift. *Daydream Nation* sounds like an antidote to a digital age that hasn't yet come to pass.

'Close your eyes and make believe, you can do whatever you please,' sings bassist Kim Gordon on the taut "Cross the Breeze', and throughout the album fantasy is often where a new reality begins. The barrelling, electric riff of opener 'Teen Age Riot', which sounds like it's spurring drummer Steve Shelley on to new heights by the tune's close, was originally titled 'J Mascis for President' – a fantasy of guitarist Thurston Moore, where Mascis, the then underground frontman of Dinosaur Jr, proves to be the ultimate third party candidate. In the song, Moore's protagonist is steadfastly bed-bound, but the arrangement levitates as the bass moans in oceanic appreciation of what is unfolding.

The dreams of guitarist Lee Ranaldo on selections such as 'Eric's Trip' are rich and explicit, as if screwdrivers on guitar strings had replaced LSD as a way of rewriting your synapses. 'I'm over the city, fucking the future,' he declares, and the song is a series of cataclysms that refuse to slow down as Ranaldo

and Moore offer up counter-melodies that take in psychedelic flecks and razorish runs. Another Ranaldo song, 'Hey Joni', achieves take-off velocity within seconds and then eases down into impressionistic verses before it revs up again – 'Kick it' demands Ranaldo, and the song somehow does just that with joyous abandon. It was the absence of Ranaldo as a songwriter that would weaken Sonic Youth in the 1990s, but here his contributions are vital.

It's the different authorial voices that help make *Daydream Nation* so invigorating and, alongside Moore's imaginary beat-era argot and Ranaldo's vivid flashcards, there's the cool,

TRACKLISTING

01 **Teen Age Riot**
02 **Silver Rocket**
03 **The Sprawl**
04 **'Cross the Breeze**
05 **Eric's Trip**
06 **Total Trash**
07 **Hey Joni**
08 **Providence**
09 **Candle**
10 **Rain King**
11 **Kissability**
12 **Trilogy:**
 a) The Wonder
 b) Hyperstation
 c) Eliminator Jr.

evaluative prose of Kim Gordon. On 'The Sprawl' she imagines herself as a veteran of the grimy sci-fi vision of novelist William Gibson (his paperback *Sprawl* was the decaying BAMA, the singular Boston-Atlanta Metropolitan Axis), who remembers where she fought with 'the big machines'. In 'Kissability' the power structure being challenged is the patriarchal, acquisitive record business – 'You could be a star,' a leering suit tells Gordon; 'you could go far'.

Sonic Youth actually would sign to a major label for 1990's *Goo* – an outcome inspired in part by difficulties with the independent American distributor of *Daydream Nation* – but in 1988 they sounded like their fellow '80s inspirations for '90s alternative rock, the Pixies; a correct answer to a question that hadn't quite been framed. For all the momentum – aural and psychic – the quartet never sounds remotely like they're exerting themselves. The sense of effortlessness only adds to the enjoyment.

The majority of these songs – except 'Providence', an atmospheric collage that serves as a mid-album exhalation (of pot) – played equally well in the moshpit and on headphones. That duality culminated in the three-part finale, 'Trilogy', where Moore's nighttime odyssey through New York goes through ecstatic release and slow-motion violence (he gets mugged at 3am) before Gordon turns the sexual fervour at the beginning of 'Eliminator Jr.' into a criminal prosecution. On *Daydream Nation* the only given is that the songs don't just end in unexpected places, they begin in them as well.

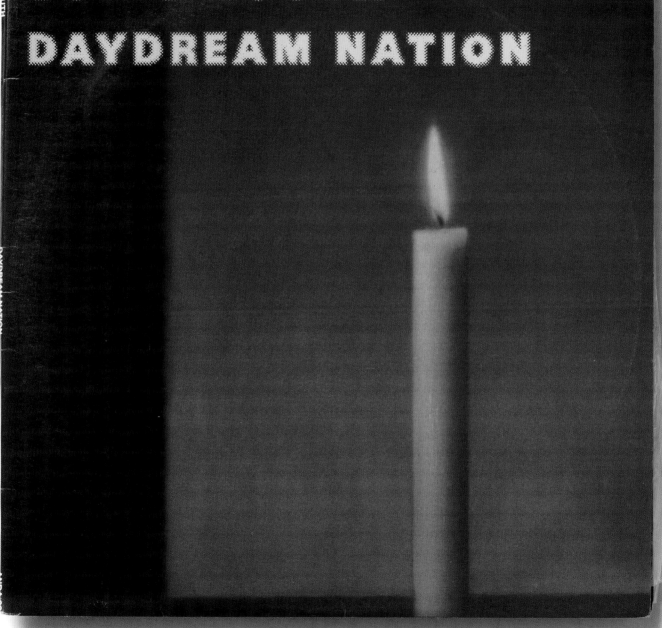

N°:44

BRUCE SPRINGSTEEN
BORN TO RUN

Columbia
Produced by Bruce Springsteen, Mike Appel and Jon Landau
Released: August 1975

In the summer of 1975 Bruce Springsteen saved rock & roll. Bruce Springsteen and the E Street Band had made two albums for Columbia that had gained positive reviews but little sales. Springsteen, with some justification, thought that his third album was his last chance. If the record didn't work he could look forward to a life of playing New Jersey bars. 'The record closely mirrors a lot of things in my life that I was going through,' he reflected in 2005. 'That's why everybody on *Born to Run* is out trying to get out. "Thunder Road": trying to break free; "Tenth Avenue Freeze-Out", "Backstreets": somebody is out and somebody is left behind; "Born to Run": trying to get out. Everything is filled with that tension of somebody struggling … trying to find some other place.'

Springsteen spent six months in the studio working on the title track alone. At the end of it he lost drummer Ernest 'Boom' Carter and pianist David Sancious (they were replaced for the rest of the album by Max Weinberg and Roy Bittan respectively). Recording the rest of the album continued for another seven months; month after month of overdubbing parts to create mini operas for the alleys. Clarence Clemons' saxophone solo on 'Jungleland' alone took 16 hours straight.

Springsteen's first two albums had been jammed with elaborate, colourful words and different styles of music, trying to tell the stories of the Jersey Shore. On *Born to Run* he stripped back the language. 'The music was composed very, very meticulously,' he said. 'I wrote it and I rewrote it and I rewrote it. What I kept stripping away was cliché, cliché, cliché. I just kept stripping it down until it started to feel emotionally real.'

'*Born to Run* is that feeling of that one endless summer night,' says singer Patti Scialfa. 'The whole record seems like it could all be different stories taking place in the course of one evening

TRACKLISTING

01 **Thunder Road**
02 **Tenth Avenue Freeze-Out**
03 **Night**
04 **Backstreets**
05 **Born to Run**
06 **She's the One**
07 **Meeting Across the River**
08 **Jungleland**

in all different locations on one long summer night.' Each song begins with a brief instrumental theme. 'I was interested in setting the scene that's why the [instrumental] introductions,' said Springsteen. 'They set the scene. I was interested in writing these mini epics and the introductions were meant to make you think something auspicious was going to occur.'

Springsteen's vision for the sound of the album drew on the epic romanticism of Phil Spector's records. During the course of the recording the relationship between Springsteen and his manager/producer Mike Appel broke down. Music critic and record producer Jon Landau came on board and helped Springsteen focus his concept. 'He got Bruce to look at himself and the band and the songs in a different way and it changed from that point,' said Bittan on Landau's input.

The final result was a new wall of sound that could reach the emotional heights to which Springsteen aimed ('I wanna know if love is wild, baby, I wanna know if love is real'). 'To me the primary questions I'd be writing about for the rest of my work life were in the songs on *Born to Run*,' he said. 'What do you do when your dreams come true? What do you do when they don't? Is love real?'

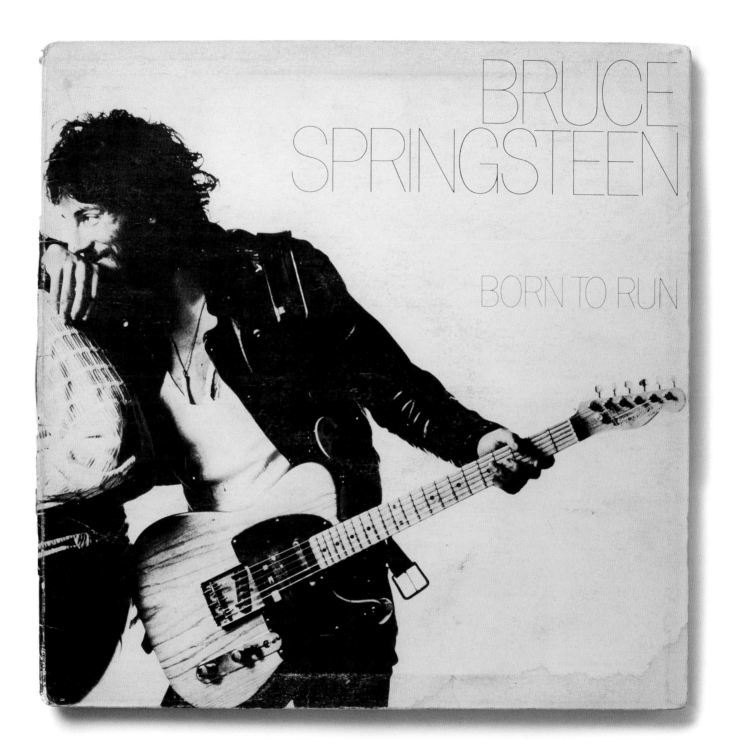

Nº:45

THE BEATLES
ABBEY ROAD

Apple
Produced by George Martin
Released: September 1969

Understandably, after more than six years of non-stop madness, the Beatles were over it. Although *Let It Be* was the last Beatles album released, the songs had been recorded before *Abbey Road*. Knowing it was the end, Paul McCartney rallied the troops back to the studio to end it on a high note. John Lennon was off in his own art project/marriage with Yoko Ono. Meanwhile, George Harrison was tired of having his efforts belittled by Lennon, McCartney and producer George Martin. ('Paul would always help when you had done his ten songs,' Harrison said sarcastically.)

Although relegated to just two songs, George Harrison's are clearly the best. 'Here Comes the Sun' was picked out one afternoon in Eric Clapton's backyard and is what it says: a warm, irresistible tune; while 'Something', which had begun during sessions for the previous album, is arguably the best of all of the Beatles' ballads. Harrison borrowed a line from James Taylor ('Something in the way she moves') and wove a sublime melody that was so captivating that even Frank Sinatra recorded it. '"Something": A great song,' said Lennon. 'Possibly a single. If I can get "Come Together" on the back side I'll be very pleased ... so that I can listen to it without listening to the whole album.'

John Lennon also has a purple patch. 'Come Together' was based on Chuck Berry's 'You Can't Catch Me' (the obvious similarity would come back to haunt Lennon) and was originally written for LSD guru Timothy Leary.

It's nonsense-but-clever lyric is set against a swampy, bass-heavy track and a loping beat that is as grungy as the Beatles ever got. Lennon's other strong contribution to the album was 'I Want You (She's So Heavy)', which consisted of him chanting, 'I want you' on top of massed guitar overdubs from him and Harrison. The final overdub session for 'I Want You' would be the last time all four Beatles worked in the studio together.

TRACKLISTING

01 **Come Together**
02 **Something**
03 **Maxwell's Silver Hammer**
04 **Oh! Darling**
05 **Octopus's Garden**
06 **I Want You (She's So Heavy)**
07 **Here Comes the Sun**
08 **Because**
09 **You Never Give Me Your Money**
10 **Sun King**
11 **Mean Mr. Mustard**
12 **Polythene Pam**
13 **She Came in Through the Bathroom Window**
14 **Golden Slumbers**
15 **Carry That Weight**
16 **The End**
17 **Her Majesty**

Although Yoko Ono is often accused of breaking up the Beatles, in fact she encouraged Lennon to move beyond his Tin Pan Alley roots and start to take creative chances with his work. The sophistication she brought to Lennon, and indirectly to the band, was part of the Beatles' creative salvation and meant they were remembered for more than just silly love songs.

Ono's influence was most obvious on 'Because'. The melody came to Lennon after hearing her play Beethoven's *Moonlight Sonata* on the piano. He reversed the melody and added a lyric inspired by Ono's book *Grapefruit*. The Beatles then added harmonies to what is one of Lennon's most deceptively complex tunes. It was also the last song recorded on the last Beatles album.

For all of McCartney's enthusiasm he was not at his best on *Abbey Road*. His two complete songs, 'Maxwell's Silver Hammer' and 'Oh! Darling', are twee juvenilia, albeit well-executed. His real contribution came with the medley on side two. Eight scraps of songs written by either Lennon or McCartney were rolled together into what was a dazzling, seamless whole. If he couldn't keep the band together, McCartney at least knew how to end it in style. 'The End' is a beautifully small song that features Ringo Starr's only drum solo and then Paul, George and John each take a guitar solo followed by one of McCartney's best lyrics: 'And in the end the love you take/Is equal to the love you make'. And then it was done.

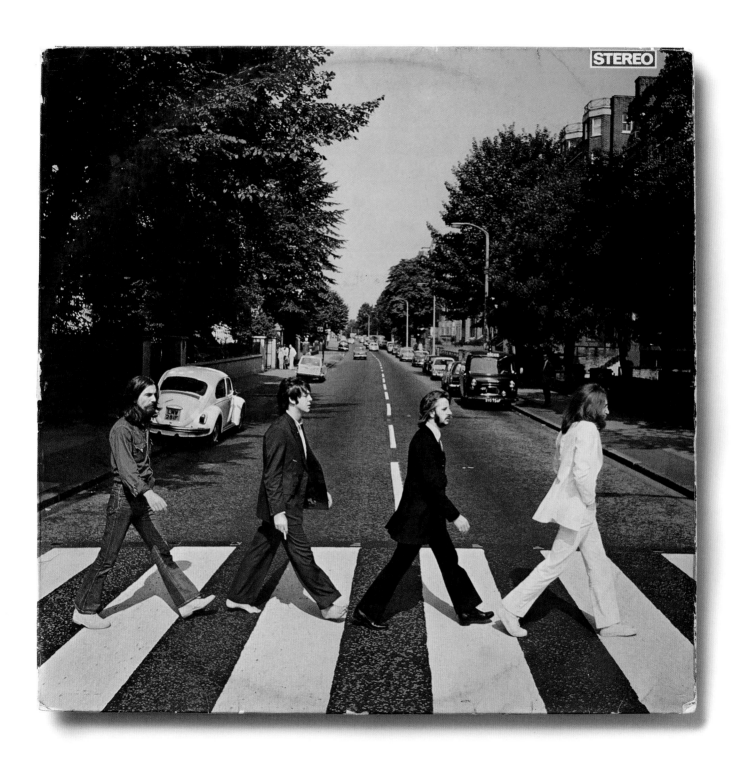

Nº 46

GUNS N' ROSES
APPETITE FOR DESTRUCTION

Geffen
Produced by Mike Clink
Released: July 1987

1988 certainly needed them. From January through to the middle of June that year only three albums held the top position on the American album charts: the *Dirty Dancing* soundtrack, the self-titled debut from long-forgotten teen popette Tiffany, and George Michael's *Faith*. When Guns N' Roses debut album – the scabrous, searing *Appetite for Destruction* – arrived at the top of the pile after a year-long journey that had seen the group's fortunes slowly improve via a grinding tour schedule, it marked a rebirth for rock & roll after a decade where the genre had been detached and diluted. One listen to Axl Rose, Guns N' Roses' inflammatory frontman, and all bets were off.

They were undoubtedly products of the ludicrous yet lucrative Los Angeles hard rock scene. All five band members – Rose, guitarists Slash (Saul Hudson) and Izzy Stradlin, bassist Duff McKagan and drummer Steve Adler – had (dyed) roots in the city's dive clubs and dingy apartments. But there was no hair metal fantasy to the band's songs, no wish fulfilment for impressionable teenagers. Rose was a small town kid who didn't deal well with authority, and he channelled his rage into a condemnation of his surroundings. 'If you want it you're gonna bleed,' he sings on the opening 'Welcome to the Jungle', and *Appetite for Destruction* is a record where everything comes with a price.

The lynchpin of the band's sound was the interplay and versatility of the guitarists. Slash was the archetypal lead guitarist, and

his solos have a dazzling brevity and just enough grit to offset the flamboyance, while Stradlin was a Keith Richards devotee who held the line. They were an enormously complementary pair, and they staffed the record's 12 tracks with unexpected touches, such as the plangent 12-string guitar that repeatedly rises up in 'Think About You' or the turbo '70s boogie of 'Paradise City'.

With their five-piece line-up and palpable mix of hedonism and anti-social rancour, Guns N' Roses drew comparisons to the Rolling Stones. The oft-made compliment was that they made rock & roll dangerous again, but if that's the case then parts of *Appetite for Destruction* are as likely to encourage self-harm as a riot (and

TRACKLISTING

01 **Welcome to the Jungle**
02 **It's So Easy**
03 **Nightrain**
04 **Out ta Get Me**
05 **Mr. Brownstone**
06 **Paradise City**
07 **My Michelle**
08 **Think About You**
09 **Sweet Child o' Mine**
10 **You're Crazy**
11 **Anything Goes**
12 **Rocket Queen**

the touring for the album veered close to a few of those). Rose was writing off the LA scene before he got famous, and his cynicism has a tragic authenticity on the likes of 'My Michelle': 'And this hotel wasn't free/So party till your connection call/Honey I'll return the key'.

Misogyny and self-loathing go hand in hand on *Appetite for Destruction* and it sounds like the only thing that was keeping the singer in line on these songs was the catharsis promised by his bandmates. Producer Mike Clink was an engineer making his production debut (a dalliance with Kiss frontman Paul Stanley as a possible producer had thankfully not eventuated), and the sound is rugged and authoritative. There's the propulsive 'Nightrain', which does have enough cowbell, the high octane 'Mr. Brownstone' with its allusions to heroin use ('I used to do a little but a little wouldn't do'), and the frenzied 'You're Crazy'.

The album did have a ballad, but it was a typically early Guns N' Roses idea of one. Introduced by a warm-up riff Slash used to play in the dressing room that he didn't think was anywhere near special, 'Sweet Child o' Mine' found a hint of hope in Rose's opera-strength yowl and a contemplative melody. It was a moment of mid-tempo respite on an album that became emblematic both to the lost boys and girls it was written about and the general public, going on to sell 28 million copies. In the future they'd exceed the drama, but the music was never as unfettered and essential as it was here.

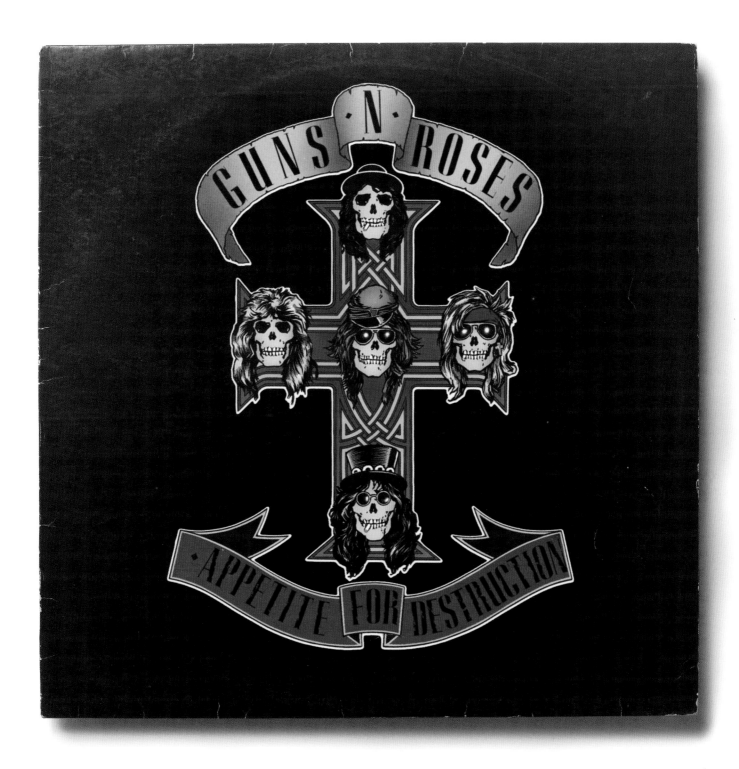

N°:47

BLACK SABBATH
PARANOID

Vertigo
Produced by Rodger Bain
Released: September 1970

The most influential album in the history of heavy metal – whole decades of Marshall stack usage stem from these eight songs – was created by four working class lads from Birmingham in England with zero pretensions. They didn't want to change the world, but they were awfully keen on beer. That's how it should be, of course. Heavy metal is the most democratic of music genres; the one where the distance between the audience and the artists is essentially one of stage height, and *Paranoid* is a record where listeners hear their basic existential fears amplified so that they sound like the end of the world. This is the most exciting downer in the history of rock & roll.

The four-piece Sabbath – vocalist Ozzy Osbourne, guitarist Tony Iommi, bassist and main lyricist Geezer Butler and drummer Bill Ward – had only been together for little more than two years when they cut their second album *Paranoid* (and even that time-frame included Iommi briefly doing a runner to Jethro Tull and quickly coming back disillusioned). On January 1970's self-titled debut there were still notable vestiges of their blues rock background, but this follow-up, quickly recorded to take advantage of their growing profile, put an end to that later in the year. The record is a deathblow to '60s sunshine and hippie optimism, introducing the new heaviness.

'Finished with my woman 'cause she couldn't help me with my mind,' Osbourne declares on the title track, and the song sums up a worldview where destruction – whether from nuclear war or chemical obliteration – appears the only likely outcome. 'Think I'll lose my mind if I don't find something to pacify,' he adds, and the oblique reference to the Vietnam War (where one of the US Army's strategies was 'pacification') is used not to signify protest but to acknowledge a personal malaise. The vengeful creature at the centre of 'Iron Man' – 'Nobody wants him/They just turn their heads' – is adolescent alienation writ large.

Black Sabbath didn't talk down to their audience, and they made this journey into a suburban heart of darkness palatable with some of the most distinctive and distinctly famous riffs ever to be coaxed from an electric guitar. Iommi would later admit he

TRACKLISTING

01 **War Pigs**
02 **Paranoid**
03 **Planet Caravan**
04 **Iron Man**
05 **Electric Funeral**
06 **Hand of Doom**
07 **Rat Salad**
08 **Fairies Wear Boots**

was at a loss to explain where he plucked them from, but song after song on this album breaks new ground for the six-string. The electrifying central motif of 'Paranoid' was conceived last-minute as the basis for a filler piece, while the churning, discombobulated riff that underpins 'Electric Funeral' (offset by a burst of bluesy boogie in the middle) takes psychedelia to new extremes, and 'Planet Caravan' ventures into a desert soundscape.

But Iommi could be as fluid as he was crushing and on the opening 'War Pigs', where the wagers of the Vietnam War are memorably compared to witches, the band stretches out over eight minutes, alternately brutal and moving. At the opening, as sirens wail, Butler sounds like he's using a brick for a plectrum, but the arrangement is perfectly balanced, taking in drum cracks, doom-laden feedback and clusters of electric punctuation that dazzle by way of contrast. The song is a pocket symphony; an Old Testament that successors will always look to.

Subtleties aside, Black Sabbath tended to the monolithic, but it was hardly a stretch. Ozzy's horizon-reaching yowl was made for songs like 'Hand of Doom', where the rhythm virtually demands that head banging be invented. The group's golden age wouldn't last for long – when lines replaced pints they lost their balance – but *Paranoid* lives on, with all the magnificent fury of heavy metal but none of the questionable accoutrements.

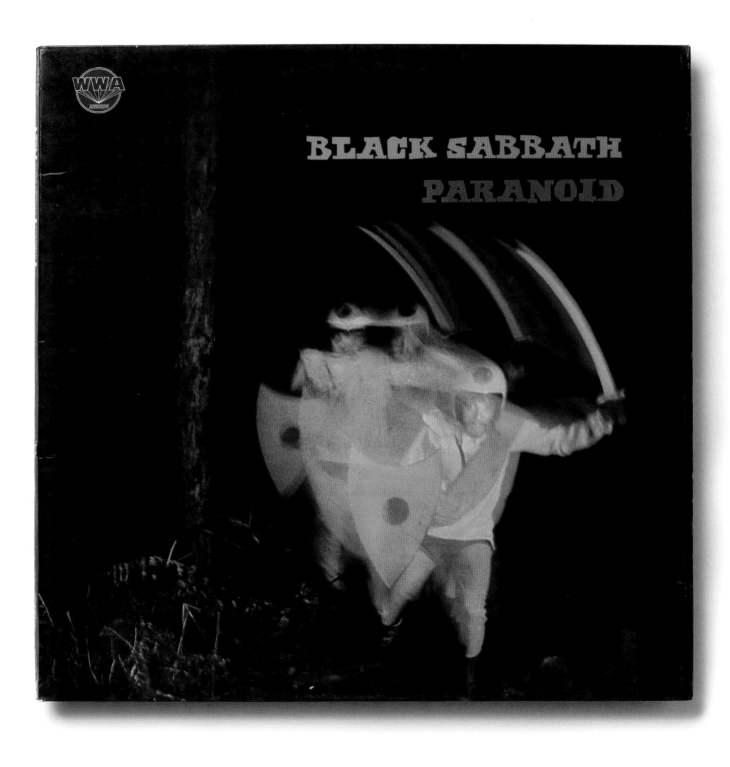

N°:48

GEORGE HARRISON
ALL THINGS MUST PASS

Apple
Produced by George Harrison and Phil Spector
Released: November 1970

'Even before I started, I knew I was gonna make a good album because I had so many songs and I had so much energy,' said George Harrison of his first solo album *All Things Must Pass*. 'For me to do my own album after all that – it was joyous.'

All Things Must Pass is a curious record, swinging as it does between seeking to transcend ego and the material world on one hand, and on the other dealing with being in the most famous quartet of all time. Harrison clearly learned much at the knee of Lennon/McCartney and by the end of the Fab Four's life the student was the equal of the teacher.

Inexplicably, on the Beatles' final albums Harrison remained consigned to his quota of one song per side. The Beatles passed on 'Art of Dying', 'All Things Must Pass', 'What Is Life', 'Isn't It a Pity' and 'Let It Down' – all of which would have improved the *Let It Be* album. One of this album's best songs, 'Wah-Wah', was written to John, Paul and Ringo after Harrison, frustrated by the bickering, walked out of a Beatles session and almost the group. 'Apple Scruffs', meanwhile, was inspired not by the Beatles but the devoted female fans who camped out the front of the Apple offices in Savile Row.

In 1968 Harrison had struck up a friendship with Bob Dylan. In 1969 he and Eric Clapton had toured with Delaney and Bonnie and Friends. These new friendships formed the basis for *All Things Must Pass*. Dylan gave Harrison 'If Not for You' and together they wrote 'I'd Have You Anytime'. The Delaney and Bonnie band – Eric Clapton, Dave Mason, Carl Radle, Jim Gordon,

Jim Price, Bobby Keys and Bobby Whitlock – formed one studio band. For the other tracks Harrison mostly used Ringo Starr and Beatles insiders Billy Preston and Klaus Voormann, and brought in some newfound friends like Procul Harum's Gary Wright. The result is a record that simply bursts with excitement.

George Harrison's frustrations with the Beatles coincided with his spiritual quest that had

TRACKLISTING

01 **I'd Have You Anytime**
02 **My Sweet Lord**
03 **Wah-Wah**
04 **Isn't It a Pity (Version 1)**
05 **What Is Life**
06 **If Not for You**
07 **Behind That Locked Door**
08 **Let It Down**
09 **Run of the Mill**
10 **Beware of Darkness**
11 **Apple Scruffs**
12 **Ballad of Sir Frankie Crisp (Let It Roll)**
13 **Awaiting on You All**
14 **All Things Must Pass**
15 **I Dig Love**
16 **Art of Dying**
17 **Isn't It a Pity (Version Two)**
18 **Hear Me Lord**
19 **Out of the Blue**
20 **It's Johnny's Birthday**
21 **Plug Me In**
22 **I Remember Jeep**
23 **Thanks for the Pepperoni**

begun some years before. Songs like 'My Sweet Lord', 'Wah-Wah', 'What Is Life', 'All Things Must Pass', 'Awaiting on You All' and 'Beware of Darkness' are all about searching for a higher power or, in the spirit of oriental mysticism, of transcending ego.

The best-known song on the album is 'My Sweet Lord' – the first #1 for any solo Beatle. The song hitches both Christian and Hindu prayers to a massive rock gospel backing track that features a dozen of the best players extant and a choir. The double drums of Ringo Starr and Jim Gordon swing the backing behind the Edwin Hawkins Singers, while Harrison's exquisite slide guide provides an unforgettable hook. (An unfortunate resemblance to the Chiffons' hit 'He's So Fine' prompted a court case that overshadowed the triumph of the song.) Barely missing a beat, the album moves up a notch with 'Wah-Wah', which starts with Harrison's Beatlesque riff, and features the double drums plus a gospel choir and a guitar duet with Eric Clapton, all building to a magnificent statement of defiance to the other mop tops. Phil Spector's production is mostly an encouragement to Harrison's ambition.

'It was a really nice experience making that album,' Harrison recalled. 'Having this whole thing with the Beatles had left me really paranoid. I remember having those people in the studio and thinking, "God, these songs are so fruity! I can't think of which song to do." Slowly I realized, "We can do this one," and I'd play it to them and they'd say, "Wow, yeah! Great song!" And I'd say, "Really? Do you really like it?" I realised that it was okay ...'

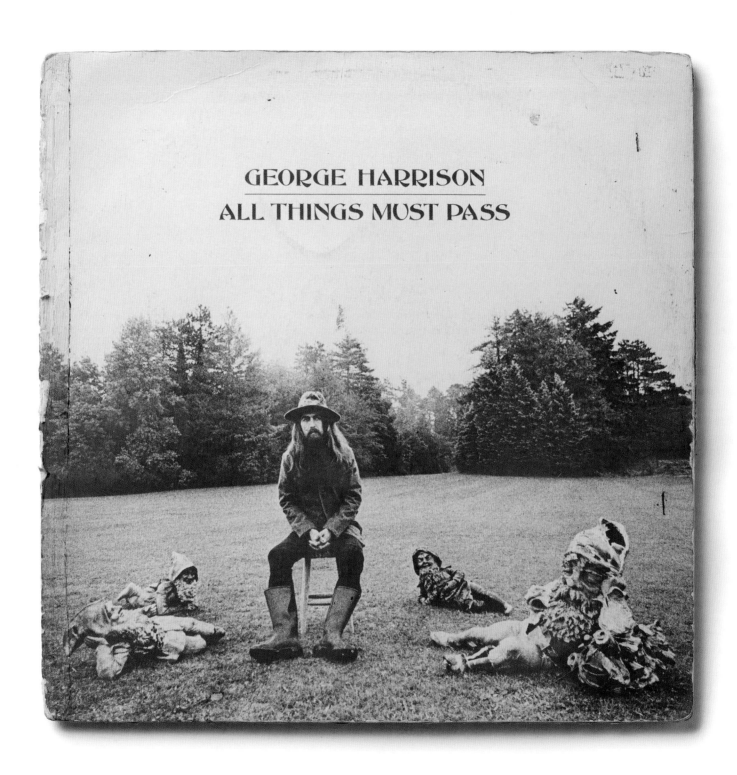

GREEN DAY
AMERICAN IDIOT

Reprise
Produced by Rob Cavallo and Green Day
Released: September 2004

It may well go down in history as the most crucial theft in popular music. In 2003 Berkeley, California punks Green Day cut what was to be their seventh album, but just after they finished tracking the 20 songs for a release to be titled *Cigarettes and Valentines*, the master tapes were stolen. Faced with the choice of re-recording their songs or starting from scratch, the trio admitted to producer Rob Cavallo that the songs weren't the best work they were capable of. So they went back to it and the following year put out *American Idiot*, a landmark set that made rock & roll vital for a generation that had struggled to identify the real thing.

American Idiot is a great, sprawling cross-section of rebellion and social commentary, pathos and plunder, which calls on the Who at their concept album best and the Ramones at their bluntest. It was a beast of a record, with 13 songs – two of which had five distinct movements each – taking in almost an hour. And it was the qualities that once would have been anathema to the band, such as grandeur and thematic ambition, that knotted it together and made the songs move from fictional characters to catching the tenor of the times.

American Idiot was a long way from the truncated pop-punk diatribes that had elevated the band from all-ages punk clubs to the top of the charts in 1994 with their third album, *Dookie*, but *American Idiot* stayed true to the band's lineage. Bassist Mike Dirnt and drummer Tre Cool remained a righteous rhythm section, turning a pummelling into a pleasure on the likes of the firebrand anthem

'St. Jimmy' and that major inducement to the hips that is 'She's a Rebel'.

The 'Homecoming' suite began with Dirnt recording a brief song by himself, and when Cool and guitarist/vocalist Billie Joe Armstrong cut their own efforts, competition gave way to cohesion and Green Day found

TRACKLISTING

01 **American Idiot**

02 **Jesus of Suburbia**
 I. Jesus of Suburbia
 II. City of the Damned
 III. I Don't Care
 IV. Dearly Beloved
 V. Tales of Another Broken Home

03 **Holiday**

04 **Boulevard of Broken Dreams**

05 **Are We the Waiting**

06 **St. Jimmy**

07 **Give Me Novacaine**

08 **She's a Rebel**

09 **Extraordinary Girl**

10 **Letterbomb**

11 **Wake Me Up When September Ends**

12 **Homecoming**
 I. The Death of St. Jimmy
 II. East 12th St.
 III. Nobody Likes You
 IV. Rock and Roll Girlfriend
 V. We're Coming Home Again

13 **Whatsername**

that they could deploy everything they'd absorbed – whether it was '80s underground hardcore or Kinks-like melancholy. When they slowed the pace, resonance grew up out of the silence and clear-headed imagery. 'Summer has come and passed/The innocent can never last,' Armstrong sang on 'Wake Me Up When September Ends', and the tune's heartbreak beat gave the album's rock opera characters a weary believability.

The sparkplug frontman traded in broad sentiment on *American Idiot* – 'this dirty town was burning down in my dreams,' he declares on 'Are We the Waiting' – but the palpable intent and often ferocious flourishes bridged cliché and allowed personal meaning to seep into the images. 'I walk alone' was the repeated hook from 'Boulevard of Broken Dreams', but through the song, and the rest of the album, Green Day found a rallying cry that would result in cathartic scenes on the subsequent touring.

And Armstrong didn't hesitate to call his shots. The album was released little more than a month before George W. Bush, – at the height of his 'Mission Accomplished' propaganda – crushed John Kerry in the 2004 US Presidential election. If there was a genuine opposition at the time it was Armstrong, who excoriated the Republican administration from the blitzkrieg opening title track onwards. With visceral songs that piled up on each other, so that the winning 'Extraordinary Girl' cut straight to the charging 'Letterbomb', Green Day made sense of a strange and troubled time. *American Idiot* was the friend who kept you on your feet until you were ready to pogo on your own.

N°:50

THE DOORS
THE DOORS

Elektra
Produced by Paul A. Rothschild
Released: January 1967

On the evening of 26 August 1966 the Doors nervously assembled to record their first album at Sunset Sound Recorders. They could not have imagined what a fuss that record would cause. 'On the first album, Elektra didn't want to spend much,' said Jim Morrison. 'Some of the songs [on *The Doors*] took only a few takes.' The Doors were not even the most popular band on the Sunset Strip at the time. Columbia records had already signed and dropped them. Caution was warranted.

Essentially the Doors' debut was based on their live act. Ray Manzarek on keyboards, Robby Krieger on guitar and drummer John Densmore came from jazz and R&B backgrounds but meshed together for a sound that had a sleazy undertow but flashy filigree. They agreed that a bass player would make them sound like the Animals or a million other bands so they eschewed bass (session man Larry Knechtel does play on some of these tracks). Their wild card in every sense of that phrase was Jim Morrison who was sexy and unpredictable, had the mind of a poet and the best rock & roll voice since Elvis Presley.

And the songs were something else. Their first hit single was 'Light My Fire', a song by Krieger. 'Up until then the Doors were doing three-chord type songs that were pretty simple like "I Looked at You" or "End of The Night". I wanted to write something more adventurous,' says the guitarist. 'I decided I was going to put every chord I knew into this song and did!

There's about 14 different chords in there. We said, Let's do it like Coltrane, A minor to B minor like he did on "My Favourite Things". As we played it over the next year the solos got longer and longer. It was very organic.'

The Doors were careful about showing their influences. Morrison, like every other poet on the Strip, dropped the names of the Beats and French writers. For the album they chose to cover Brecht and Weill's 'Alabama Song' and also Howlin' Wolf's 'Back Door Man', representing the heart and the head of rock music.

The album opens with 'Break on Through' which was Jim Morrison's roadmap to the

TRACKLISTING

01 **Break on Through (To the Other Side)**
02 **Soul Kitchen**
03 **The Crystal Ship**
04 **Twentieth Century Fox**
05 **Alabama Song (Whisky Bar)**
06 **Light My Fire**
07 **Back Door Man**
08 **I Looked at You**
09 **End of the Night**
10 **Take It as It Comes**
11 **The End**

palace of wisdom via the road of excess. According to producer Paul Rothschild there was some LSD consumption during the sessions and this song certainly fits with the contemporary psychedelic ideology.

Most striking and memorable was 'The End', a long improvisation around a poem by Morrison that gets into the head of a madman who kills his family and rapes his mother. Who knows where the inspiration came from? Whether Morrison was picking up on the speed freak vibes on the mean streets of Los Angeles or whether he had really seen into the zeitgeist and could tell that horrors like the Manson family were coming down the line, we'll never know. In any case, it's a tour-de-force performance, done in two takes.

As producer Rothschild recounts: 'We were about six minutes into it when I turned to Bruce [Botnick, the engineer] and said "Do you understand what's happening here? This is one of the most important moments in recorded rock & roll". When it was done, I had goose bumps from head to toe.'

The combination of Krieger's complex pop masterpiece 'Light My Fire' and the dark weirdness of 'The End' considerably expanded the parameters of what a rock album could do and it set up the Doors for the strange days ahead. As Morrison claimed, 'maybe you could call us erotic politicians. We're a rock & roll band, a blues band, just a band ... but that's not all.'

DAVE GROHL ON GEORGE HARRISON

His quiet sensitivity always seemed so noble. His songs seemed sweeter and deeper than the rest. He was the secret weapon.

Dave Grohl (Nirvana/Foo Fighters)

EDDIE VEDDER ON THE RAMONES

They obliterated the mystique of what it was to play in a band. You didn't have to know scales – with the knowledge of two barré chords you could play along with their records and that's what people did … Within weeks they were starting bands with other kids in town who were doing the same thing.

Eddie Vedder (Pearl Jam)

MICHAEL STIPE ON *HORSES*

I bought Patti Smith's first album on the day it came out in 1975. I was 15 years old. I sat up all night listening to it and eating a bowl of cherries and in the morning I threw up and went to school with the idea in my fifteen-year-old head that that was what I was going to do with my life … [*Horses*] pretty much tore my limbs off and put them back in a different way … The song 'Birdland', I think it's the third track, it's about a boy whose father has died and he imagines his father coming down in a spaceship to take him away to another place. It's a beautiful song … She is such an influence and such an unbelievable force in music …

Michael Stipe (R.E.M.)

CHRIS FRANTZ ON THE RAMONES

The Ramones were like a punch in the stomach … They were extraordinary both in the musical way and in their look. In the days of glam-rock they were savage and extreme and in the days of the long suites they hit them with two-minute songs.

Chris Frantz (Talking Heads)

ZACK DE LA ROCHA ON *HORSES*

The opening to 'Gloria' might be one of the greatest moments in American music.

Zack de la Rocha (Rage Against the Machine)

SIR PETER BLAKE ON *KIND OF BLUE*

It's still remarkable. It's timeless. It relaxes me. But above all it makes you feel hip. It's so cool.

Sir Peter Blake (artist, designer of Sgt. Pepper's album cover)

BONO ON *BORN TO RUN*

Here was a dude who carried himself like Brando, Dylan, and Elvis. If John Steinbeck could sing; if Van Morrison could ride a Harley Davidson. But he was something new, too. He was the first whiff of Scorsese – the first hint of Patti Smith, Elvis Costello, and the Clash. He was the end of long hair, brown rice, and bell bottoms. He was the end of the 20-minute drum solo. It was goodnight Haight-Ashbury, hello Asbury Park.

GRAHAM COXON ON *ABBEY ROAD*

Abbey Road came out the year I was born – 1969. They had got through their problems with The White Album and *Let It Be*, and this was a really great goal after two deflections. McCartney's singing is amazing, much better than Lennon's. McCartney was just as avant-garde, but he was exploring it rather than mouthing off about it. Graham Coxon (Blur)

QUINCY JONES ON *KIND OF BLUE*

That [*Kind of Blue*] will always be my music, man. I play *Kind of Blue* every day – it's my orange juice. It still sounds like it was made yesterday. Quincy Jones (producer)

JULIAN CASABLANCAS ON *THE DOORS*

The Doors changed my life. I heard it and I could understand what was happening musically. I had a sense I could do something like that. It just triggered something. Holding on to that feeling has been important.

Julian Casablancas (the Strokes)

NICK HORNBY (AUTHOR) ON BRUCE SPRINGSTEEN

I'd like my life to be like a Bruce Springsteen song. Just once.

N°: 51

PINK FLOYD
THE DARK SIDE OF THE MOON

Harvest
Produced by Pink Floyd
Released: March 1973

Drummer Roger Mason described Pink Floyd's masterpiece in terms of an air crash. 'You need a whole bunch of things to go wrong before you actually get the accident,' he explained. 'The lyrics are very important, but the music is important as well, and so are the sound effects, the voices, the concept, the fact that these ideas are rolled into one. There's a bit of avant garde, a bit of rock & roll. You've probably got five different things that work for it.'

Pink Floyd started in 1965 playing psychedelic blues. After three years they had released their first hit 'See Emily Play' and founder Syd Barrett had gone mad. He was replaced by guitarist David Gilmore and the group settled into prog grooves which they described as 'epic sound poems' and others called 'a blues band with alarm clocks'. In 1971 bassist Roger Waters proposed a concept album.

'The concept was originally about the pressures of modern life – travel, money and so on,' Mason said. 'But then Roger turned it into a meditation on insanity.' Waters had long been haunted by the death of his father during the war and the recent breakdown of his friend Barrett. He threw himself into the lyrics for the album and much of its intensity comes from Waters.

'You make choices during your life, and those choices are influenced by political considerations and by money and by the dark side of all our natures,' says Waters describing his lyrics. 'So when I say, "I'll see you on the dark side of the moon", what I mean is, "If you feel that you're the only one ... that you seem crazy 'cos you think everything is crazy – you're not alone".'

Pink Floyd spent 38 days in the studio recording *Dark Side*, but while the album was in progress they road-tested the whole album in a month of concerts called 'Dark Side of the Moon – A Piece for Assorted Lunatics'.

The band launched themselves enthusiastically into not only writing the music but also suggesting production ideas and sound effects.

TRACKLISTING

01 **Speak to Me**

02 **Breathe**

03 **On the Run**

04 **Time (includes 'Breathe (Reprise)')**

05 **The Great Gig in the Sky**

06 **Money**

07 **Us and Them**

08 **Any Colour You Like**

09 **Brain Damage**

10 **Eclipse**

Noises of clocks, heartbeats, cash registers and random snippets of dialogue became an integral part of composition. They experimented with synthesisers, which were just starting to come into use. Keyboardist Richard Wright had a piece left over from the band's soundtrack for the film *Zabriskie Point*, which became 'Us and Them' and 'The Great Gig in the Sky'. Session singer Clare Torry improvised a breathtaking wordless vocal on this track that complemented the often cold electronica elsewhere on the album.

Obsessed with sound, the band mixed the record as a quadraphonic album (for four speakers rather than two). 'Hi-fi stereo equipment had only recently become a mainstream consumer item,' recalled Mason. '*Dark Side* became one of the definitive test records that people could use to show off the quality of their hi-fi system.' It was also highly regarded as a record to get stoned to.

On its release, *The Dark Side of the Moon* went from being an album to a phenomenon. It became the biggest selling record in history at that time and remained on the charts for the rest of the decade.

'We struggled and sweated and argued and fought over every bar, all the way through the whole album,' says Gilmore. 'We really, really worked to get as near to perfect as we could get it. Our music has depth, and attempts philosophical thought and meaning with discussions of infinity, eternity and mortality.'

Nº: 52

JAMES BROWN
LIVE AT THE APOLLO

King
Produced by James Brown
Released: May 1963

One of the greatest live albums ever made was cut on a Wednesday night and paid for by the artist, because his sceptical label didn't see the commercial benefit in putting out a record that didn't have a new single on it. Syd Nathan, the founder of King Records, was famously wrong, but it's worth bearing those circumstances in mind. On 24 October 1962, when *Live at the Apollo* was cut in front of approximately 1500 deliriously elevated fans, James Brown had a lot to prove. Legend and critical acclaim, let alone national recognition, had not yet been conferred on him, but much of it would come when this set – a pocket battleship of soul classics running all of 31 minutes – was released.

'So now ladies and gentlemen, it is Star Time. Are you ready for Star Time?' asks the MC, Fats Gonder, by way of introduction, and the massed horns of the James Brown Band provide stings to illustrate every stoking of the audience's fire for the appearance of 'Mr. Dynamite'. A lesser artist might have held his musicians back, but Brown wasn't short on confidence, and when he finally took the stage the audience's approval was clear. 'You gotta live for yourself, yourself and nobody else,' the then 29-year-old pledges on the first song, 'I'll Go Crazy', and it soon sounds as if the fans are ready to follow Brown and his backing band wherever they take them.

Live at the Apollo not only gave Brown national prominence in America, it also made clear the arrival of soul music. In 1962 Motown and Stax were just hitting their stride, while future titans such as Marvin Gaye and Otis Redding were still neophytes. Soul had grown out of traditional gospel and 1950s R&B, and it combined the devotion of church music and the looming desires of secular grooves. With his mastery of the call and response style and his seditious tone – 'I wonder if you know what I'm talking about,' Brown wails on the slow burn seduction of 'Lost Someone' – Brown was the preacher ready to minister to more than just souls.

TRACKLISTING

01 **Introduction to James Brown**
02 **I'll Go Crazy**
03 **Try Me**
04 **Think**
05 **I Don't Mind**
06 **Lost Someone**
07 **Medley: Please, Please, Please/ You've Got the Power/I Found Someone/Why Do You Do Me/I Want You So Bad/I Love You, Yes I Do/Strange Things Happen/ Bewildered/Please, Please, Please**
08 **Night Train**

He's helped immeasurably by backing vocalists the Famous Flames, who cushion and caterwaul as require, and a backing band 14-strong on the night, who had been honed by years on the road with their fearsomely disciplined leader. Individual members shine through, whether it's the alternately sighing and slashing guitar chords of Les Buie or the rousing rhythm that Clayton Fillyau produces for the intoxicating 'Think'. But what resonates is their unison of action. The Famous Flames could change direction on a pinhead and on the famous, exhausting medley, where 'Please, Please, Please' serves as bookends for the various truncated tunes, they embrace the deep groove of late night devotion and raucous deliverance.

You can't see what Brown, a legendarily physical performer, was doing on that Wednesday night, but the audience's response – not hysterical, as the Beatles would hear two years later in America, but excited to the point of surrender, as if they can't possibly handle another refrain or demand for affection – and the wordless physical punctuation of Brown's expressive voice make it all easy to imagine. By the closing number, a ferocious rendition of the hit 'Night Train', the Macon, Georgia singer and his band are the combustible definition of soul music. James Brown would return to the Apollo for future live albums, adding heavy funk to his arsenal, but he would never top the original *Live at the Apollo*.

N^o: 53

CREEDENCE CLEARWATER REVIVAL
COSMO'S FACTORY

Fantasy
Produced by John Fogerty
Released: July 1970

Cosmo's Factory was the third #1 album that Creedence Clearwater Revival released in the space of 12 months. The neo-industrial title must have seemed apt. The San Franciscan quartet (John Fogerty on vocals, keyboards and guitar; Tom Fogerty on rhythm guitar; Stu Cook on bass and Doug 'Cosmo' Clifford on drums) was an anomaly at the time. They were a genuine working class rock & roll band, which had been playing local bars since the late 1950s. When flower power swept through the Bay Area in the mid-1960s, Creedence were still wearing flannelette shirts and singing about the swamps in Louisiana. The 'factory' was their rehearsal space.

There are two keys to Creedence. The first is their long apprenticeship. They built up a substantial repertoire of rock & roll and blues standards and, like the Beatles, this informed and improved their own songs when they started coming. The other key is John Fogerty. Ambitious to the point of obsessive, Fogerty slaved over songs, measuring himself against the legends whose songs he covered. 'Every night I worked on writing songs from about 9 o'clock until about 4 o'clock in the morning,' he said. 'I had a routine that went on for about two years. All the songs weren't great. But the music was coming really quickly, and it was really good. There was so much stuff at a really high level.' Not since Chuck Berry

and the early Beatles had anyone produced a stream of short, sharp, classic rock & roll songs. Fogerty applied the same perfectionism to his instrument and he demanded the same from the rest of the band.

'For me, a great rock & roll record must include these elements,' Fogerty said. 'First, it has a great title. No. 2, it has a great sound. I tried like crazy to come up with great guitar hooks to fashion a record around. I think that's why the stuff is so popular. It's easy to listen to, it's simple to play, and it sounds real good in a simple setting. You don't need a lot of equipment. It becomes magical even

TRACKLISTING

01 **Ramble Tamble**
02 **Before You Accuse Me**
03 **Travelin' Band**
04 **Ooby Dooby**
05 **Lookin' Out My Back Door**
06 **Run Through the Jungle**
07 **Up Around the Bend**
08 **My Baby Left Me**
09 **Who'll Stop the Rain'**
10 **I Heard It Through the Grapevine**
11 **Long as I Can See the Light**

if you're in a bar in Winnemucca, which, believe me, I have heard.'

Like the Band's Robbie Robertson, Fogerty went deep into the mythology of America to create his own world, based in the swamps of the South. The albums *Green River*, *Bayou Country* and *Willie and the Poor Boys* all had their mysteries and legendary characters.

Cosmo's Factory features tributes to the masters – Roy Orbison ('Ooby Dooby'), Elvis ('My Baby Left Me') and Bo Diddley ('Before You Accuse Me'). Then Fogerty drops a bunch of his own classics – 'Travelin' Band', 'Up Around the Bend', 'Lookin' Out My Back Door' – each of them under three minutes. He goes back to the swamp for 'Run Through the Jungle' and stretches out for the seven-minute 'Ramble Tamble'. The real epic on the album is their version of Marvin Gaye's 'I Heard It Through the Grapevine', which is 11 minutes of glorious jamming that completely transforms the soul song into a different kind of masterpiece. Many long guitar solos were recorded at the turn of the 1970s but few have lasted as well as this.

Recorded almost entirely in a month, *Cosmo's Factory* showcases all of Creedence's strengths. 'It may actually be our best record,' Fogerty said. 'I always thought it was the culmination. By that time, Creedence had all these records and we looked back and put everything on it. It was almost redemptive, you might say.'

Nº 54

PEARL JAM

VS.

Epic
Produced by Brendan O'Brien and Pearl Jam
Released: September 1993

'Escape is never the safest place,' howls Eddie Vedder on 'Dissident', and the Seattle five-piece's acclaimed second album would bear out his belief. Having found themselves as a leading light of the grunge movement with the success of their 1991 debut *Ten*, the band recoiled at their own success and the perception that they were the commercially acceptable sound of the Pacific Northwest in the face of Nirvana's volatile angst. By the time they got to recording at the Site, an out of the way Californian studio, they were done with MTV, commercial obligations and their own profile.

But *Vs.* is not an album that sets out to tear down Pearl Jam from within; there's not even a whiff of wilful self-destruction. Instead it's the sound of a band going in pursuit of what they want and ignoring outside expectation. The five-piece – frontman Vedder, guitarists Stone Gossard and Mike McCready, bassist Jeff Ament and drummer Dave Abbruzzese – go to extremes on a record that would sell almost 1 million copies in America alone during its week of debut, and if they were capable of everything from acoustic folk to seething funk rock and ground zero rock & roll, then the unifying elements would be complete commitment and a commensurate level of passion.

By the time Pearl Jam were deep into recording *Vs.*, Vedder was sleeping rough in his truck and exuding an intensity that would find its way into the finished tracks. The first song, 'Go', literally begins with the band warming up, all feints and flickers, but once the instrumentation explodes it is Vedder that harnesses it. He bookends a quicksilver guitar solo with tight, sparse lines: 'Never acted up before, don't go on me now', and just when he sounds boxed-in the sound segues into the roiling funk-inflected rock of 'Animal', where he ties the song together with his vocal authority.

Pearl Jam's roots stretched back to Seattle's Green River in the middle of the 1980s, when Gossard and Ament had been paired with half of Mudhoney, but on *Vs.* they had the breadth of a rock & roll band barely aware of genre

TRACKLISTING

01 **Go**
02 **Animal**
03 **Daughter**
04 **Glorified G**
05 **Dissident**
06 **W.M.A.**
07 **Blood**
08 **Rearviewmirror**
09 **Rats**
10 **Elderly Woman Behind the Counter in a Small Town**
11 **Leash**
12 **Indifference**

rules. Like the Who, a major influence on Vedder, they could render personal unease as public catharsis, and they made the most of their twin guitar attack – with Gossard the clipped, efficient rhythm hand and McCready adding livewire lead breaks. They could rumble buildings on the likes of 'Blood', but step aside on the roiled, percussive 'W.M.A.', one of several Vedder lyrics that gave voice to outcasts and minorities pushed to the brink.

At the same time there were classic examples of storytelling, clearly tied to the folk-rock stream. The warm, uplifting strum of 'Daughter' reveals a child with a learning disability who is abused by her parents as their frustration gives way to anger, and it builds and abates with melancholic precision, while 'Elderly Woman Behind the Counter in a Small Town' sketches the hardy fixture in a hamlet with sympathy and insight. 'I changed by not changing at all,' the track reveals with concise grace, and that tells you everything you need to know about the ageing protagonist.

But it was in the middle of the record that Pearl Jam captured the essence of *Vs.* with 'Rearviewmirror'. From the opening guitar riff the song coils up and seethes with energy as Vedder describes the feeling of being trapped, even as his bandmates prepare his exit. A lead line edges up beside the vocal and then abates during the song's breakdown, but when the chorus surges the electrifying guitar signal reappears. It sounds, as Pearl Jam do on much of this album, emphatic and totally undeniable.

N°:55

THE WAILERS

BURNIN'

Tuff Gong/Island
Produced by Chris Blackwell and the Wailers
Released: October 1973

Had it not been for two men, reggae music would never have left Jamaica. Chris Blackwell, the owner of Island Records, loved reggae but believed that this rebel music needed a leader and that man was Bob Marley. A young Jamaican whose early years in the US attuned him to soul music, Marley was a Rastafarian on a mission for social justice and the sanctity of marijuana.

The Wailers originally referred to the vocal trio of Marley, Peter Tosh and Bunny Livingston. They were joined by keyboardist Earl 'Wire' Lindo and the Barrett brothers: bassist Aston 'Family Man' and drummer Carlton, one of the greatest-ever rhythm sections. So much of reggae depends on the bass and Family Man wrote the manual. 'The Wailers was the best vocal group and I group was the best little backing band at the time,' Family Man recalled. 'So we say, "Why don't we just come together and smash the world?"'

The Wailers had recorded a collection of long jams ideal for the Jamaican market. Blackwell and Marley then edited the original tapes to shape these grooves into songs. The result was the *Catch a Fire* album and the word spread in the UK about a new sound. *Burnin'* followed *Catch a Fire* and the titles tell the tale.

The album opens with a call to arms: 'Get Up Stand Up', co-written by Marley and Tosh. It's followed by 'Hallelujah Time', and then the song that would make Marley a household name, 'I Shot the Sheriff'. 'That message is a kind of diplomatic statement,' Marley said. 'I shot the sheriff is like I shot wickedness. That's not really a sheriff, it's just the elements of wickedness. But the elements of that song is people been judging you and you can't stand it no more and you explode, you just explode.' When Eric Clapton covered the song the following year he had a global hit.

Be that as it may, the Wailers were calling for revolution by any means necessary. In 'Burnin' and Lootin' they sing 'How many rivers do we have to cross/Before we can talk to the boss?', a slap in the face to Jimmy Cliff's 'Many Rivers to Cross'. Marley had that messianic quality and he knew it. 'I was at Harry J's,' Island's Richard Williams recalled. 'I was prepared to find someone talented, because I knew the records, but it quickly became obvious that Bob simply was Marvin Gaye or Bob Dylan, or both.'

Burnin' was also a nod to the past. 'Duppy Conqueror', 'Small Axe', 'Put It On' and 'Pass It On' are re-recordings of songs the Wailers had played around Jamaica for years. When not planning the overthrow of the ruling class, the Wailers grooved on 'herb', an irresistible combination of themes in the 1970s. It was a transitional period for the Wailers; Marley started to dominate the group and this was the last album to feature Tosh and Livingston. But there is a strength of purpose here that was the bedrock for reggae.

It was a whole new sound, as Robert Christgau wrote: 'This is as perplexing as it is jubilant – sometimes gripping, sometimes slippery. It's reggae, obviously, but it's not mainstream reggae, certainly not rock or soul, maybe some kind of futuristic slow funk.'

N°:56

THE MONKEES
HEADQUARTERS

Colgems/RCA
Produced by Chip Douglas
Released: May 1967

Once loudly decried as the Pre-Fab Four, the Monkees now appear in a completely different light. The Beatles rewrote pop music by being not only fab but also able to write and play their own material. Using songwriting genius from Tin Pan Alley and virtuoso session players was suddenly no longer authentic. In 1966 show business struck back, taking the image the Beatles created in *Help!* and creating a TV show with four mop tops singing songs written by the best writers and played by the best players. A series of perfect pop records ensued but they were tainted as not being 'credible' or 'authentic'. Now, four decades on, the workings of show business have been laid bare and creditability is more laughable than any episode of *The Monkees*. Now we know that Carole King is a genius and that the people playing on records by the Byrds and other righteous combos were the same people doing the Monkees' sessions. Now that the tents have all been struck and the caravan has moved on all we have is the music.

No-one felt the stigma more acutely than the Monkees – Peter Tork, Davy Jones, Mike Nesmith and Micky Dolenz. And so it was that Nesmith scorned a $250,000 cheque from music director Don Kirshner and smashed his fist through a Beverly Hills Hotel wall as the Monkees demanded to be allowed to be a real group. Kirshner was fired and then he went on to create the Archies – a band that, being cartoons, couldn't talk back.

'*Headquarters* was our record. At that point we behaved like a musical group,' said Tork. Producer Chip Douglas was enlisted to help fulfil the band's vision and to play a bit of bass. Otherwise the instruments are almost entirely played by the Monkees.

Two tunes came from Boyce and Hart – the team behind *The Monkees* theme song. Mann and Weil provided 'Shades of Grey' and Hildebrand and Keller offered 'Early Morning Blues and Greens'. The latter two

TRACKLISTING

01 **You Told Me**
02 **I'll Spend My Life with You**
03 **Forget That Girl**
04 **Band 6**
05 **You Just May Be the One**
06 **Shades of Gray**
07 **I Can't Get Her off of My Mind**
08 **For Pete's Sake**
09 **Mr. Webster**
10 **Sunny Girlfriend**
11 **Zilch**
12 **No Time**
13 **Early Morning Blues and Greens**
14 **Randy Scouse Git**
 (aka 'Alternate Title')

songs ventured towards country and it's been suggested that with *Headquarters* the Monkees prefigured the explosion of country that was to occur in coming years.

While not always to the standard of their early material, the Monkees proved themselves capable composers. Mike Nesmith's 'You Just May Be the One' is a fine piece of writing. His 'Sunny Girlfriend' is a gem that would have been a hit on the country charts. Peter Tork's 'For Pete's Sake' is a wonderful Aquarian song and although the lyric now seems a little dated, the tight arrangement and playing are not. 'Zilch' features random lines run together, prefiguring the music concrete that the Beatles would soon explore on 'Revolution #9'. Then there is the band-composed rave up of 'No Time', which is as good as any garage rock from the period. The best is kept for last. 'Randy Scouse Git' was written by Dolenz after a visit to London where he met the Beatles ('the four kings of EMI'). In the space of two minutes he encapsulates the turmoil of the '60s; from pop royalty to the generation gap and it rocks.

'The thing about the Monkees is we were a project, a TV show, a record-making machine,' said Peter Tork, coincidentally describing how most pop music is made in the 21st century. 'The four of us were just the front. At the same time, we were the Monkees. It was a unique phenomenon, to be a member of a group that wasn't really a group and yet was a group.'

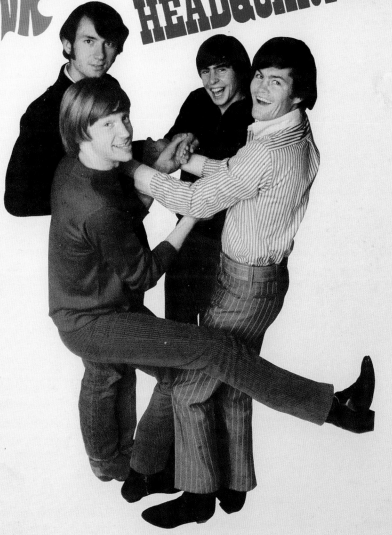

COLGEMS

COM-103

N°: 57

TALKING HEADS
REMAIN IN LIGHT

Sire
Produced by Brian Eno
Released: October 1980

It was an album of great synthesis, where new wave and African music found a startling union and the lyrics suggested a new way of looking at the anxiety of superpower citizens, but it was made in a totally out-of-sorts way. There were arguments about credits, the bassist thought the singer was a control freak, the producer initially wasn't keen to return to the fold, and recording engineers bridled at what was demanded of them. But as David Byrne, the singer and lyricist of Talking Heads, would bray on 'Crosseyed and Painless' – one of the efficient and arresting tracks on *Remain in Light* – 'Facts are simple and facts are straight/ Facts are lazy and facts are late'.

Remain in Light is a strangely beautiful album, a groundbreaking work that suggested that after 1976's cataclysmic uprising the best popular music didn't have to be insular and cut-off. It's intellectual dance music, inclusively made for the hips and the head, and just when you think that one side has won out the other reasserts itself. On 'The Great Curve' an urgent Afrobeat, illuminated with a quicksilver guitar figure, provides an irresistible foundation, before a skewered, dive-bombing guitar break punctuates an incantatory lyric about female deliverance. Like many of the tracks collected here, the world looks off-kilter or redrawn after the song has been your soundtrack.

It was the fourth album for Talking Heads – Byrne, drummer Chris Frantz, bassist Tina Weymouth and guitarist Jerry Harrison – and it capped their rapid evolution. They'd been the technocrats of New York punk, more dada than danger, on *Talking Heads: 77*, catchy and eclectic on 1978's *More Songs About Buildings and Food*, and trying to find a middle ground between soundscapes and disco on 1979's *Fear of Music*. After the latter there had been individual projects, and no-one was quite sure how to begin again as a band. The solution was to be a new band, putting aside the notion of musicians backing the iconic Byrne, and jamming arrangements first instead of writing music to pre-existing lyrics.

It was the band's third album with producer Brian Eno, and while there would be subsequent debate about his presence in the songwriting credits (the one complex thing about the record that doesn't appear deceptively simple), it was the former Roxy Music maven who introduced sampling and loops of chords. On a track like 'Once in a Lifetime', the album's initially unsuccessful single, there's an energy borne of repetition that rises to the transcendent as it's defined by the clipped, minimal bassline and keyboard shimmer.

Alternating between questions about the vagaries of a mercantile society and affirmations of nature's primacy ('same as it ever was,' repeats Byrne), encapsulated Byrne's lyrical approach, living with the rhythms until the sounds he was singing to them became lyrics. Words poured out of Byrne – whether as a monotonal confession on the sci-fi funk of 'Seen and Not Seen' (a song that foretells modern celebrity culture's addictive hold on the public), or racing to the surface with lines bubbling up, as on 'House in Motion'.

Crucial guests helped complete the record, with Nona Hendryx (who Harrison had just produced an album for) singing harmonies, while guitarist Adrian Belew ranged across the tracks like an errant transmitter. But for all the discord, it was a triumph for the four members of Talking Heads, who cut their best album even as they were fracturing as a group. It would take them three years to complete another studio record, but the wait didn't matter when it was the price paid for *Remain in Light*.

TRACKLISTING

01 **Born Under Punches (The Heat Goes On)**

02 **Crosseyed and Painless**

03 **The Great Curve**

04 **Once in a Lifetime**

05 **Houses in Motion**

06 **Seen and Not Seen**

07 **Listening Wind**

08 **The Overload**

TALKINGHEADS

REMAIN IN LIGHT

Nº: 58

ROD STEWART
EVERY PICTURE TELLS A STORY

Mercury
Produced by Rod Stewart
Released: May 1971

'We had no preconceived ideas of what we were going to do,' said Rod Stewart in a typically disingenuous summation of the making of *Every Picture Tell a Story*. 'We would have a few drinks and strum away and play. That whole album was done in 10 days, two weeks …' The album does sound rough and ready, almost sloppy. A couple of tunes seem like afterthoughts and one track is pilfered from Stewart's 'day job' band, the Faces. But the reality is that there's a fierce ambition at work here that makes the complex look effortless and disguises the extraordinary leaps this album takes. Stewart blends traditional English ballads to American folk tunes, an obscure Bob Dylan track and then some blistering R&B and a timeless mid-tempo ballad into a seamless whole.

By early 1971, when this album was begun, it was three years since Stewart had given up grave digging and soccer to be a professional singer. He had made two acclaimed albums (*Truth*, *Beck Ola*) as singer for the Jeff Beck Group and two well-received solo LPs and he was the singer with the Faces. He was match fit. The team was well selected: drummer Mickey Waller, whose style was referred to as 'the Waller Wallop', was a devotee of Buddy Rich. The bass player was Ronnie Wood, who had become Stewart's best mate. Guitarist Martin Quittenton and pianist Pete Sears rounded out the core ensemble.

The title track opens with acoustic guitar that crashes into one of Stewart's best and most honest lyrics: 'Spent some time feeling inferior/ Standing in front of my mirror/Comb my hair in a thousand ways/But I came out looking just the same'. Loosely autobiographical, it's the story of an innocent abroad told with self-deprecating humour. But the key to its charm is Waller's drums, rolling like a thunderstorm. He pounds out the beat and then lets fly with manic fills, always keeping the mood reckless and carefree, building the pace and then dropping away.

Another Stewart classic starts the album's second side. 'Maggie May' is an anecdote from Stewart's youthful odyssey, the story of a young man seduced by an older woman. The singer dispenses with his usual bravado and laddish wordplay and delivers this song perfectly straight and it's impossible not to be moved. The track is dominated by Quittenton's guitar until the coda when Ray Jackson's mandolin

TRACKLISTING

01 **Every Picture Tells a Story**
02 **Seems Like a Long Time**
03 **That's All Right**
04 **Amazing Grace**
05 **Tomorrow Is a Long Time**
06 **Henry**
07 **Maggie May**
08 **Mandolin Wind**
09 **(I Know) I'm Losing You**
10 **Reason to Believe**

comes in and elevates things further. Stewart follows, and maybe even tops 'Maggie May' with 'Mandolin Wind'. As Nick Hornby wrote, '"Mandolin Wind" is as tender and generous-spirited as anything by any of those bedsit people, and a good deal less soppy'.

Stewart's great talent in those days was his ability to judge a song. He said at the time, 'I look for a song that's probably been forgotten, that no one's done for a long time. Something that can fit my voice so I can sing it right, and something with a particularly strong melody.' He found Bob Dylan's 'Tomorrow Is a Long Time' on an obscure folk album and he found new melodies in the song that not even Dylan realised were there. He tackles 'Amazing Grace' and makes it his own, thanks in large part to breathtaking guitar work from Sam Marshall, and his take on Arthur 'Big Boy' Crudup's 'That's All Right' matches Elvis Presley's. There are also a couple of well-chosen folk tunes, 'Seems Like a Long Time' and Tim Hardin's brilliant 'Reason to Believe'.

Just so you know that Stewart hasn't gone completely wet he includes a cover of the Temptations' '(I Know) I'm Losing You' recorded live at Olympic studios with the Faces. This is perhaps the Faces' finest moment (and it's not their album!). The sound is just huge; the ensemble playing is perfectly balanced right into Kenny Jones' drum solo and the battle between Wood and pianist Ian McLagen takes the song out.

Then they went to the pub.

N°: 59

DEVO
Q. ARE WE NOT MEN? A. WE ARE DEVO!

Warner Bros
Produced by Brian Eno
Released: August 1978

It took Devo two decades to earn Gold certification (500,000 units sold) in America for their 1978 debut, an album of the most uptight new wave music ever put on record, and that feels about right. A timespan of 20 years allows for successive generations of the curious, and those who refused to be cowed, to discover this still remarkable set. It continues to spread by word of mouth as its belief in the banal plasticity of mass culture only appears to grow stronger. *Q. Are We Not Men? A. We Are Devo!* still makes perfect sense which means that, while there's no joke, something is definitely still on us.

This is another Brian Eno production – he graces this book multiple times – and it's testament to the strength of Devo's vision that his input is felt so lightly. What Devo needed wasn't someone to remake them, just a producer who actually understood them. The group's gestation lay in Kent State University, where art theories underpinned the initial line-up that came together after the infamous campus shootings by National Guard members in 1970. Devo's early performances were humorously confrontational, and it's fairly certain that in the middle of the 1970s they were the most un-prog rock band on the planet.

The band's public image remains resolutely fixed in the song and attendant video clip for their 1980 hit 'Whip It' – the matching outfits, the viral synths and declamatory vocals, the flowerpot hats. But two years and two albums

earlier the band was mixing guitars, live drums and keyboards, making them a vital if unexpected part of the punk breakthrough. The band – frontman Mark Mothersbaugh, guitarist Bob Mothersbaugh, keyboardist Bob Casale, bassist Gerald Casale and drummer Alan Myers – shared the same surrealist humour as punk's instigators, but it played out in a completely different way.

'Got an urge, got a surge/And it's out of control,' Mark Mothersbaugh sings on the spiky 'Uncontrollable Urge'; but the cathartic never gets a look in on this album, where modern life is perceived as a force that saps and depletes the means of expression and pleasure. Part of Devo's genius is to pursue this idea of

TRACKLISTING

01 **Uncontrollable Urge**
02 **(I Can't Get No) Satisfaction**
03 **Praying Hands**
04 **Space Junk**
05 **Mongoloid**
06 **Jocko Homo**
07 **Too Much Paranoias**
08 **Gut Feeling/(Slap Your Mammy)**
09 **Come Back Jonee**
10 **Sloppy (I Saw My Baby Getting)**
11 **Shrivel Up**

being merely a cog in society's bland machine and turn it into a covert means of expression. On their cover of the Rolling Stones' '(I Can't Get No) Satisfaction' the libido is replaced by herky-jerky rhythms and Mothersbaugh's regimented squawk – the song isn't a pose, it's a statement of fact, and the more Devo pursued this the stronger they sounded.

Devo took their name from the theory of de-evolution, and it made for mordant social criticism, especially as they came up against middle American audiences. A riot was the furthermost thing from Devo's mind. Instead they put together the proto-industrial groove and eerie synths of 'Mongoloid' to describe the life of a man with Down Syndrome and suggest that his comparative happiness was a reflection of society's debilitating nature. On the caterwauling 'Jocko Homo', where the massed vocals sound like robots on the military parade ground, the group joyously announced 'we are not whole'.

The opening two minutes of 'Gut Feeling', a surging, quicksilver instrumental, is typical of their ability to surprise, and the restlessness of *Q. Are We Not Men?* extends to stylistic reliability. Devo will rarely be what you expect them to be. But once you fall into their way of thinking, their debut is a fascinating and incisive song cycle that sounds like a template for so much of what was to follow, even as the band dutifully swear that they're the end of the road. A dead end has never sounded so inspirational.

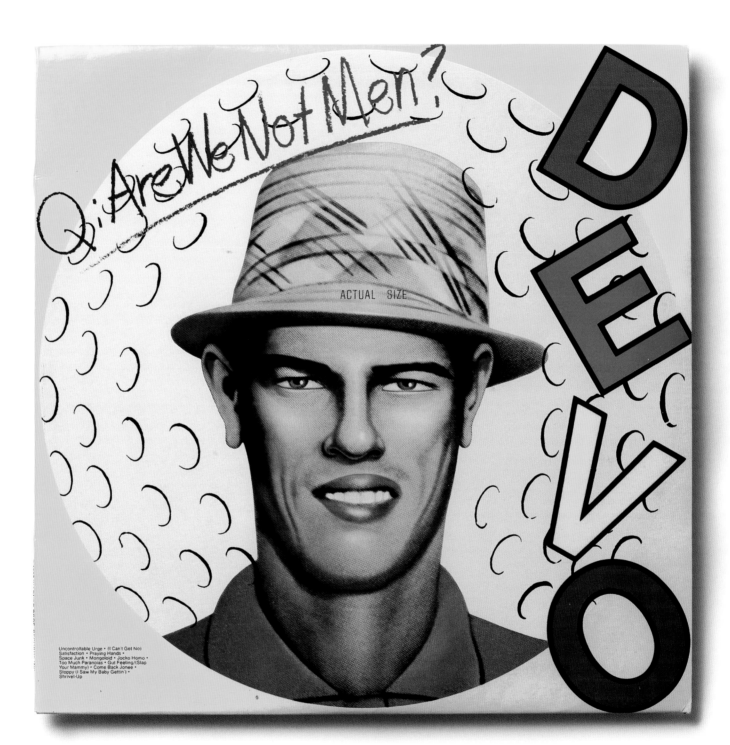

Q: Are We Not Men?

ACTUAL SIZE

DEVO

Uncontrollable Urge • (I Can't Get No)
Satisfaction • Praying Hands •
Space Junk • Mongoloid • Jocko Homo •
Too Much Paranoias • Gut Feeling/(Slap
Your Mammy) • Come Back Jonee •
Sloppy (I Saw My Baby Gettin') •
Shrivel-Up

Nº: 60

CHUCK BERRY
AFTER SCHOOL SESSION

Chess
Produced by Leonard and Phil Chess
Released: May 1957

You could argue about who invented it, but there's no disputing that Chuck Berry was the first rock & roll poet. Berry gave a language to the rock & roll generation and the standard he set in terms of humour, metaphor and metre is what shaped rock & roll music until the present day. According to Paul Simon, 'Chuck Berry was the first time that I heard words flowing in an absolutely effortless way – and not just cliché words. He had a very powerful imagery at his disposal.'

Berry, however, never intended to start a revolution. He wanted to be a blues singer like Muddy Waters. It was the Chess brothers, Leonard and Phil, who saw the potential in the blues 'Ida Red' and turned it into 'Maybelline'. Chuck was a quick student. Within months he was busy inventing or rewriting rock & roll. The tracks that make up *After School Session* are from Berry's first sessions at Chess. It's worth noting that Willie Dixon is credited on bass. Dixon had a hand in almost every great blues song to come out of Chicago and it's likely that he was the uncredited producer. Also in attendance, at least on 'School Days', was Hubert Sumlin, Howlin' Wolf's guitarist. Berry's other key ingredient was Johnnie Johnson whose stride piano style was the icing on all Berry's songs.

After School Session, Berry's first album and the second release from Chess Records, is not simply a compilation of hits. Rather than reinforcing the teen operas, this album tends towards Berry's blues roots. There's 'Wee Wee Hours' which was Berry's first pitch to the record company and here it's a showcase for Johnson's witty piano playing. Elsewhere there's the Latinate ballads 'Drifting Heart' and 'Havana Moon'. In 1957, Berry had not realised it was his destiny to create rock & roll. Over these dozen tracks you can see how he played with the blues to make something new.

'Downbound Train' is Berry's best blues and certainly not the stuff of teen dreams: 'The

TRACKLISTING

01 **School Days**
02 **Deep Feeling**
03 **Too Much Monkey Business**
04 **Wee Wee Hours**
05 **Roly Poly (aka Rolli Polli)**
06 **No Money Down**
07 **Brown Eyed Handsome Man**
08 **Berry Pickin'**
09 **Together (We'll Always Be)**
10 **Havana Moon**
11 **Downbound Train**
12 **Drifting Heart**

engine with blood was sweaty and damp/ And brilliantly lit with a brimstone lamp/And imps for fuel were shoveling bones/While the furnace rang with a thousand groans/The boiler was filled with lots of beer/The devil himself was the engineer'. The production is heavy on the echo but mostly it's a very dry, guitar-driven sound; you picture Chuck much as he is on the cover of this album, alone in the void.

Bob Dylan acknowledged that 'Subterranean Homesick Blues' is based on 'Too Much Monkey Business' – Berry's critique of modern America. It starts out with a guitar riff that's exactly like an alarm bell ringing. His complaints range across the usual – bad bosses, low wages, scheming women, duplicitous government – but the song goes further. The singer is fed up with the bill of goods on offer. It's the first protest song for this generation. The phrasing and the sentiment form one of the foundation stones of hip-hop.

Of course there are hits here. 'No Money Down' is a Muddy Waters style blues, and yet another song about cars, that Berry rocks away and brings his wit and his eye for detail to. 'Brown Eyed Handsome Man' is a song about racism done cleverly enough to get it played on Top 40 radio. And the album opens with 'School Days', the first high school anthem that has been endlessly adapted. And it features the classic lines: 'Hail, hail rock and roll/Deliver me from the days of old'. Exactly.

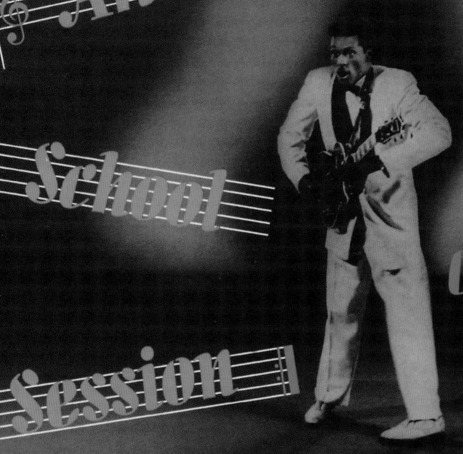

LARS ULRICH ON BLACK SABBATH

If there was no Black Sabbath hard rock and heavy metal as we know it today would look, sound and be shaped very, very differently. — Lars Ulrich (Metallica)

DAVE NAVARRO ON BLACK SABBATH

In Jane's Addiction, we were into a groove that was very repetitive, riff-oriented and hypnotic – similar in a lot of ways to a song like 'War Pigs', off of *Paranoid* (my favorite Sabbath album). And of course, both bands have a singer with a really high-end voice that cuts through all the chaos below. I'm still coming up with stuff that is a complete and blatant rip-off. There's just no escaping them.

Dave Navarro (Jane's Addiction)

WAYNE COYNE ON *THE DARK SIDE OF THE MOON*

When I was growing up in the 1970s, Pink Floyd were ever-present. My brothers and my older sister and all their friends constantly played records in their rooms while they smoked pot. Especially *Dark Side of the Moon*. You heard that every day of your life, for at least three or four years around then. Turning 14 years old is already a heavy combination of things. For *Dark Side of the Moon* to be playing in the background during that time was perfect. As you looked deeper into their music, everything you find out leads to something interesting. — Wayne Coyne (Flaming Lips)

JOHN LENNON ON CHUCK BERRY

Don't give me that sophisticated crap. Give me Chuck Berry.

HENRY ROLLINS ON *PARANOID*

You drive up to a house party on a winter night when it's too cold to stand outside. There are four guys standing outside on the porch drinking cold beer 'cause either they can't get into the party or they don't want to be in the party. Those are your Black Sabbath fans – the lonely stones, the ones that congregate and party in the woods, not at the dance. That's a Black Sabbath fan.

LITTLE RICHARD ON JAMES BROWN

I invented rock & roll. Jimi Hendrix was my guitarist. James Brown was my vocalist.

BRUCE SPRINGSTEEN ON CREEDENCE CLEARWATER REVIVAL

They were hits, and hits filled with beauty and poetry, and a sense of the darkness of events and of history, of an American tradition shot through with pride, fear, and paranoia. And they rocked hard. In the late '60s they weren't the hippest band. Just the best.

BONO ON *BURNIN'*

Here was this new music, rockin' out of the shanty towns, born from calypso and raised on the chilled-out R&B beamed in from New Orleans. Lolling, loping rhythms, telling it like it was, like it is, like it ever shall be. Skankin', ska, bluebeat, rocksteady, reggae, dub, and now raga.

IGGY POP ON *LIVE AT THE APOLLO*

The first time I heard him [James Brown] was on *Live at the Apollo* … He whacks you, and the band replies. Nothing is casual, but it doesn't sound forced or straitjacketed.

DAVE SITEK ON *REMAIN IN LIGHT*

When I was a kid, I was really into hardcore punk. Hardcore was very rigid. Talking Heads was the first band I remember telling my punk friends about, saying, 'Yo, check this out! This four-chord thing we're doing? We're missing out on something!' The first song I really liked was 'Once in a Lifetime.' MTV had just started to sink its claws into people, and that song was like an anthem for coked-up adults trying to make sense of their world.

Dave Sitek (TV on the Radio)

N°:61

EMINEM
THE MARSHALL MATHERS LP

Interscope
Produced by Dr Dre, Mel-Man, The Bass Brothers, Eminem and the 45 King
Released: May 2000

Eminem begins *The Marshall Mathers LP* the way he intends to go on: 'When I was just a little baby boy, my momma used to tell me these crazy things/She used to tell me my daddy was an evil man, she used to tell me he hated me/ But then I got a little bit older and realized she was the crazy one,' remembers the rapper. Madness, deceit, painful realisations that come with time – Eminem's third album starts here and then spirals out of control. As 'Kill You' continues he makes death threats, laughs them off, references prescription drugs and sets out to offend everyone he possibly can. The backing loop, compact and sweetly lyrical, remains the same, but Eminem invokes hysteria and self-hate. His success is a curse, his failings are triumphs. The result is transfixing.

The album – titled after the hip-hop artist's real name – was his third, and it arrived hot(headed) on the heels of 1999's *The Slim Shady LP*, a breakthrough release that had taken the Detroit rapper from obscurity to fame. Court cases were becoming a part of his life (his own mother had already sued him for slander) and success only seemed to accentuate his misanthropic outlook. 'Whatever you call me, that's what I'm going to be,' he would tell anyone who questioned his lyrics, and *The Marshall Mathers LP* took his virulent worldview to extremes. On 'Kim' he fantasised about kidnapping and murdering the mother of his young daughter, exploring the scenario in lurid detail so that it sounded like a psychotic slasher film.

The album also has a remarkable sense of control. Even when it is knee deep in blood and threats, the tracks never lose their exemplary technique. Eminem barely wastes a syllable in 'Stan', the hit single that ties an arrangement culled from Dido's gentle 'Thank You' to an extended character piece ending in more loss of life, and every inflection adds to the eerie dread that consumes the song. Eminem gives

TRACKLISTING

01 **Public Service Announcement 2000**
02 **Kill You**
03 **Stan**
04 **Paul**
05 **Who Knew**
06 **Steve Berman**
07 **The Way I Am**
08 **The Real Slim Shady**
09 **Remember Me?**
10 **I'm Back**
11 **Marshall Mathers**
12 **Ken Kaniff**
13 **Drug Ballad**
14 **Amityville**
15 **Bitch Please II**
16 **Kim**
17 **Under the Influence**
18 **Criminal**

voice to letters written by his 'biggest fan', and they grow steadily more angry and revelatory as the writer despairs at the lack of response and his own circumstances. By the time Eminem replies, calm and conciliatory, it's too late. The production is concise and expressive, framing the torrent of words emanating from Eminem. There was a belief that the rapper was popularising the horrorcore genre, but Eminem was such a consummate inhabitor of his characters that he could take them to unforeseen places with the lightest of backing. 'I murder a rhyme, one word at a time,' he declares on 'I'm Back' and the tune's funk groove is so laidback that it's almost horizontal. But the verses are taut and accusatory, flipping between sarcasm and self-loathing.

'I don't do black music, I don't do white music/I make fight music,' Eminem observes on 'Who Knew'. *The Marshall Mathers LP* put aside racial boundaries in hip-hop, making clear that talent transcended skin colour. It also offered a new take on hip-hop success – the accoutrements of wealth had no place in these songs, where self-analysis was the twisted privilege Eminem bought himself. 'Drug Ballad' makes a night out into a screwed-up life sentence, imagining a world of destructive repetition. 'What's a little spinal fluid between you and a friend,' asks Eminem, and it's just one line among many, but typical of Eminem's twisted insight. As often as you may tremble at what he becomes, you're surprised at where he takes it. No-one can keep up with Eminem on this album, but trying to results in a fascinating journey.

N°: 62

BLONDIE
PARALLEL LINES

Chrysalis
Produced by Mike Chapman
Released: September 1978

Two pips of a telephone ringing down the line and then a tough-as-nails declaration, as the guitars chime in, that 'I'm in the phone booth it's the one across the hall/If you don't answer, I'll just ring it off the wall'. That is Debbie Harry beginning Blondie's third album, a record that would swiftly take them from the periphery to superstardom. *Parallel Lines* would go on to sell 20 million copies, making it the iconic commercial face of the new wave scene and taking Blondie from the seedy confines of CBGBs to the expansive Madison Square Garden.

Blondie wouldn't take no for an answer on 'Hanging on the Telephone' and it was the same with *Parallel Lines*. This was pop as a joyous invocation and a tart putdown; this was tough cookie music. Blondie had had the right elements, but not the finish, on their 1976 self-titled debut and 1978's *Plastic Letters*. And despite successful singles in Australia and Britain they were unknown at home. Part of the solution was Mike Chapman, the Australian-born producer who'd cut a swathe through the British charts with bubblegum glam bands and brought a serious work ethic with him to New York's Record Plant studio.

'The group didn't know what hit them,' Chapman wrote in his liner notes to the album's 2001 reissue. 'I was a taskmaster when I worked. Everything had to be as good as it possibly could be.' Blondie had an offhand charm, but Chapman wasn't interested in that

stance taking hold in the studio. Working with the band – Harry, her partner and lead guitarist Chris Stein, guitarist Frank Infante, bassist Nigel Harrison, keyboardist Jimmy Destri and drummer Clem Burke – he helped forge a fusion of punk energy and girl group mystique, street smarts and disco dreams.

Genres were rendered irrelevant on *Parallel Lines*. On the burbling autobahn rhythms of 'Heart of Glass', where Harry leaves a trail that Madonna would follow a few years later, Blondie set romantic disillusionment to dancefloor grooves, while 'Pretty Baby' was a '56 in '76 mash-up of new wave guitars

TRACKLISTING

01 **Hanging on the Telephone**
02 **One Way or Another**
03 **Picture This**
04 **Fade Away and Radiate**
05 **Pretty Baby**
06 **I Know But I Don't Know**
07 **11:59**
08 **Will Anything Happen?**
09 **Sunday Girl**
10 **Heart of Glass**
11 **I'm Gonna Love You Too**
12 **Just Go Away**

and doo-wop breakdowns that served as a contrast to the eerie art-rock monument that is 'Fade Away and Radiate'. The spread was also a reflection of the songwriting options. The Harry/Stein team was augmented by contributions from Destri, Harrison and Infante – the latter's 'I Know But I Don't Know' is rock & roll pomp with disparate but electrifying elements that predate sampling.

'One way or another, I'm going to find you,' sings Harry on 'One Way or Another', and it's one of many songs where she played herself as the pursuer; a woman of action at odds with the sex kitten image that had started to cling to her. As the music attained a studio sheen she began to celebrate her imperfections, and Harry's vocal performances are evocative and eclectic: wary but exposed on 'Pretty Baby', yearning on Destri's breakneck '11:59' and levelling doubts with 'Picture This'.

Stein's lead guitar licks were mixed up beside Harry's vocals, making for an album where no single voice dominates. Blondie would struggle to get that balance again (Chapman's liner notes delineate the various rivalries that would eventually become untenable). But any claim that they were simply a great singles band who couldn't last an entire album is repudiated by *Parallel Lines*. This was pop music made for and by adults and it still feels reliably straight up. Don't be fooled by Debbie Harry's stern demeanour on the cover – the record has winning ways.

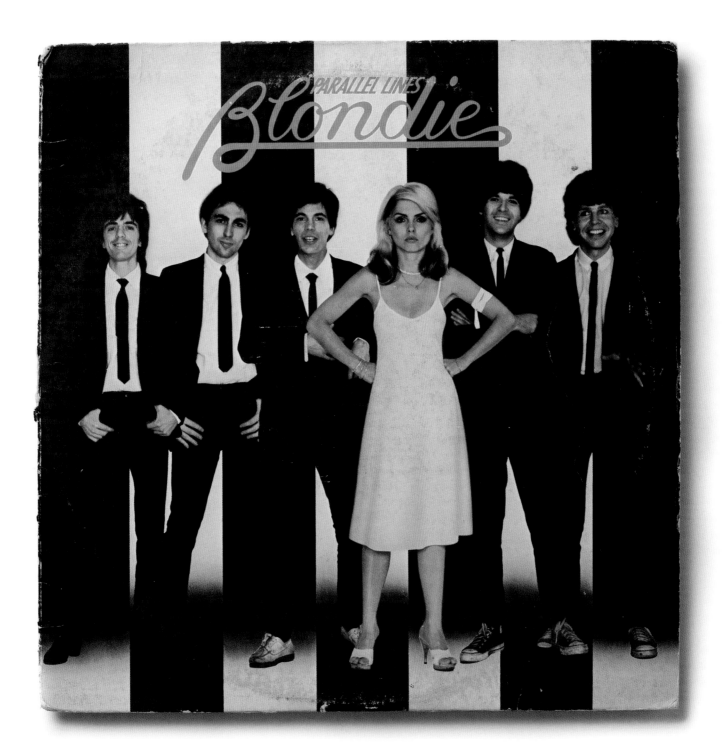

N°:63

DUSTY SPRINGFIELD
DUSTY IN MEMPHIS

Atlantic
Produced by Jerry Wexler, Tom Dowd and Arif Mardin
Released: March 1969

In 1968 Dusty Springfield was edging towards irrelevance. The English pop singer, who had debuted as a solo artist in 1963 with the hit single 'I Only Want to Be With You', had amassed a strong body of work, turning to songwriters such as Burt Bacharach while bringing American R&B artists across the Atlantic.

But with the rise of Jimi Hendrix and Eric Clapton, not to mention the first heady rush of psychedelia, her glorious ballads risked being perceived as yesterday's music. Her solution was to take her golden voice to America, specifically Memphis, where she would make an album at the ground zero of soul music, American Sound Studios.

The result is the magisterial *Dusty in Memphis*, a record that confirmed Springfield as the leading white soul singer of the ages – despite initially faltering commercially before beginning a slow journey of redemption, as the album was subsequently taken up by fans both old and new. These are songs where every syllable is perfectly matched to the rhythm, exquisitely teasing out nuance and knowingness with each line. There's a decade-long journey contained in a line from the closing 'I Can't Make It Alone', where Springfield sings: 'There's something in my soul that will always lead me back to you', and the way she sings it – the elongation of 'there's' and 'always', the melancholic acceptance placed on 'you' – brings the emotional burden of those years into sharp focus.

Springfield idolised Aretha Franklin, so she'd signed with Atlantic Records and stipulated that Jerry Wexler, the producer who famously said that Franklin had to musically go back to church, had to be behind the desk or the deal was void.

But it was not an easy collaboration. At their first meeting Wexler played Springfield 80 tracks he believed they could craft a winning album from. Springfield didn't okay a single one. A few months later, at a second meeting, Wexler played her 20 of the original acetates and this time Springfield signed off on each and every one. It took time, but it was worth it: Gerry Goffin and Carole King, Randy Newman, Bacharach and Hal David constituted the writing talent.

TRACKLISTING

01 **Just a Little Lovin'**
02 **So Much Love**
03 **Son of a Preacher Man**
04 **I Don't Want to Hear it Anymore**
05 **Don't Forget About Me**
06 **Breakfast in Bed**
07 **Just One Smile**
08 **The Windmills of Your Mind**
09 **In the Land of Make Believe**
10 **No Easy Way Down**
11 **I Can't Make it Alone**

Springfield later explained that she was too intimidated to sing in the recording booth used by Wilson Pickett while Aretha Franklin's musicians played, and eventually she recorded nearly all of the vocals in a later session at a studio on 57th Street in New York with just the three producers present. The dates were different, but the connection is definitely there, with the likes of bassist Tommy Cogbill adding a soulful depth to the yearning of 'Don't Forget About Me' and 'Breakfast in Bed', where in less than three minutes Springfield turns consolation into carnality. Arif Mardin's string arrangements were also masterful, and the final touch was the backing singers the Sweet Inspirations, who provided a running commentary on the single 'Son of a Preacher Man', among several selections.

'Dusty Springfield's singing on this album is among the very best ever put on record by anyone,' writes Elvis Costello in the liner notes to the 2002 reissue. 'It is overwhelmingly sensual and self-possessed but it is never self-regarding.' He's absolutely right. *Dusty in Memphis* is a record where all involved stepped beyond their already obvious talents: the Memphis funk players took to the likes of Michelle Legrand's European hit 'The Windmills of Your Mind', while Springfield could reach the limits of heartache on Randy Newman's 'Just One Smile'. According to the producers, Springfield had the volume in her headphones at an ear-splitting level when she finally cut the vocals, so she couldn't hear herself sing. Everyone else, fortunately, still gets that privilege.

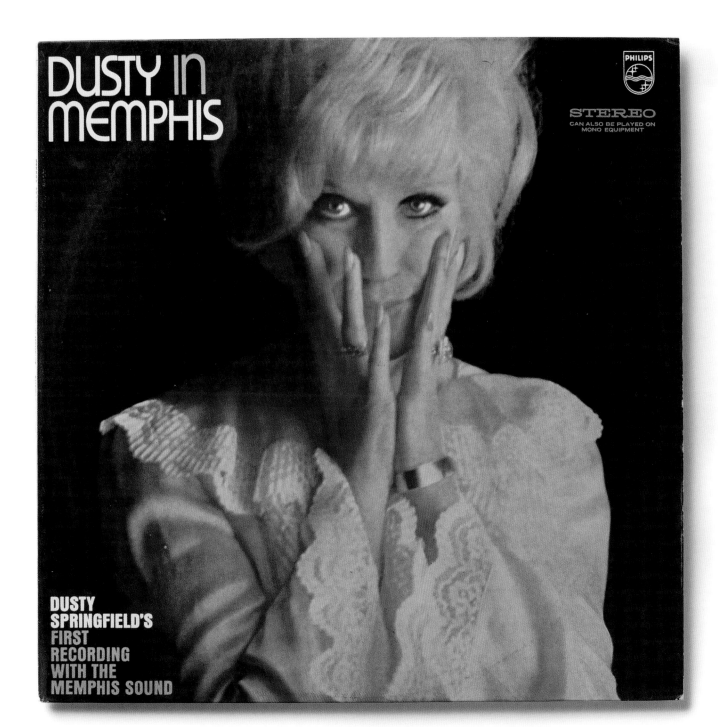

R.E.M.
AUTOMATIC FOR THE PEOPLE

Warner Bros.
Produced by Scott Litt and R.E.M.
Released: October 1992

'This record was a nine-month metamorphosis,' said R.E.M.'s drummer Bill Berry. 'It went from being a caterpillar to being a rat to being a dog to being a chicken. It went all over the place.' In the beginning, guitarist Peter Buck (as ever) wanted to make a noisy rock album, but as the songs evolved the mood was increasingly introspective, even sombre. 'The world that we'd been involved in had disappeared,' said Buck. 'The world of Hüsker Dü and the Replacements, all that had gone. We were just in a different place and that worked its way out musically and lyrically.'

In February '92, when R.E.M. began recording their seventh album in Bearsville Studios, they were following up *Out of Time*, which had taken them from college rock darlings to international superstars. Ostensibly the new record had fewer pop songs, was more down-tempo but it turned out to be the highpoint – commercially and critically – of their career. '*Out of Time* and this one are not of a piece, really, but in mood they're similar,' said Buck. 'Lyrically it's dark and musically it's oddball.'

As usual Buck, Berry and Mike Mills had worked up some 30 songs to which Michael Stipe later added words. 'The stuff we were turning out was pretty dark,' Buck told John O'Donnell at the time of the album's release. 'It wasn't as if we gave Michael a bunch of pop songs and he wrote down these lyrics. Overall the record is pretty positive, but there are certain songs about death.'

Many of the songs reflect back to earlier times. 'Nightswimming', which Coldplay's Chris Martin called 'the greatest song ever written', harked back to their college years in Athens, Georgia of late-night parties and skinny dipping. 'Man in the Moon' Buck described as 'a funny little song about two people who are dead but are supposed to be alive: Elvis, and the comedian Andy Kaufman'. The song touches on death and fame and the games of youth. 'Drive', which references David Essex's classic 'Rock On', is also addressed to 'the kids'. It's an elegiac song about rock & roll and what was then referred to as Generation X, and Stipe seems ambivalent about the whole circus. Strings arranged by Led Zeppelin's John Paul Jones enhance that feeling.

TRACKLISTING

01 **Drive**
02 **Try Not to Breathe**
03 **The Sidewinder Sleeps Tonite**
04 **Everybody Hurts**
05 **New Orleans Instrumental No. 1**
06 **Sweetness Follows**
07 **Monty Got a Raw Deal**
08 **Ignoreland**
09 **Star Me Kittem**
10 **Man on the Moon**
11 **Nightswimming**
12 **Find the River**

Peter Buck was to get his one and only rock song with 'Ignoreland', but it is a firecracker, loading both barrels and firing them directly at the prevailing conservatism of the Reagan/ Bush administration. Elsewhere, the track 'The Sidewinder Sleeps Tonight' (based on the Tokens' 'The Lion Sleeps Tonight') is not exactly rock but is at least up-tempo.

However, the real centrepiece of the album is 'Everybody Hurts'. The song is about exactly what it says: when you're at the depths of despair remember that you're not alone and that this too will pass.

'Bill brought it in, and it was a one-minute long country-and-western song,' says Buck. 'It didn't have a chorus or a bridge … it went around and around, and he was strumming it. We went through about four different ideas and how to approach it and eventually came to that Stax, Otis Redding, "Pain in My Heart" vibe. I'm not sure if Michael would have copped that reference. It took us forever to figure out the arrangement and who was going to play what, and then Bill ended up not playing on the track. It was me and Mike and a drum machine.' The downbeat optimism of 'Everybody Hurts' glues this disparate album together.

The title of the album clarifies the band's intent. 'There's a soul food restaurant round here run by this really nice guy and that's his slogan,' said Buck. 'When you order something, he goes, "It's automatic!"' On *Automatic for the People*, R.E.M. were serving five-star soul food.

N°:65

THE SUPREMES
WHERE DID OUR LOVE GO

Motown
Produced by Brian Holland, Lamont Dozier, Smokey Robinson, Norman Whitfield and Robert Gordy
Released: August 1964

Where Did Our Love Go was the album that not only made the Supremes America's leading vocal group, it also transformed Motown from a successful record label into a brand name with universal recognition. It was the first album in the history of the Billboard charts to have three #1 singles featured on the same record, and by the time it had finished conquering one audience after another the pop landscape was irrevocably changed. By the time the album had hit internationally, the trio were the equals of the Beatles in America and black music had done its bit in helping bring the colour barrier to an end.

It was, in many ways, the articulation of the ambitions and plans long held and actively fostered by Motown boss, Berry Gordy. The only difference was that the Supremes were not the group anyone expected to deliver such precedents. They had begun as a quartet in 1958 in Detroit's Brewster–Douglass housing projects, and initially the three core high school students – Diana Ross, Mary Wilson and Florence Ballard – were knocked back by Gordy as being too young and inexperienced.

At the beginning of 1961 Gordy relented and signed the group. What followed was an unmitigated run of failure. Motown released eight singles from the Supremes over two years and not one of them was a hit. At a label that obsessed over successful 45s, that was a cardinal sin. The 'No-Hit Supremes' was how they were unofficially referred to inside Motown. However, at the end of 1963 there were several crucial changes, with Gordy designating Ross as the group's lead singer, displacing Ballard (a move that would sow the seeds of bitter rivalry and eventual dissolution), and he made them the recipient of a song from his best songwriting team. The Holland–Dozier–Holland composition 'When the Lovelight Starts Shining Through His Eyes' was a modest hit, beginning the run of success that would be captured on Where Did Our Love Go.

Another Holland–Dozier–Holland tune, 'Run, Run, Run', failed in February 1964, but it moved the group's sound from R&B towards pure pop, and everything came together in the middle of the year with 'Where Did Our Love Go'. The Marvelettes rejected the song and the Supremes initially weren't keen on it, but by August 1964 it was a #1 single in America. The foot-stomping beat is reportedly a pair of boards being used as percussion, and they created a primal appeal for the sweet melody and juke-joint raw sax break.

Diana Ross couldn't hit the vocal heights of Florence Ballard, but she had a modern approachability to her voice that mirrored the new teenage demographic. Ross could wend together the adolescent dreams suggested by Eddie Holland's lyrics, and she could make a track such as 'Come See About Me' both gently vulnerable and firmly defiant. These were first kiss songs, especially the singles, and true love trumped sexual desire in every instance, even though there were expressive peaks and valleys in the arrangements and production of Lamont Dozier and Brian Holland.

There's a gentle, semi-acoustic ballad in the form of 'I'm Giving You Your Freedom', while the Smokey Robinson-penned 'Long Gone Lover' has a sly R&B groove (Motown's house band, the Funk Brothers, were on duty) and some evocative handclaps. But nothing can top the voodoo and pure delight of 'Baby Love', where Ross pursues a wayward love via an effervescent rhythm track. The song, like the Supremes, proved to be irresistible, and almost 50 years on these are some of the simplest and purest pop songs ever cut. Come see about them.

TRACKLISTING

01 **Where Did Our Love Go**
02 **Run, Run, Run**
03 **Baby Love**
04 **When the Lovelight Starts Shining Through His Eyes**
05 **Come See About Me**
06 **Long Gone Lover**
07 **I'm Giving You Your Freedom**
08 **A Breathtaking Guy**
09 **He Means the World to Me**
10 **Standing at the Crossroads of Love**
11 **Your Kiss of Fire**
12 **Ask Any Girl**

THE SUPREMES
WHERE DID OUR LOVE GO

✳ BABY LOVE ✳ COME SEE ABOUT ME ✳ LONG GONE LOVER ✳
WHEN THE LOVE LIGHT STARTS SHINING THROUGH HIS EYES ✳
RUN, RUN, RUN ✳ A BREATH TAKING GUY ✳ YOUR KISS OF FIRE
✳ HE MEANS THE WORLD TO ME ✳ I'M GIVING YOU YOUR FREEDOM
✳ STANDING AT THE CROSSROADS OF LOVE ✳ ASK ANY GIRL ✳

621 MOTOWN RECORD CORP.

N°:66

OASIS
(WHAT'S THE STORY) MORNING GLORY?

Creation
Produced by Owen Morris and Noel Gallagher
Released: October 1995

Anyone with an interest in rock & roll in May 1995, when Oasis began two months of recording at Rockfield Studios in Wales, would have told you that the next Oasis record would have been a monster. However, perhaps no-one then could have predicted that it would be one of the most important British records since *A Hard Day's Night*.

Oasis' debut album, *Definitely Maybe*, put the lead back into the pencil of British rock & roll. They cut through the self-loathing that grunge had brought to rock. They were not ironic, they were not trying to reinvent rock & roll; they just wanted to pull birds, take drugs and most of all play big, loud songs with melodic guitar hooks. They were, it must be said, a very good rock & roll band – Liam and Noel Gallagher with guitarist Paul 'Bonehead' Arthurs, bassist Paul McGuigan and new drummer Alan White – that were as tight and smart as Carnaby Street trousers.

Oasis arrived coincidentally with Tony Blair's new vision for Britain – a new era of optimism dubbed Cool Britannia. According to Noel Gallagher, 'Most of the songs [on *What's the Story?*] are about pride and sticking your chest out and standing up for yourself'. The title track, with its reference to being chained to a mirror and a razor blade or walking down the street with a Walkman playing the Beatles, is set against a massive bank of overdriving guitars and Liam's huge declamatory rail. It's the single biggest-sounding UK rock song since the Sex Pistols.

Producers Owen Morris and Noel Gallagher created a huge compressed guitar sound that was more forceful than any of their contemporaries. On some tracks it's like the roar of a jet plane. The group proved itself on its ability to deliver live and the sessions for the album were preceded by two weeks of intense rehearsal. Once in the studio the album was cut almost live – a track a day for most songs. 'Roll with It', 'Hello' and 'Morning Glory' were done in one take each. Only the seven-minute epic 'Champagne Supernova' took 'some thinking' and stretched to two days.

The album is in part a love letter to British rock: the Jam's Paul Weller guests on guitar on 'Champagne Supernova', the track 'Cast No Shadow' was written about Verve singer Richard Ashcroft, and the song 'Wonderwall' takes its name from a George Harrison soundtrack album. Elsewhere, 'She's Electric' features a guitar solo not far from Harrison's 'While My Guitar Gently Weeps' and the album's opening cut borrows heavily from Gary Glitter.

Gallagher's benchmark, however, was always the Beatles. 'It's beyond an obsession. It's an ideal for living,' he said. 'I don't even know how to justify it to myself. With every song that I write I compare it to the Beatles. I've got semi-close once or twice. "Live Forever" I suppose, "Don't Look Back In Anger", "Whatever". The thing is, they got there before me. If I'd been born at the same time as John Lennon I'd have been up there. Well, I'd definitely have been better than Gerry and the fuckin' Pacemakers, I know that.'

His finest song to that point was the ballad 'Wonderwall' inspired by his then girlfriend Meg Matthews. Initially he wanted to sing the song but his brother disagreed strongly (natch!) and Liam does perhaps his best vocal; unsentimental and tough, but dripping with emotion. 'Wonderwall' was the track that put Oasis over the top around the world. As Noel put it: 'We've got nothing to prove to other bands. We set out to be the biggest and best band in the world – and we've achieved it.'

TRACKLISTING

01 **Hello**
02 **Roll with It**
03 **Wonderwall**
04 **Don't Look Back in Anger**
05 **Hey Now!**
06 **Untitled (aka 'The Swamp Song – Excerpt 1')**
07 **Some Might Say**
08 **Cast No Shadow**
09 **She's Electric**
10 **Morning Glory**
11 **Untitled (aka 'The Swamp Song – Excerpt 2')**
12 **Champagne Supernova**

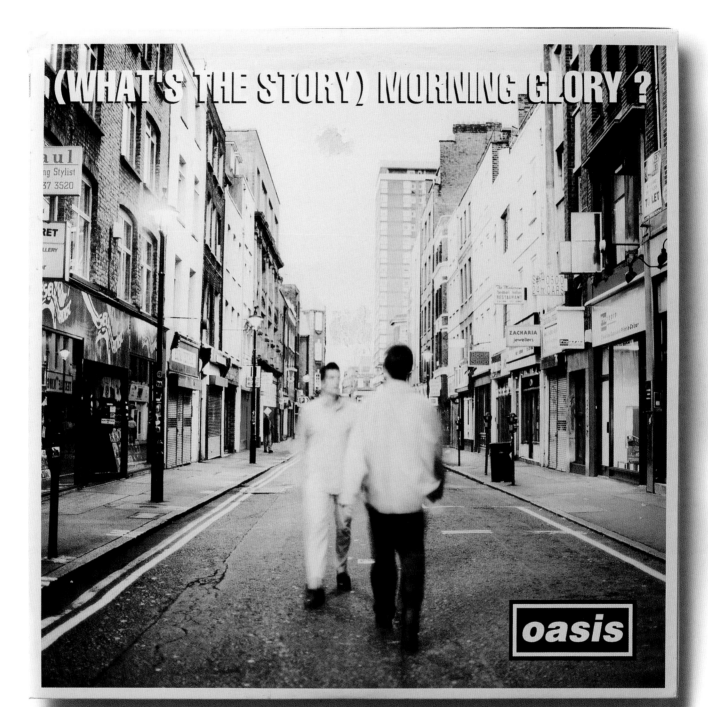

N^o:67

KANYE WEST
MY BEAUTIFUL DARK TWISTED FANTASY

Roc-A-Fella
Produced by Various, including Kanye West
Released: November 2010

'End of century anthems based off inner-city tantrums,' declares Kanye West on 'Gorgeous', a lengthy therapy session that moves between swimming pools, award ceremonies and the indignity of flying economy class. If that sounds ambitious, and possibly infuriating, then across this remarkable album the Chicago rapper uses his genius – and his genius for harnessing collaborators – to raise the stakes on himself and the listener. *My Beautiful Dark Twisted Fantasy* was a sweeping step forward for hip-hop, using the full scope of pop music and the idiosyncrasies of the genre to offer a vision of West's world that opened him up even as it approached mythology.

Two years prior, in the grip of heartbreak and personal loss, West had cut his melancholic fourth album, *808s & Heartbreak*, where icy electronica and Auto-Tuned vocals served as a direct distillation of his emotional state. Eventually he returned to Hawaii and set to work again, flying guests in and out and running three recording rooms in the Avex Recording Studios, so that if he was blocked on one song he could simply bounce to another tune and another recording rig. He held the framework of the songs in his head, always looking for the next improvement, and guests and co-authors alike contributed ideas that matched his vision. The atmosphere was collegial, the results electrifying.

The process can be heard in songs that are sonically expansive and fiercely attuned. Dense, muggy rhythms explode into life as a choir might offer redemption, or a fuzzed-out guitar gently weeps, and the songs move up and down through their gears until you can't believe it's possible that they have anywhere else to go. The surging 'Power' combines gospel chants, spindly, condensed percussion parts and a climactic King Crimson sample, and each part feels intrinsically connected, serving the song's rollercoaster ride from manic dominance down to a plangent suicide fantasy.

The album appeared at a time when mainstream hip-hop had settled into a self-satisfied, eulogistic phase; pop singer hooks for commercial radio were the crux of too many songs. West had hooks, but he was just as likely to rub them in the listener's face as caress the ear – you could be aghast and find yourself dancing, or entranced and fearful of the rapper's next step. On the spectral jam that is 'So Appalled', Jay-Z and the Wu-Tang Clan's RZA transform hip-hop dilapidated extremes into a kind of moral bankruptcy; it's *Bonfire of the Vanities* with a languid backbeat.

When Sigmund Freud and Carl Jung formulated psychoanalysis they described it as 'the talking cure', and West took the concept to its limits in a celebrity age he couldn't stomach and couldn't quit. 'Ain't no question, if I want it I need it,' runs a solemn chorus on 'Gorgeous' and West would mix boasts and contrition, simultaneously wise and wired. 'Let's have a toast for the douchebags,' 'Runaway' urges, and Kanye was more than willing to include himself. Minutes later in the same song there's a plaintive dedication to a partner who has endured his foibles.

By the sparsely atmospheric 'Blame Game', monologues and extended samples are clashing like voices arguing inside West's head, and the further *My Beautiful Dark Twisted Fantasy* goes on, the more it draws you into Kanye's worldview. The album is both exhilarating and immersive, and it was readily – sometimes painfully – apparent that its creator was intent on not just leaving hip-hop in his wake, but obliterating his own back catalogue. 'Who will survive in America?' is the last line heard, and the unspoken but obvious answer was: Kanye West.

TRACKLISTING

01 **Dark Fantasy**
02 **Gorgeous**
03 **Power**
04 **All of the Lights (Interlude)**
05 **All of the Lights**
06 **Monster**
07 **So Appalled**
08 **Devil in a New Dress**
09 **Runaway**
10 **Hell of a Life**
11 **Blame Game**
12 **Lost in the World**
13 **Who Will Survive in America**

N°:68

JEFF BUCKLEY
GRACE

Columbia
Produced by Andy Wallace
Released: August 1994

Jeff Buckley had a voice from the gods, but he meant business. During the sessions for *Grace*, the young singer-songwriter's audacious and sadly sole studio album, there were multiple recording options in place so that Buckley could move from one idea to the next, one sound to the next, one dream to the next, as required. He carried a famous name from a father – Tim Buckley – that he'd only met once, and he'd made his bones as a guitarist for hire who did funk sessions and toured with a dancehall reggae act. Having gained his chance at prominence, he didn't intend to play it safe on his debut album. The result is a go-for-broke record that soars where the merely ambitious simply crash and burn.

Released in a year of distortion, the album begins with the ethereal; all delicate guitar washes and wordless sighs as 'Mojo Pin' takes shape. Buckley's voice stretches from a whisper to soulful defiance, and already the song's dynamic feels tangled but irresistible as the singer finds himself in a place he'd come to define – longing. 'If only you'd come back to me/If you laid at my side,' he sings, and to define that need the band escalate into a brief, pummelling pocket that contrasts the jazzy nuance with hard rock animosity. By the song's end, Buckley and his rhythm section – bassist Mick Grondahl and drummer Matt Johnson – are blazing away with guitarist and old friend Gary Lucas.

A minute – maybe two if you're curmudgeonly – into the third track of the album, the mystic rock of 'Last Goodbye', and it's clear that Jeff Buckley is a stone cold original. He had a voice that could invoke or intimidate, and yet he was sparing about how he used it.

'Grace' works up an evocative head of passion; one that's perfectly matched by the otherworldly force of the guitar tone, but on 'The Last Goodbye' he finds his peak in a powerfully controlled vocal performance that marries anger and regret as strings accentuate the melodic heft. *Grace* is an album that covers more ground than you initially realise – its heartache comes with a restlessness that stirs both the soulfulness and the sounds.

TRACKLISTING

01 **Mojo Pin**

02 **Grace**

03 **Last Goodbye**

04 **Lilac Wine**

05 **So Real**

06 **Hallelujah**

07 **Love, You Should've Come Over**

08 **Corpus Christi Carol**

09 **Eternal Life**

10 **Dream Brother**

Buckley, who had already made his name as a solo artist when he shifted from Los Angeles to New York and took up a live residency, also knew the right material to put his stamp on. Nina Simone's song 'Lilac Wine' has a sombre eeriness, while his take on classical composer Benjamin Britten's 'Corpus Christi Carol' ties the allegorical visions of a crucified figure into folk music's lineage.

But the album's highlight is the definitive version of Leonard Cohen's 'Hallelujah'; seven minutes of transfixing guitar and voice where the lyric about 'the minor fall and the major lift' comes to reflect what happens from syllable to syllable as Buckley inhabits the lyric with bittersweet enchantment.

There are moments when the spell is broken, but most of *Grace* is astounding and it refuses to be pinned down. Just when the mood feels like it could constrict, there's 'Eternal Life', a rock & roll workout with grinding bass that foretold the subsequent world tour where Buckley and his bandmates would literally kick out the jams. The swirling, psychedelic ghost of 'Dream Brother' closes the record, and if the final lyric, 'asleep in the sand, with the ocean washing over', is a portent of Buckley's death in 1997 when he accidentally drowned in a tributary of the Mississippi River, then the song itself is a kind of pledge. Right to the end Jeff Buckley wanted to break on through to every other side.

N°:69

THE WHITE STRIPES
ELEPHANT

XL
Produced by Jack White
Released: April 2003

'What is recording?' the White Stripes' Jack White rhetorically asked journalist Barney Hoskyns. 'Is it a record of something that actually happened or is it a complete fallacy? What's it like to grow up in a generation where you don't know what instrument you're hearing on the radio? You just hear that noise and you don't know what's making it. And you don't care. I can't imagine being a young musician and not caring what makes that sound. You used to hear someone playing an oboe and you'd think, "I can't believe what he's doing on the oboe". Now it's like, "Can you believe what he's doing with ProTools?". I mean, it's hard to respect that.'

The White Stripes were one of the biggest bands of the early 21st century but it was an unlikely set up – just Meg White on drums and Jack White playing guitar or piano. The extreme minimalism was like a breath of fresh air on their early albums *The White Stripes* (1999), *De Stijl* (2000) and *White Blood Cells* (2001). In his early work, White acknowledged a debt to pre-war bluesmen like Blind Willie McTell, Son House and Robert Johnson, but there was also some Howlin' Wolf thrown in for a bit of salt.

Going back to the blues did a number of things for the White Stripes: it set them apart as musically literate and of course nothing appeals to rock critics more than citing Blind Willie McTell. It gave them a well of stories and imagery to draw from, but it was also a challenge to do something new with a form that had been wrung dry. White somehow pulled it off and created a blues music that had never been heard before.

A love of old blues determined the White Stripes' direction: rough, organic sounds recorded on analogue equipment rather than the prevailing digital technology and typically *Elephant* was recorded in a tiny eight-track studio. 'If we can't produce something that sounds good under those conditions, then it's not real to begin with,' said White at the time of the album's release. 'Getting involved with computers is getting involved with excess, especially when you start changing drumbeats to make them perfect or make the vocal melody completely in tune with some programme – it's so far away from honesty.'

The album was supposedly about the 'death of the sweetheart' and certainly there are songs that hark back to antique sensibilities, but the overall attack from the Whites is decidedly modern.

The mystery Jack White peddled was romance. The relationship between the Whites was a matter of regular speculation that Jack refused to clarify, insisting that all you need to know is in the songs, which were certainly romantic in every sense of that word. 'All music and art comes down to love,' he said. 'You just find out how to tell that story. That's the oldest story in the book.'

The lead single, 'Seven Nation Army', sounds like it could have been recorded by Howlin' Wolf with its stomping beat and razor wire guitar. But then again it couldn't. Messing with history was one of the other intriguing things about Jack White.

'The intent to push forward in the era after Warhol, Dylan, and the Beatles is a tricky one,' he told Hoskyns. 'I'm not too sure what "forward" is anymore. I think inward is a better direction, getting more soulful and away from plastic computer production.'

TRACKLISTING

01 **Seven Nation Army**
02 **Black Math**
03 **There's No Home for You Here**
04 **I Just Don't Know What to Do with Myself**
05 **In the Cold, Cold Night**
06 **I Want to Be the Boy to Warm Your Mother's Heart**
07 **You've Got Her in Your Pocket**
08 **Ball and Biscuit**
09 **The Hardest Button to Button**
10 **Little Acorns**
11 **Hypnotize**
12 **The Air Near My Fingers**
13 **Girl, You Have No Faith in Medicine**
14 **It's True That We Love One Another**

N°70

EAGLES
HOTEL CALIFORNIA

Asylum
Produced by Bill Szymczyk
Released: December 1976

It didn't start out to be a concept album but it became one after all,' said Don Henley just days after the release of *Hotel California*. No record captured the spiritual decline of America better than this Eagles album.

The Eagles started out in the early '70s as cosmic cowboys; their second album *Desperado* had been the first rock horse opera. However, the two prime movers in the band – Glenn Frey and Don Henley – were cowboys only as much as Brian Wilson was a surfer. Quite at home in Los Angeles, they hung with literate songwriters like Jackson Browne and tapped into the zeitgeist of the time which was, one way or another, decadence. Frey and Henley had an ear for hooks and they had built the Eagles into one of the biggest bands in America. By March 1976, when they began to record their fifth album, original guitarist Bernie Leadon, who was responsible for much of their country sound, had been replaced by Midwestern rocker Joe Walsh. Walsh also brought a synthesiser while, according to Glenn Frey, additional guitarist Don Felder brought the rock & roll.

The Eagles may have had a song called 'Peaceful Easy Feeling' but life in the quintet was never that. Henley, Walsh and Frey were all alpha males whose brutality to each other was amplified by massive amounts of cocaine and the excess for which the '70s was noted. One track Felder brought to the equation was an instrumental called 'Mexican Reggae' which describes the feel. Henley and Frey grabbed it and spun a tale of a fictional hotel, where 'you can check out, but you can never leave'.

'I meant it to be a symbolic piece about America in general, which is a land of excess,' said Henley. 'Lyrically the song deals with classical themes of conflict: darkness and light, good and evil, youth and age, the spiritual versus the secular. I guess you could say it's a song about loss of innocence.' This trip to the dark side was set against a roiling guitar duel between Walsh and Felder – one of the most tense guitar workouts in rock.

If the title track defines the album, 'Wasted Time', 'The Last Resort' and 'Life in the Fast

TRACKLISTING

01 **Hotel California**
02 **New Kid in Town**
03 **Life in the Fast Lane**
04 **Wasted Time**
05 **Wasted Time (Reprise)**
06 **Victim of Love**
07 **Pretty Maids All in a Row**
08 **Try and Love Again**
09 **The Last Resort**

Lane' reinforce it. In fact, a coke dealer suggested the latter title to Frey as they sped along the freeway.

Sessions for the album began in March 1976 and were mostly done at Criteria in Miami but the group, who were notoriously perfectionist in the studio, dragged the process out until October, interspersed with touring in the US. The Eagles were out to make a big statement and would not rush anything. The reference point for this album was not musical but literary – the books by Raymond Chandler and Nathanael West's novel *The Day of the Locust*, which had portrayed LA as a metaphor for the spiritual corruption of old America. Now greed on one hand and cocaine on the other was eating the soul of a new generation. Ironically, the Eagles became the very thing that 'Hotel California' critiqued.

'It's the Bicentennial Year, and this is our Bicentennial statement,' Henley told journalist Chris Charlesworth. 'It's about the demise of the '60s and the decadence and escapism we are experiencing in the '70s. It's also about the kind of limbo we're experiencing in the music business while we're waiting for the next big surge of inspiration, like the Beatles or whatever.'

Glenn Frey added: 'We think that this album represents the whole world, not just California, as something elegant which has been corrupted'.

ELTON JOHN ON ROD STEWART

Bar none, he's the best singer I've heard in rock & roll. He's also the greatest white soul singer.

ELTON JOHN ON EMINEM

When Eminem and I did 'Stan' at the Grammys in 2001, we got together to rehearse out in the Valley. We had never met or really spoken, so I was a little intimidated. When we started to do the song and Eminem made his entrance, I got goose bumps, the likes of which I have not felt since I first saw Jimi Hendrix, Mick Jagger, James Brown and Aretha Franklin. Eminem was that good. I just thought, 'Fuck, this man is amazing'. There are very few performers who can grab you like that the first time – only the greats.

KURT COBAIN ON R.E.M.

If I could write just a couple of songs as good as what they've written [on *Automatic for the People*]. God, they're the greatest.

RON WOOD (FACES/ROLLING STONES) ON ROD STEWART

He's just an insecure little boy with more front than Harrods.

SHIRLEY MANSON ON *PARALLEL LINES*

Touching on influences as diverse as punk and disco, to '60s girl-group trash and reggae, they [Blondie] fashioned a new sound, keeping one eye fixed on the past, and another focused on the future.

Shirley Manson (Garbage)

"ELIZABETH FRAZER (COCTEAU TWINS) ON JEFF BUCKLEY

I was sweating like a June bride when I first heard him. "

"AHMET ERTEGUN ON THE SUPREMES

The emergence of the Supremes provided the perfect American counterpoint to the British Invasion of the 1960s. From mid-1964 to mid-1965 alone, the Supremes had no less than five consecutive number one pop hits. Transcending racial and musical boundaries, they created timeless, soulful pop music that defied imitation. "

Ahmet Ertegun (founder Atlantic Records)

"LIAM GALLAGHER (OASIS ... IN HAPPIER TIMES) ON NOEL GALLAGHER

He's the best songwriter in the world. End of fuckin' story. What else is there to say? "

"ELVIS COSTELLO ON *DUSTY IN MEMPHIS*

Dusty Springfield's singing on this album is among the very best ever put on record by anyone. It is overwhelmingly sensual and self-possessed but it is never self-regarding. The delivery might be confidential, intimate or vulnerable in the opening lines of a song only to explode in the chorus with unknowable emotion. Every crescendo is well judged; the performances are never showy or bombastic. The most striking impression throughout is one of honesty ... "

N°:71

WILCO
YANKEE HOTEL FOXTROT

Nonesuch
Produced by Wilco
Released: April 2002

There should be too many great stories, too many moments of perfect symbolic illumination, surrounding Wilco's *Yankee Hotel Foxtrot* for the album to actually be that worthy. But the not-so-tall tales exist, in print and on film, and yet the record outweighs any portent or easy summation.

Wilco's fourth album is a remarkably cohesive, deeply involved song cycle. While it became notorious that one arm of Warner Music (Reprise) parted ways with the band because they didn't favour the record, and that another Warner Music label (Nonesuch) ultimately signed the band (at considerable additional cost) and released the record to huge acclaim, songs as stunningly good as 'Ashes of American Flags' and 'Jesus, Etc.' render such anecdotes minor.

It has been a record that was coming, in good and not-so-good ways. Wilco's third album, 1999's *Summerteeth*, had introduced a brooding lyricism and embrace of studio texture to a band that was supposedly one of alt-country's great hopes. The Chicago band's chief songwriter and frontman, Jeff Tweedy, wasn't going to forsake creativity for lineage, and with multi-instrumentalist and studio boffin Jay Farrar as his consigliere, they remade Wilco as a sound, and then as a band. It took various recruits, formal and otherwise, to finish *Yankee Hotel Foxtrot*, and it suits an album that unexpectedly reveals more with each listen.

On the opening track, 'I Am Trying to Break Your Heart', elements start and fade, grabs of percussion augment the guitar and electronic textures but never quite fall into line, and what sounds like a zither has a brief ascendancy. The song, and the singer, are trying to find the right path. 'Let's forget about the tongue-tied lightning,' sings Tweedy, 'Let's undress just like cross-eyed strangers'. Making amends for self-inflicted loss is a central theme, but little on this album simply tries to be persuasive. The album aims further: to create a world where the only fitting outcome is to heal the existing rift as a way of going forward together.

Yankee Hotel Foxtrot was recorded prior to the 9/11 attacks, but first streamed online in the immediate months afterwards, and numerous people heard that strange, uncertain new

TRACKLISTING

01 **I Am Trying to Break Your Heart**
02 **Kamera**
03 **Radio Cure**
04 **War on War**
05 **Jesus, Etc.**
06 **Ashes of American Flags**
07 **Heavy Metal Drummer**
08 **I'm the Man Who Loves You**
09 **Pot Kettle Black**
10 **Poor Places**
11 **Reservations**

world in songs such as 'Kamera'. Songs have their own lives, but it's not hard to see how a desire to make amends, to find something to share – even if it's an unpleasant truth – would resonate at the start of the century. In the tremulous, gently hopeful 'Poor Places', Tweedy sharply sketches a character broken and cut off ('his fangs have been pulled,' runs one line), but by the track's end 'my' replaces 'his' and a noise collage of feedback and menacing short wave samples has taken over.

In the rich lyrical language there are lifetimes to be found and, as a band, Wilco gave them definition. The stinging guitar that vamps and slices through 'I'm the Man That Loves You' plays off and eventually eclipses Tweedy's bouncy vocal phrasing, while the atmospheric, late-era Beatles dream that is 'Radio Cure' has a quiet optimism that outlasts the tired distance of the lyric. And when the release of nostalgic memory was required, 'Heavy Metal Drummer' (one of several tracks that strikingly introduced new drummer Glenn Kotche) offered music as a shared communion.

Nothing is cut and dried on *Yankee Hotel Foxtrot*, so time after time it admits you, whatever your emotional standing. You can satisfy divergent needs with this record, and it gives pleasure and sustenance as required. It was the sprightly 'War on War' that found the key to unlocking this reinvention of rock & roll intent: 'You have to learn how to die, if you wanna be alive'.

N°72

BEASTIE BOYS
PAUL'S BOUTIQUE

Capitol
Produced by Beastie Boys, Dust Brothers and Mario Caldato Jr
Released: July 1989

This is the Beastie Boys? Seriously? When *Paul's Boutique* dropped in 1989 there was a collective double-take. The frat-boy rap trio who had introduced heavy metal to hip-hop under the tutelage of Rick Rubin and turned teenage parties worldwide up to 11 with the beer-spraying single '(You Gotta) Fight For Your Right (to Party!)'? This is them? The band that had sold millions of copies of the subsequent debut album, *Licensed to Ill*, and given the British tabloids their favourite source of musical outrage since the Sex Pistols? Something had gone very right.

Believed by many to be incapable of assembling a legitimate follow-up, the Beastie Boys simply stopped playing the game and invented a whole new sport. The trio – Ad-Rock (Adam Horovitz), Mike D (Michael Diamond) and MCA (Adam Yauch) – had walked out on their label, Def Jam, which was the epicentre of hip-hop, after a dispute over earnings. They decamped from New York to Los Angeles, where they got together with producers the Dust Brothers and proceeded to assemble a tribute to '70s funk and fast talking that had a minimal connection to their first long player. Misogyny and AC/DC were out, punchlines and Afrika Bambaataa samples were in.

By linking up with producers Michael Simpson and John King – who as the Dust Brothers had just hit it big with Tone Loc – the Beastie Boys found the basis of their new patois. The tracks on *Paul's Boutique* are densely inspirational and defiantly funky. As arrangements they're packed with references, but they combine seamlessly to create a sense of time and place that the rappers couldn't help but inhabit. 'Egg Man', a tripped-out paean to urban freaks that became a statement on unity, put together the Commodores ('I'm Ready'), Curtis Mayfield ('Superfly'), and Elvis Costello ('Pump It Up'), but the end result is a distinct synthesis. Beastie Boys always sound like more than the sum of their considerable studio parts.

Songs with grooves as deep as '3-Minute Rule', where dubbed-out bass cushioned the percussion, or as propulsive as the disco and cowbell ensemble 'Hey Ladies', spurred the

TRACKLISTING

01 **To All the Girls**
02 **Shake Your Rump**
03 **Johnny Ryall**
04 **Egg Man**
05 **High Plains Drifter**
06 **The Sound of Science**
07 **3-Minute Rule**
08 **Hey Ladies**
09 **5-Piece Chicken Dinner**
10 **Looking Down the Barrel of a Gun**
11 **Car Thief**
12 **What Comes Around**
13 **Shadrach**
14 **Ask For Janice**
15 **B-Boy Bouillabaisse**

three rappers to new heights. *Paul's Boutique* is dense with language, as lines are traded with breakneck enjoyment and jokes hit like rim-shots as vocal samples supply exhortations. Beastie Boys sound like an extended Jerry Lewis and Dean Martin sketch, albeit one where Lewis won't even pause to take a breath and Martin is taking hits of nitrous oxide.

If they'd previously played at being a gang, here the description made sense. They finished each other's sentences and riffed off one comment after another until the chain was deliriously complex. The album prefigured the internet with the depth of its cultural references and, if *Paul's Boutique* was too much for casual fans upon release, it soon made a devout following willing to inhabit these tracks. In a golden age for hip-hop, with De La Soul's *3 Feet High and Rising* and Public Enemy's *It Takes a Nation of Millions to Hold Us Back* circulating, Beastie Boys made the party wild and esoteric.

'We're just three MCs and we're on the go,' they rap on 'Shadrach', and the beauty of *Paul's Boutique* was that anyone was welcome to join them. They were still ruffians, but now they were inclusive. The Beastie Boys remade themselves as the life of everyone's party, culminating in the final 'B-Boy Bouillabaisse', where they traversed hip-hop with a 12-minute tour-de-force. For almost a quarter of a century after this record's release, they were one of the few bands we all agreed upon, and not even the passing of Adam Yauch on 4 May 2012 could lessen that. *Paul's Boutique* was, and always will be, the Beastie Boys, seriously!

Nº:73

TOM WAITS
RAIN DOGS

Island
Produced by Tom Waits
Released: September 1985

Rain Dogs begins with Tom Waits shipping out on 'Singapore': 'We sail tonight for Singapore,' the singer-songwriter gruffly declares, somehow sounding delighted and a touch demented at the same time. But by the album's final track he's ready to settle down on 'Anywhere I Lay My Head'. This album, the ninth from an artist already judged one of the most distinctive in popular music, is about going there and coming back, in every sense of the phrase.

Waits was one of those eccentric Californian kids, the kind that reflect the state's open space and comparatively brief history by remaking themselves as they see fit. Having got through the 1960s and a stint in the US Coast Guard, he made his name in Los Angeles in the early 1970s. However, from the start commercial success came at a remove. His most successful compositions were covers performed by the likes of Tim Buckley and the Eagles. With each album he refined his sound and found a deeper fascination with the odd corners of American life, whether it was strange jazz tendrils and pimps, or vaudeville and saloon houses.

Rain Dogs took him to New York, and much of the album was penned during a few months in 1984 in a basement room in lower Manhattan. 'It was a good place for me to work. Very quiet, except for the water coming through the pipes every now and then. Sort of like being in a vault,' Waits would later recall, although the songs saw markedly different visions of the city take flight. 'All the donuts have names that sound like prostitutes,' Waits declared on '9th &

Hennepin', a semi-spoken ode to an old diner where he sounds like a detective from a noir novel who's forgotten what his assignment is.

The album built on the foundation of 1983's acclaimed *Swordfishtrombones*, putting aside any vestiges of his lounge lizard act from

TRACKLISTING

01 **Singapore**
02 **Clap Hands**
03 **Cemetery Polka**
04 **Jockey Full of Bourbon**
05 **Tango Till They're Sore**
06 **Big Black Mariah**
07 **Diamonds & Gold**
08 **Hang Down Your Head**
09 **Time**
10 **Rain Dogs**
11 **Midtown**
12 **9th & Hennepin**
13 **Gun Street Girl**
14 **Union Square**
15 **Blind Love**
16 **Walking Spanish**
17 **Downtown Train**
18 **Bride of Rain Dog**
19 **Anywhere I Lay My Head**

the 1970s for something leaner and far more compelling. With Marc Ribot as his guitarist – who soon discovered that Waits preferred his backing band not to know, let alone rehearse, the song they were about to record – Waits could turn from the voodoo boogie of 'Union Square' to the twisted ragtime lament 'Tango Till They're Sore'. The tracks had eccentric grooves and oddball percussion, and it sounded like they were grounded in the strange undercurrents of the American metropolis.

Keith Richards played on a handful of tracks, adding wiry licks to the primal R&B groove of 'Big Black Mariah' among others, but the most notable contributor barely made the credits. Kathleen Brennan was credited as the co-writer on 'Hang Down Your Head', but the screenwriter, who he married in August 1980 and dedicated Rain Dogs to, was credited by Waits with shifting his focus. With Rain Dogs Waits could jump from style to style, but the record was tied together by his iconic voice and the sad beauty of the city's lost denizens. 'The only kind of love is stone blind love,' he notes on 'Blind Love', and that sense of acceptance for better or worse sums up the world of Rain Dogs, where the many protagonists on these 19 songs stake out their seats at the bar without a hint of judgment from their creator. At the height of rock's slick studio age, Tom Waits turned the history books upside down and shook free the minor accomplices no-one ever paid that much attention to. Rain Dogs is an idiosyncratic masterpiece.

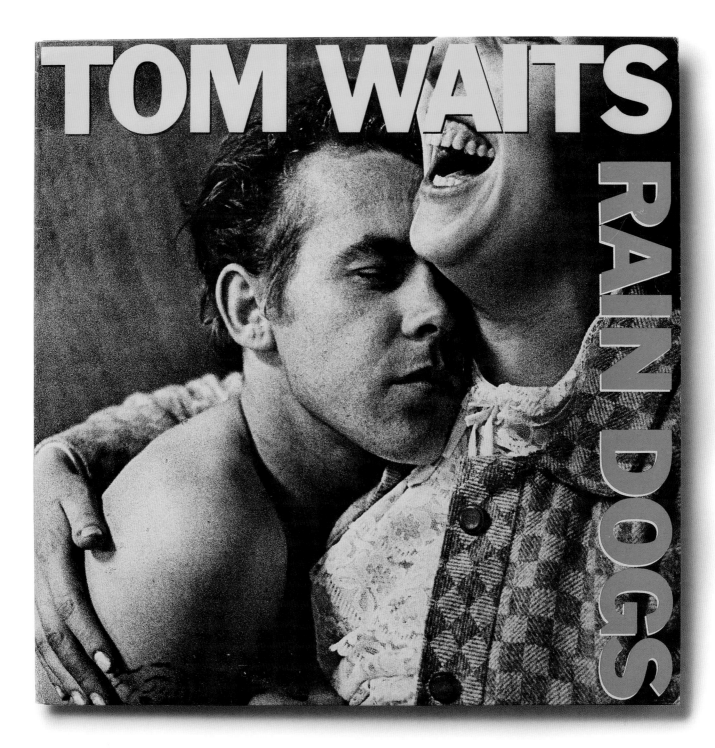

Nº74

KATE BUSH
HOUNDS OF LOVE

EMI
Produced by Kate Bush
Released: September 1985

Kate Bush was 27 years old when *Hounds of Love* was released, but for much of the album she sounds not so much wise beyond her years as simply timeless. The singer-songwriter's fifth album is a repository of deeply felt wisdom and extended artistic expression, allied to technical innovation and a very British sense of pop music as being the most pleasurable of creative experiments. The record, which typically appeared fully formed just at the point where critics and fans were wondering what had become of Bush, shared the spotlight in the close of 1985 with Madonna's *Like a Virgin*, and more than a quarter of a century on it has totally eclipsed that rival.

On the opening 'Running Up That Hill', which sets the framework of prominent percussion, striking melodies and extensive use of the then new Fairlight synthesiser, Bush sings that, 'If only I could, I'd make a deal with God', but the album was borne of her need for control. Bush, with the help of Pink Floyd's Dave Gilmour, had been signed to EMI in the mid-1970s while still attending a Catholic girls' school in London. They gave her time to complete her studies and mature artistically. But soon after 'Wuthering Heights' and her debut album, *The Kick Inside*, announced her in 1978, she was asserting her independence.

By the time she began working on *Hounds of Love*, Bush controlled her publishing and management companies and had built her own studio in a barn behind her family's farm house, where she was the producer. The singer wasn't going to wear the threat of an oversized recording bill wielded by the record company as justification for prematurely releasing a record. She was just as in control on the songs that resulted in the two years of sessions that followed 1982's *The Dreaming*. These songs are dazzling and fierce, knowing and mesmeric.

It's an album made for vinyl with a Side A and a Side B (Bush has said she thinks of it as two separate records), although they still feel dovetailed. *Hounds of Love* ushered in a succession of gloriously rich pop tunes, most of which went on to be released as singles. 'Cloudbusting', a grown son's memories of his father inspired by the renegade psychiatrist Wilhelm Reich, while the title track, with Bush's nuanced vocal, turns into a joyously defiant appeal for her lover's support.

If the first side looks upwards, literally taking in the wonders above on 'The Big Sky' and equating it with creative necessity, then the flipside is immersed in water and the struggle to survive. Entitled *The Ninth Wave*, the suite of interconnected songs functions as a single, eclectic piece, 25 minutes in length with inspiration via Tennyson's poem of the same name. A woman floats in the water, through day and night and, as she weakens, her mind wanders and the setting skips between intricately assembled passages – discordant art-rock on 'Waking the Witch', biting Celtic folk on 'Jig of Life', and ambient sound collages on 'Watching You Without Me'. On the latter track she imagines life for those she loves without her, but it's typical of *Hounds of Love* that the passing that comes to bear on 'Hello Earth' culminates with a sense of rebirth on the glistening 'The Morning Fog'.

These 12 tracks suggest so much, including the circular nature of life. If there are intensely human traits at play, such as vulnerability and mortality, it's still worth pondering whether Kate Bush, hoping to make a deal with God, isn't some minor deity in her own right.

TRACKLISTING

01 **Running Up That Hill (A Deal with God)**
02 **Hounds of Love**
03 **The Big Sky**
04 **Mother Stands for Comfort**
05 **Cloudbusting**
06 **And Dream of Sheep**
07 **Under Ice**
08 **Waking the Witch**
09 **Watching You Without Me**
10 **Jig of Life**
11 **Hello Earth**
12 **The Morning Fog**

Kate Bush

Hounds Of Love

Nº 75

THE WHO
LIVE AT LEEDS

Track/Decca
Produced by Jon Astley, Kit Lambert and the Who
Released: May 1970

The best live album ever recorded. Hands down.

In the five years prior to Valentine's Day 1970, the Who had gone from a pimply London mod band to authors of *Tommy*, the first 'rock opera'. *Tommy* gave the Who a conceptual edge over their rival the Rolling Stones. But it also made them seem more than a little pseudo-intellectual.

Whether to counter the pretension of *Tommy* or just to get something into the market, the Who decided to make a live album. According to then-manager Kit Lambert, 'In those days live albums were always *Live at the Coliseum in Rome* or *Live at the Palladium* or the Hollywood Bowl. I said, "live" isn't really like that. Touring is much seedier. So why didn't we think of *Live at Grimsby* or *Live at Mud-on-Sea*. I looked at the schedule and said, "You're in Hull on Wednesday and Leeds on Thursday, so it's going to be *Live at Hull* or *Live at Leeds*". Things didn't go too well at Hull, so it had to be Leeds.'

It may have been as prosaic as that but *Live At Leeds* – packaged like a bootleg – is the most profound conceptual statement the Who made – rock operas notwithstanding. The concert at Leeds went for much longer than the originally released vinyl album, with the band choosing to edit out the rock opera *Tommy*, the mini-opera 'A Quick One' and many of their great '60s singles. The album's

track-listing would be bizarre if it wasn't so exhilarating: what we have on side one is two covers about being an angry young man ('Summertime Blues', 'Young Man Blues'), a version of the first British rock & roll song (Johnny Kidd's 'Shakin' All Over') and the Who's best early single ('Substitute').

The Who were a band of four soloists: Roger Daltrey carried the songs, John Entwistle's bass carried most of the riffs and the melodies, Townshend's guitar ripped the songs to pieces and Keith Moon's drums detonated explosions under everything.

Side two has a 15-minute version of the Who anthem 'My Generation'. It starts off with a straight reading of the single and then goes off into an improvisation on the musical themes of *Tommy*. As John Wood in the *New Yorker* put it, 'John Entwistle's incessantly mobile bass was like someone running away

TRACKLISTING

01 **Young Man Blues**

02 **Substitute**

03 **Summertime Blues**

04 **Shakin' All Over**

05 **My Generation**

06 **Magic Bus**

from the scene of the crime, and Keith Moon's drumming, in its inspired vandalism was the crime itself'.

Moon's drumming is the key to the genius of the Who. As Wood said, 'The first principle of Moon's drumming is that drummers do not exist to keep the beat. He did keep the beat, and very well, but he did it by every method except the traditional one ... he is in revolt against consistency. Moon's drumming is about putting things in the wrong place: the appearance of astonishing disorder.' The unpredictability of Moon's drumming kept the music alive. He rode the kick drum, impatiently punching out accents to the beats and his cymbals were like a riot. With Moon in his prime the Who could never become rigid or rehearsed, every bar had to be discovered anew. The rhythm section in the Who was so forceful that it came on like a hurricane – completely unpredictable and violent. When the music goes quiet you know it's only the calm before another blistering storm. 'My Generation' ebbs and flows with Townshend calming the waters and then waving the tsunami of Moon and Entwistle to overwhelm him. The melodies are almost simplistic but the sheer explosive weight of the Who as an entity is a wonder to behold. Wood's description of Keith Moon perfectly sums up *Live at Leeds*: 'Formally controlled and joyously messy. Propulsive but digressively self-interrupted, attired but disheveled, careful and lawless, right and wrong.'

N°:76

JOY DIVISION
CLOSER

Factory
Produced by Martin Hannett
Released: July 1980

It's difficult, nigh on impossible, to separate Joy Division's second and final album, *Closer*, from the circumstances surrounding its release. On 18 May 1980, with the album finished and awaiting release, the Manchester group's frontman, Ian Curtis, hung himself in the kitchen of his family home. His estranged wife, Deborah, discovered his body. His death is the lens through which the singer and lyricist's life's work is now viewed; the music and the man's passing inextricably linked. But while these nine tracks hold portents of Curtis' future, they also exist as an immaculate listening experience. It's one that is movingly beautiful in its contemplation of the human experience.

The '70s end and the '80s begin with *Closer*. It is an album that ushers out punk's rage and introduces post-punk's space, offering a synthesis of the guitar and the keyboard, the emotive and the distant. It is close to scary to consider how quickly Curtis, guitarist Bernard Sumner, bassist Peter Hook and drummer Stephen Morris had moved. In 1977 they'd been playing catch-up; an awkward punk band playing abrasive, limited tunes around England's north-west. They became Joy Division in early 1978, and released their debut album, *Unknown Pleasures*, in June 1979 as they became increasingly cohesive and transformative. They improved season to season, growing more popular in Britain and Europe.

One of their few outside influences was eccentric producer Martin Hannett, who'd help catch the cold post-industrial threat of Manchester on *Unknown Pleasures*. For *Closer* he helped turn the band inwards, matching Curtis' lyrics to a sound that's heartbreakingly still. With their precise, separated drum sounds, minimalist keyboards and the pulse-like bass of Hook, the songs are witnesses to the interior landscape Curtis sings about. *Closer* is an album without physicality and detail – what's tangible is the emotional topography.

'This is the crisis I knew had to come/ Destroying the balance I'd kept,' begins Curtis on 'Passover', 'Doubting, unsettling and turning around/Wondering what will come next', and steadily his bandmates make clear what will come next as the icy splash of percussion and brief guitar squalls grow stronger as Hook's bass briefly imposes

TRACKLISTING

01 **Atrocity Exhibition**
02 **Isolation**
03 **Passover**
04 **Colony**
05 **A Means to an End**
06 **Heart and Soul**
07 **Twenty Four Hours**
08 **The Eternal**
09 **Decades**

before the song drifts away. The singer – who was suffering epileptic attacks on stage and trying to manage the resulting prescription drug-induced depression – was evolving as a vocalist, with his distressed vigour on the likes of 'Colony' counter-pointed by the stark baritone croon he used for 'Eternal'.

Joy Division would evolve into New Order after Curtis' death, and there are hints of that group's sensibility on 'Isolation' – an icy, glinting piece of alternative disco whose framework would prove enormously influential to the first wave of electronic acts in the '80s. Barely a note feels wasteful on *Closer*, and it has a distinct power that grows more apparent as the nine tracks unfold. The high bass and determined rhythm of 'A Means to an End' gives way to the nervy rhythms and elegant melody of 'Heart and Soul' before the swirling 'Twenty Four Hours' takes hold.

Numerous lines speak to the personal struggles Curtis was enduring, but it would be wrong to write off *Closer* as a morbid, self-obsessed piece of work. By the closing 'Decades', where the setting reaches 'hell's dark chambers', the music has attained a touching transcendence. Ian Curtis never wallowed in suffering. More often he was brave to describe what he was going through, and it made for a singular and enduring album that was the musician's best hope. 'But if you could just see the beauty/ These things I could never describe,' he sang on 'Isolation'. 'These pleasures a wayward distraction/This is my one lucky prize.'

·CLOSER·

JOY DIVISION FACT 25A FACTORY RECORDS PRODUCT CLOSER

N°:77

KRAFTWERK
TRANS-EUROPE EXPRESS

Kling Klang
Produced by Ralf Hütter and Florian Schneider
Released: March 1977

In 1976 and 1977 it was as if Kraftwerk intrinsically understood everything. 'He made up the person he wanted to be/ And changed into a new personality,' intones Ralf Hütter on the spectral pulse of 'The Hall of Mirrors'. 'Even the greatest stars change themselves in the looking glass.' As punk and disco were unleashing that very transformation, with the reinvention prescribed by the song occurring in grim council flats and sun-soaked mansions around the world, Kraftwerk were creating the psychogeography of popular music's next order.

Trans-Europe Express, the then West German quartet's sixth studio album, is the starting point for modern electronic music; the digital age is born in these seven songs.

Trans-Europe Express is crushingly influential. Without it there is no new romantic movement or its 21st century revival, techno music is never birthed by a handful of Detroit DJs, hip-hop doesn't have key early samples, and rock bands such as Radiohead don't have a crucial signpost. But the album goes beyond those linear links. Even though it was recorded in seclusion at the band's Kling Klang studio in Düsseldorf, the outcome alerted even the most unlikely listener to where they should go next. The clues to post-punk's urban suites are held in the industrial percussion and sparse production line rhythm of 'Metal on Metal', and throughout the record Kraftwerk's sombre presence suggests prescience.

The four-piece – founders and mainstays Ralf Hütter and Florian Schneider, who between them handled songwriting, synthesisers, vocals and production, supported by the electronic drums of Karl Bartos and Wolfgang Flür – were virtually self-sufficient by the time they made *Trans-Europe Express*. Kling Klang not only afforded them creative control, but it housed advances in still nascent keyboard technology that allowed for sequenced parts. The streamlined complexity that resulted is apparent from the opening 'Europe Endless', where the driving beat and sleek textures suggest a panoramic view that cuts up time and reality.

'Life is timeless,' the track's lyric begins, 'parks, hotels and palaces', and one of the fascinating strengths of *Trans-Europe Express* is that even while it broadcasts the future it's finding a synthesis with the past. The Europe that once was – 'elegance and decadence', as 'Europe Endless' puts it – permeates these tracks,

TRACKLISTING

01 **Europe Endless**
02 **The Hall of Mirrors**
03 **Showroom Dummies**
04 **Trans-Europe Express**
05 **Metal on Metal**
06 **Franz Schubert**
07 **Endless Endless**

with the rich melody that flows across the repetitive building blocks of 'Franz Schubert', adding a romantic echo to sessions that were being conducted as the West German state was convulsing with the trials of the Baader-Meinhof terrorist group.

In a 1975 *Creem* magazine profile, Hütter flatly told writer Lester Bangs that the band supplied the media with their own photos 'because we are paranoid', and much was made of Schneider and Hütter's belief in the menschmaschine (man-machine) philosophy. With their vocoder vocals, seemingly direct from a science-fiction movie, and their sleek perfection, Kraftwerk were not short of robotic precision. But these studio symphonies flicker with human desire and an obvious love for music's possibilities. The crescendos that illuminate the title track transcend their construction to create a heartfelt beauty.

They even had a sense of humour. On 'Showroom Dummies' Kraftwerk imagine themselves as little more than mannequins, playing to uninformed clichés, but in the song they come alive and break the window (cue sound effects), moving through the city until they find the dancefloor at a club. 'We're being watched and we feel our pulse,' they declare and *Trans-Europe Express* can still have the same outcome – to bring the inanimate to life – on those introduced to it today. A copy of this album deserves to be on every spacecraft that ever leaves this planet's gravity.

KRAFTWERK

TRANS EUROPE EXPRESS

N°: 78

RANDY NEWMAN
SAIL AWAY

Reprise
Produced by Lenny Waronker and Russ Titelman
Released: May 1972

Randy Newman was called the King of the Suburban Blues Singers by his childhood friend Lenny Waronker. The two Jewish boys were born into the music business – Newman's uncles were acclaimed composers in old Hollywood and Waronker's father founded Liberty Records and was an acclaimed producer. Without those connections it's unlikely that an artist as unique and provocative as Randy Newman would ever have seen the light of day. In the early '70s, Waronker funded eccentrics such as Van Dyke Parks, Lowell George and Ry Cooder, who created an exciting new kind of American music that didn't sell. *Sail Away* is the perfect example of this rare moment in time.

Having already made three albums and seen some success as a songwriter for hire for Alan Price and Barbra Streisand, *Sail Away* was Newman's bid for commercial success. But, as he told *Rolling Stone*, it was a long shot. 'I don't think the stuff I end up doing is the type of stuff that a lot of people are going to like. Not because they're dumb or anything, but because they're not maybe that serious about it. It isn't their fault, I mean it isn't the type of stuff that you can put on while you're getting loaded. It requires that it be the thing you're listening to.'

Sail Away featured the cream of Waronker's crew with Van Dyke Parks handling the string arrangements, Ry Cooder adding menacing guitar and Jim Kelter's warm and reliable drums.

Newman's deep love of America is best expressed by his melodies, which draw on all the strands of American music. Aaron Copeland, Gershwin, big band jazz, dirty New Orleans blues and rock & roll all make appearances in the tunes on this album. Not since Cole Porter has an American songwriter been so versatile and playful with such serious intent. And like Porter, Newman is best known for his lyrics.

In the early '70s, when it was all the rage to put your diaries to music, Newman wrote songs from the point of view of characters. The title track is the spiel coming from the slave trader inducing Africans to cross the mighty ocean for the good life in America.

TRACKLISTING

01 **Sail Away**
02 **Lonely at the Top**
03 **He Gives Us All His Love**
04 **Last Night I Had a Dream**
05 **Simon Smith and the Amazing Dancing Bear**
06 **Old Man**
07 **Political Science**
08 **Burn On**
09 **Memo to My Son**
10 **Dayton, Ohio – 1903**
11 **You Can Leave Your Hat On**
12 **God's Song (That's Why I Love Mankind)**

The words are underscored by the swelling orchestration that could have come straight out of any Hollywood blockbuster. There has rarely been a better analysis of America, and Newman does it in less than three minutes.

Few of Newman's characters are likeable. There's the misogynistic lover ('You Can Leave Your Hat On'), the ungrateful children ('Old Man'), the spoilt star ('Lonely at the Top') and the jingoistic, stupid American ('Political Science'). 'A lot of the people I write about are insensitive or a little crazy in a different way than I'm crazy,' Newman told Bruce Pollack. 'Still, they're more interesting to me than heroic characters. Way more interesting. I don't interest me, writing about me. I couldn't name you any song where I was writing about me.'

Newman reserves his best lyrics for God. On 'He Gives Us All His Love', Newman mostly restates the title phrase over swelling strings and a plaintive piano. You can take the phrase any way you like. The final track, 'God's Song (That's Why I Love Mankind)', is more pointed. Phrased as God's reply to Job: 'I take from you your children and you say how blessed are we/You must all be crazy to put your faith in me/That's why I love mankind'.

Sail Away was not a commercial success, although 'You Can Leave Your Hat On' was a hit for Joe Cocker, and 'Political Science' is frequently quoted to describe George W. Bush's foreign policy. Like Cole Porter, Newman's songs will last as long as America.

RANDY NEWMAN SAIL AWAY

N°: 79
PAVEMENT
CROOKED RAIN, CROOKED RAIN

Matador
Produced by Pavement
Released: February 1994

The cut from *Crooked Rain, Crooked Rain*, the inspired second album from American rockers Pavement, which hovers in the mainstream music consciousness, is 'Range Life'. In it the band's songwriter, Stephen Malkmus, imagines life amid the front line of alterative rock's then new superstars. 'Out on tour with the Smashing Pumpkins/Nature kids, they don't have no function,' the lanky vocalist declares over a golden hued country-rock jam. 'The Stone Temple Pilots, they're elegant bachelors/They're foxy to me, are they foxy to you?' It's snarky, but glancing – Malkmus would diffidently claim it was written from the viewpoint of an ageing hippy, but it was enough to infuriate Smashing Pumpkins' dictator Billy Corgan, who was unhappy about subsequently sharing a stage with the Californian five-piece.

Yet on the same song, less than 60 seconds earlier, there's a remarkable verse that encapsulates the lonely beauty and uncertain possibilities of teenage life: 'Out on my skateboard, the night is just hummin'/And the gum smacks are the pulse that I'll follow, if my walkman fades/But I've got absolutely no-one, no-one but myself to blame'. That contrast, and the way that the playfully spiky digs are recalled and the transcendent verse is buried, is typical of *Crooked Rain, Crooked Rain*. It's an album that has had to survive all manner of generational statements tied to the mid-1990s before it could shine through as a sustained piece of songwriting that reveals more with each listen.

The band had been formed in 1989 in the central Californian city of Stockton, by teenage friends Malkmus and Scott Kannberg, who originally envisaged Pavement as a studio project. They recorded lo-fi EPs in a local studio run by Gary Young, an older musician who became their decidedly eccentric first drummer. By 1992 bassist Mark Ibold and percussionist Bob Nastanovich had been added, and Pavement were touring their fuzzy and idiosyncratic debut album, *Slanted & Enchanted*. By 1993, after extensive international touring where Young's loose playing and penchant for running around the stage mid-song had begun to grate on his bandmates, the drummer was replaced by Steve West as the sessions for this sophomore record began.

TRACKLISTING

01 **Silence Kid**
02 **Elevate Me Later**
03 **Stop Breathin'**
04 **Cut Your Hair**
05 **Newark Wilder**
06 **Unfair**
07 **Gold Soundz**
08 **5-4=Unity**
09 **Range Life**
10 **Heaven Is a Truck**
11 **Hit the Plane Down**
12 **Fillmore Jive**

There was a noticeable change on the resulting record as well, with the affection of Malkmus and Kannberg for English post-punk provocateurs the Fall being replaced by an appreciation of R.E.M.'s early 1980s output. It's not just the guitar sound – pure Peter Buck jangle – on the stirring 'Gold Soundz' that sells it, but the realisation that Malkmus' lyrical outlook harbours a judicious eye. Like a young Michael Stipe, Malkmus is the all-American alien, alert to the friction within his culture but deeply connected to its tradition. His distaste for Los Angeles and its celebrity lifestyle – a repeat feature on the likes of 'Elevate Me Later' and 'Unfair' – was couched in post-modern satire, matching a surge of imagery to ringing classic rock on the former and blazing alternative licks for the latter.

Pavement assumed – and mastered – every style they approached on *Crooked Rain, Crooked Rain*. They turned the dilapidated groove and sweet harmonies of 'Cut Your Hair' into an anthem – a song that almost made them into the stars the verses mock – while the fractured, tender track, 'Stop Breathin', circles unease until it offers a defiant send-off. For good measure they even put together a spectral jazz instrumental with '5-4=Unity'. On the six-minute epic final cut, 'Fillmore Jive', a drunken Malkmus makes outrageous demands and then passes out on a couch, dreaming of mods and rockers as his bandmates find an elegiac orbit and the singer views his own screening of *Quadrophenia*. The esoteric has rarely sounded so satisfying.

N°: 80

CURTIS MAYFIELD
CURTIS

Curtom
Produced by Curtis Mayfield
Released: September 1970

By the time Curtis Mayfield left the Impressions to go solo in 1970 he was a legend. He started with the Impressions at the age of 14 and had his first #1 hit in 1961 when he was 19. In 1965 he penned the unofficial civil rights anthem, 'People Get Ready', about which he said: 'The nice, spiritual gospel feel dictated the words, which came from the inspiration of the church and different sermons. It just all came together properly.' Mayfield's talent was to combine political and progressive songwriting with warm, soulful funk.

'It was always my way,' he said in 1985. 'I always believed that whatever I should speak or sing about should have some value. I'm not totally about being just an entertainer, making people grin. It means a little bit more to me than that.'

Mayfield grew up in Chicago in the 1940s and 1950s in the wake of the 'Chicago Renaissance', which saw a cultural revolution in black communities across all the arts. Chicago also had a thriving jazz scene, while Muddy Waters presided over a thriving blues scene on the South Side. And then later, of course, there was Sam Cooke. Mayfield absorbed all these influences, added a strong Latin flavour and created his own distinctive sound. His distinctive guitar playing significantly influenced rock players – especially Jimi Hendrix and Robbie Robertson. Mayfield in turn absorbed some of the directness of rock music, most evidently on this, his debut solo album.

Mayfield was one of the first R&B writers to address ghettos issues, and by 1970 James Brown, Marvin Gaye, Sly Stone and Motown's Norman Whitfield were all talking about a revolution. Mayfield is a little more subtle and more seductive than his contemporaries. His gift for visual imagery and his dramatic use of horns and strings makes *Curtis* a totally cinematic experience. The six-minute epic 'We the People Who Are Darker Than Blue' moves through a palette of jazz to funk and soul but is somewhat more than any of them. It's message couldn't be clearer.

TRACKLISTING

01 **(Don't Worry) If There's a Hell Below, We're All Going to Go**

02 **The Other Side of Town**

03 **The Makings of You**

04 **We the People Who Are Darker Than Blue**

05 **Move On Up**

06 **Miss Black America**

07 **Wild and Free**

08 **Give It Up**

'(Don't Worry) If There's a Hell Below, We're All Going to Go' begins with a fuzz bass and a woman citing the Book of Revelations, exhorting the listener to take note of the good book. Then the voice comes in with Mayfield shouting, 'Sisters! Niggers! Whities! Jews! Crackers!/Don't worry, If there's a Hell below, we're all gonna go!', and the song explodes in a fury of chopping wah wah guitar and soaring horns and strings. The danceability of this music belies the steely despair in the lyrics and this was a style that Mayfield would refine on 'Pusherman' on the *Superfly* soundtrack the following year. This is an unromantic view of ghetto life, both literate and heartfelt, and one of the milestones on the road to a new black consciousness.

The other key track, 'Move On Up', could well be the sequel to 'People Get Ready' with its strong gospel melody, its positive message and its firm political line. Mayfield takes a political slogan but delivers it like a spiritual message. One of the most covered soul songs of the period, 'Move On Up' continues to be influential when most '70s soul is now nostalgia.

'It's now time to carry the message in a more personalised vein,' Mayfield said in 1972. His records were clearly political but never polemic. 'That way people relate easier. General statements are all very well but fit the statement into a personal context, which the listener can place himself into, and you then have something with much more impact.'

RYAN ADAMS ON JACK WHITE OF THE WHITE STRIPES

I am so jealous of that guy. Motherfucker knows rock & roll like sugar knows ice cream.

ROB HIRST ON THE WHO'S *LIVE AT LEEDS*

Here's a band where both the bassist and the drummer play continuous solos, while the guitar player, mixed low under the most extraordinary bass sound, chops away at the rhythm. ... What the audience at Leeds University thought of the performance that winter's night is unclear – you can't hear them. What you can hear is the live album by which all others would be judged – neither the Stones nor Zeppelin ever got close.

Rob Hirst (Midnight Oil)

DARRYL 'DMC' MCDANIELS ON BEASTIE BOYS

When *Paul's Boutique* came out, it didn't sell as well as their debut. Now people realize it's one of the best albums of the '80s.

Darryl 'DMC' McDaniels (Run-D.M.C.)

ANDY MCCLUSKEY ON *TRANS-EUROPE EXPRESS*

The juxtaposition of the humanity and the technology creates the melancholy tension. *Trans-Europe Express* was the apex, where the beauty and the machinery chimed together. It was also their first witty record ...

Andy McCluskey (Orchestral Manoeuvres in the Dark)

PATTI SMITH ON THE VELVET UNDERGROUND & NICO

They were the stark, elusive balloon that burst upon a deflated scene, injecting that scene with a radiance that connected poetry, the avant-garde and rock and roll.

SHERYL CROW ON THE EAGLES

To this day, it simply doesn't get any better than that guitar riff from 'Life in the Fast Lane'.

BILLY CORGAN ON PAVEMENT

They're just annoying. I think history has judged the bands appropriately. My band continues to be a source of excitement, and their band continues to be a source of record critics' masturbatory diatribes. Billy Corgan (Smashing Pumpkins)

BOB DYLAN ON RANDY NEWMAN

Yeah, Randy. What can you say? I like his early songs, 'Sail Away', 'Burn Down the Cornfield', 'Louisana', where he kept it simple. Bordello songs. I think of him as the Crown Prince, the heir apparent to Jelly Roll Morton. His style is deceiving. He's so laid back that you forget he's saying important things. Randy's sort of tied to a different era like I am.

BOB DYLAN ON TOM WAITS

Tom Waits is one of my secret heroes..

ALISON GOLDFRAPP ON KATE BUSH

There was this time during my teenage years when everyone was doing ecstasy and going out to raves, and I was at home listening to Kate Bush. On ecstasy.

BONO ON IAN CURTIS OF JOY DIVISION

His voice was holy. I always sort of saw Ian Curtis as a kind of Roy Orbison of our generation. I've always liked people to take themselves painfully seriously.

SEAN JOHN COMBS ON CURTIS MAYFIELD

Curtis Mayfield has always been a divine artist in every sense of the word. He's a teacher, a preacher, a poet, a founding funk pioneer. From his early days in Chicago, he brought a sense of religious purity to his music, whether he was creating his songs for the church, or his songs for the streets. Curtis realized there was no difference. Curtis wrote songs connected with singers and saints, and other people that had to get ready. Whether they were songs of hope or songs or despair, he wrote about the human experience with amazing grace and remarkable honesty. His music has always communicated a sense of the holy and the sting of the truth. Growing up, it was hard to imagine some of these creations were actually written by a man. They sounded timeless, God-given – and I believe they were. Sean John Combs (P. Diddy)

N°: 81

ROXY MUSIC
FOR YOUR PLEASURE

Island
Produced by Chris Thomas, John Anthony and Roxy Music
Released: March 1973

Bryan Ferry thought *For Your Pleasure*, Roxy Music's second album, was the band at its most complete. 'It's the one that captured what I wanted to do most clearly,' he reflected. 'We enjoyed making *For Your Pleasure* more [than their debut], because we felt more in control. We still had a producer, but Brian [Eno] had a lot more to do with the sound. And I underestimated what a help Brian was to me when we split up.' Ferry is, of course, speaking in hindsight because, as it turned out, the band wasn't big enough for both his and Eno's expanding egos and before long Eno would be gone.

Roxy Music had arrived like an alien spaceship into the pop scene of 1972 with a self-titled debut that was glamorous and dangerous, resplendent in irony and outré fashion, with a sound quite unlike any other. According to Ferry, 'The original idea for Roxy Music was, to put it very bluntly, to combine arty music with sexy music'. Ferry looked like Dirk Bogarde walking on the wild side while Brian Eno just looked odd, and in between there were the surreal looking Phil Manzanera on guitar, jazzer Andy McKay on saxophone and drummer Paul Thompson, who looked like he just stepped off a building site. If they looked strange that was nothing compared to their sound – a touch of '50s rock & roll, some prog and the rest of it was completely new. The whole package was wrapped up in a cold, ironic distance, part kitsch and part art.

Bryan Ferry had recently graduated from art school and the sensibility that drove his songs owed as much to British pop art and the Independent Group as it did to any rock & roll band. It was this maverick art sensibility that encouraged Ferry to enlist Eno into the band. Eno at that time couldn't play an instrument but he did like to play with electronic sounds. 'I saw Bryan's songs in the context of pop art,' said Eno. 'We wanted to say, "we know we're working in pop music, we know there's a history and that it's a show biz game but we want to do something new".'

TRACKLISTING

01 **Do the Strand**

02 **Beauty Queen**

03 **Strictly Confidential**

04 **Editions of You**

05 **In Every Dream Home a Heartache**

06 **The Bogus Man**

07 **Grey Lagoons**

08 **For Your Pleasure**

The band's first album, *Roxy Music*, had alerted the British public to the band ahead of them entering London's AIR studios in February 1973 to record its follow-up. The title track had been decided before the sessions began, and that's certainly the outer limits of where pop music was going to go at the time – hypnotic piano, washes of electronica and snatches of guitar and saxophone power along a sophisticated version of the Velvet Underground (with a faint sample of actress Judi Dench in the mix). 'Beauty Queen', which was Ferry's idea of a torch song, throbbed with electronics and yet it somehow managed to drip with emotion while sounding cold and cool at the same time.

With its pounding piano and driving guitars, 'Do the Strand' was sexy and frightening, obscure and challenging. It was a dance song with no instructions how the Strand was actually done. But 'Do the Strand' became a UK hit single and this avant-garde band was thrust firmly into the mainstream.

The album's classic is the epic 'In Every Dream Home a Heartache', which owed a big debt to artist Richard Hamilton, who had been Ferry's teacher and who designed the Beatles' 'White Album'. This dark, funny satire on modern consumerism is a love song to an inflatable sex doll featuring the classic line, 'I blew up your body but you blew my mind'. Indeed. No album has ever mixed art and music better than this.

N°:82

THE STROKES
IS THIS IT

Rough Trade/RCA
Produced by Gordon Raphael
Released: July 2001

'**M**y idea was always to take undergroundish, cool music and make it mainstream. That was my goal,' said Strokes singer Julian Casablancas. He went on to acknowledge that perhaps mainstream music never did become cool, but certainly the Strokes can claim to have launched hundreds of British guitar bands and shaken up rock & roll in the early 21st century.

Backwards to the future, the Strokes' sound recalled the smart traditions of New York rock & roll. The sexual play of the New York Dolls, the dry drones of the Velvet Underground and the spiky guitars of Television were all clear influences on their sound. It's as though they brought back the all-night style of New York City, long after Max's Kansas City had closed. And while they may have worn their influences on their sleeves, they wore an entirely new skin on the old ceremonies. For a start *Is This It* sounds like a whole lot of fun. 'We represent what New York creates,' Casablancas explained. 'But it's not like when we go to play in England we're giving the New York message. It's actually trying to be as universal as possible.'

The Strokes – Casablancas, drummer Fabrizio Moretti, bass player Nikolai Fraiture and guitarists Albert Hammond Jr and Nick Valensi – mostly came from well-heeled families. Hammond's father was a well-known songwriter and Casablancas' father owned a model agency.

However the group that formed in 1998 was determined to make their own mark.

The band had come to the attention of Gordon Raphael, who owned a cheap studio on the lower east side of Manhattan and he recorded a three-track demo, *The Modern World*, which was picked up in the UK by Rough Trade. Almost overnight the Strokes were hailed in Britain as the next big thing. RCA Records signed the band and put them into a studio with Gil Norton who had produced the Pixies and many platinum-selling bands. After three songs, the Strokes decided to forget

TRACKLISTING

01 **Is This It**
02 **The Modern Age**
03 **Soma**
04 **Barely Legal**
05 **Someday**
06 **Alone, Together**
07 **Last Nite**
08 **Hard to Explain**
09 **New York City Cops**
10 **Trying Your Luck**
11 **Take It or Leave It**

The US CD version has 'When It Started' as track 9 instead of 'New York City Cops'

the modern studio and name producer, and returned to Raphael and his dank basement.

The album was cut over March and April 2001, recording as close to live as possible in midnight-to-dawn sessions. 'Before the album was made, Albert and Julian actually brought me things to hear, to show me the tones and energy that they liked,' says Raphael. 'Julian said "We want to sound like a band from the past that took a time trip into the future to make their record". The Strokes had already announced to me that they wanted to take what was happening in music and go in a completely different direction, doing something that wouldn't sound like it was made today. That was one of the prerequisites mentioned in our first meeting.'

The songs by Casablancas have an air of recklessness. They conjure a sense of being loose and up for anything in the big city. Nothing much matters and nothing matters much. The music matches that carefree tone although, sharp as a switchblade, the guitars still bristle with melody and Moretti's drums have a joyful but driven bounce.

One of the best things about the album was its conciseness. Clocking in at just over half the length of most CDs, *Is This It* demonstrated that whenever rock & roll starts getting too full of itself, it's best to go back to the modernist classics – black and white images, two guitars, bass and drums. Less is always more.

N°:83

MIDNIGHT OIL
DIESEL AND DUST

CBS
Produced by Warne Livesey
Released: August 1987

In the winter of 1986 Midnight Oil spent a little over a month on the Blackfella/Whitefella tour of Aboriginal settlements in Northern Australia. Jim Moginie, the band's guitar/keyboard genius, articulates what is a shared band view: 'My life is divided into two halves, the first half is before the Blackfella/Whitefella tour, and the second half is everything after'. The adventure was a first-hand lesson in the beauty of the Australian heartland, the resilience and deep spirituality of the indigenous people who live there and the terrible privations that have been visited on these people since the European settlement of Australia. Midnight Oil's response was their stunning sixth album.

'When you lie back in your swag in the desert looking up and you've never seen the heavens so bright,' drummer Rob Hirst wrote in 2008. 'Sometimes it'd scare you out of your skin. You understand why Aboriginal peoples' lives and their dreaming are all related to what happens in the sky. Gradually, we learned how to use space in our music, to breathe the slower rhythms of the desert. In other words, to fill the gaps between the beats, notes and words with "The Great Quiet".'

The band – Moginie, Hirst, singer Peter Garrett, guitarist Martin Rotsey and bassplayer Peter Gifford – returned to Sydney and distilled their experiences into *Diesel and Dust*. They already had 'The Dead Heart' and the evolving 'Beds Are Burning', and Moginie added 'Warakurna' and Hirst 'Bullroarer'. The album was rounded out by tracks that were pro-conservation ('Dreamworld'), anti-nukes/anti-terrorism ('Put Down That Weapon' – a reaction to the sinking of Greenpeace's *Rainbow Warrior*) and the more personal, existential dramas that occasionally found their way into the band's canon ('Whoah' and 'Arctic World').

The band spent months rehearsing and demoing the tracks to get them just right. 'We wanted to get all the fat out of the songs. Simplicity was the key,' remembers Moginie. 'Rob became very interested in the idea of a driving beat. We'd used drum machines a bit in the past. He'd always said in jest, "Machines play so relaxed", which Kraftwerk said anyway. But that feel, played on the drums combined with the acoustic guitars on which the songs were written around campfires sounded fresh, so we went with it.'

TRACKLISTING

01 **Beds Are Burning**
02 **Put Down That Weapon**
03 **Dreamworld**
04 **Arctic World**
05 **Warakurna**
06 **The Dead Heart**
07 **Whoah**
08 **Bullroarer**
09 **Sell My Soul**
10 **Sometimes**
11 **Gunbarrel Highway**

The band settled on Englishman Warne Livesey to produce *Diesel and Dust*, largely based on his work on The The's acclaimed album *Infected*. Recorded in early 1987, at Albert studios in Sydney, Moginie remembers the sessions as having a great spirit and being 'remarkably easy'.

The creation of the song 'Beds Are Burning' is a perfect example of the Midnight Oil chemistry at its best. 'I had the chorus, that was the foundation point,' Hirst explained to journalist Debbie Kruger. 'Then we had some dummy lyrics for a while, until we went to the desert, and I rewrote the lyrics. Then Jim had the riff ... and we had a basic song. Pete came in and said, "We've actually got to make a statement", as is Pete's wont. He said, "Something like 'The time has come!' You know, 'Give it back!'". And I said, "Right, okay" ... Jim said, "We need something to wake people up at the beginning of the song". So three big chords, like a wake-up call. And then Warne Livesey had the idea of throwing the drum kit down the stairs, that big percussive break.' The song about the Western Desert became a hit single from New York to Paris.

In an interview with the band during the Blackfella/Whitefella tour Hirst said, 'I've always had this dream that this band could write an Australian music that people overseas could get on to and understand and which would enlarge their whole vision of Australia past Vegemite sandwiches and kangaroo hops'. With *Diesel and Dust* that dream came true.

Nº 84

COLDPLAY
VIVA LA VIDA OR DEATH AND ALL HIS FRIENDS

Parlophone
Produced by Markus Dravs, Brian Eno and Rik Simpson
Released: June 2008

It was as if the blinkers had been removed. After the diligent, emotionally dogmatic *X&Y* album of 2005, Coldplay exploded into life on *Viva la Vida or Death and All His Friends*, the kaleidoscopic long player that finally matched the English four-piece's commercial success to an arresting artistic vision. Established parameters vanished, rules no longer applied.

It is not entirely surprising to find the name Brian Eno in the sleeve credits. The former Roxy Music maven has long been an influential producer and collaborator for bands hoping to break new ground, having had a hand in everything from the elevation of U2 in the 1980s to the invention of ambient music. Eno was one of three outside producers for the extensive *Viva la Vida* recording sessions, with added thanks for 'sonic landscapes'. It's a telling notation. Eno used keyboard pulses and background washes to define a song's architecture – tracks acquire space, they breathe.

Viva La Vida makes good use of this framework. The sound is varied and expressive, and while there are 10 songs formally listed, several comprise diverse pieces that are contracted together, adding to the sense of depth. The album is not a left turn into artistic self-endowment, instead it gave new, varied voices to Coldplay's obvious craftsmanship and the combination of the familiar and the unexpected lifted the band.

Songs cut in mid-beat and segue unexpectedly; they no longer have the stubbornly clear through line that previously made Coldplay so attractive to radio programmers. The track '42' begins as a tender piano ballad, burnished by mournful strings, before it unexpectedly acquires a skittering beat and muscular bass. The latter part has the queasy majesty of post-punk champions Echo & the Bunnymen, one of several English icons subtly referenced; another is modernist composer Michael Nyman, who can be discerned in the deft, lyrical orchestration underpinning the title track.

Yet another presence, broader still, is London itself. Coldplay had rarely exhibited a particular sense of time or place – frontman Chris Martin's constructs had traditionally been universal. But here, beginning with the rousing 'Cemeteries

TRACKLISTING

01 **Life in Technicolor**
02 **Cemeteries of London**
03 **Lost!**
04 **42**
05 **Lovers in Japan/Reign of Love**
06 **Yes**
07 **Viva la Vida**
08 **Violet Hill**
09 **Strawberry Swing**
10 **Death and All His Friends**

of London', he ruminates on the city's history. Where a Ray Davies latches onto geography, Martin sees London as a collective memory. On the thumping, percussive single 'Violet Hill', lovers silently walk towards a favoured place, where they will forever part, imagining the strife that has previously swept these streets. Bibles and rifles are referenced – as the couple prepare for their own personal conflagration.

Previously Martin's tendency was to avert such crises, but here he either invokes the pain without offering solace, or ignores it completely. *Viva la Vida* is instead thick with nods to the departed and the rituals of the dead. 'You thought you might be a ghost/But you didn't get to heaven but you made it close,' he sings on '42', setting up shop in the netherworld. The singer even takes a stab at carnal desire on the seven-minute epic 'Yes', a cut whose eastern-influenced instrumentation drifts off into a swooning, diffused ocean of noise. Coldplay's ambitions are not always fulfilled, but even when they prove merely interesting – as with the Afropop of 'Strawberry Swing' – you're left with a side of the band previously unseen.

Anything appeared possible for Coldplay after the release of *Viva la Vida*, and the rich breadth of music on the record was in no way an impediment to the band's status as one of the decade's few new stadium-filling acts. They didn't come close to matching the moment on 2011's *Xylo Myloto*, but if this is to be the group's highpoint, then there's no doubting just how far they leapt forward.

N°:85

THE KINKS

THE KINKS ARE THE VILLAGE GREEN PRESERVATION SOCIETY

Pye/Reprise
Produced by Ray Davies
Released: November 1968

The Kinks were the first English rock & roll band. The Beatles, the Who and the Rolling Stones all played American music. Then in May 1967 Ray Davies wrote 'Waterloo Sunset', and suddenly his band had created a distinctly English sensibility and language in rock & roll, something else that wasn't just an English version of American modes.

In the months following 'Waterloo Sunset' Davies began to compose songs and characters that exemplified the traditional English village life that was being swept away by the turbulent '60s. 'I wanted it to be *Under Milk Wood*, something like that,' he said. 'Somebody told me that I preserve things, and I like village greens and preservation societies. The title track is the national anthem of the album, and I like Donald Duck, Desperate Dan, draught beer.'

The songs do touch on characters and descriptions of rustic life but the overwhelming theme of the record is one of memory and loss, which is at the heart of all of Davies' work. When asked when he thought life was good, Davies replied, 'I'll tell you when it was good. When I was walking down the road with Michelle Gross, whose dad owned the sweetshop. She was about a foot taller than I was and she had her arm around me and I said, "God, if I can stay with this girl forever I can have all the sweets I ever want". That was when it was good.' Davies isn't about recreating or wishing for a return to bygone days. Mindful of William Faulkner's quote 'The past isn't dead and buried. In fact, it isn't even past', this album is about acknowledging the past and seeing how it affects the present. A photograph of a happy family contains in it the hopes and dreams – did they come true? Have we lived up to the promises we made to ourselves?

There is a wonderful uplift in songs like 'Picture Book', 'People Take Pictures of Each Other', 'Animal Farm' and 'Sitting by the Riverside'.

TRACKLISTING

01 **The Village Green Preservation Society**
02 **Do You Remember Walter?**
03 **Picture Book**
04 **Johnny Thunder**
05 **Last of the Steam-Powered Trains**
06 **Big Sky**
07 **Sitting by the Riverside**
08 **Animal Farm**
09 **Village Green**
10 **Starstruck**
11 **Phenomenal Cat**
12 **All of My Friends Were There**
13 **Wicked Annabella**
14 **Monica**
15 **People Take Pictures of Each Other**

Songs like 'Johnny Thunder' and 'Wicked Annabella' are whimsically dyspeptic and give great scope for the doomy riffing that Dave Davies pioneered on the early Kinks hits. 'Last of the Steam-Powered Trains' is their one nod to American influences – a rewrite of Howlin' Wolf's 'Smokestack Lightning', which features some wonderfully sharp guitar. It may well be that the Kinks here are making a comment on the place of '50s blues in 1968. Or indeed now.

In the studio the Kinks (Ray and Dave Davies, drummer Mick Avory and bassist Pete Quaife) struggled. Always a volatile band – onstage fistfights between the Davies brothers were already the stuff of legend. Relations with the record label were strained. By the end of the album bassist Quaife quit the band. This was to be the last Kinks album with their original line-up.

Davies seems to have been unable to decide for himself the real shape of the LP, pushing for a double album. Pye records demurred and a 15-song single album was released, inexplicably without the tracks 'Days' and 'Mr Songbird', two of Davies' most catchy tunes. Amid all this confusion and disarray in the band, it's not surprising that *The Kinks Are the Village Green Preservation Society* was a commercial disaster.

Appropriately, history and critics have been kind to the album and it's now regarded as the Kinks' finest hour and slowly and surely has become their single biggest album.

THE KINKS

ARE THE VILLAGE GREEN PRESERVATION SOCIETY

N°: 86
PRETENDERS
PRETENDERS

Real
Produced by Chris Thomas and Nick Lowe
Released: January 1980

Classic rock radio has been having its way with the various singles from the Pretenders' cocksure 1980 debut album for over three decades now. But steady rotation for the likes of 'Brass in Pocket' or 'Stop Your Sobbing' hasn't diminished them a touch, especially when they're back in the company of these tough and revelatory rock & roll songs. *Pretenders* still sounds like a great album, fresh and a step ahead of expectations and, as a debut, it's close to perfect in how it encapsulates the band's aesthetic. This record can still stare down any newcomers.

A huge degree of the credit for that goes to vocalist, rhythm guitarist and songwriter Chrissie Hynde, who grew up like a cultural time bomb in Akron, Ohio that went off when she got to London in 1973. She moved through all the touchstones of London pre-punk – wrote for *New Musical Express*, worked for Malcolm McLaren and Vivienne Westwood at their clothes store, Sex, and played in all manner of bands – generally the ones featuring someone who went on to start a successful group in 1977. Hynde was sidelined for punk's explosion, and while she was forlorn at her exclusion at the time, it would pay off in retrospect.

By 1978, when her demos started turning heads and Hynde had recruited bassist Pete Farndon, guitarist James Honeyman-Scott and, lastly, drummer Martin Chambers to form the Pretenders, the frontwoman had moved past easy influences or shock tactics. It made sense that in the video clip for 'Brass in Pocket' (one of the first handful that MTV launched with) Hynde played a waitress in a greasy spoon café – she was independent but never otherworldly, and the like-it-or-lump-it authenticity of her persona extended to her songs, where she could be flint-edged and dismissive, or painfully vulnerable with equal candour.

Dipping into street slang and primal noise – the grunt at the start of 'The Wait' sets the scene for the song's rush of images and pile up of phrases – Hynde wasn't easily pinned down in her songs. She could be hardened and judgmental in a verse, but flick into yearning for the chorus. On the contained, coruscating 'Private Life', the singer rips into the duplicitous

values of a married suitor. 'Your sentimental gestures only bore me to death/You've made a desperate appeal now save your breath,' she sings. The expressive breadth of her vocals opened up these songs, allowing for lyrics as morally and emotionally complex as 'Tattooed Love Boys', where Hynde surveys the boys in a band on tour and the women around them, including herself.

What makes the album stand out is that there's a second voice almost as strong as Hynde's in the form of guitarist James Honeyman-Scott. In a band that had punkish vigour and rock & roll brio, he added layers of introspective textures and sudden, searing solos. Hugely influential on a generation of guitarists that followed him, Honeyman-Scott struck a ringing tone on 'Up the Neck', while 'Space Invader' is an instrumental showcase for a sweeping style that could have come from post-punk experimentalists such as PiL.

The balance of that line-up wouldn't last, with Farndon fired in June 1982 (he died of a heroin overdose the following year) and Honeyman-Scott passing away two days later due to heart failure as a result of cocaine intolerance. The quartet also made 1981's fine *Pretenders II*, but it's their debut that truly endures, from their classic first 45, a stirring take on the Kinks' 'Stop Your Sobbing', through to the melodic warmth of 'Kid' and the elegiac 'Lovers of Today'. There wasn't a great deal the Pretenders couldn't pull off on their first album, and they had no problem letting listeners know.

TRACKLISTING

01 **Precious**
02 **The Phone Call**
03 **Up the Neck**
04 **Tattooed Love Boys**
05 **Space Invader**
06 **The Wait**
07 **Stop Your Sobbing**
08 **Kid**
09 **Private Life**
10 **Brass in Pocket**
11 **Lovers of Today**
12 **Mystery Achievement**

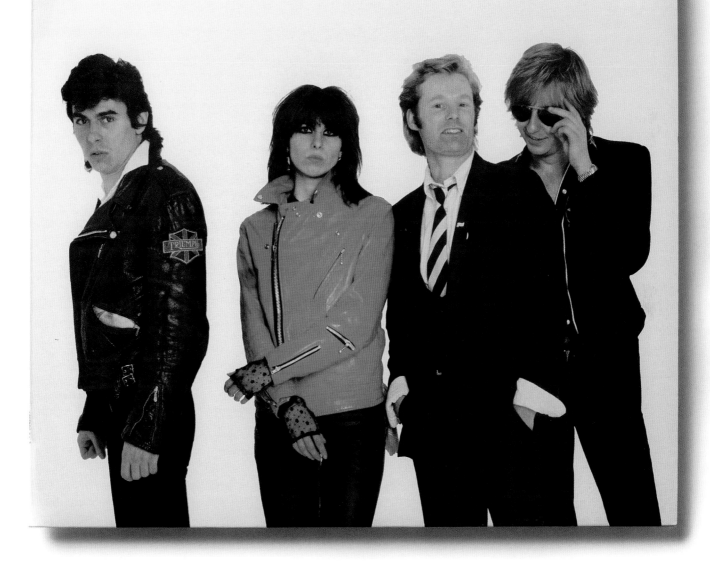

N°:87

THE MODERN LOVERS
THE MODERN LOVERS

Beserkley
Produced by John Cale, Robert Appere and Alan Mason
Released: August 1976

Few albums have taken five years to go from studio to the record store, but then few record companies would know what to make of Jonathan Richman. Growing up in Boston on a diet of the Stooges and, in particular, the Velvet Underground, Richman ran away to New York as a teenager to join the bohemian version of the circus, hanging around Warhol's Factory. On moving back to Boston in 1970 he formed the first version of the Modern Lovers – with keyboard player Jerry Harrison (later of Talking Heads), drummer David Robinson (later of the Cars) and bassist Ernie Brooks – to play his quirky, dry, dark songs.

Richman took the sound of the Velvet Underground – an arid, almost monotonous rhythm, with simple chords and deadpan delivery – and married it with lyrics that were self-consciously prosaic, almost Warholian in their celebration of the ordinary objects of modern urban life. By 1971 the Modern Lovers were playing gigs with the New York Dolls and other underground acts and causing a stir. Warner Bros. put them in the studio with Velvet Underground alumnus John Cale and A&M had demos produced by Robert Appere and Alan Mason. A deal with Warner Bros. was struck but soon after the band was dropped by the label. They then disbanded and Richman changed musical direction. The recordings were shelved and quietly became the stuff of legend. That is until 1976, when independent label Berserkly released *The Modern Lovers* and a cult sprang up around it.

Some of the songs like 'She Cracked' and 'Hospital' clearly show the Velvet Underground influence, taking subjects that pop music had formerly avoided and singing about them, such as the case of a girl in an asylum. Elsewhere Richman plays the innocent naïf, singing lyrics more suited to the bobby sox years of the late 1950s but with the sinister monochromatic Velvets' style backing of the Modern Lovers.

Although Richman would largely repudiate this album it did sketch out his persona as a virginal man looking for pure love in a sinful world. 'I think that whole form of love is outmoded because it really isn't love,' he said. 'When I say "Modern Love", I mean the time when you don't have to force the issue, when you don't have to prove anything to yourself. When you think you're all right. When you don't need sex to feel all right.' As Ian Birch wrote in 1977, 'He is the vulnerable boy scout from the suburbs who somehow maintains

TRACKLISTING

01 **Roadrunner**
02 **Astral Plane**
03 **Old World**
04 **Pablo Picasso**
05 **She Cracked**
06 **Hospital**
07 **Someone I Care About**
08 **Girlfriend**
09 **Modern World**

a perpetual sense of wonder and fractured innocence, translating mundane experiences into screwball or chilling surrealism: Doris Day mated with Iggy Pop.'

The two best-known Modern Lovers songs are 'Pablo Picasso' and 'Roadrunner'. The first, co-written with John Cale, observes that when Picasso walked down the street he was not 'called an asshole' but was delivered with a dark, arch tone. 'Roadrunner' is one of the great rock & roll driving songs of all time and was a minor hit in the UK and was subsequently covered by the Sex Pistols. Essentially it's the story of a teenage Richman cruising around Boston listening to the radio, high on regular life.

'We used to get in the car and just drive up and down Route 128 and the Turnpike,' recalled his friend John Felice. 'We'd come up over a hill and he'd see the radio towers, the beacons flashing, and he would get almost teary-eyed. He'd see all this beauty in things where other people just wouldn't see it.'

The music of 'Roadrunner' was clearly based on the Velvet epic 'Sister Ray', although Richman reduced the number of chords from three to two and fused it with a little of the VU's 'What Goes On'. According to Cale, his suggestion of adding backing vocals was met with displeasure as they reeked of 'production values'. Perhaps appropriately the songs were recorded in a studio owned by a local church. 'Little old ladies with blue hair were sitting in the front office doing tapes of hymns and the Bible while we were inside thrashing out these things.'

Nº:88

PRIMAL SCREAM
SCREAMADELICA

Creation
Produced by The Orb, Hypnotone, Jimmy Miller, Hugo Nicolson and Andrew Weatherall
Released: September 1991

The British independent music scene was on its last legs by the end of the 1980s. Anyone who could break new ground had either departed the underground or simply split up, and all that was left were the imitators. Stagnation and calcification were the order of the day, as twee melancholy and '60s dogma held sway, and the only hope for new impetus was far across the Atlantic.

That Primal Scream was the band who would not so much change this status quo as detonate expectations and put them back together in three dimensions, would have initially seemed ludicrous. Formed around one-time Jesus and Mary Chain drummer, Bobby Gillespie, almost a decade prior, the group had moved through line-ups, influences and degrees of quality at a fast rate without distinguishing themselves. They'd been jangle pop exponents and rock & roll revivalists and neither phase had felt real or lasting.

But if their sound was shaky, the aesthetic was rock solid: punk outlook, an appreciation of black music's history and a convert's dedication. When the acid house and rave scene took off in England, brought back from Ibiza in Spain with DJs and pills, Primal Scream were primed to synthesise it with guitar, bass and drums. It was influential DJ Andrew Weatherall, a friend of the band, who would remix a tune – 'I'm Losing More Than I Ever Had' – from their self-titled second album, and create the transformative single 'Loaded' with drum loops and B-movie samples. But it was

the vast, kaleidoscopic *Screamadelica* that would define the moment.

Recorded on the run, with a collaborative mindset between the band and various producers and mixers, *Screamadelica* turned out to be an epochal release. The songs were an invocation to a chemical generation, and an implicit declaration that the seemingly endless Conservative party rule begun by Margaret Thatcher was no longer to be feared. The album made the case for a new youth culture, and chemicals were an explicit element. 'Don't Fight It, Feel It' was one title, 'Higher Than the Sun' another; on a swirling cover of 13th Floor Elevators' 'Slip Inside This House', where psychedelia met Italo House, Gillespie would repeatedly sing, 'trip inside this house'.

TRACKLISTING

01 **Movin' On Up**
02 **Slip Inside This House**
03 **Don't Fight It, Feel It**
04 **Higher Than The Sun**
05 **Inner Flight**
06 **Come Together**
07 **Loaded**
08 **Damaged**
09 **I'm Comin' Down**
10 **Higher Than The Sun (A Dub Symphony In Two Parts)**
11 **Shine Like Stars**

Dance music became a form of faith on the album, an impression bolstered by samples that extolled music's back catalogue as a gateway to spiritual redemption. The songs – which, aside from the 13th Floor Elevators cover, were written by Gillespie, Robert Young and Andrew Innes – could summon dancefloor delerium, reaching joyous bliss on the likes of the seven-minute 'Don't Fight It, Feel It', where Denise Johnson takes the lead vocal from Gillespie and sings of getting high and dancing all night long.

But it was the composition, which offset the sweat and the club kid solidarity, that made *Screamadelica* more than a mere turning point. The hushed, Lou Reed meets Sly Stone vibe of 'I'm Comin' Down' was a ballad for the morning after, while the tender country-rock of 'Damaged' could have been an outtake from an early '70s Rolling Stones session (incidentally, the same person was behind the desk, in the form of Jimmy Miller).

More than anything, however, *Screamadelica* just kept finding new frontiers and declaring them open. The album's fulcrum is the astral transcendence of 'Higher Than the Sun', a song that proves that in space everyone can hear you dream. The arrangement's spectral breakdown and reverent swell is gorgeously otherworldly, and it made clear that Primal Scream hadn't just seen the light, they'd become one with it. Gillespie's dreamy vocal, less a boast than a promise, celebrated their breakthrough. 'What I got in my head,' he sang, 'you can't buy, steal or borrow'.

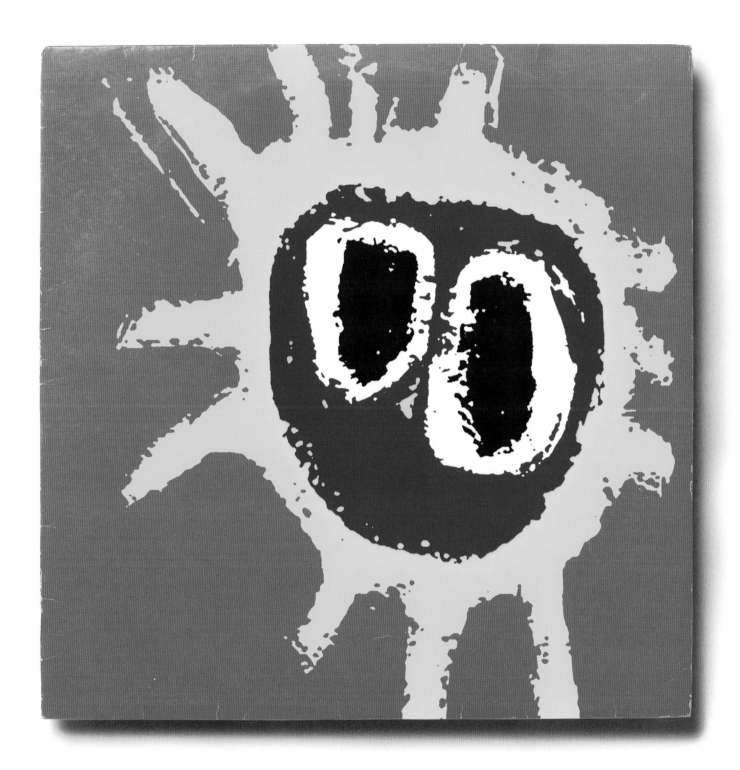

N°: 89

FAIRPORT CONVENTION
UNHALFBRICKING

Island
Produced by Joe Boyd, Simon Nicol and Fairport Convention
Released: July 1969

The cover looks innocent enough. An elderly English couple poses on an unprepossessing suburban London street while in the background a group of hippies enjoy a picnic. When Eric Hayes shot the *Unhalfbricking* cover photo no-one could have anticipated the tragedy behind it.

Fairport Convention drummer Martin Lamble, bass player Ashley Hutchings and guitarists Richard Thompson and Simon Nicol were folkie students managed by an American producer, Joe Boyd. Boyd's dream of putting Thompson's unique guitar style with Sandy Denny, another vocalist from the folk scene, had come to pass in 1968. The group, initially inspired by American singer-songwriters, soon started to develop their own vocabulary.

'*Music from Big Pink* by the Band hit London,' recalls Boyd. 'Fairport effectively said, "We want to create something as English as this is American". So much of what they'd done until then was American in style. *Big Pink* said, "Forget it, you're never gonna come close to understanding this music".'

'We thought because we were British we should be playing the indigenous music,' said Thompson. 'This was something at which we could excel, whereas we may never excel at being second-rate B.B. Kings or third-rate Waylon Jenningses. We also saw that there was a need for the traditional music in this country to be revived. It was unpopular with British

people, so we wanted to bring it up to date. We were white liberal intellectuals, I suppose.' Boyd secured one song, 'Million Dollar Bash', from the demos that Dylan and the Band had recorded at Big Pink. There were two other Dylan tracks – the unrecorded 'Percy's Song', about the aftermath of a car accident, and 'If You Gotta Go, Go Now'. The latter track was retitled 'Si Tu Dois Partir' and translated into French by backpackers in a drunken backstage jam and was to be Fairport's only hit single.

Thompson opens *Unhalfbricking* with his first real composition 'Genesis Hall', a perfect template for one of the truly unique guitarists in rock & roll.

Then there's 'A Sailor's Life', an ancient English ballad that Denny had learned from Martin Carthy. Martin Lamble sets the tale with

TRACKLISTING

01 **Genesis Hall**

02 **Si Tu Dois Partir**

03 **Autopsy**

04 **A Sailor's Life**

05 **Cajun Woman**

06 **Who Knows Where the Time Goes?**

07 **Percy's Song**

08 **Million Dollar Bash**

oceanic washes of his cymbals and Denny embodies the young woman standing on the shore and staring at the sea anticipating the dangers and temptations her lover would face: 'A sailor's life, it is a merry life/He robs young girls of their hearts' delight/Leaving them behind to weep and mourn/They never know when they will return'. Then in comes Thompson's guitar, roiling like the wine dark sea itself. Thompson's guitar is tailed by Dave Swarbrick, not yet in the band, whose banshee violin flys around the melody. In 11 minutes and 11 seconds it's complete, and English folk rock is born.

Denny had also brought along her signature tune, 'Who Knows Where the Time Goes'. The song had been recorded by her previous band the Strawbs, but with Thompson's liquid lines flowing around her wistful melody, the song found its perfect form on *Unhalfbricking*.

Recorded at the Olympic studios in London between January and April 1969, the sessions were trouble free. Then tragedy struck. On 11 May, while returning from a gig, the band's car ran off the road killing Thompson's girlfriend Jeannie and Martin Lamble. The news devastated the always-fragile Denny and accelerated the alcoholism that claimed her, too, in 1973. Neil and Edna Denny, the placid pensioners on the cover, were devastated by Sandy's fate. It's all there on the cover: joy, camaraderie and doom. *Unhalfbricking* is the perfect soundtrack.

ELVIS COSTELLO AND THE ATTRACTIONS
THIS YEAR'S MODEL

Radar
Produced by Nick Lowe
Released: March 1978

Journalist Nick Kent hit the nail on the head in the *New Musical Express* when he summed-up *This Year's Model* as 'uneasy listening'.

In 1976 Elvis Costello was a 22-year-old computer operator in the Elizabeth Arden cosmetics company, living in the suburbs with his wife and son and playing mediocre country rock in his spare time. A lengthy stint with the first Clash album convinced him to uncover his own feelings of rage and disgust that were channelled into his debut *My Aim Is True*. Recorded on the run, that album was a watershed at the height of the punk summer in July 1977.

'The only two things that matter to me, the only motivation points for me writing all these songs are revenge and guilt,' Costello told Nick Kent in his first press interview. 'Those are the only emotions I know about, that I know I can feel. Love? I dunno what it means, really, and it doesn't exist in my songs.' The question then was how to find a band that could be both nasty and literate to do these songs justice?

The first album was recorded with a band who just happened to be there. But Costello needed a combo of his own and the Attractions was hastily assembled. Keyboard player Steve Nason aka Nieve was a teenage student at the Royal Academy of Music, while bassist Bruce Thomas and drummer Pete Thomas were unrelated jobbing musicians. It proved a devastatingly potent combination, with Nieve's Vox Continental loading Costello's poisonous pen with hydrochloric acid, while the rhythm section steadily punched body blows. His targets were love on 'Lipstick Vogue' ('Sometimes I think that love is just a tumour/You've got to cut it out'), fascists on 'Night Rally', the music business on 'Lip Service' – and that was just the start of it.

'The Attractions made a huge difference to these songs,' Costello admits. "(I Don't Want to Go to) Chelsea" originally used the same stop-start guitar figure as the Who's "I Can't Explain" (or for that matter the Clash's "Clash City Rockers"). Bruce and Pete came up with a more syncopated rhythm pattern and Steve found a part that sounded like sirens,

TRACKLISTING

01 **No Action**
02 **This Year's Girl**
03 **The Beat**
04 **Pump It Up**
05 **Little Triggers**
06 **You Belong to Me**
07 **Hand in Hand**
08 **(I Don't Want to Go to) Chelsea**
09 **Lip Service**
10 **Living in Paradise**
11 **Lipstick Vogue**
12 **Night Rally**

although he rarely played the same thing twice so you had to pay attention.'

Pete Thomas pounded up a storm on 'Chelsea' with its spastic reggae and staccato guitar as Costello spat out lyrics like 'They call her Natasha when she looks like Elsie' – a putdown worthy of Dylan. The last song written and recorded was the monster beatfest 'Pump It Up', which was cut in one take. According to Costello it questions 'Just how much can you fuck, how many drugs can you do, before you get so numb you can't really feel anything?'.

The album – which Costello described as 'a ghost version of [the Rolling Stones'] *Aftermath*, the album to which I listened more than any other at this time' – was recorded in a total of 11 days and was squeezed between constant touring across the UK and the US on a diet of alcohol and speed, while Costello's marriage was crumbling around him. And it glows with the sound of a man whose greatest dreams have just come true – everything is a little excited, a little nervy and definitely paranoid. But at his moment of triumph Costello faces his own shortcomings. It's hard to look away from a psychic car crash.

'It was at that point that everything – whether it be my self-perpetuated venom – was about to engulf me,' Costello reflected on *This Year's Model*. 'I was rapidly becoming a not very nice person. I was losing track of what I was doing, why I was doing it, and my own control.' And yet, as so often happens, Costello's turmoil was our reward.

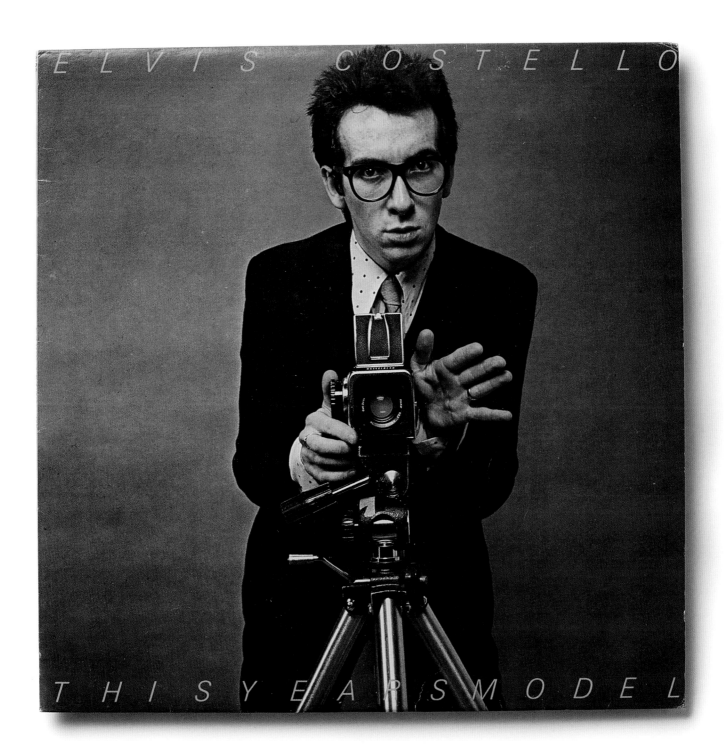

NEIL YOUNG ON THE PRETENDERS

This is one of the greatest rock & roll bands that ever lived. They went through all of the heartache that rock & roll is built on.

PETER BUCK ON THE KINKS

When I first heard *Village Green Preservation Society*, in 1971, I got this picture in my head of small-town English life: village greens, draft beer. But when R.E.M. went to England in 1985, I drove through Muswell Hill – and it certainly wasn't romantic-looking. I had this picture of a gorgeous vista – when it's really a kind of grimy area. I realized these songs were all acts of imagination, that Ray was commemorating an England that was slipping away.

Peter Buck (R.E.M.)

DAVID LEE ROTH (VAN HALEN) ON ELVIS COSTELLO

The reason critics hate Van Halen and like Elvis Costello is because most of them look like Elvis Costello.

DAVE GROHL ON QUEEN

I once said in an interview, after playing in front of 250,000 people, that if you want to learn how to connect to an audience that size, you'd either watch the Pope or Freddie Mercury.

Dave Grohl (Nirvana/Foo Fighters)

KEITH RICHARDS ON AC/DC

I love AC/DC. The whole band means it. You can hear it. It has spirit.

COURTNEY LOVE ON P J HARVEY

The one rock star that makes me know I'm shit is Polly Harvey. I'm nothing next to the purity she experiences.

IAN MCCULLOCH (ECHO & THE BUNNYMEN) ON COLDPLAY

I want to hate Coldplay, but they're so good.

SMOKEY ROBINSON ON *WHAT'S GOING ON*

Marvin was much more than just a great singer. He was a great record maker, a gifted songwriter, a deep thinker – a real artist in the true sense. *What's Going On* is the most profound musical statement in my lifetime. It never gets dated. I still remember when I would go by Marvin's house and he was working on it, he would say, 'Smoke, this album is being written by God, and I'm just the instrument that he's writing it through'.

STEVEN TYLER ON *BACK IN BLACK*

AC/DC is the ultimate middle finger aimed at the establishment. Think about it. The monster meet-me-in-the-backseat backbeat, the shredding vocals, that 100,000 megaton guitar assault, and let's not forget about that schoolboy uniform, which begs the question, 'How do such big balls get in such small pants?'.

Steven Tyler (Aerosmith)

JANET JACKSON ON *WHAT'S GOING ON*

On *What's Going On* Marvin was our John Lennon.

N°91

PORTISHEAD
DUMMY

Go! Discs
Produced by Portishead and Adrian Utley
Released: August 1994

If *Dummy* reminded you of the soundtrack to a 1960s-style spy movie – black and white, Richard Burton's self-loathing, no way out – there was a good reason. They'd already made one. Before they released their seminal debut album, the then English duo Portishead made their own short film. *To Kill a Dead Man* was the splintered story of an assassination and its aftermath, with lead roles played by the duo who were slowly hatching their own conspiracy – vocalist Beth Gibbons and instrumentalist/producer Geoff Barrow. The strategy was typical of a band that had little time for orthodoxy, and *Dummy* itself proved to be a slow-motion coup.

As grunge shuddered to a creative halt and the first wave of Britpop was preparing to go over the top, Portishead emerged from Bristol in England's south-west with an album of tortured soul ballads and haunting sci-fi grooves. It was, to say the least, unexpected, and although the pair – who soon after the record's release added co-writer and guitarist Adrian Utley as a formal member – didn't have a great deal to say (Gibbons didn't do interviews and Barrow liked to talk about the recording process), the record spoke with a smoky, transformative voice. On *Dummy* stillness roiled and noise proved satiating.

'Mysterons' was the ideal opening scene, with a spooked-out theremin, percussive clangs, scratching and a revolving drum part. 'Inside you're pretending/Crimes have been swept aside,' declares Gibbons, a hint of condemnation

in her melancholic voice. 'Somewhere where they can forget.' It sets the tone for an album where public and private wrongs keep swapping places. The record's intimacy felt like a defence against a foreboding world, like Winston and Julia's brief trysts in *1984*. 'All for nothing,' adds Gibbons, introducing the power of regret.

The Bristol scene at the time was a potent underground that was about to become a brand. Barrow had worked as a tape operator in a local studio, a position that introduced him to Massive Attack and, in turn Tricky, but Portishead proved to be distinct from both. The newly invented genre of trip-hop would be used to describe all three acts, but Portishead

TRACKLISTING

01 **Mysterons**
02 **Sour Times**
03 **Strangers**
04 **It Could Be Sweet**
05 **Wandering Star**
06 **It's a Fire**
07 **Numb**
08 **Roads**
09 **Pedestal**
10 **Biscuit**
11 **Glory Box**

were too eclectic to be easily pigeonholed. Hip-hop interested them rhythmically, but their tracks equally revealed a yen for 1930s Berlin cabaret and film scores. On 'Sour Times' they sampled both Lalo Schifrin's score for *More Mission Impossible* and 'Spin It Nig' from grandstanding '70s funk singer Smokey Brooks.

'It could be sweet/Like a long-forgotten dream,' Gibbons promises on 'It Could Be Sweet', and the album title *Dummy* makes you think of a mark in a film noir flick. It is full of seductive promises that can't quite make it to the end of the song. 'You don't get something for nothing,' the track later adds, and that could be Portishead's motto. The grooves here are for reflection, not dancing, and songs such as 'Wandering Star', with its ominous throb and eerie samples, build up the pressure in the room until it feels like something has to give.

It takes an entire album to get there, through the gentle invocation of 'It's a Fire' and the orchestral soul of 'Roads', but on the closing 'Glory Box' Portishead sound like a crackling 78 record, with Gibbons playing the jaded temptress. However, the song can't easily hold her confessions, and cool verses are repeatedly usurped by the searing chorus. 'I just want to be a woman,' she quietly pleads, before a strung-out guitar coaxes out electric tangles, and just as it appears the album has finally revealed itself, the song's opening steps back in, as if the tape was doctored and the fix was in. Some mysteries aren't meant to be solved.

PORTISHEAD

DUMMY

AC/DC
BACK IN BLACK

Alberts
Produced by Robert John 'Mutt' Lange
Release Date: July 1980

It could be the most perfect opening to any album. For a full 20 seconds there's nothing but the lone, eerie sonics of a giant ringing church bell. Then Malcolm Young plays an impossibly slow, circular rhythm guitar riff that is pure funeral march. The song is 'Hells Bells', the album is *Back in Black* and this is AC/DC farewelling their dead frontman, Bon Scott. The much-loved Scott had died on 19 February 1980 after a typically huge drinking binge.

If the central theme of *Back in Black* is to pay tribute to Scott, the album is equally an unapologetic statement about moving on. AC/DC, which had been formed by guitarist brothers Angus and Malcolm Young in 1973, had worked relentlessly to establish themselves as a major band in Australia, Europe and, with 1979's *Highway to Hell*, in the USA. The Young brothers were not about to walk away. Malcolm recalled to *Q* magazine, 'At the funeral, Bon's dad said "You can't stop, you have to find someone else"'.

The search for a replacement didn't take long – the band soon settling on Brian Johnson, previously of Scottish heavy rockers Geordie. The songs for *Back in Black* had been started with Scott, who also played drums on the original demos. The band scrapped Bon's lyrics and Johnson wrote his own. Within six weeks of Bon's death AC/DC and their new lead singer were ensconced at Compass Point Studios in the Bahamas with *Highway to Hell* producer, Robert 'Mutt' Lange. 'We got the title before we'd even written a word,' Malcolm explained. 'Angus said, "Why not call it *Back in Black* and make a black album cover as a tribute to Bon?".'

The resulting album is pure, unadorned, timeless rock & roll – and 30 years later it is remarkable how little it has aged. *Rolling Stone* magazine called it '(perhaps) the leanest, meanest record of all time'. As always, the unique, synergistic riffing of the Young brothers and the intuitive rhythm section in bassist Cliff Williams and drummer Phil Rudd fuse traditional blues with stadium rock dramatics.

TRACKLISTING

01 **Hells Bells**
02 **Shoot to Thrill**
03 **What Do You Do for Money Honey**
04 **Given the Dog a Bone**
05 **Let Me Put My Love into You**
06 **Back in Black**
07 **You Shook Me All Night Long**
08 **Have a Drink on Me**
09 **Shake a Leg**
10 **Rock and Roll Ain't Noise Pollution**

If AC/DC had grown up through albums *High Voltage, T.N.T., Dirty Deeds (Done Dirt Cheap), Let There Be Rock, Powerage* and *Highway to Hell* to become masters of the art of heavy rock, they were still back in junior high school when it came to lyrics. In Bon's hands, the band's political incorrectness came across as cheeky, harmless smut, which he always delivered with his mischievous smile. Johnson is more what-you-see-is-what-you-get on tracks like 'What Do You Do for Money Honey' and 'Given the Dog a Bone'.

At the core of it all, calling the shots and setting the new agenda, was the unbreakable bond of the brothers Young. 'We had been touring on *Highway to Hell*, and he [Malcolm] put the "Back in Black" riff on a cassette and played it for me,' Angus remembers. 'It was just on a little acoustic guitar that Mal used to trail around with him. He said, "What do you think of that? Is it rubbish? Should I trash it?" So I said, "If you're gonna trash it, give it to me and I'll say I wrote it" [laughs]. Some of the great licks, like that little flicky one at the beginning of "Back in Black", I played, but it was me copying what he had from that cassette. Mal always says, "The two of us together, we play as one".'

Back in Black closes with the epic 'Rock and Roll Ain't Noise Pollution' that says it all: 'We're just talkin' about the future/Forget about the past/It'll always be with us/It's never gonna die, never gonna die'.

N^o:93

BECK
ODELAY

Geffen
Produced by Beck, the Dust Brothers, Mario Caldato Jr, Brian Paulson, Tom Rothrock and Rob Schnapf
Released: June 1996

One grandfather was a Presbyterian minister, another was a visual collage artist. On *Odelay*, the groundbreaking 1996 album that unexpectedly established him as a major artist, the impish singer-songwriter Beck paid tribute to both sides of his lineage. Painstakingly developed – Pavement's Stephen Malkmus joked that the title was a play on 'oh delay' – the album was a masterfully casual assemblage of hip-hop grooves and bluesy spiritualism, generational tweaks and digital freak-outs. *Odelay* was an end of the world party where you could dance until the strangeness got too much, and even then it was as intriguing when you were horizontal as vertical.

Beck Hansen had been a street musician in Europe and then Los Angeles, where he crashed open mic nights and developed a sonic hobo aesthetic that came to fruition with 1994's 'Loser', a playful send-up of Generation X angst that started out as a joke and ended up as a salve once Nirvana's Kurt Cobain committed suicide. He used trashed drum machines and rapped in a dulled monotone, which might have suggested a malaise if he wasn't putting out multiple albums a year on various labels.

Odelay was, in various ways, Beck's attempt to consolidate his career. His second release for a major label (he'd reportedly signed to DGC for less money and more creative independence), it began as an acoustic record – and elements of that approach remain – but the sessions finally hit their stride when he hooked up with

co-producers and co-writers the Dust Brothers, who had a history in hip-hop and were able to make sonic sense of Beck's eclectic ear. *Odelay* was the first Beck album where the sounds didn't lag behind his imagination. He didn't have to use limitations to define his songs, and the result is richly evocative.

The tunes could be wicked on the body. The female subject of Beck's fascination on 'The New Pollution' is essayed via a rhythm track of precise bass and a drum loop predicated on a sweet snare sound that gives way to an expertly spotted sax break – from Joe Thomas' 'Venus' – that sounded like the most rhapsodic of dreams alongside a woman who's 'got a

TRACKLISTING

01 **Devil's Haircut**
02 **Hotwax**
03 **Lord Only Knows**
04 **The New Pollution**
05 **Derelict**
06 **Novacane**
07 **Jack-Ass**
08 **Where It's At**
09 **Minus**
10 **Sissyneck**
11 **Readymade**
12 **High 5 (Rock the Catskills)**
13 **Ramshackle**

hand on the wheel of pain'. As the grunge era's vast rage settled into inchoate angst, Beck was a wordsmith who used detailed imagery to dazzle and obscure quiet truths.

'I'm a loser, baby, so why don't you kill me?' was the oft-shared refrain from his breakthrough single, but on *Odelay* Beck had a far more complex persona; one that required the audience to attune to his swaying vocal flow, which sometimes felt as if it would lose track of the beat but seemed to finish every line exactly where it should. 'Something's wrong 'cause my mind is fading/And everywhere I look/There's a dead end waiting', were the album's opening lines on 'Devil's Haircut', and amid the pop-art poetry and surrealist imagery ('Stealing kisses from the leprous faces', the same verse announced) Beck was ready to laugh until he cried.

Every track was a journey into sound, with 'Novacane' linking funk grinds and CB radio vocals to a sweet guitar lick and digital squawks, while the barely feeling the gravity vibe of 'Where It's At' aligned a narcotised keyboard loop to what could be the album's motto: 'I got two turntables and a microphone'. By way of contrast there's 'Jack-Ass', an autumnal psychedelic pop ballad, and the Stonesy country lament 'Lord Only Knows'. Put together it was a radical leap of faith, not to mention a success that Beck has never quite been able to duplicate, and the artist knew exactly what he'd come up with. As he declares on 'Jack-Ass', 'I'll put it together. It's a strange invitation.'

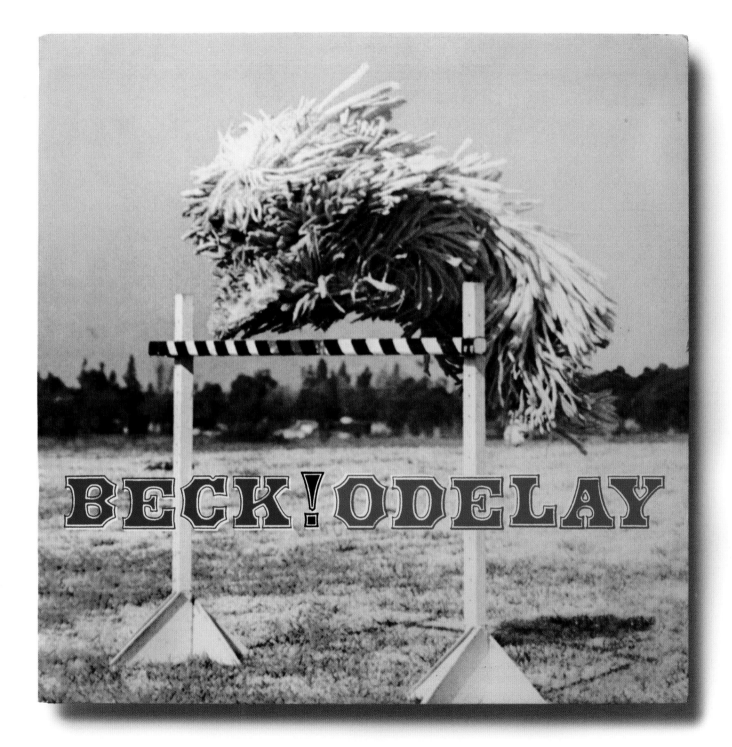

BECK! ODELAY

N°:94

GANG OF FOUR
ENTERTAINMENT

EMI
Produced by Jon King, Andy Gill and Rob Warr
Released: September 1979

If you wanted to question the basic givens of a modern western society – that is the cycle of everyday living and the assumption that work and leisure are separate things – then Leeds in the unholy year of 1977 was the perfect place to start. There were violent clashes on the streets and in pubs between the far right National Front and those who opposed them. Albums by the Clash and the Sex Pistols supplied a soundtrack to social discontent, and the Labour government of James Callaghan was stumbling towards oblivion as Margaret Thatcher and Thatcherism loomed. In such circumstances, how could the Gang of Four not make perfect sense?

The band that was formed around the Leeds University milieu in 1977 – vocalist Jon King, guitarist Andy Gill, bassist Dave Allen and drummer Hugo Burnham – released their debut album in 1979 and *Entertainment* remains one of the key releases of the then nascent post-punk era. It's hard-edged in sound, as if a metal machine press had started to malfunction, and furiously inquisitive in terms of its worldview. It's one of those albums were you can logically identify the quartet's diverse precursors, but the end result is a revelation. *Entertainment* somehow leaves you shattered and elated.

Dave Allen had responded to an ad seeking a bassist for a 'fast R&B band', and in a very simple way that's where Gang of Four began, taking the stripped-down sound of the brief pub-rock scene (punk's spiritual predecessor in the UK) and pummelling it into a new

shape. That transformation left gaps that the group filled, whether with dub bass or asphyxiated funk grooves, industrial racket or simply menacingly evocative silence. On 'Damaged Goods' Gang of Four sound urgent but scared; there's not a hint of catharsis and the rhythm section ratchet up the tension until the final, repeated shouts of 'goodbye' sound like fleeting final words.

Of the many dialogues engendered by *Entertainment*, the most prominent is between King's voice and Gill's guitar. The former sounds harried, as if caught between fear and seduction, while the latter is caustic and expressive. 'Anthrax' begins with a slow, dilated scrawl of feedback that has

TRACKLISTING

01 **Ether**

02 **Natural's Not in It**

03 **Not Great Men**

04 **Damaged Goods**

05 **Return the Gift**

06 **Guns Before Butter**

07 **I Found That Essence Rare**

08 **Glass**

09 **Contract**

10 **At Home He's a Tourist**

11 **5.45**

12 **Anthrax**

the expressiveness of a monologue, while the sparks that illuminate the opening of 'At Home He's a Tourist' make clear the song's idea that the trappings of a regular life are simply the mechanism of imprisonment. 'She said she was ambitious, so she accepts the process', King sings, and Gill's viscous, electric accompaniment brings it to life.

Inspired by texts spawned from France's fractious, and ultimately unsuccessful, revolutionary movement of 1968, Gill and King wrote songs about what we want to do, what we're compelled to do, and whether there is any real difference between the two forces. 'Barricades close the street but open the way', was one graffiti slogan in Paris a decade prior, and Gang of Four did the same to rock & roll. The beginning of 'Return the Gift' made vinyl listeners think the record was stuck on a scratch, but then it burst into desperate life as Gill's playing ricochets off the unyielding rhythm.

The reason that the numerous ideas worked into *Entertainment* are so richly recognisable is because the songs are starkly engaging. The way the guitar, bass and drums combine on 'Natural's Not in It' initially sounds slapdash, almost simplistic; but within a few bars they're locked together into something that sounds compelling by itself while serving as a crucible for King's dissection of the interchangeability of consumerism and pleasure. And like all the songs on this record, it's finished before you're entirely at ease with it. Gang of Four never outstayed their welcome.

GANG OF FOUR

entertainment!

The Indian smiles, he thinks that the cowboy is his friend.

The cowboy smiles, he is glad the Indian is fooled.

Now he can exploit him.

№ 95

MARVIN GAYE
WHAT'S GOING ON

Motown
Produced by Marvin Gaye
Released: May 1971

Whether the lens is soul music or Motown Records, whatever way you look at Marvin Gaye's seminal 1971 album *What's Going On*, it is a transformative record of almost unparalleled effect. It changed the face of black music, turned one of the 1960s' brightest pop stars into the chronicler of a wayward world, and offered a requiem for a decade that had petered out in bloodshed and loss. There is music before *What's Going On* and after *What's Going On* – the latter is still producing records and styles that are defined by Gaye's spiritual grooves.

Love is everywhere on these nine songs. 'All He asks of us is we give each other love,' Gaye sings in 'God Is Love' and, while the mood on the record is conciliatory and redemptive, it was birthed in acrimony and despair. Gaye turned 30 in April 1970 and it marked a brewing change in the artist long dubbed 'The Prince of Motown'. Gaye was tired of label boss Berry Gordy's production line aesthetic and insistence on hit singles. Gaye didn't just want to produce his recordings, he wanted to write about concerns outside Motown's contours. When he cut the title track in 1970 Gordy called it 'the worst thing I've ever heard in my life'.

Gaye had cut hit single after hit single for Motown – 'How Sweet It Is (to Be Loved by You)', 'Ain't That Peculiar' and 'I Heard It Through the Grapevine' – but he shut down after Motown rejected 'What's Going On', only to be vindicated when the song was finally issued in January 1971 and it reached #2 on the pop charts. But if he had the creative freedom he needed to make the album, Gaye was dogged by depression and external pressures. Even as he was grieving for Tammi Terrell, the musical partner he'd cut his best duets with, Gaye was being pursued by the IRS over tax issues. 'The place where the good feeling awaits me', which is foretold on 'Flyin' High (in the Sky)' must have appeared far away.

The finished album, cut in quick bursts and reconfigured during mixing, is a concept record, written from the viewpoint of a US soldier returning from Vietnam to a country he doesn't recognise. (It was a viewpoint that reflected the experiences of Gaye's younger brother, Frankie.) In these songs there are picket lines and money is short – 'radiation under ground and in the sky' – but these are not protest songs, nor are they laments that wallow in defeat.

What's Going On describes a world in pain, but it also creates a feeling of deliverance. The battle between the sensual and the spiritual was a constant in Marvin Gaye's career, but on this album he prescribes faith and hope in a way that makes them all consuming. Even on the despairing 'Save the Children', where he wonders what will become of the generations to follow his, there's an uplifting sense of belief. It stemmed in part from the arrangements, which added layers of percussion to Motown's engine room, the Funk Brothers, then introduced jazz-influenced horns and David Van DePitte's evocative string arrangements.

This was a new soul music, one that carried a vivid, existential weight, and it spurred Gaye on to some of his finest vocal performances on the likes of the closing 'Inner City Blues (Make Me Wanna Holler)' and 'Mercy Mercy Me (the Ecology)'. Many of the album's concerns didn't feature again in Gaye's work, which moved towards the carnal with 1973's *Let's Get It On*, but it didn't matter. *What's Going On* remains a remarkable, self-contained invocation. Salvation, in whatever form you're willing to take it, resides in these tracks.

TRACKLISTING

01 **What's Going On**
02 **What's Happening Brother**
03 **Flyin' High (in the Friendly Sky)**
04 **Save the Children**
05 **God Is Love**
06 **Mercy Mercy Me (the Ecology)**
07 **Right On**
08 **Wholy Holy**
09 **Inner City Blues (Make Me Wanna Holler)**

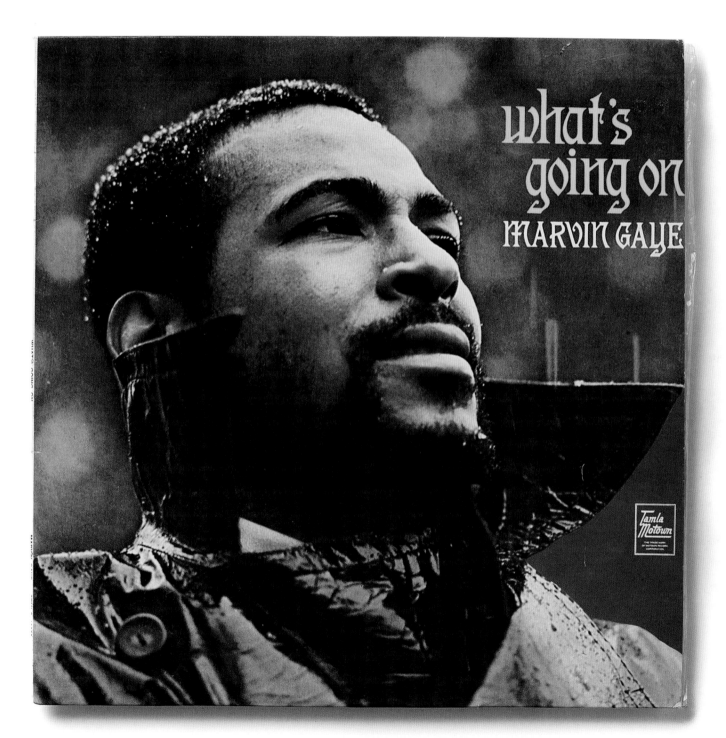

N°96

ARCTIC MONKEYS

WHATEVER PEOPLE SAY I AM, THAT'S WHAT I'M NOT

Domino
Producers: Jim Abbiss and Alan Smyth
Released: January 2006

As records go, the Arctic Monkeys' propulsive, offhand but intricate debut, *Whatever People Say I Am, That's What I'm Not*, would object to being included in this list. 'Get off the bandwagon, and put down the handbook', runs the refrain in 'Fake Tales of San Francisco', and it's typical of the group's then teenage songwriter, Alex Turner, that he was onto those who might grandly elevate his band before they'd even had a chance to mention the phrase 'canon'.

The fastest selling debut album in British history – almost 120,000 copies on the first day, a total just shy of 364,000 in the first week – *Whatever People Say I Am* was a blistering amalgam of biting, frenzied guitars, whiplash lyrics that mixed idiom and idiocy with a novelist's eye for detail, and a sense of time and place that put the 13 tracks in the pantheon of British youth culture. The album didn't have an axe to grind or a stake to claim, but via Turner's broad Yorkshire accent it illustrated the grim streets and bright dancefloors of Sheffield that could easily have come to encompass his life.

'There's only music so there's new ringtones,' Turner sings on the closing 'A Certain Romance', but the album sets that notion right. Arctic Monkeys sound like a band with no shortage of ideas and vitality across the song cycle of a frenzied night dissolving into a reflective day. The first 10 seconds of their breakthrough single, 'I Bet You Look Good on the Dancefloor' could be Rage Against the Machine's high octane fury, while the next 20 were classic British new wave pop. Everything is shaken up before Turner has even started to bob and weave through the lust-filled nightlife ('Oh there ain't no love, no Montagues or Capulets/Just banging tunes 'n' DJ sets', runs one memorable couplet).

The group – vocalist and guitarist Turner, guitarist Jamie Cook, drummer Matt Helders and soon-to-depart bassist Andy Nicholson – were firmly plugged into the recent history of British guitar music, taking in the one-liners favoured by Oasis' Noel Gallagher, the clatter and melancholy of the Libertines and the joyous

TRACKLISTING

01 **The View from the Afternoon**
02 **I Bet You Look Good on the Dancefloor**
03 **Fake Tales of San Francisco**
04 **Dancing Shoes**
05 **You Probably Couldn't See for the Lights but You Were Staring Straight at Me**
06 **Still Take You Home**
07 **Riot Van**
08 **Red Lights Indicates Doors Are Secured**
09 **Mardy Bum**
10 **Perhaps Vampires Is a Bit Strong, But...**
11 **When the Sun Goes Down**
12 **From the Ritz to the Rubble**
13 **A Certain Romance**

pop smarts of Franz Ferdinand. But they were beholden to none of them, or a fixed historic perspective, and Turner was not unaware of hip-hop. They could take what they needed and not look back, frenetic to the point that the cymbal wash on 'Still Take You Home' is pure excitement, while 'The View from the Afternoon' spits out lyrics and power chords before the razor-like rhythm kicks back in.

On 'When the Sun Goes Down', a sombre Turner sings about the prostitutes and their pimp that the group would sight near their rehearsal room and the images are switchblade sharp above barely-there guitar chords: 'And I've seen him with girls of the night/And he told Roxanne to put on her red light/They're all infected but he'll be alright,' he observes, but instead of embracing the maudlin, the band charge forward and envelope the characters. These songs haven't dated because there are few easy judgments. Even 'A Certain Romance', which picks over the UK's working class chav culture with clear eyes, ends with the acknowledgment that some of them are Turner's mates.

With tracks such as 'From the Ritz to the Rubble', Arctic Monkeys simply sound like the bolshiest band for the ages. Even as Alex Turner sings about the lack of clarity that dogs the previous night's ironclad resolutions, he and his bandmates make jumping up and down and yelling with great gusto sound like pure deliverance. Everything makes sense on *Whatever People Say I Am, That's What I'm Not*, but it takes one heck of a ride before you realise just how that came to be.

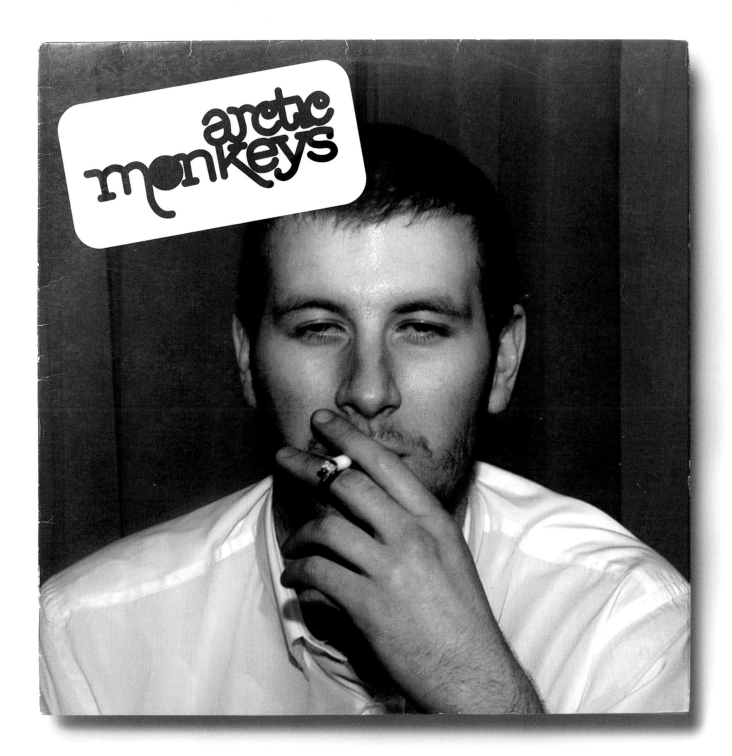

Nº:97

QUEEN
A NIGHT AT THE OPERA

EMI
Produced by Roy Thomas Baker and Queen
Released: November 1975

Whatever it is, as long as it's remotely connected to rock & roll, then there's a fairly good chance you'll find it on *A Night at the Opera*. Queen's fourth album, reportedly the most expensive record ever made at that point in history, is an ambitiously expansive set that covers everything you can think of and a little bit more. Want earnest English folk? Try "39". Ready for an operatic suite of stadium rock bravado? Here's 'Bohemian Rhapsody'. Hardnosed glam your thing? Cue up 'Sweet Lady'. In fact you can make the case that the 13 songs here cover 13 genres. What matters, however, is the skill and pleasure contained in their creation.

Queen sound like they're having the time of their lives on this record, and the reputed expense isn't easily discerned. What shines through is the complementary value of having a band with four distinctive songwriters. All four members of Queen – vocalist and pianist Freddie Mercury, guitarist Brian May, bassist John Deacon and drummer Roger Taylor – contributed compositions to *A Night at the Opera*. Deacon was the least experienced of the four, but even his contribution, 'You're My Best Friend', proved to be instantly recognisable, with the warm Wurlitzer electric piano tones giving way to Mercury's persuasive vocal and May's sure-fingered guitar licks.

Setting up a record where the unexpected is the default setting, 'Death on Two Legs (Dedicated to…)' opens proceedings with a snarling dismissal of a former manager, who Mercury dismembers line by line. 'Misguided old mule, with your pigheaded rules … You're a sewer rat decaying in a cesspool of pride,' the flamboyant frontman sings but, amid the lean, direction-setting piano chords and drum fills, there are touches that would come to define the album, including the biting precision of May's playing and the stratospheric harmonies Mercury and his bandmates could effortlessly deploy.

When the album was released – a breath of fresh air in a year when rock music was stagnant and pop music had few ambitions – there was still a perception that Queen was essentially a prog rock band. *A Night at the Opera* put an end to that, revealing a band that could turn their hand to any style they pleased. Mercury's 'Lazing on a Sunday Afternoon' integrated the English music hall tradition into Queen's canon, while 'Seaside Rendezvous' is a mutant mix of seaside cabaret and trad jazz: 'We'll ride upon an omnibus and then the casino,' sings Mercury, as if he's visiting from 1925.

When they did take on prog, it was with the striding, colossal 'The Prophet's Song'. This is an eight-minute-plus epic that May conceived after a bout of illness, which touches on the idea of scourging floods and Noah's Ark, complete with an extended vocal breakdown that turns Mercury's voice into a self-contained studio orchestra. Like much of the album, if Queen winked it would simply be daft, but played straight it proves to be a triumph. Producer Roy Thomas Baker, who is still being hired by artists desperate for a touch of *A Night at the Opera*'s essence, gives it all presence without resorting to monolithic simplicity.

Queen's self-belief reached its zenith on 'Bohemian Rhapsody', a song which had three parts, not one of which was a single. Part-opera, part-hard rock and completely barmy, the song harnesses a vast soundscape to enduring fatalism. As anthems go, 'Bohemian Rhapsody' is not the province of victors, but few rules – either then or now – are upheld by *A Night at the Opera*. By the time it ends, with Brian May's sci-fi take on 'God Save the Queen', it's clear who fans were prepared to pledge their loyalty to.

TRACKLISTING

01 **Death on Two Legs (Dedicated to...)**
02 **Lazing on a Sunday Afternoon**
03 **I'm in Love with My Car**
04 **You're My Best Friend**
05 **'39**
06 **Sweet Lady**
07 **Seaside Rendezvous**
08 **The Prophet's Song**
09 **Love of My Life**
10 **Good Company**
11 **Bohemian Rhapsody**
12 **God Save the Queen**

Queen
A Night At The Opera

N°:98

DEREK AND THE DOMINOS
LAYLA AND OTHER ASSORTED LOVE SONGS

Atco
Produced by Derek and The Dominos. Executive Producer Tom Dowd
Released: November 1970

You've probably heard the story of 'Layla', where guitarist Eric Clapton falls in love with his pal Beatle George Harrison's wife Pattie. A book of Persian poetry from the 12th century gives Clapton the name for his song about this *ménage a trios*. However, the story would be nothing more than a footnote in Beatle biographies were it not for the fact that Clapton had assembled one of the best bands in the history of rock & roll and they execute this, and everything, with soulful blues rock majesty. And more striking perhaps is that while the best known, 'Layla' is not even the best track on the album.

'What was appealing to me about that band was that they were serious American musicians with pedigree,' Clapton recalled. 'My criterion was Booker T. and the MGs. If we were just left in a room that band would just play grooves 24 hours a day. When we first got together they all came to live in my house, and we played all day. Never left the house. And played. And it was real. Proper music: soulful R&B and blues. But then, you know, we had to make a record [laughs]. Songs! Singing! All of that.'

The players who became the Dominos – bassist Carl Radle, drummer Jim Gordon and Bobby Whitlock on piano, organ and guitar – had toured with Delaney and Bonnie, Mad Dogs and Englishmen and done sessions for George Harrison's *All Things Must Pass*. They brought southern soul to Britain and married it with the best of British blues.

Whitlock arrived first and began writing with Clapton. In August 1970 they decamped to Criteria Studios in Miami to work with Tom Dowd, who had cut most of the legendary Atlantic R&B hits and the second Cream album.

With less than enough material for a single album, the Dominos started jamming and Dowd rolled tape non-stop. His main contribution to the album was to introduce the then little known Duane Allman to Clapton. Allman slotted right in. When they arrived in Florida they barely had an album's worth

TRACKLISTING

01 **I Looked Away**
02 **Bell Bottom Blues**
03 **Keep on Growing**
04 **Nobody Knows You When You're Down and Out**
05 **I Am Yours**
06 **Anyday**
07 **Key to the Highway**
08 **Tell the Truth**
09 **Why Does Love Got to Be So Sad?**
10 **Have You Ever Loved a Woman**
11 **Little Wing**
12 **It's Too Late**
13 **Layla**
14 **Thorn Tree in the Garden**

of material but songs just kept flowing. A band was recording Big Bill Broonzy's 'Key to the Highway' next door and the Dominos just decided to throw that song into the mix. There are inspired remakes of standards like 'Nobody Knows You When You're Down and Out' and a gorgeous reading of Hendrix's 'Little Wing'. The full force rush of 'Keep On Growing' is matched by the sublime delicacy of 'Thorn Tree in the Garden'.

And Clapton and Whitlock's originals were all strong and their voices blended as well as the guitars. Perhaps the album's best track is 'I Am Yours' – a luminescent melody Clapton put to a poem by Nizami, the author of 'The Story of Layla and Majnun'.

Finally there is the title track – a 7-minute epic built on six layers of guitars based on an Albert King riff ('As the Years Go Passing By'). The duel between Clapton's blues notes and Allman's high slide guitar is monumental and furious. Just when the fury of the song seems burned out comes a delightful melancholy piano coda written by Jim Gordon. This final piano piece didn't emerge until the album had been mixed and the band suggested adding the outro. And finally the album ends with Whitlock's bittersweet 'Thorn Tree in the Garden'.

Tom Dowd summed it up best: 'When we were saying goodbye I said to the band "This is the best damn album I have been involved in since The Genius Of Ray Charles back in '59". It was a new kind of music with great artistry. It was inspiring.'

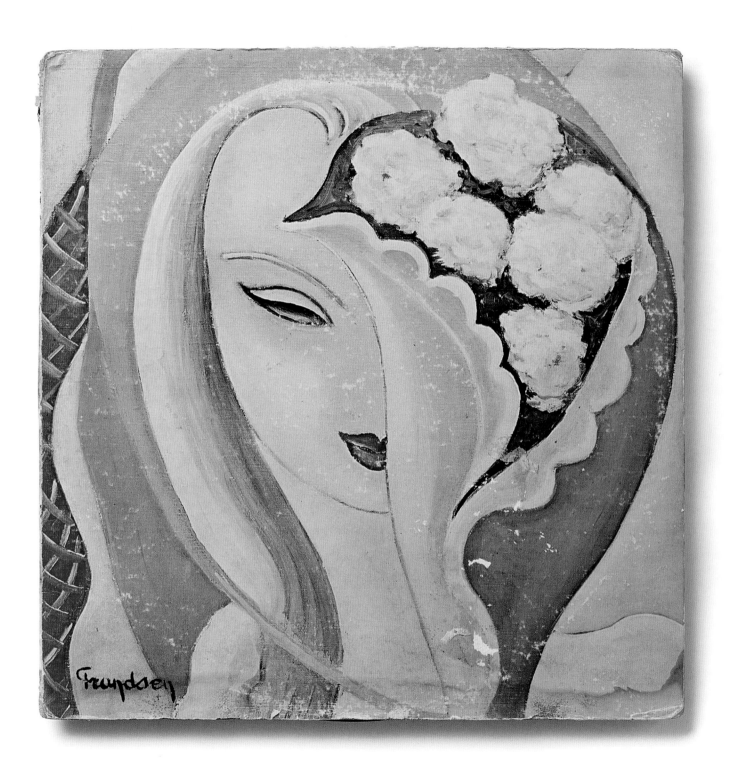

N°99

P J HARVEY
LET ENGLAND SHAKE

Island
Produced by P J Harvey, Mick Harvey, John Parish and Flood
Released: February 2011

'Goddamn Europeans! Take me back to beautiful England,' sings a wary and tense Polly Jean Harvey on 'The Last Living Rose', a track from her astutely mesmeric album *Let England Shake*. But neither the track nor the album have time for blind declarations of patriotism. In the song Harvey arrives in London but can only see the faults and the timeless flaws, the ghosts and the hints of what still stands tall. The album is a journey into a land's blighted history and how the future condemns the present.

This was Harvey's eighth studio album and, almost two decades on from the bruised dynamics of her brilliant debut *Dry*, it was astoundingly unexpected. The energy drawn from sexual desire and the struggle to believe that love was optimistic had defined most of her previous works, whether joyously accessible in 2000's *Stories from the City, Stories from the Sea* or coldly, blackly funny on 2007's *White Chalk*. And in a way that continued on *Let England Shake*, except that the recipient was no mere male but instead her homeland.

Here the thwarted romance is between individuals and their country, and the terrible things that can happen when one faithfully serves the other. The record has a feel for the allure of patriotism, and sometimes the protagonists most beyond hope are those with the strongest of beliefs. 'I live and die through England,' Harvey declares on the otherworldly 'England'. 'It leaves a sadness … you leave a taste/A bitter one,' she adds, but as the distant mellotron gains purpose, there's a 'never failing/Love for you, England'. Nothing breaks easily on this record.

It's played, essentially, by a trio of multi-instrumentalists: Harvey, John Parish and Mick Harvey. The long-time collaborators matched the solemn words to a new sound; an alternately flowing and clenched mix of autoharp, electric guitar, sparsely produced percussion and stray woodwind. It suggests a new kind of folk music while accessing the oral traditions of the genre's earliest days. These were songs that could have been sung by soldiers, sometimes before the battle and sometimes long after, and those they would never come back to.

TRACKLISTING

01 **Let England Shake**
02 **The Last Living Rose**
03 **The Glorious Land**
04 **The Words That Maketh Murder**
05 **All and Everyone**
06 **On Battleship Hill**
07 **England**
08 **In the Dark Places**
09 **Bitter Branches**
10 **Hanging in the Wire**
11 **Written on the Forehead**
12 **The Colour of the Earth**

It tells stories that news reports would never be able to capture. On 'All and Everyone' Harvey invokes the Gallipoli campaign of World War I, where Allied forces suffered terrible casualties in an attack upon Turkey (the campaign remains a touchstone to Antipodean history and Australian Mick Harvey helped Harvey research the century-old battles and escorted her to commemorative services). 'Death was everywhere', is the first line, and the song's looming dread makes the claim undeniably true, and the arrangement's respite is simply an acceptance of what is to come.

'Written on the Forehead', with its 'trench of burning oil', could be a letter home from the occupation of Iraq, where images of destruction have a surreal pitch, and vocal samples from other dimensions float amid the menacing guitar chords, turning pop songs into promises. And when the war is over and the fallen combatants are buried, the landscape turns out to be the victor, absorbing the repeated references to blood and healing every scar left upon it.

P J Harvey took no moral judgment or easy superiority from these songs. She lived out the images, sometimes with the bitterest trace of humour borne of unexplainable loss – 'what if I take my problems to the United Nations?' asks 'The Words That Maketh Murder', and the song knows it embraces futility. Line by line, song by song, the tracks coalesce into something powerful. The songs dug deeper than any grave, making *Let England Shake* a document for this time and too many others.

N°: 100

THE BYRDS
SWEETHEART OF THE RODEO

Columbia Records
Produced by Gary Usher
Released: August 1968

'As a commercial venture it was a disaster. We were rejected by both the country and the city folks,' said Roger McGuinn. 'We miscalculated there, although now it's an appreciated album. A sort of heirloom.'

In the space of five months Gram Parsons joined the Byrds and alienated their original audience, created country rock and had the band run out of Nashville and then quit the band, leaving a confused Roger McGuinn wondering where his career had gone. Fortunately, the brilliant and unique *Sweetheart of the Rodeo* remained; an album that was misunderstood at the time but one which has revealed its greatness over the years.

In 1965, the Byrds – Roger McGuinn, Chris Hillman, David Crosby, Gene Clark and Michael Clarke – were going to be the American Beatles. Their first single 'Mr. Tambourine Man' created folk rock and was followed by a series of peerless psychedelic folk pop records. However, by 1967 the volatile quintet was now a duo of McGuinn and Hillman and in January 1968 Hillman suggested that hiring pianist Gram Parsons might be a good idea.

According to McGuinn, Parsons wanted 'to really do something revolutionary by melding the Beatles and country music'. 'I love country music,' Hillman recalled. 'And now I had an ally, and we nudged Roger along.

'I wanted to do a chronology of American music, right from modal music and then up into contemporary folk music, bluegrass and rock & roll and then off into space. I was talked out of it,' McGuinn recalled. 'First of all it would take a lot of homework and a lot of doing, and secondly, [producer] Gary Usher and Chris Hillman persuaded me that the country music market was worth attacking.'

On 9 March 1968 the band decamped to Columbia's recording facility in Nashville, where they cut Gram Parson's 'Hickory Wind' – an example of what Parsons called Cosmic American Music. On 15 March, at the end of their Nashville stay, the Byrds became the first rock band to perform at the Grand Ol' Opry. They were booed through Merle Haggard's 'Sing Me Back Home'. Then Parsons deviated from the program to sing 'Hickory Wind' and alienated the Nashville establishment further. They were banned from the Opry for life.

TRACKLISTING

01 **You Ain't Goin' Nowhere**
02 **I Am a Pilgrim**
03 **The Christian Life**
04 **You Don't Miss Your Water**
05 **You're Still on My Mind**
06 **Pretty Boy Floyd**
07 **Hickory Wind**
08 **One Hundred Years from Now**
09 **Blue Canadian Rockies**
10 **Life in Prison**
11 **Nothing Was Delivered**

They returned to Los Angeles to complete the album. The repertoire went deep into Americana with traditional songs such as 'I Am a Pilgrim' and the Louvin Brothers' 'The Christian Life', together with more traditional Nashville, including Haggard's 'Life in Prison'. McGuinn's folk roots were acknowledged by Woody Guthrie's 'Pretty Boy Floyd' and there were two Dylan songs from the then unreleased but already notorious 'basement tapes' – 'Nothing Was Delivered' and the album's opener 'You Ain't Goin' Nowhere'. The most radical song was William Bell's 'You Don't Miss Your Water'. The transformation of this Stax soul tune into a glorious country lament made for the first country soul record.

Not only had Parsons penned the album's originals, he was now singing the majority of the songs and so in circumstances that still remain clouded in some mystery and controversy, the vocals on a number of songs including 'The Christian Life' and 'You Don't Miss Your Water' were replaced by McGuinn's.

In July 1968 with the album in the works, Parsons quit the Byrds taking Hillman with him. By the time the album was released McGuinn was the last Byrd standing and their old audience was definitely not ready to go country.

'I think it was a noble experiment for the time,' said Hillman. 'There are some great songs, including two of Gram's best. He was like a young colt let out of the corral, rearing to go, and that was good for Roger and me. I think we opened a lot of doors for people who otherwise would never had listened to that kind of music.'

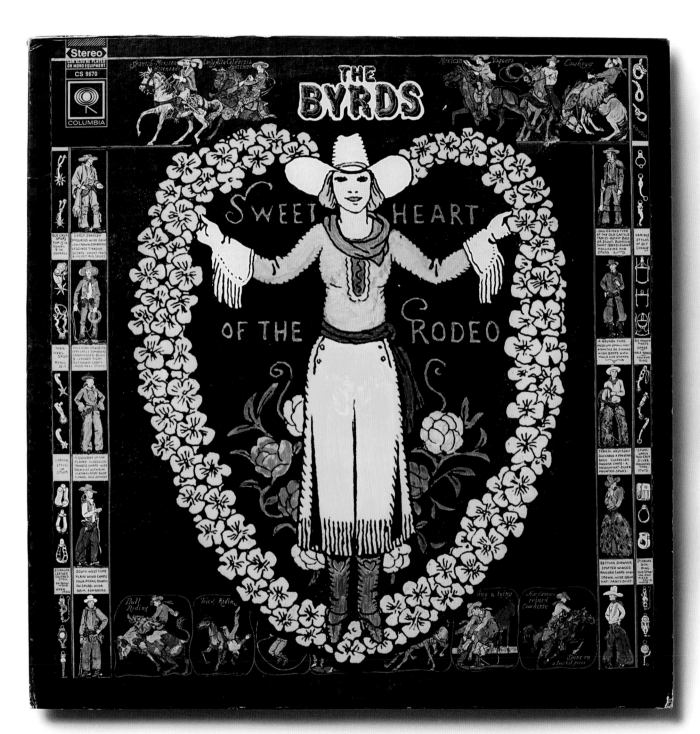

Index
ARTISTS

Index
ALBUMS

Published in 2013 by Hardie Grant Books

Hardie Grant Books (Australia)
Ground Floor, Building 1
658 Church Street
Richmond, Victoria 3121
www.hardiegrant.com.au

Hardie Grant Books (UK)
Dudley House, North Suite
34–35 Southampton Street
London WC2E 7HF
www.hardiegrant.co.uk

A Cataloguing-in-Publication entry is available from the catalogue of the National Library of Australia at www.nla.gov.au.

The 100 Best Albums of All Time

ISBN: 978 1 7427 0301 5

Publishing Director: Paul McNally
Executive Editor: John O'Donnell
Managing Editor: Lucy Heaver
Editor: Ariana Klepac
Design Manager: Heather Menzies
Designer: Debaser
Vinyl Photography: Andy Morris
Production Manager: Todd Rechner

Colour reproduction by Splitting Image Colour Studio
Printed and bound in China by 1010 Printing International Limited

Photography credits:
Page 15 – Bob Dylan: Don Hunstein/Sony Music Archives. Page 16 – Bob Dylan 'Like a Rolling Stone' playback: Michael Ochs Archives/Getty Images. Pages 17 & 19 – Bob Dylan in studio: Don Hunstein/Sony Music Archives. Page 23 – The Beatles in studio: Apple Corps Ltd. Page 26 – Joe Strummer: Pennie Smith. Page 27 – The Clash: Pennie Smith. Page 30 – Nirvana live: Charles Peterson. Page 31. Nirvana: Paul Bergen/Getty Images. Pages 34/35 – Van Morrison: Elliott Landy/Getty Images. Pages 38 & 39 – Joni Mitchell: Jack Robinson/Getty Images. Page 42 – The Rolling Stones: courtesy of Rolling Stones Records. Page 46 – Fleetwood Mac: courtesy of Rhino Entertainment Company, A Warner Music Group Company. Page 47 – Fleetwood Mac: Michael Ochs Archives/Getty Images. Page 50 – John Cale, Sterling Morrison, Lou Reed: Charlie Gillett Collection/Getty Images. Page 51 – Velvet Underground, Nico and Andy Warhol: courtesy of Universal Music. Page 54 – Chuck D: Janette Beckman/Getty Images. Page 54 – Flavor Flav: Janette Beckman/Getty Images. Page 55 – Public Enemy: Lisa Haun/Getty Images.

CHUCK BERRY
RANDY NEWMAN
THE BEATLES
THE WHIT...
KINKS
BOB DYLAN
WILCO
NW ASSA...
Jeff Buckley
Jo... M...
MILES DAVIS Dev...
PAVEMENT
KRAFTWERK
STOOGES
PEARL
TELEVISION
PEARL JAM
GUNS N' ROSES
Iggy & the Stooges
PRETENDERS
the EAGLES, Queen
COLDPLAY Stewart
Rod Stewart
for this ho...
the SUPER A...
Massive Attack
THE WHO
TOM WAITS
PRIMAL SCREAM
THE DOORS
the Rolling Stones
NIRVANA
ROXY MUSIC
the CLASH
DEREK & THE DOMINOS
John Lenn...
EMINEM